VELÁZQUEZ

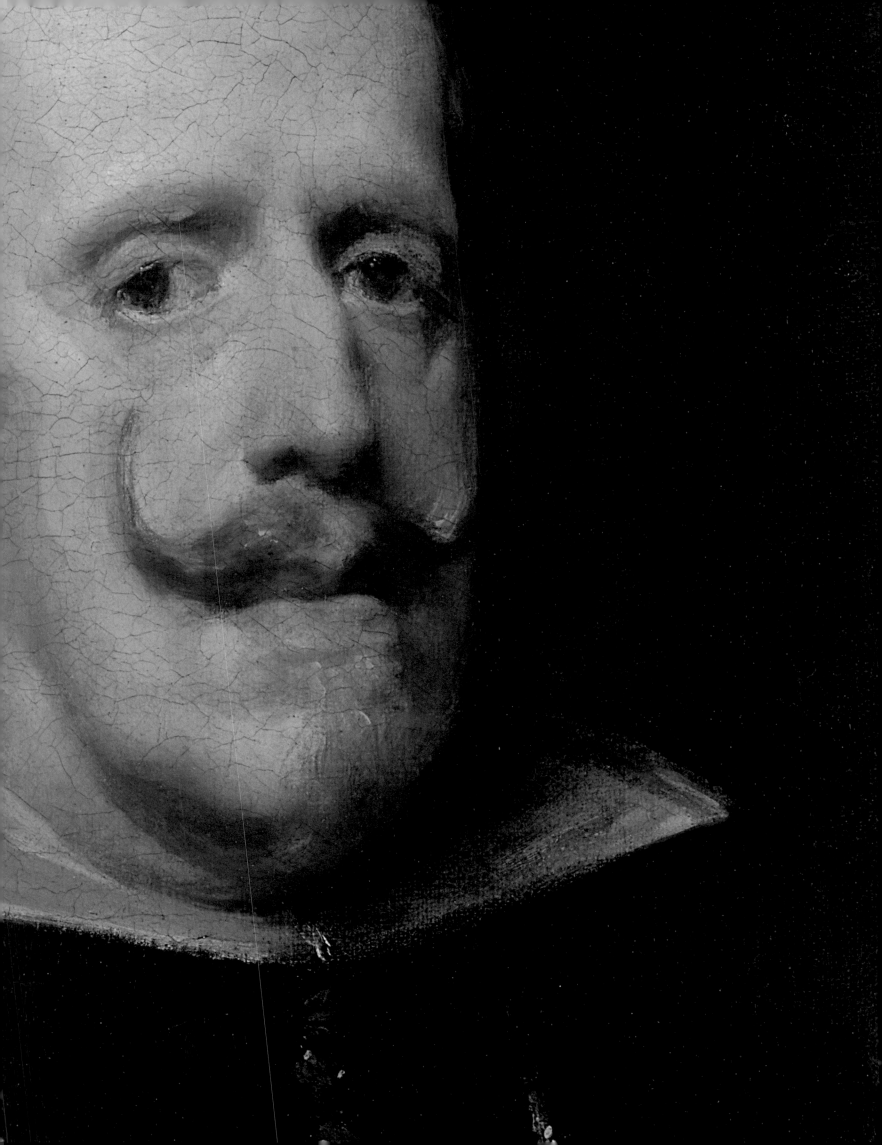

Velázquez

Dawson W. Carr
with Xavier Bray, John H. Elliott,
Larry Keith, Javier Portús

CATALOGUE ENTRIES

Xavier Bray, Dawson W. Carr, Simona Di Nepi, Gabriele Finaldi,
Giorgia Mancini, Wolfgang Prohaska

National Gallery Company, London
DISTRIBUTED BY YALE UNIVERSITY PRESS

For Enriqueta Harris Frankfort (1910–2006)

This book was published to accompany the exhibition

Velázquez

held at the National Gallery, London
18 October 2006 – 21 January 2007

Sponsored by Abbey

© 2006 National Gallery Company Limited

All rights reserved. No part of this publication may be transmitted in any form or by any means, electronic or mechanical, including photocopy, recording, or any storage and retrieval system, without the prior permission in writing from the publisher.

First published in Great Britain in 2006 by
National Gallery Company Limited
St Vincent House
30 Orange Street
London WC2H 7HH
www.nationalgallery.co.uk

HB ISBN 10 1 85709 303 8
HB ISBN 13 978 1 85709 303 2
PB ISBN 10 1 85709 308 9
PB ISBN 13 978 1 85709 308 7

British Library Cataloguing-in-Publication Data
A catalogue record is available from the British Library
Library of Congress Control Number: 2006928429

Publisher KATE BELL
Project Editor TOM WINDROSS
Editor DIANA DAVIES
Designer PHILIP LEWIS
Picture Researcher KIM KLEHMET
Production JANE HYNE AND
 PENNY LE TISSIER

Printed and bound in Italy by Conti Tipocolor

All measurements give height before width
Works by Velázquez unless noted otherwise

Contributors

XB XAVIER BRAY
DC DAWSON CARR
SDN SIMONA DI NEPI
GF GABRIELE FINALDI
GM GIORGIA MANCINI
WP WOLFGANG PROHASKA

FRONT COVER
Infanta María Teresa (detail of cat. 43)

TITLE PAGE
Philip IV of Spain (detail of cat. 44)

PAGES 8/9
The Immaculate Conception (detail of cat. 9)

PAGES 24/25
An Old Woman cooking Eggs (detail of cat. 3)

PAGES 54/55
The Toilet of Venus ('The Rokeby Venus')
(detail of cat. 37)

PAGES 68/69
Mercury and Argus (detail of fig. 103)

PAGES 90/91
Pope Innocent X (detail of fig. 28)

PAGES 112/113
Saint John the Evangelist on the Island of Patmos
(detail of cat. 10)

Contents

✳❆❈❆✳

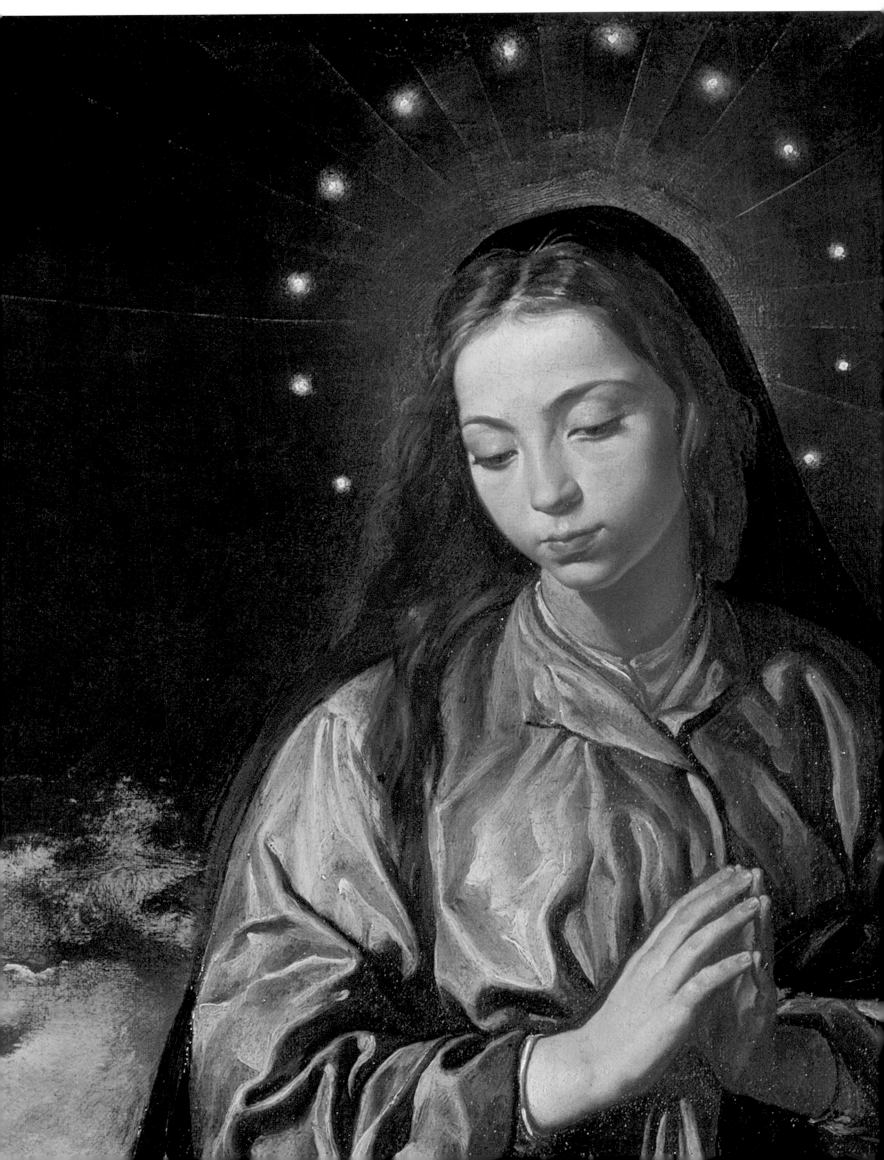

Appearance and Reality in the Spain of Velázquez

JOHN H. ELLIOTT

'*Reality and Appearance*. Things do not pass for what they are but for what they seem; few look within, and many are satisfied with appearances.' (Baltasar Gracián, *The Oracle*, 1647)[1]

THE SPAIN IN WHICH Diego Rodríguez de Silva Velázquez was born in 1599 was a country in which appearances showed increasingly ominous signs of being at odds with reality. The old king, Philip II, had died in the previous year, after a reign of forty-two years. The most powerful monarch in Europe, he had left the young Philip III an exhausted realm of Castile, an immense burden of debt, and a faltering mission to preserve his dynastic inheritance intact and rescue Christendom from the advance of heresy. No expense was spared, however, to celebrate the deceased king's exequies in a manner worthy of the ruler of a global empire, officially known as the Spanish Monarchy, the *monarquía española*. Seville, the city of Velázquez's birth, surpassed even its own reputation for lavish display by erecting in its cavernous cathedral a massive catafalque on which the late king's virtues were emblematically represented, his achievements depicted, and the extent of his world-wide dominions proclaimed. The crowds gazed in awe at the impressive monument. 'I vow to God', wrote Cervantes in a famous sonnet, 'that the grandeur of it terrifies me. . .' But the irony behind his exaggerated reaction to this proud assertion of the king's undying glory did not escape contemporaries (fig. 1).[2]

Seville could no doubt afford the outlay on the catafalque. As the receiving point for the annual remittances of silver from the mines of Mexico and Peru, it was one of the richest cities of the western world. Yet Cervantes was not alone in detecting the disparity between the grandiloquence of the statement made by this ephemeral monument and the realities of the world beyond the doors of the cathedral. A memorialist writing at the turn of the century commented pointedly on the internal contradictions of the Spain of his day. 'Never', he wrote, 'were there vassals so rich as today, and never such poverty as is found among them. Never before was there a king so powerful nor with so many kingdoms and sources of revenue, and never has one embarked on a new reign with his estates so diminished and pledged away.' He attributed this to the fact that the cascade of silver from America had blinded his compatriots to the fundamental truth that the source of genuine wealth was hard work and productive investment. 'And so', he continued, 'the reason why Spain has no money, or gold and silver, is because it has them, and the reason why it is not rich is because it is.' Deluded by its misperceptions, Spain had become 'a republic of enchanted men, living outside the natural order of things'.[3]

It was in this Spain, and in Seville, the richest – and poorest – of its cities, that the young Diego Velázquez, the grandson of Portuguese immigrants from Oporto, and the son of the notary in charge of the cathedral chapter's tribunal for dealing with testamentary provisions,[4] embarked on his artistic career and grew to maturity. It was a Spain in which the new ministers of a new monarch struggled to conserve a burdensome legacy. In spite of the American silver still reaching Seville in massive quantities, the crown's finances were in no state to sustain the vastly expensive military and foreign policy commitments incurred by Philip II. Reluctantly the new regime, headed by Philip III's favourite and first minister, the Duke of Lerma, beat a phased retreat. Sixteen years of open war with the England of Elizabeth were ended by a treaty concluded in 1604 with her successor, James I and VI; and five years later Madrid agreed to a twelve years' truce with the king's rebellious subjects in the Netherlands, where Spain's impressive army of Flanders was bogged down in an immensely costly, and apparently unwinnable, war to bring the revolt to an end. The government sought to distract attention from the humiliations of a truce signed with heretics and rebels by ordering on the same day the expulsion from Spain of its population of some 300,000 Moriscos, the nominally Christianised Moors who had remained in the peninsula after the surrender of the last Moorish king of Granada in 1492. As a boy, Velázquez would have seen the straggling line of around 18,000 Moriscos on its way to embark in Seville for the ports of North Africa.[5] Seventeen years later, Philip's son and successor, Philip IV, chose this supreme act of royal piety as the subject for a competition between his court artists. The competition was won by Velázquez with a painting, now lost, which showed Philip III in armour pointing with his baton at a group of weeping men, women and children, with the majestic and matronly figure of Spain seated on his right.[6]

An act that can be interpreted as an example of Spain's dedication to the cause of pure religion, or as a necessary solution to an intractable ethnic problem, was also an assertion of gesture politics. Questions of honour and reputation ran through the life of Spanish, as of all European, society in this period. 'How to preserve reputation' was the theme of a section of *Reason of State* (1589) by Giovanni Botero, one of the most influential political theorists of the age,[7] and the ministers of Philip III, as representatives of the greatest monarch in the world, were acutely aware of the importance of maintaining the reputation of their king. The need for this was all the greater at a time when Spain's military power appeared to be flagging, and financial necessity was dictating at least a temporary suspension of arms. Lerma and his colleagues used every art to ensure that the resulting peace would look like peace on their own terms, a *pax hispanica*. Spanish diplomats, assisted by Spanish money, worked with skill and devotion to ensure that the

reputation of their royal master was upheld in the courts of European princes, and that Spain's international pre-eminence would be as readily acknowledged in a time of peace as of war.[8]

By 1618 the storm clouds would again be gathering, and Europe would be on the brink of a new international conflagration, the Thirty Years' War. Although the interlude of peace brought some respite, and allowed the court and the aristocracy to indulge in conspicuous consumption on a lavish scale, Madrid depended heavily on artifice and sleight-of-hand diplomacy to maintain the image of overwhelming Spanish power. As the more perceptive of contemporary observers recognised, this image did not accord with the underlying economic and social realities that Lerma's corrupt and profligate government proved reluctant to address. Imagery and rhetoric were no substitute for reform.[9]

Imagery and rhetoric, however, were integral to Spanish Baroque society, as to that of early seventeenth-century Europe as a whole. This was an age of theatre and illusion, and nowhere more so than in the Seville of Velázquez. In the opening years of the new century the city was the theatrical capital of Spain. Around 1600 it boasted four public theatres, and the Coliseo, a splendid new municipal theatre, opened its doors to the public in 1607.[10] Theatre in Seville, however, was not confined to the *corrales de comedias* (playhouses). The city provided a spectacular backdrop for the street theatre which constituted a permanent accompaniment to civic life. Much of this theatre was religious in character. *Autos sacramentales*, descendants of medieval mystery plays, were performed in public places before large crowds, and the clergy, municipal dignitaries, members of religious confraternities and large numbers of the populace would process through the streets in celebration of a local saint or some great event in the liturgical calendar, such as the feast of Corpus Christi. In these great processions, elaborately carved and painted images of Christ, the Virgin and saints, produced in Seville's numerous workshops, were borne aloft or carried on *pasos*, or religious floats. Sevillians were fervently devoted to the cult of the Virgin, and when the doctrine of her Immaculate Conception was disputed by a Dominican preacher in 1613, the city rose in fury at this stain on her honour. Innumerable masses were performed and sermons preached in support of the controversial doctrine. The painting of the *Inmaculada* (cat. 9) by Velázquez in 1619 was one among the many images created in a campaign that set religious orders at each other's throats and added further complications to Spain's always complex relations with the papacy.[11]

It would not be surprising if Velázquez, as an apprentice in the studio of one of the city's leading artists, Francisco Pacheco, was deeply influenced by the theatre that he saw all around him. The description of his lost Expulsion of the Moriscos makes it sound like the depiction of a scene from a play. There is a theatrical

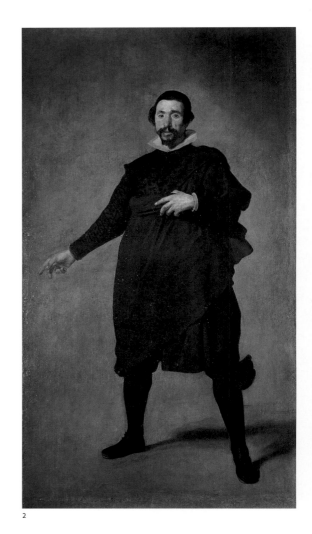

2

quality, too, to *Christ after the Flagellation contemplated by the Christian Soul* (cat. 16), and to some of the portraits, like that of Pablo de Valladolid (fig. 2), standing alone as if on an empty stage.[12]

There was more to Seville, however, than the theatre which shaped and coloured so much of public life (fig. 3). As a great port city, Seville was the meeting-point of several different worlds: the Indies, which were popularly said to have paved the city's streets with gold; Spain's beleaguered northern outpost of Flanders, whose merchants constituted an important foreign community in the city; and Italy, the artistic and spiritual capital of Counter-Reformation Europe, with which Seville's ties were close.[13] A relatively affluent and well-educated civic élite, consisting of members of the local nobility, cathedral canons, and other members of the clergy and the professional classes, was therefore exposed to the many influences entering Seville from abroad. The Casa de Pilatos, the family home of the Dukes of Alcalá, contained a famous collection of Roman antiquities, and the third duke, Don Fernando Enríquez Afán de Ribera, maintained the humanist traditions of his predecessors, building up a splendid library, and becoming a notable patron of the arts.[14]

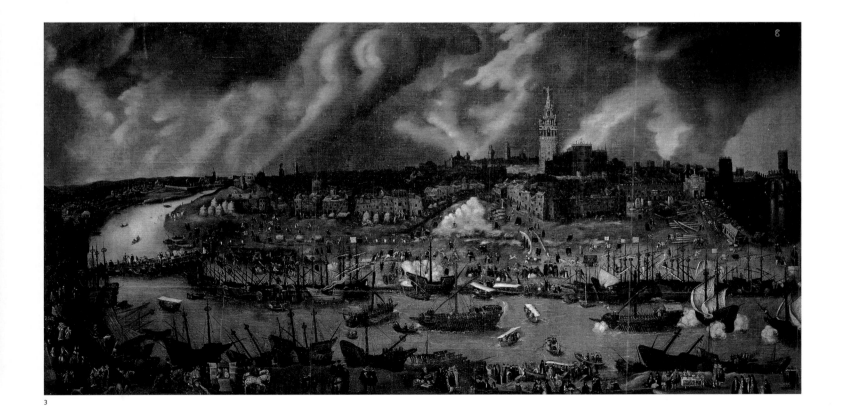

3

Velázquez's master, Pacheco, who was commissioned by the duke to decorate his study in the Casa de Pilatos, headed one of the several 'academies' or informal groups that flourished in the city in the early seventeenth century. Poets, scholars, artists and men of letters would gather in his house and those of other eminent figures in the city to discuss questions of literary and artistic theory or of antiquarian concern, and engage in the conceits which so delighted the learned world of the seventeenth century. Here, in addition to learning the technical skills required for the licence to practise as a painter, Velázquez was introduced to a world of ideas that would inform his work as an artist for the remainder of his life. It was a world which, although imbued with classical learning, was also alive to recent advances in science and mathematics, and displayed a particular interest in optics and the laws of perspective. Significantly, Velázquez's personal library would contain a high number of scientific texts.[15] The literary and artistic vitality of the Seville of his youth created a promising environment for the development of a gifted and intelligent young artist. But as Velázquez set up as a painter in his own right, marrying his master's daughter, Juana Pacheco, and establishing a growing reputation for himself in Seville, he came up against limits imposed both by the nature of his profession and by an environment that ultimately could not give him all he needed if he were to develop his genius to the full. For all its cosmopolitan traits, Seville remained a provincial city at heart. It was in the court of Madrid that the true action lay. Moreover, artists in the Spain of Velázquez were still regarded as no more than artisans, and their social status, as practitioners of a purely mechanical art, was not high. Velázquez's father-in-law would regard it as his mission to dignify and ennoble the profession: had not Apelles secured the exalted approbation of Alexander the Great, and Titian been knighted by the Emperor Charles V?[16] Only at the court of the king could a great artist win the fame and rewards he deserved, and secure for his profession the elevation of status that had long been its due.

A Velázquez aspiring to greater opportunities than those offered by Seville was fortunate in that his hopes for a career at court coincided with a spectacular change of regime in Madrid. The Duke of Lerma fell from power in 1618, and his successors were struggling helplessly in the face of a rising tide of demands for reform when Philip III died unexpectedly on 31 March 1621 at the age of forty-two. His sixteen-year-old son and heir, now Philip IV, immediately acted to remove his father's ministers from power. As his principal minister he chose an experienced diplomat and councillor, Don Baltasar de Zúñiga, but everybody knew that the power behind the scenes was Zúñiga's nephew, the ambitious Count of Olivares, who had won Philip's favour while he was still the heir to the throne. Within little more than a year Zúñiga was dead, and Olivares moved to take over the levers of power, which he would control for the succeeding twenty years.

4.
Philip IV of Spain, 1623–4
Oil on canvas, 61.6 × 48.2 cm
Meadows Museum,
Southern Methodist
University, Dallas
Algur H. Meadows Collection
(67.23)

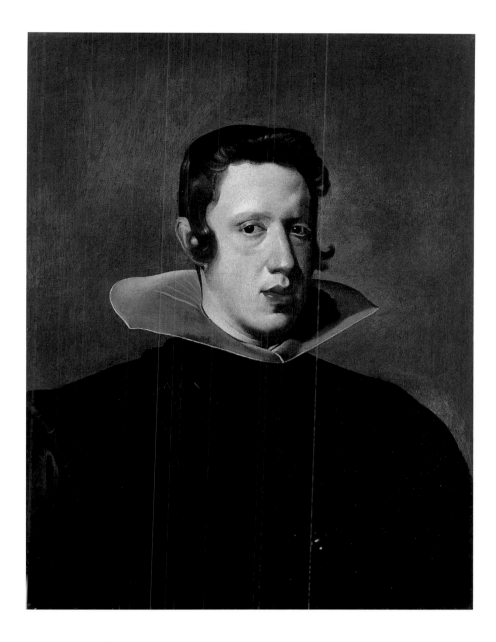

Although born in Rome, where his father had been the Spanish ambassador, the Count of Olivares – or the 'Count-Duke', as he came to be known following his elevation to a dukedom in 1625 – prided himself on being a 'son of Seville', and he lived in the city between 1607 and 1615, the year in which he secured a post in the household of the heir to the throne.[17] In those Seville years he was a noted, and flamboyant, patron of poets and men of learning, and is known to have had his portrait painted by Francisco Pacheco.[18] Velázquez in the days of his apprenticeship may therefore well have come into contact with the man who would dominate the Spanish political scene during the first half of the reign of Philip IV.

When Olivares captured power at court in 1621 it was natural that his Sevillian friends and acquaintances, together with a host of aspirants, should flock to Madrid in the hope of receiving offices or favours from a man whom they regarded as one of their own. Velázquez was only one among the many ambitious Sevillians who took the road to Madrid in these opening years of the reign, and although his first visit, in 1622, proved abortive, with the support of friends at court, and presumably with the active approval of Olivares, he was named painter to the king

in the following year. It was the beginning of a court career in which, in addition to being the king's favoured artist, he would also move by degrees up the ladder of palace appointments, beginning in 1627 with that of usher in the royal chamber.[19]

These palace appointments – Assistant in the Wardrobe (1636), Assistant in the Privy Chamber (*ayuda de cámara*) in 1643 – not only brought Velázquez useful income additional to the stipend he received as painter to the king, but gave him a secure place in the royal household, with all that this meant in terms of access to the royal person, and all the additional benefits that such proximity could entail. Yet while it made him a member of a select group of some 350 principal royal servants in a court that numbered around 1,700 household officials and service staff,[20] it also involved him in time-consuming and increasingly onerous duties, and tied him to the routine of palace life. With the exception of his two visits to Italy, in 1629–31 and 1649–50, and those periods when the king escaped with members of his entourage into the countryside to go hunting, or made a journey further afield, he was to spend most of the rest of his existence in and around the Alcázar in Madrid.

With the capture of power by Olivares and his relatives and dependants, Seville itself may be said to have come to Madrid. The Sevillian tradition of pageantry and patronage brought new vitality to a court at the centre of which now stood a young king who was still unformed, but who already possessed a taste for the theatre and music, and would soon show that he had inherited the Habsburgs' discriminating eye for the visual arts.[21] Olivares, who was thirty-four years old at the time of his conquest of power, had high ambitions for a royal master who was half his own age (cat. 20 and fig. 4). The King of Spain was the greatest monarch on earth, and Philip had to be trained to fill the exalted role to which God had called him. During the 1620s Olivares introduced an initially indolent and pleasure-seeking youth to the business of government, and prepared for him an extensive reading programme to broaden his knowledge of history and the world in which he lived. Philip was endowed with a natural intelligence, and the programme was successful. By the early 1630s, Philip had acquired an impressive and wide-ranging private library in his palace apartments where every day he spent two hours reading after dinner, and set himself to translate into Spanish Books VIII and IX of Guicciardini's *History of Italy*.[22]

A genuinely cultivated prince was central to Olivares' ambitions for Spain and its ruler. He and his supporters had come to power with a programme designed to restore the strength and reputation of Spain after what they regarded as the failures and humiliations of the Lerma years. 'I think I can truly assure Your Majesty', wrote Olivares in 1625, looking back to the moment of the king's accession, 'that the reputation of Spain and its government was as low as the rivals of its greatness could have wished.'[23] The rivalry between the princes of seventeenth-century Europe

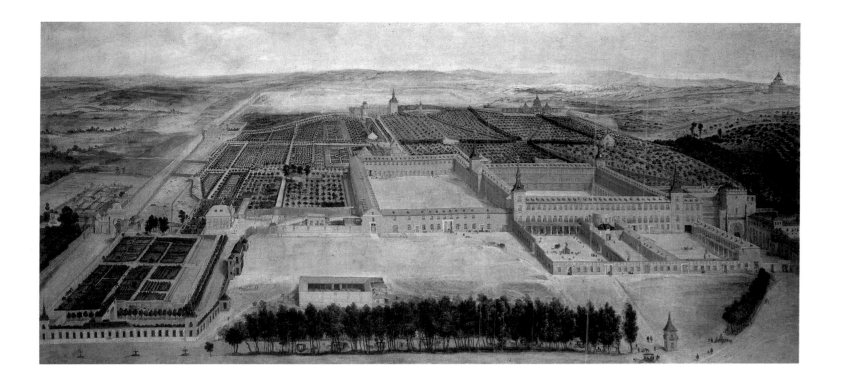

was not confined to the battlefield. The unexpected visit of the Prince of Wales to Madrid in 1623 in a bid to win the hand of the king's sister, the Infanta María, brought the king face to face with a prince five years his senior, whose culture and connoisseurship had exposed his own inadequacies.[24] A King of Spain could not afford to remain in second place in the world of the arts. He must be the central luminary in the most brilliant and cultivated court in Europe, a true 'Planet King', as he came to be styled by court poets and playwrights after the fourth planet, the sun.

Olivares and the king were fortunate in that the first half of the seventeenth century was a period of brilliant creativity for the arts in Spain, but they used their patronage to ensure that this creativity was concentrated in the court, although Luis de Góngora, whom Velázquez would paint while he was looking for preferment in Madrid, would eventually return home to Córdoba, a disappointed man (cat. 15). Others, however, were more successful. The two greatest playwrights of the age, Lope de Vega and Pedro Calderón de la Barca, wrote play after play for court performances; the corrosive wit of Francisco de Quevedo was harnessed, if with difficulty, to the service of the Olivares regime; the Andalusian playwright Luis de Guevara, appointed a gentleman usher in 1625, delighted the court with plays that created a vogue for works depending for their effects on the deployment of elaborate stage machinery; and, rising head and shoulders above the other court artists, Velázquez created a series of unforgettable images of the king and the royal family.

Velázquez, as part of a tight-knit group of courtiers, palace officials and dependants of the Count-Duke, seems to have been very much at home in this court environment. His selection as the king's chosen artist opened doors to him that would otherwise have been closed, and gave him some of the standing for which he craved. It also afforded him the opportunity to study at leisure the works of Titian and other Venetian masters so well represented in the royal collection, and to examine them in the expert company of Rubens, when the great Flemish artist

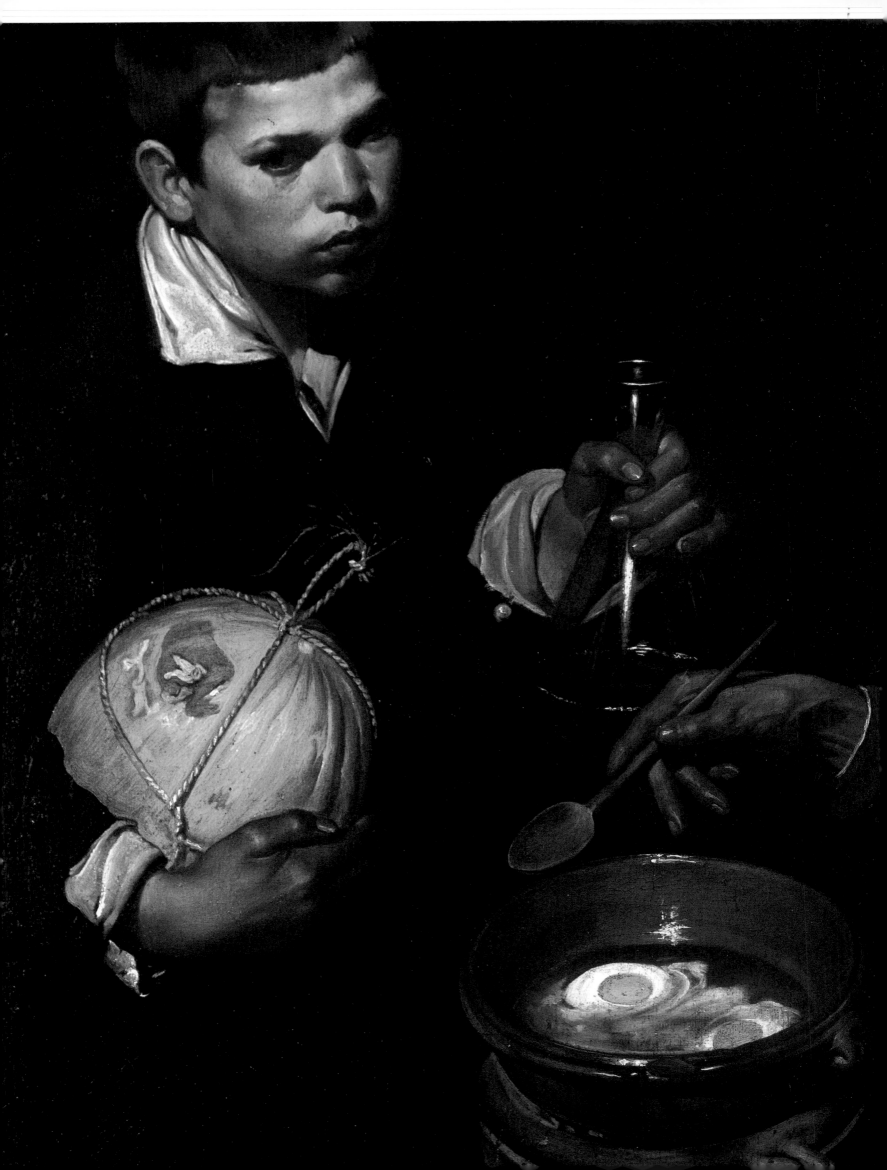

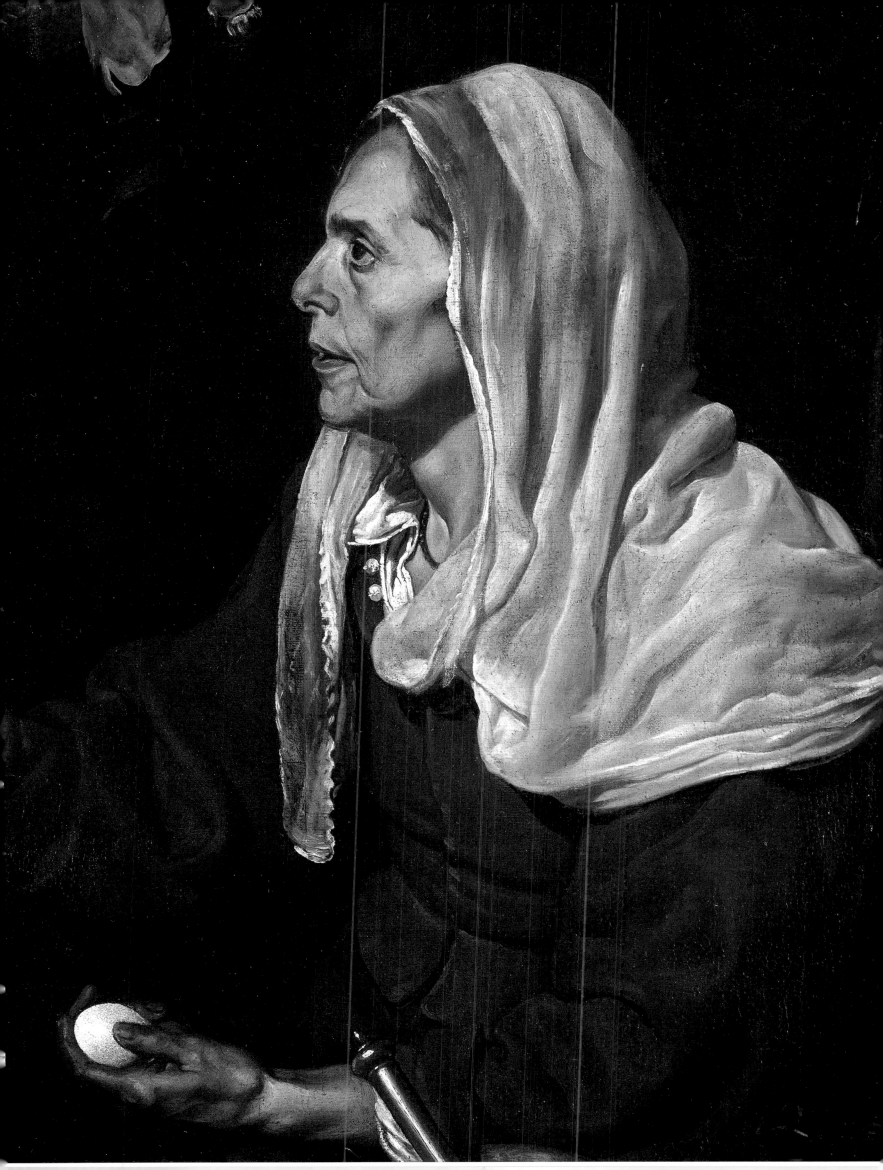

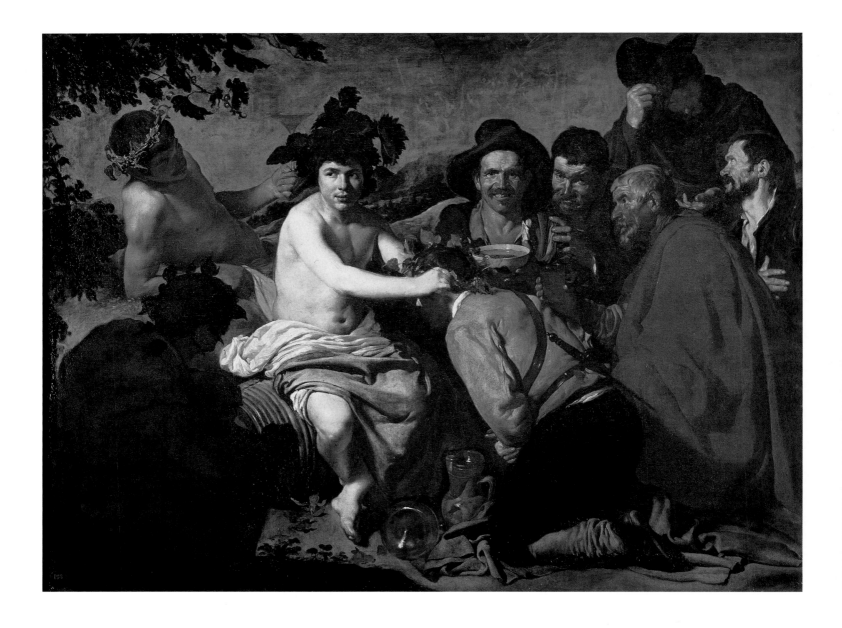

Velázquez's first mythological scene, *The Feast of Bacchus* (fig. 15), was created around the same time and emphatically proclaimed his inventive abilities and his independence from the conservative classicism of the other court painters.[19] The god is being crowned with vine leaves by a follower, as one would expect to find in a bacchanal, but he is otherwise surrounded by characters from a Madrid tavern. This mix was long thought to be a parody of the classical god providing a moral on the evils of drink, but it has been shown to be quite the opposite. Poets, mythographers and emblem-makers of the preceding generation celebrated the young Bacchus as the bringer of the virtues of wine to soothe the harshness of life, but none with the visual relevance of Velázquez.[20] He presents a modern-day Bacchus, who initiates a follower, while the expressions of the others indicate their familiarity with the delights wine brings. Behind a figure in shadow approaches and, whether he seeks to join the gathering or another form of solace, alms, he is a poignant foil, illustrating the condition the others have escaped. In this work, Velázquez showed that his naturalistic style was not incompatible with the depiction of mythological themes and that his primary goal would be to endow such ancient tales with contemporary significance.

In 1628, Peter Paul Rubens, one of the most famous artists in Europe, visited Madrid and provided Velázquez with his first true, living role model.[21] Rubens had complained of the incompetence of Spanish artists on his first visit to Spain in 1603, but he recognised the talent and intelligence of Velázquez, twenty-two years his junior. They shared a studio and are reported to have spent many hours looking at pictures in the royal collection together. Though Velázquez had already achieved a body of outstanding work, Rubens surely realised that it was still provincial and that Velázquez needed the experience of Italy that had completed his own education. Rubens also provided another significant example. He was not in Madrid to paint, but to negotiate a peace treaty with England, and his status confirmed for Velázquez that service in the royal household was the way to success in art and life.

Italy

The watershed moment in Velázquez's career was his first trip to Italy. The king, no doubt encouraged by Rubens, gave Velázquez leave to set off in the summer of 1629 and he returned only in January 1631. Distinct from virtually every artist who had made the trip before, Velázquez possessed advanced knowledge of European painting from daily contact with the royal collection. He had a better group of works by Titian at home than he would find in any one collection abroad, but the first-hand experience of Italy was transforming.[22]

It is generally accepted that *Joseph's Bloody Coat brought to Jacob* (cat. 17) and *Apollo at the Forge of Vulcan* (cat. 18) were painted in Rome, even if this is only first stated in 1724, because they show an artist converted by the grandeur and clarity of Roman design.[23] His intent to prove himself at the centre of the art world is evident in the scale of the works, and in his choice of unusual subjects, each an intricate human drama testing his ability to express principally through the figure, the aim of history painting. In all probability, Velázquez truly selected these scenes himself because the canvases were only sold to the crown in 1634, which implies that they were made on his own initiative during his period of leave.[24]

Velázquez found a dizzying variety of pictorial styles being practised in Italy, which surely encouraged him, already an experienced artist in his own right, to develop his own distinctive manner. In 1630, the exuberant and artful High Baroque style was burgeoning in Rome, as epitomised by Pietro da Cortona's *Rape of the Sabines* (Pinacoteca Capitolina, Rome), but it was probably easier for Velázquez to relate to the classical strain in Baroque art. He might have visited Poussin while he was painting *The Death of Germanicus* (Minneapolis Institute of Arts) and Guido Reni was busy working on *The Abduction of Helen* (Musée du Louvre, Paris).[25] From works such as these, he experienced the ways in which his colleagues were using

Velázquez had surely pondered Jan van Eyck's homage to this idea in *The Arnolfini Portrait* (National Gallery, London), then in the royal collection in Madrid, but Velázquez's mirror puzzle in *Las Meninas* lays emphasis on art as deception. It is clear enough that it reflects an image of the king and queen – their visages executed with Velázquez's customary brevity in treating small figures – but the source of the reflection is not so obvious. Are the monarchs standing just outside the picture space, essentially where the viewer is, or does the mirror reflect their image on the canvas on which Velázquez is working?

Velázquez made sure that we could not be certain about what he is painting. Is it a portrait of the king and queen, for which they are posing? Or, are they merely visiting as he works? The chamberlain's presence in the doorway behind suggests that they are passing through as his responsibilities included opening doors before them. Why then is Velázquez still painting? Have they interrupted him at work on a portrait of the infanta? It seems a rather large canvas for a little princess. Perhaps he is painting *Las Meninas* itself. There are many intriguing clues, many possibilities, but few answers. The dialogue with the viewer is endless, a solution always evading us.

The actions within the painting are caught midway to suggest an instant frozen in time. They are vague enough to allow for the intrusion of the viewer, or for the king and queen. If the characters in the painting are responding to the royal presence, they are exhibiting a familiarity that implies that nothing out of the ordinary is going on. However, the presentation of the Spanish royal family in such a casual context was unprecedented, and by showing himself in their company, Velázquez made a claim for the nobility of his art and for himself. Here, in a scene apparently true to life, Philip IV visits Velázquez, as Alexander the Great visited Apelles. Velázquez's claim for painting as a liberal art is embodied in his attitude. His brush is poised, but he is looking and thinking. He pictures himself in a moment of inspiration, a member of the extended family of Philip IV, the great image maker of his reign.

As one approaches the canvas, the marvellous illusion, Velázquez's claim to immortality, dissolves into paint. With seeming effortlessness, he built the image using the minimum means possible. The ground colour serves as a mid-tone and broad washes are broken up with strokes and dabs, some long and gestural, others short and staccato. The delicate hand gestures emerge from the barest suggestion of form and the hazy definition of features increases in the darkness behind. It is perhaps the very greatest *tour de force* of western painting. In subject and execution, it is as the French philosopher Michel Foucault wrote in 1966, the representation of representation.[50]

The elusiveness of *Las Meninas* suggests that life, and art, are an illusion. This idea permeated Spanish culture in the seventeenth century, founded on the

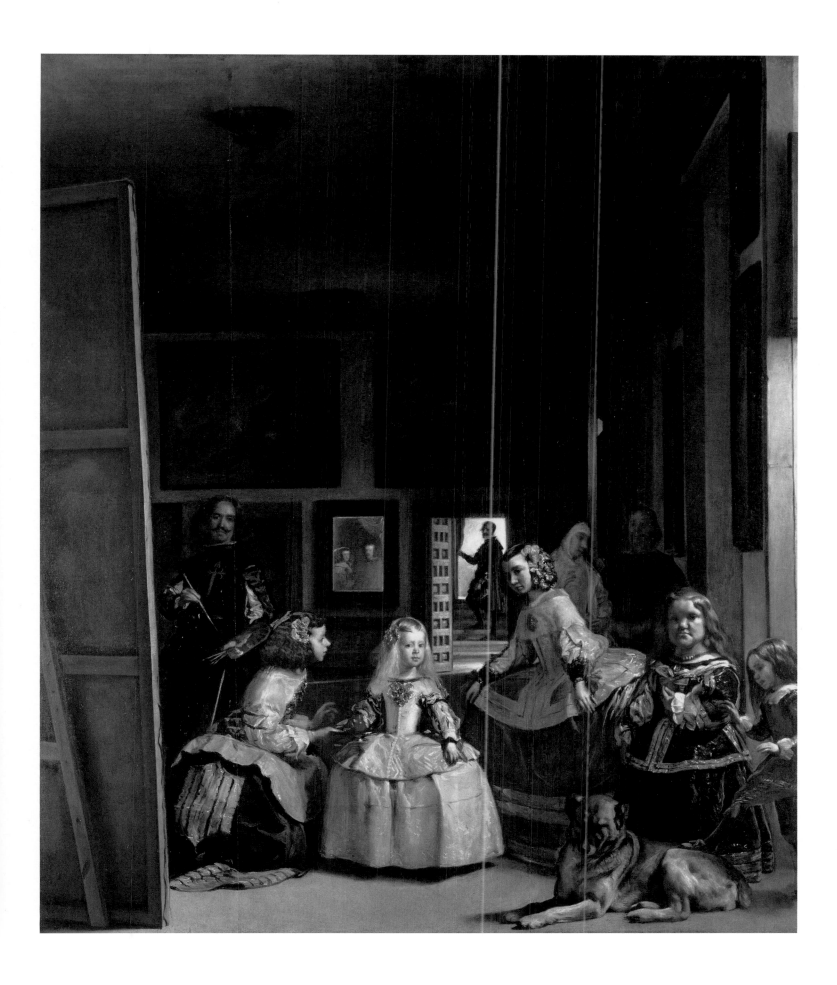

31.
**The Fable of Arachne
('The Spinners')**, 1656–8
Oil on canvas, 220 × 289 cm
Museo Nacional del Prado,
Madrid

Christian concepts of true life after death, and that temporal truth is not necessarily skin deep.[51] The notion that existence is nothing more than a semblance of reality is expressed in the literature of the period, most eloquently in Calderón de la Barca's *Life is a Dream*, the work often interpreted as the literary equivalent of Velázquez's painting:

> What is life? A frenzy. What is life?
> A shadow, an illusion, and a sham.
> The greatest good is small; all life, it seems
> Is just a dream, and even dreams are dreams.[52]

Calderón was born the year after Velázquez and was granted the habit of a knight of Santiago in 1637, but the painter would have to wait a while longer.

Velázquez painted only one other history painting in his last years, *The Fable of Arachne*, known as *The Spinners* (fig. 31),[53] created for a friend, Pedro de Arce, the Master of the Hounds and a great connoisseur of painting. It would seem that Velázquez determined the subject because it depicts the story of a proud mortal artist who pitted herself against the gods. Ovid's *Metamorphoses* (6:1) tells of Arachne, a Lydian girl from humble origins, who gained fame for her amazing skill as a weaver. Swollen with pride, Arachne dared to challenge Minerva, the goddess of wisdom and patron of the arts, to a weaving contest. Minerva depicted scenes of insolence punished, while Arachne chose to show the gods' most shameful exploits, beginning with Jupiter's abduction of Europa. Already enraged by the insolent choice of subjects, Minerva could stand no more when her rival's tapestry was judged the equal of her own, tearing it to bits and turning Arachne into a spider.

The moment of Arachne's triumph is depicted in her light-filled studio, where finely dressed women attend her and a musician is poised to play. Arachne stands before her tapestry, for which Velázquez quoted one of Titian's greatest compositions from the royal collection, *The Rape of Europa* (fig. 33). Minerva raises her arm to effect the transformation and Velázquez freezes the action.

One final time, Velázquez employed the strategy of reversing the classical order of composition that had intrigued him since his youth. Here he foregrounds the menial work that precedes weaving, clearly distinguishing the dark world of craft from the light-filled chamber of art behind. The sort of humble task that had fascinated the young artist becomes the focus of his most extraordinary painterly illusions, the depiction of motion in the spinning wheel, and the flurry of fingers winding thread. Velázquez had sought to imply movement in his vague indications of form and contour, but here he captures transient optical effects of motion in the static medium of paint and the choice of motifs was not accidental. Velázquez owned a copy of Pliny's *Natural History*, the principal source on ancient art, which lauds two painters for capturing movement, Aristides, who showed wheels turning

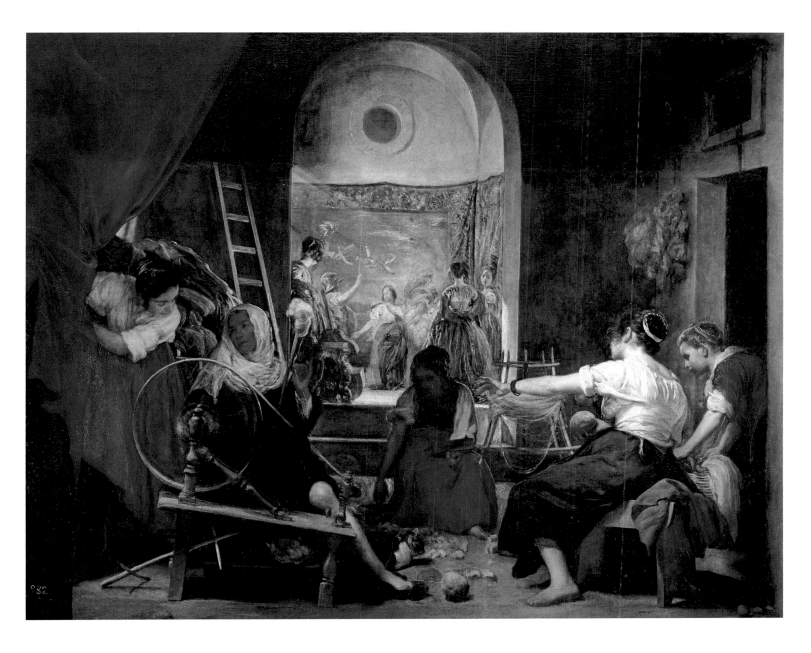

on a carriage, and Antiphilus, who depicted 'a spinning room, in which all the women are plying their tasks'.[54] By giving Arachne's tapestry the appearance of Titian's painting, Velázquez pays homage to his predecessor, equating his work with the best Minerva could produce. By showing movement, he achieved something not realised since antiquity, surpassing Titian, and fulfilling a quest that began forty years before when he tried to capture the transformation of an egg in hot oil.

The 'gods' of Velázquez's world were the nobility. His nomination by the king for admission to the Order of Santiago was twice rejected, but two papal dispensations regarding his noble lineage were obtained and finally, on 28 November 1659, he was made a knight.[55] While early legend would have Philip IV painting the cross of Santiago onto the painter's coat in *Las Meninas*, Velázquez probably took care of this task himself, adding this clear sign that he and his art were truly noble.

Velázquez was deeply involved in the planning and staging of the historic meeting on the Isle of Pheasants on 6 June 1660 (fig. 8), when Philip IV delivered his daughter María Teresa (cats 42–3) for marriage to his nephew, Louis XIV. In particular, he was responsible for the decoration of the Spanish side of the pavilion with tapestries from the royal collection. Velázquez is said to have participated in

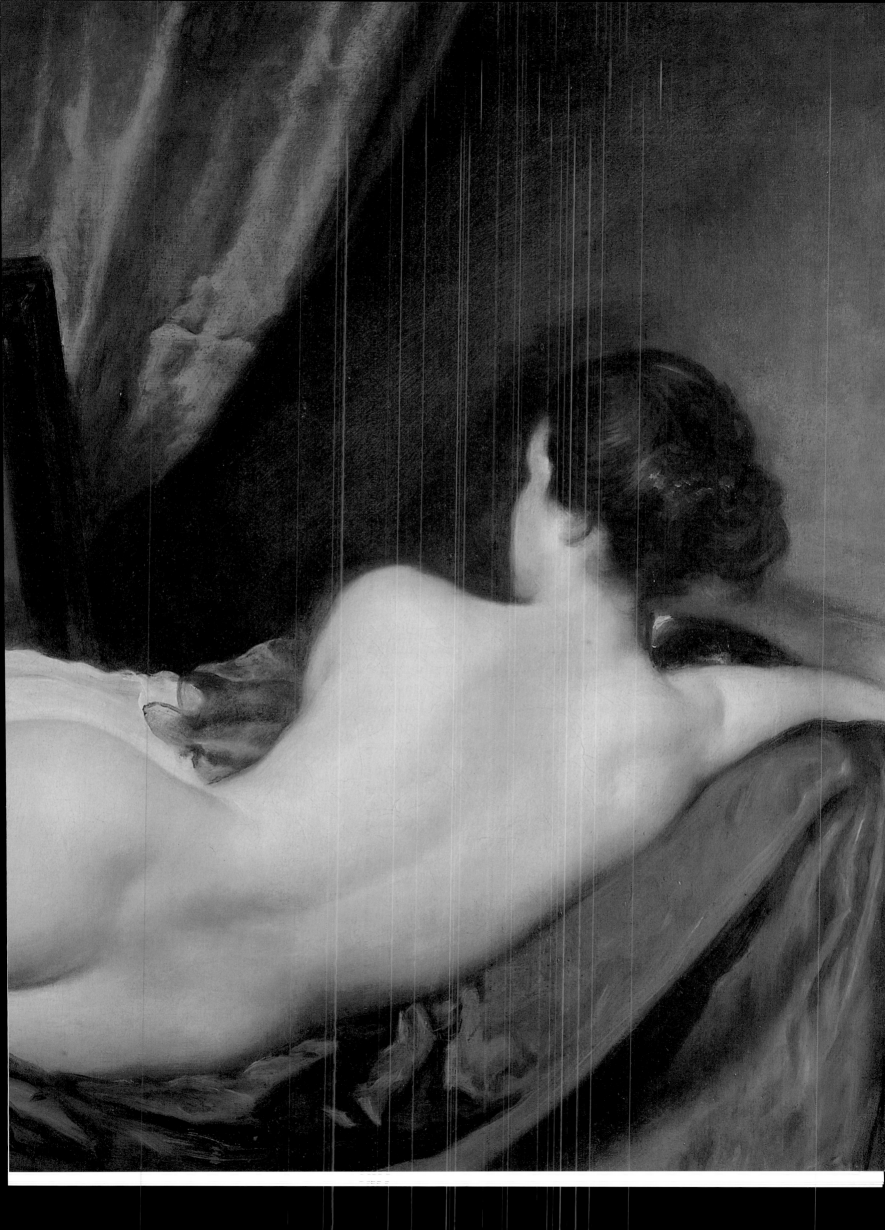

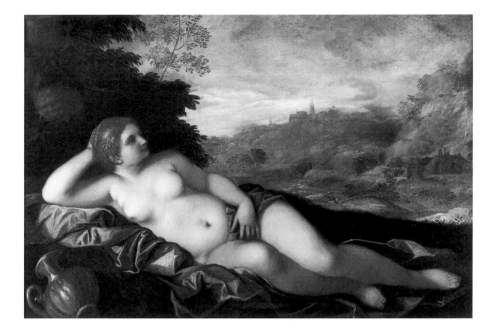

aristocrats who were the principal owners of such works. Paravicino proposed the total destruction of all paintings of this type, an opinion that would undoubtedly have seemed excessive to Braganza.

Nude painting had a very particular status in Spain at this period, not just because of its erotic character and the fact that it was seen as a threat to morality, but also because of the artistic values attached to it.[32] In western tradition, the nude was one of the subjects most directly linked to the idea of 'art',[33] and this was further emphasised in Spain, where the most important paintings in royal and aristocratic collections were mythological compositions. An outstanding example of the prestige that these works enjoyed in the great collections is to be found in the 1636 inventory of the paintings in the Alcázar in Madrid.[34] The most private part of the collection was located from the 1620s at the far north end of the building in the so-called 'lower summer apartments'.[35] As mentioned earlier, one of the rooms in this area was described as where 'His Majesty retires after eating', that is to say, one of the most important of the king's private rooms. Here, the inventory lists nine paintings, all of outstanding quality, all by Titian, and all erotic in content. They are the six *poesie*, plus *Adam and Eve*, *Venus with Cupid and a Musician* (both now Museo Nacional del Prado) and *Tarquin and Lucretia* (now Fitzwilliam Museum, Cambridge). In other words, this was not a room of mythological paintings – but a room of nudes. In fact, rooms with similar collections, feature regularly in the history of royal and courtly collecting in Spain from the late sixteenth century to the early decades of the nineteenth.[36] Concealing such highly esteemed paintings from the public eye in rooms of this type was a response to social pressure, but we should also bear in mind that the resulting collection was a remarkable combination of nude painting and artistic beauty.[37] Without a doubt, the paintings that Philip IV reserved for his most private room would have been among his most treasured,[38] and of all the rooms in the Alcázar, this was probably the one where he could most fully express his love of painting.

The Toilet of Venus was created in this context of high esteem for nude painting. Titian and Rubens – the two key reference points for courtly taste at this period – were both outstanding painters of the nude, and during the 1630s Rubens and his

39.
Francisco de Goya
(1746–1828)
Naked Maja, before 1800
Oil on canvas, 97 × 190 cm
Museo Nacional del Prado,
Madrid

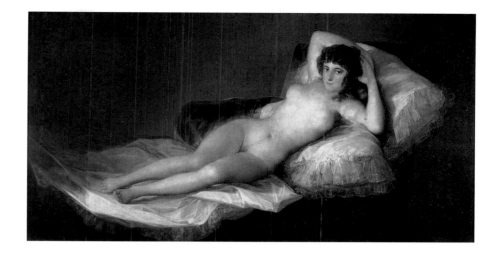

workshop produced a huge number of paintings of this type for the Alcázar and other royal palaces. When Velázquez painted his *Venus* he could not ignore the connotations of the subject and the wide variety of meanings and emotions it aroused, as well as the highest aesthetic and narrative values it expressed. The religious authorities might ban its creation, but the monarch and the most elevated ranks of the aristocracy valued it highly, and there was already a clearly established link between mythological painting and power. This very tension that these double standards created – between the real risk of social stigma and the love of beauty – emphasises the special status enjoyed by Velázquez, the only Spanish painter permitted to execute a work of such overt sensuality.[39]

Velázquez was well aware of his unique position, and his entire oeuvre reflects an ongoing dialogue with tradition and his desire to formulate his response to it.[40] This is above all evident in the *Venus*, a completely original and innovative work. Although the device of the mirror was already to be seen in a painting by Titian in the Alcázar,[41] and Venus' pose has precedents in prints[42] and classical sculpture,[43] the final result is totally different from the work of any other artist.[44] As was customary practice with Titian and Rubens, Velázquez used the richness of colour and fabric to surround and highlight the sensuality of the nude. The way Venus' body is constructed, however, has little in common with the style of the other two artists, who sought to equate opulence and sensuality. Velázquez creates his Venus from a subtle interplay of curves which together form a marvellous arabesque: the curves of the head, of the neck flowing into the shoulders, the curves formed by the body and the exquisite curves of the hips, thigh and calves. These define the woman's body and in turn interact with other interior and exterior curves, such as the line that describes the backbone and its extension into the buttocks, and the beautiful line made by the fold in the sheet on which the goddess is lying. In contrast to the works of Titian and Rubens, in which the idea of flesh and solid form prevailed, Velázquez has here depicted the female nude as a series of rhythms in which each element is closely related to the others, together forming an organic and lifelike whole. Again in contrast to his predecessors – and to his own work such as *Mars* (cat. 36) – he depicts the surface of the skin as smooth and almost devoid of irregularities, lines or creases, avoiding a thick, impastoed appearance. To model the body he used subtle plays of light that highlight the pearly tones of the flesh as they fall across it. The balance between line and colour is beautifully achieved without the artist having to renounce one of his most characteristic

features: the use of apparently unfinished areas, such as the right foot and arm here. Together with the ambiguous manner in which the outlines of the face and torso are realised, these areas emphasise the feeling of pulsating life that fills the painting. Applied to the flesh, this technique was one of Velázquez's greatest achievements and represents a further step on the path towards the realistic representation of the living body initiated by illustrious predecessors such as the Venetian painters and Rubens.[45]

Velázquez's unique pictorial approach is also evident in his treatment of the narrative. The artist emphasises the intimate way in which the model is presented, thus approximating her to representations of Danaë and distancing her from many of the figurative conventions normally used to depict Venus.[46] The visual and pictorial devices that he uses are directed far more towards conveying the reality of a naked female body than towards constructing a narrative. The very fact that Venus is shown from behind and very close to the foreground, and that her face is simply a blur on a mirror, serves to arouse our emotions. As a result, the rhythms of her body become the main focus of the painting, to the extent that whoever compiled the inventory of the Marquis of Heliche's collection forgot that this was a Venus or some other goddess and simply described her as 'a reclining nude'.[47]

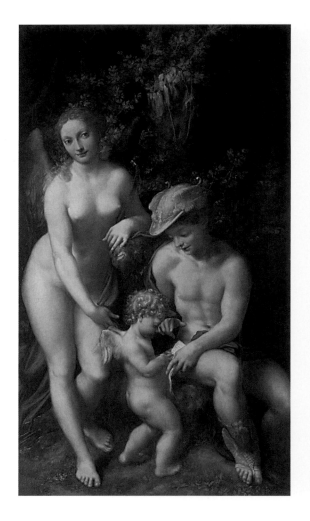

The painting's later history reaffirms its status as a nude painting. For many years, as Enriqueta Harris and Duncan Bull have shown, Velázquez's painting was hung next to a sixteenth-century Italian painting (private collection, fig. 38)[48] depicting a reclining Venus with her head resting on her right hand, seen frontally in a landscape setting.[49] Such a pairing, characteristically found in paintings of the nude, was similar, as Harris and Bull pointed out, to Titian's intentions with the *Danaë* and *Venus and Adonis*, sent to Philip II. Pairing such pictures served to emphasise the formal aspects of the composition over its narrative content, and was frequent in private galleries of nudes, which featured works from different narrative genres (mythology, the Bible, ancient history, etc.). It is not surprising that the present *Venus* and her companion later entered one of the most important private cabinets of nude painting in eighteenth-century Spain, that of Don Manuel Godoy. There the painting shared wall space with works such as Correggio's *Venus and Mercury with Cupid* (fig. 40) and Goya's *Majas* (fig. 39), whose naked version[50] is the first female nude in art not to represent a figure such as Danaë, Eve or Venus.[51] As we all know, however, the story of the *Toilet of Venus* does not end here: the painting still bears the scars of wounds inflicted in April 1914 by a suffragette, who attacked not so much a mythological painting as a naked woman.[52] Like Paravicino, this protestor also believed that the finer the nude, the greater the danger.

1 *Corpus velazqueña* 2000, p. 482, no. 735.

2 Published in Pita 1952, pp. 223–36. The complete inventory was recently published in Burke and Cherry 1997, pp. 462–83.

3 See McLaren and Braham 1970, pp. 125–9.

4 Aterido 2001, pp. 91–4. Guerra Coronel's inventory was published in Saltillo 1944–5, pp. 43–8.

5 Montagu 1983, pp. 683–5.

6 For the collection of Luis de Haro, see Brown 1995; and Burke in Burke and Cherry 1997, pp. 153–6.

7 For Heliche, see Andrés 1975.

8 On Heliche as a collector, see López Torrijos 1991, pp. 27–36; and Burke in Burke and Cherry 1997, pp. 156–70.

9 The inventory, in Burke and Cherry 1997, pp. 465–81. Nos 73, 102, 138, 149, 159, 163, 164, 165 and 301 in this inventory.

10 Burke and Cherry 1997, pp. 902–4, 906–9, 914–17.

11 Ligo 1970, pp. 345–54.

12 López Rey 1995, no. 101.

13 'Un lienzo grande del rey nuestro señor en un caballo castaño y su Majestad armado con un bastón en la mano y el sombrero puesto y en el aire unas mujeres que llevan la esfera sobre su cabeza y detrás del caballo un indio que lleva en la mano la celada. El caballo y cuerpo del rey y mujeres de la mano de Juan Bautista del Mazo y la cara del rey de Velázquez.' (A large canvas of his Majesty on a chestnut horse and in armour with a staff in his hand and wearing a hat and in the sky various women bearing the globe above his head and behind the horse an Indian carrying the helmet in his hand. The horse and king's body and the women by Juan Bautista del Mazo and the face of the king by Velázquez). Burke and Cherry 1997, p. 476.

14 This is probably the painting in the Metropolitan Museum of Art, New York. On problems relating to its attribution, see Brown 2000, pp. 54–6.

15 'Una mujer desnuda y postrada sobre la mejilla con una paloma' and 'Una Venus con un candil encendido en la mano que alumbra a un cupidillo.'

16 For the painting in the collection of Jean Néger, see Bettina and William Suida, *Luca Cambiaso. La vita e le opere*, Milan 1958, p. 154. It measures 120 × 95 cm. The work in the Heliche collection seems slightly smaller as it measures 'vara y cuarta de caída y una de ancho' (a vara and a quarter high by one wide).

17 There are examples in the Museo Nazionale de San Martino, Naples, and in the Musées Royaux des Beaux-Arts, Brussels.

18 '223. Una pintura en lienzo de un fauno y una mujer con muchas diversidades de frutas y una cornucopia compuesta con cantidad de frutas' (223. A painting on canvas of a faun and a woman with a great variety of fruit and a horn of plenty with much fruit). Said to be a copy. It may resemble the painting by Rubens and Snyders in the Museo Nacional del Prado, Madrid (inv. 1672).

19 Two varas by two and a half. It has been assumed that *The Rape of Europa* is the same painting as that which was offered at Sotheby's in London on 10 July 2003 and which was at Rokeby Hall from at least 1769. See the catalogue of the auction, lot 5. With thanks to Gabriele Finaldi for drawing my attention to this copy.

20 'Una hortelana desnuda de medio cuerpo arriba y un mozo que le está hablando.'

21 Delaforce 1972, pp. 742–52.

22 Studied by Orso 1986, pp. 74ff.

23 See Checa 1994.

24 The 'cuarto bajo de Verano', 'Sala donde se retira su Majestad después de comer' and 'Bóvedas de Tiziano', respectively.

25 Muller 1989, pp. 94ff.

26 Nos 97 and 173.

27 Armas 1985, pp. 31–42.

28 *Copia de los pareceres y censuras de los reverendísimos padres maestros y señores catedráticos de las insignes universidades de Salamanca, y de Alcalá, y de otras personas doctas, sobre el abuso de las figuras, y pinturas lascivas y deshonestas, que se muestra, que es pecado mortal pintarlas, esculpirlas y tenerlas patentes donde sean vistas.* Commentary and transcript in Calvo Serraller 1981, pp. 237–60.

29 *Novissimus librorum prohibitorum es expurgandorum index*, Madrid, Diego Díaz 1640. Quoted by Cordero de Ciria 1997, p. 53.

30 The 'parecer' was entitled 'Respuesta del Maestro Hortensio a una consulta sobre lo lícito, o ilícito de las pinturas lascivas'. It was posthumously published in *Oraciones evangélicas*, Madrid 1766, vol. VI, pp. 429–35. Published and studied in Portús 1996, pp. 77–105.

31 Idem., p. 102.

32 Civil 1990, pp. 39–50; Cordero de Ciria 2003, pp. 29–65.

33 Two texts on this subject with widely differing critical viewpoints but which both make this association are Clark 1981, and Nead 1992, p. 1.

34 The inventory is in the Archive of the Palacio Real, Madrid.

35 Volk 1981, pp. 513–29.

36 For the history of rooms displaying nude paintings in Spain, see Portús 1998. For the room in which the Titians were to be found in 1636, see pp. 95ff.

37 Portús 1998, p. 95.

38 Checa 1994, p. 156

39 For its sensuality, the *Venus* can only be compared in a Spanish context with some of Alonso Cano's female nudes (such as those in the Museo del Prado and the Galleria degli Uffizi). These, however, are drawings, which is a far more discreet medium than oil painting.

40 Albers 1999, pp. 13ff., has emphasised this point.

41 Lost, but there is a version in the National Gallery of Washington. For an account of the relationship between Velázquez's *Venus* and Rubens's *Venus*, see Morán Turina 2004, pp. 43–68.

42 Sánchez Cantón 1960, pp. 137–48. That author pointed out its similarities with various prints by Agostino Vereziano, Hans Sebald Beham and Theodor de Bry.

43 Justi pointed to the *Hermaphrodite*. Justi 1889 pp. 462; and Maclaren to the *Ariadne* in the Villa Medici.

44 Brown (1986, p. 183) had already indicated how the *Venus* goes far beyond any of its possible models.

45 For a reflection on the connotations associated with this technique, see Prater 2002, pp. 89ff.

46 It has been suggested that the painting is not a Venus, but rather a Danaë. See Bernal 1990, pp. 113–18.

47 Among authors who have emphasised this tension between narrative and the nude, see Prater 2002, pp. 73–4.

48 Published by Harris 1990, p. 555.

49 Bull and Harris 1986, pp. 643–54; Harris and Bull 1990.

50 On Godoy's private room of paintings and the presence of the *Majas* in it, see Pardo Canalis 1978–9, pp. 300–11, and Rose 1987, pp. 137–52.

51 On the *Majas* and the process by which the nude became a pictorial genre, see Portús 1997.

52 For an account of the precautions taken with regard to the *Venus* during its first century in Great Britain, see Haskell 1939.

Velázquez's
Painting Technique

LARRY KEITH

'Much to admire and nothing to surpass'
(Antonio Palomino, *Lives of the Eminent Spanish
Painters and Sculptors*, 1724)

VELÁZQUEZ OCCUPIES an unusual place in the history of art in that our appreciation of him is so strongly based on our sense of how he applied paint. Of course no one would deny the sophistication of his iconography, or the erudition of such works as the *Spinners* (fig. 31) or, most famously, *Las Meninas* (fig. 30). To a modern eye, however, it is the more abstract qualities of his facture which seem most astounding and out of time – for example, his intuitive understanding of optical phenomena which lie at the heart of impressionist painting, or his cool exploitation of the expressive qualities of gestural brushwork. That he deployed these qualities within compositions of such minimalist formal elegance has only increased his appeal for our contemporary tastes. Velázquez has always had a special attraction for fellow artists. Manet famously described him to Henri Fantin-Latour as 'the painter's painter', and to Baudelaire he wrote that 'at last I've really come to know Velázquez and I tell you he's the greatest artist there has ever been; I saw 30 or 40 of his canvases in Madrid, portraits and other things, all masterpieces; he's greater than his reputation and compensates all by himself for the fatigue and problems that are inevitable on a journey in Spain.'[1]

Emphasising formal elements and the defining characteristics of individualised style is a particularly rewarding way to examine an artist of Velázquez's qualities. Yet as compelling as it may be for us to view him essentially through Manet's modern eyes, it is also important to remember that Velázquez developed in a cultural milieu with different artistic concerns. However transcendent his genius, it was none the less of his time. If we make the effort to place his painting technique within the context of his contemporaries, it ultimately deepens our appreciation of the way he worked, and how he set down his vision in paint.[2]

Velázquez's most important teacher was Francisco Pacheco, with whom he was apprenticed from about 1611 to 1617,[3] and who was to provide his essential formation. Pacheco's fame now rests largely on his association with Velázquez[4] but it also comes as the result of the publication of his *Arte de la pintura*, published posthumously in Seville in 1649.[5] The book lies within a tradition of writing about the method of painting firmly established in sixteenth-century Italy by such writers as Lomazzo, Borghini, Armenini and Vasari. Like them, Pacheco combines practical information about technical matters with more esoteric humanistic intellectual concerns – but his book is also something of a manifesto for the elevation of the status of the profession of painting within Spain.

It provides a fascinating insight into the artistic sensibilities which formed the foundation of Velázquez's painterly education. It sets forth a *disegno*-based, ideated art in which skill in draughtsmanship allows complete expression of a learned, humanistic vision – albeit expressed in the pedagogical manner of someone seemingly more comfortable with the rhetoric of painting than the act itself. Yet Pacheco is ultimately an intriguing figure, and however dour he may appear in print another side does emerge. His writing also shows a deep understanding for reading paintings and a genuine enthusiasm for the intrinsic merit of painting as an intellectual pursuit and profession of the highest order. There is a spare eloquence in his summation of the career of his illustrious son-in-law, all the more moving for its honest self-assessment: 'I consider it no disgrace for the pupil to surpass the master; it is more important to tell the truth.'[6]

Any association of the rather crabbed drawing-based style of Pacheco with the sublimities of the later Velázquez's paint handling may seem like an implausible leap, but there is no denying that an incredible facility with draughtsmanship is one of the bedrock qualities of Velázquez's painting – even as the purely linear elements of his paintings are progressively reduced by his increasingly free and expressive brushwork. Pacheco's stress on the craft of drawing and an eclectically sourced intellectual vigour behind the creation of images are essential elements that will remain constant within the work of his son-in-law, and are particularly evident in his earlier pictures.

These early paintings were made within the *bodegón* tradition established in Seville, which was dependent on a diverse combination of Flemish and Italianate artistic sources, both paintings and prints.[7] The stitching together of such disparate influences, whether from Flemish-inspired portraiture or still life, Italianate figural compositions, or northern European prints, was best accomplished through the method of carefully drawn compositional studies, as was specifically advocated by Pacheco.[8] Velázquez added a new component to the established mixture, however – very possibly as the result of the Caravaggesque naturalistic influences coming into Spain[9] – in that his working method included a great deal of preparation drawn from the life, of both people and still-life elements. Pacheco relates that Velázquez bribed a 'a young country lad' to serve as a model and he would adopt various attitudes and poses, 'sometimes weeping, sometimes laughing. . . . And he made numerous drawings of a boy's head and of many other local people in charcoal heightened with white on blue paper, and thereby he gained assurance in portraiture.'[10]

The *Kitchen Scene with Christ in the House of Martha and Mary* (cat. 4) is typical of works from this period and, in spite of its added Christian iconographic content, it lies squarely within the *bodegón* tradition. The picture is built up over a brown ground used in all of his paintings from this period, the so-called 'Seville clay'

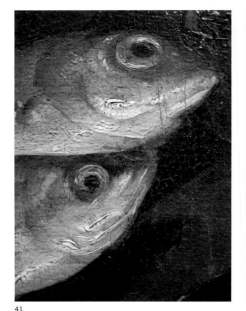

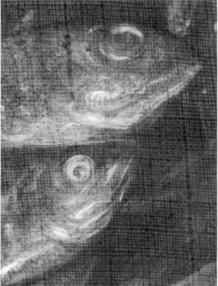

41.

42.

41–2.
Detail from *Kitchen Scene with Christ in the House of Martha and Mary* (cat. 4), with an X-ray detail showing initial laying-in (fig. 42); this was achieved with a paint that contained lead-white, shown clearly in the X-ray describing the tip of the snout of the lower fish.

(*barro de sevilla*) referred to by Pacheco.[11] The X-radiograph shows no overlapping of painted forms or indications of significant revision, suggesting a high degree of compositional planning. This evidence reinforces the sense of the painting as a careful assembly of individually studied elements,[12] which method also accounts for the odd disruptions in scale and perspectival inconsistencies. The powerful verisimilitude of the main protagonists could only have been achieved from posed models – indeed the same old woman also appears in the Edinburgh *Old Woman cooking Eggs* (cat. 3) – while the relentless intensity of the depiction of the still-life elements must also result from independent carefully observed preparatory studies. While there is evidence to suggest that some of the initial laying-in of the design was achieved with lead-white-containing paint using a very fine brush (figs 41–2) – seen here describing the tip of the snout of the lower fish[13] – this technique seems likely to have been used together with other drawing methods, for example the brown washy brushed drawing seen on other, later works.[14]

Whatever the exact drawing method, it seems clear that Velázquez proceeded by essentially filling in the various separate drawn elements with paint, which perhaps accounts for the strangely disjointed, rather fragmented feeling of many of his early works.[15] His paint application is thick and direct, with a very limited palette consisting largely of earth pigments, black and white. [16] It is fascinating to see the variety of touch already apparent in such an early work as the *Kitchen Scene*,[17] ranging from the broad and thick brushwork of the young woman's drapery to the rather nervous and quivering handling of the figures in the distant view. He already demonstrates a remarkable sureness in the precise application of highlights, whether on an eyelid, copper vessel, or fish, and the still-life elements in particular suggest the incredible facility of his more mature paint handling.

The composition of Velázquez's *Immaculate Conception* (cat. 9) is virtually identical to Pacheco's treatment of the subject now in Seville Cathedral (fig. 9),[18] and provides an intriguing demonstration of his youthful allegiance to Pacheco's teaching, as well as of his precocious overtaking of his master. The slightly awkward combination of separately studied fountain, landscape and central figure comes as no surprise, but the subtle *contrapposto* and startlingly individualised features of the Virgin are not found in Pacheco's version. Also, although most of the finished

composition carefully follows the initial laying-in, the X-radiograph shows a major change undertaken well into the course of painting, in which the blue mantle had initially been conceived billowing around the front of the Virgin's lower legs (figs 43–4).[19]

The growing painterly awareness suggested by the confident revision of the *Immaculate Conception* is taken still further in the execution of its probable pendant,[20] the *Saint John on Patmos* (cat. 10). Although the composition is broadly based on a sixteenth-century Flemish print, the painting's powerful impact is the result of working from life.[21] The X-radiograph again suggests a composition that has been carefully arranged from the outset, as can be seen where the ground just remains uncovered along carefully aligned contours such as that between the proper right leg and the drapery (fig. 45). The painting of the drapery reveals an amazing confidence of facture, whether in the hatched wet-in-wet working of the red fabric or the exuberant loading of the brush visible in the red lake glazes. There is a supreme control apparent in the tilting of the broad square-ended brush to load one side of the stroke, sometimes with two semi-blended colours at the same time, or in the careful exploitation of raised extruded ridges of paint at the edges of strokes in order to emphasise contours. There is also a typically wide variety of handling evident in the later refinements of contours or thickly applied highlights, often made with a very fine brush.

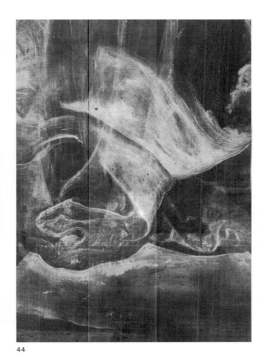

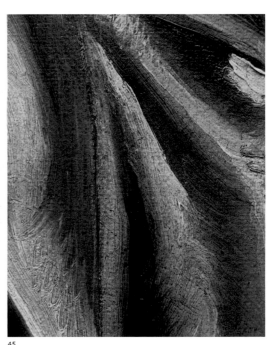

43

44

45

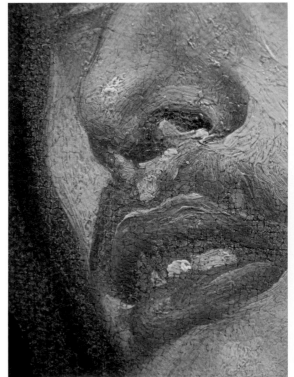

46.
Detail of *Saint John the Evangelist on the Island of Patmos* (cat. 10), showing exposed blanched ground around the saint's mouth and teeth.

47.
Detail of brush wipings from the lower left background of cat. 10. The lowermost stroke was covered by Velázquez with olive-brown paint, which would have matched the surrounding exposed ground. This indicates the degree to which it has blanched.

46

The *Saint John* is also notable for the so-called brush wipings visible in the background, although these are a constantly recurring feature of his work and are present in both the *Immaculate Conception* and the *Kitchen Scene*. Those at the left of the *Saint John* are unusual for their twisting, relatively complex shapes; they do not obviously describe a changed or missing compositional element, but seem more experimental in the sense of testing the loading of the brush through the execution of the kind of long and complex patterns visible within the finished drapery painting. They must have remained disturbingly visible in the nearly finished painting, for they were deliberately touched out by Velázquez. The olive-brown paint he used for this is now much darker than the surrounding areas of relatively exposed Seville clay ground, and provides compelling evidence for the degree of blanching and colour change which has occurred in the ground (it may be that the high proportion of silica and calcium carbonate makes the material particularly prone to blanching, possibly exacerbated by glue-paste relinings).[22] Unpainted exposed ground colour was also used in the depiction of the saint's eyes, nose and mouth (fig. 46), which now appear oddly pale; the same disconcerting phenomenon is present in parts of the Virgin's hair and face in the *Immaculate Conception*, as well as in isolated areas of the *Kitchen Scene*. If the darker colour of Velázquez's own retouching of his brush wipings – made to match the original colour of the ground – is mentally substituted in such blanched areas the modelling becomes much more effective. Another notable change which has occurred in the *Saint John* and the *Immaculate Conception* is found in the red lake pigments, which are much faded. Identified as Mexican cochineal, something of their original hue and intensity is suggested in the close observation of tiny areas where the applied glaze has pooled within the brushwork of the underlying bodycolour (fig. 47).[23]

As his working methods develop one can see Velázquez's innate painterly abilities breaking through the constraints of Pacheco's teaching, even as he also respects the primacy of drawing and *disegno*. There is a certain irony in the fact that Pacheco's inclination to see the act of painting as essentially a Florentine-style colouring-in of a drawing would provide the foundation for an artist who would do so much to expand the expressive qualities of paint. Palomino, writing about a century later, touched on this dual aspect: 'Velázquez rivalled Caravaggio in the boldness of his painting and was the equal of Pacheco on the side of the theoretical.'[24] Yet to see Velázquez's Sevillian paintings as essentially Caravaggesque is also something of an oversimplification. Given that copies or works by loosely Caravaggesque artists like Ribera were almost certainly the only sources of transmission, Caravaggio's influence was largely a matter of the written tradition of his naturalism and his general approach to composition and lighting. The technical similarities that do exist between the two painters, such as the careful laying out of the composition before painting, are just as likely to be coincidental as not,

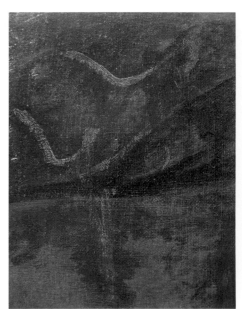

47

48.
Detail of *Christ after the Flagellation contemplated by the Christian Soul* (cat. 16), showing exposed red-brown ground typical of Velázquez's early years in Madrid.

since they can be as easily explained by Pacheco's teaching as by Caravaggio's example. Systematic exploitation of the ground colour in much of the flesh modelling, so typical of most of Caravaggio's painting, is largely absent from the richer application and more opaque modelling of Velázquez's flesh, even in the mid-tones and shadows. On the other hand, the fundamental naturalism inherent in the emphasis on drawing from the life, even if advocated by Pacheco, is an element that is difficult to imagine without some knowledge (even if indirect) of Caravaggio's example. Velázquez was therefore receptive to the innovations of Caravaggesque painting, but only selectively so; it was the sort of qualified, filtered eclecticism – as urged by Pacheco – that would continue throughout his career as he encountered the riches of the Spanish royal collection in Madrid.

Velázquez's connections and ambition soon led him to visit Madrid in search of a position at court;[25] after a first unsuccessful attempt in 1622, during which visit he produced the portrait of *Luis de Góngora* (cat. 15),[26] he eventually secured a royal post. His manifest facility in life drawing fit perfectly with the court's seemingly inexhaustible appetite for portraiture, leading him to dedicate himself almost exclusively to this genre in his first years in Madrid.[27] The intrigues and rivalries among his fellow artists at the court were considerable, and given his undeniable talent he was initially criticised for his concentration on portraiture at the expense of the more highly regarded genre of history painting.[28] However, his victory in the 1627 royal competition for the commission of a history painting of the Expulsion of the Moriscos effectively rebuffed his critics.[29]

The growth of Velázquez's interest in subject matter beyond portraiture was given further impetus in 1628 by the arrival of Rubens – a figure whose importance as both an artistic and social model is difficult to exaggerate. Rubens's influence on the young Velázquez can be seen in the ambitious iconographic complexity of his 1629 *Feast of Bacchus (Los Borrachos)* (fig. 15), while the example of Rubens's early study in Italy was surely the major catalyst for Velázquez's 1629–31 Italian tour.

It is in this context that we must consider the National Gallery's *Christ after the Flagellation contemplated by the Christian Soul* (cat. 16). The picture sits at a peculiar intersection of naturalistic and idealising influences, both Spanish and foreign, not unlike *Los Borrachos*, and the question of its dating – before, during or after Velázquez's first Italian trip – is a problem where technical evidence is often presented. Like *Los Borrachos*, the picture is painted on a red-brown ground, predominantly comprised of earths with some translucent chalk and other silicates, a material widely used by other painters at court and which was typical of works from Velázquez's initial years in Madrid.[30] It is clearly visible at the right contour of the white sleeve of the standing angel's proper left arm (fig. 48).[31]

While empirical evidence suggests that some initial chalk or charcoal drawing may have occurred,[32] there is extensive brushed drawing with brown-black paint,

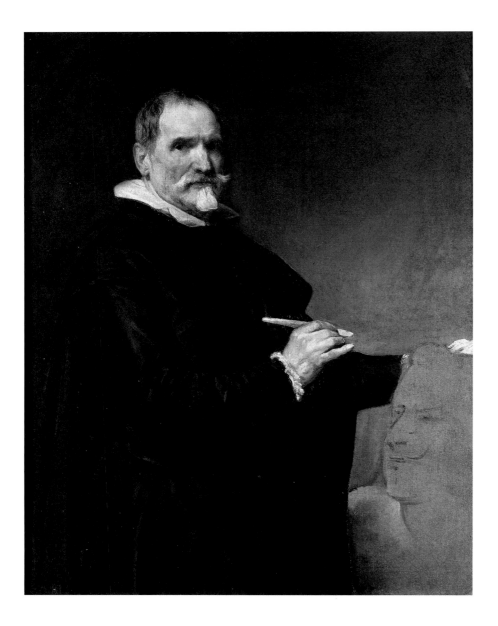

50.
The Sculptor Juan Martínez Montañés, 1635–6
Oil on canvas, 109 × 83.5 cm
Museo Nacional del Prado,
Madrid

but in the larger questions of how he approached the art of others and ultimately how he saw himself as a painter. It was the best possible preparation for his visit to Italy.

Velázquez's first trip to Italy lasted from 1629 to 1631, and was spent for the most part in central Italy.[37] It is worth remembering that his journey was different in important ways from the template of more youthful, formative study seen in the careers of numerous northern painters, in that Velázquez was already relatively mature, professionally established, and had considerable direct experience of a variety of superb Italian paintings from the Spanish royal collection. While the two large history paintings he produced in Italy, *Joseph's Bloody Coat brought to Jacob* (cat. 17) and the *Apollo at the Forge of Vulcan* (cat. 18) show his new response to the rhetorical manner and compositional devices of painters like Guercino (whom he probably met in Cento), they also contain one important technical innovation that Velázquez would maintain for the rest of his career: the use of lighter, grey grounds. The earlier *Joseph's Bloody Coat brought to Jacob* was painted on a warm reddish-brown ground similar to both his Madrid paintings and those

51

52

of the Caravaggesque Italian painters, while the later *Forge of Vulcan* was executed on a pale warm grey ground of a type seen in Veronese and central Italian painters like Guercino or Guido Reni.[38] The lighter grounds provided greater luminosity and translucency, and they also allowed Velázquez to develop a method of elaborating the sort of drawn preparatory work seen on the *Flagellation* with a warm brown glazy undermodelling which was applied directly on the pale ground. The warm tones were used locally, allowing Velázquez to exploit a warmer underlayer where it was most functional – for example in the modelling of flesh tones or the creation of cast shadows – while maintaining the cooler tones in other areas and thereby greatly extending his range of colour temperature and luminosity.[39] Something of the appearance of this preliminary working can be seen in the unfinished section of the 1635 *Portrait of the Sculptor Juan Martínez Montañés* (fig. 50), where the dry-brushed drawing of the clay head is just beginning to be developed in translucent brown tones not unlike those used to depict the background shadow.

This washy laying-in is evident in the famous *Philip IV in Brown and Silver* (cat. 24) painted just after his return from Italy. The newly adopted pale grey ground can be seen both in cross-sections and with the naked eye, for example along the contour between the proper right arm and the cape near the elbow (fig. 51). The preliminary drawing is difficult to see because of the generally thick paint application, although the dry, brushy brown-black drawing lines, as in the *Montañés* portrait, can be seen running along and ducking under the subsequently painted cape near the area of exposed ground at the proper right elbow, while boldly brushed drawn lines are just visible beneath the flesh paint in the king's chin and proper left eye. The initial local modification of the ground with warm brown washes is essential to the final appearance of much of the king's costume, providing the basic tones onto which the virtuosic shimmering, broken brushwork of the fabric is applied.[40] The degree to which the colour modifies the cooler grey of the priming can be seen in the rosette on the left knee, which is covered with this layer only on the upper right (fig. 52).

Interestingly, the painting of the head is quite opaque in its application and shows no exploitation of any warm underlayer. Its strong similarities with the head of the 1636 *Philip IV as a Hunter* (cat. 31) – a virtually identical brushstroke by brushstroke repetition – suggest that both heads were reprises of a now-missing bust-sized life study of the king. An earlier example of this working method is described by Pacheco, who mentions a 1623 portrait done in one day – which suggests a bust-length study worked up later in the studio.[41] A more concrete example can be seen in the bust-length *Infanta María* (now in the Prado) that Velázquez made from the life in Naples in 1630, which was the subsequent source of later studio-produced full-length portraits.

The comparison of the head from the National Gallery portrait (cat. 24) with that of the hunting portrait (cat. 31) also shows the extent to which the former has suffered from fading in the red lakes, severely disrupting the intended modelling of the lips and reducing the intensity of the general colour of the flesh tones. A similar degree of fading in the red curtain backdrop and tablecloth is clearly indicated by the relatively well-preserved areas around the edge of the painting, where they have been protected from light by the frame.[42] Much more surprising, however, is the discovery of the intended colour of the cape and hat, where a combination of discoloured varnish, darkened medium and faded red lakes has greatly shifted the original mauve tonality, which was comprised of red lake, azurite, black, and white pigments. Close inspection of the costume also shows small flicked strokes of better-preserved deep purple paint (fig. 53) – probably because no light-scattering white pigment is within the mixture – which would have been more telling in combination with the unaltered cape and hat.

Discussion of the pigments within the costume must bring us to the general manner in which it is painted, for the fame of the picture rests on the brilliant depiction of the embroidered fabrics. The extraordinary variety of touch we have seen quietly developing in earlier works has here taken centre stage, and the unlined state of the original canvas allows the viewer to revel in the impasto effects exactly as Velázquez intended them. The methods of application include thin washy scumbles, opaque daubs, thick dry dragging of paint across the tops of

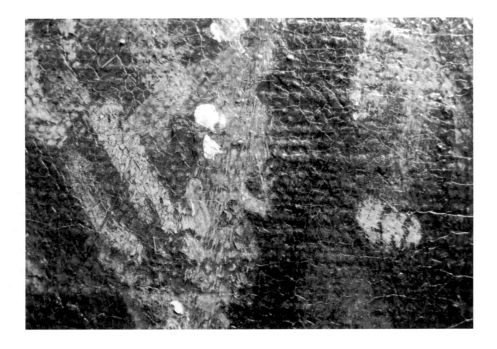

the canvas weave, and thick impasto – in some cases so thick as to create drying cracks, very uncharacteristic of Velázquez. The costume is worked up with thin umber scumbles over the warm brown glaze, followed by broadly executed daubs of grey, black, purple and white paint. It demonstrates a remarkable intuitive understanding of how the viewer's eye reassembles the fragmented application of paint when seen at the proper viewing distance. This degree of understanding of the optical phenomena of the act of viewing had never before been so spectacularly demonstrated, and is perhaps the key element of the painter's enduring appeal. It certainly met with contemporary appreciation; Palomino, in describing *Don Adrian Pulido de Pareja*, outlines a practice that could equally well describe the National Gallery portrait: 'It was painted with both fine and coarse brushes that he had with long handles and which he sometimes used for effects of greater distance and boldness; so that close up the picture cannot be understood, from a distance it is a miracle.'[43] The picture could almost be said to have two subjects – the king, and the paint itself – yet Velázquez manages to integrate his independent, almost autonomous, painterly display within an image of impeccable royal decorum.

The roots of this approach are to be found, of course, in Venetian sixteenth-century painting, and pictures such as *Philip IV in Brown and Silver* are surely a deliberate virtuosic response to Titian and Tintoretto, perhaps in some measure given greater impetus by the wish to show what he had learned from his recent travel. The extraordinary results of Charles V's patronage of Titian contained within the Spanish royal collection had, not surprisingly, created a strongly favourable critical atmosphere for those works, and seventeenth-century writers like Boschini and Palomino attest to Velázquez's particular interest in them.[44] Yet in the seventeenth century critical terms could be used in a very broad sense, and the nature of the Venetian influence is more subtle than might be expected.[45] With Velázquez the Venetian element describes a general attitude to looser brushwork and seemingly improvisatory execution within a strongly polarised critical framework of *colorito* versus *disegno*.[46] From a purely technical viewpoint the question of Venetian influence is also rather qualified. Velázquez did not reproduce the complex glazed layered paint application common in sixteenth-century Venetian painting, but instead achieved similar-looking effects in a much more direct way. Pictures like the *Philip IV in Brown and Silver* actually invert the Titianesque formula of opaque bodycolour developed with multiple applications of glaze, instead favouring a dilute wash-like application of colour given articulation and modelling with a highly selective, judiciously laid on network of broken brushstrokes of opaque colour.[47]

This was to be a technique for rendering fabrics that Velázquez used with increasing skill and economy of application. The so-called *Barbarroja* dating from the late 1630s is in large part unfinished, allowing us to see the thinly applied areas

55.
Detail of *The Toilet of Venus*
('*The Rokeby Venus*') (cat. 37),
showing Cupid's hand holding
the mirror.

of flat colour used to provide the foundation for the unexecuted modelling.[48] By the time of the 1654 *Infanta Margarita in Blue* (cat. 45) the dress is first laid in with colour so dilute that it has pooled within the texture of the canvas weave, after which the opaque colour is applied with brilliant economy to create the shimmering effect of the fabric. His 1652 portrait of the *Infanta María Teresa* (cat. 42), now also in Vienna, is even more terse in its rendition of the dress, dispensing with the initial application of dilute colour and instead using the priming itself as the basis for the colour of the fabric. The warm pale grey of the ground is modelled with a cooler grey (possibly mixed with blue pigment) made with varying degrees of white, punctuated with emphatic daubs of impastoed highlights and flickering lines of browny black very similar in appearance to the initial brushed drawing, some of which, like the ground, also remains deliberately exposed (fig. 54).[49]

For Velázquez, the whole process of artistic influence, from whatever source, was highly selective. Even before his trip to Italy he would have found confirmation of his own inclinations in the manner of Rubens's copies after Titian – which were more of a personal dialogue with the artist than an exercise in imitation.[50] Palomino also made a distinction between repetitive and interpretive copying, and his citation of Rubens's Titian copies as examples of paintings that are 'done *con magistero y libertad* which makes them better than the originals'[51] also suggests something of the critical eye with which Velázquez would have regarded the work of his peers. It is also worth noting that, between his Italian travels and the treasures of the Spanish royal collection, he would have been exposed to a tremendous variety of historical and contemporary painting of the highest quality, and his expertise and connoisseurship were the result of long study and deep absorption.[52] The phenomenon of artists travelling, and taking a keen interest in painters with whom they may have had no personal, studio-based connection, was relatively new, and changed the whole nature of the artistic influence. Velázquez's streamlined, shorthand method of painting Venetian-looking fabrics is one example of the resultant slippage between achieving painterly effects and fully understanding or replicating different painting techniques. Velázquez, as might be expected, was particularly gifted and subtle at assimilating influences, both technical and intellectual, through the filter of his own artistic concerns.[53]

The Rokeby Venus (cat. 37) is a good example of his processes of assimilation, being a picture that is ostensibly indebted to Titian and Giorgione, but is profoundly different in its technique. The picture is painted on a light, warm grey ground. The opacity of the subsequent painting means that no obvious brush drawing is visible, although cross-sections generally show thin brown-black or grey layers between the ground and main paint layers, suggesting an initial working-up not unlike the unfinished sections of the *Montañés* portrait (fig. 50).[54] The X-radiograph shows several minor adjustments to the bedclothes and to the

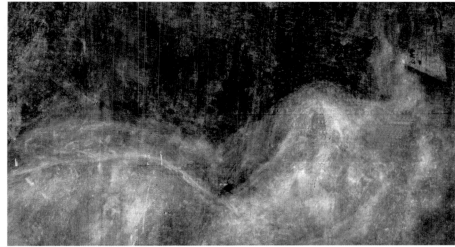

56

contour of the proper raised right elbow and arm; it also reveals that the left arm was shifted down behind the torso – presumably to accentuate the sinuous curve of the wasp waist (fig. 56). For all the variety of handling, the paint build-ups are simple; for example, the red lakes of the backdrop curtain are worked directly on the ground with modelling achieved primarily through simple mixtures applied *alla prima*, rather than superimposed layers of applied colour (fig. 57). These lakes have faded significantly in spite of the apparent intensity of the curtain, and the loss of colour from this pigment has elsewhere had a serious and surprising effect on our reading of the picture as a whole. The slate grey of the bedcover was originally a deep mauve-purple, the original effect of which must have been richly sensual and quite different from the rather sober chromatic restraint the picture now displays (figs 58–9).[55] In this context the strong red colour along the contour of Venus' inner thigh is not a Rubensian device[56] but a simple reflection of the now-lost colour of the bedcover. Velázquez's control of paint in the *Rokeby Venus* is if anything more virtuosic than in *Philip IV in Brown and Silver* for the restraint with which he seamlessly integrates a broad spectrum of effects, from the smooth, creamy blended handling of Venus' flesh, to the coarse and unblended brushwork of Cupid's hand or mirror ribbon, and the thinly applied washes of the unfocused reflected image in the mirror.

57

58

59

A similar orchestration of different painterly effects is also to be found in
Philip IV hunting Wild Boar (cat. 33), this time in the service of an unusual subject
and format. The freely worked landscape passages familiar to us in the back-
grounds of the large hunting or equestrian portraits are here brought to centre
stage, and Velázquez's facility in combining dilute and opaque applications of
paint, previously seen in the rendition of textiles, is now used to evoke foliage.
The picture is in a very compromised condition, with numerous damages and
extensively abraded areas; there may also be considerable studio participation
in the painting of some of the figures. In terms of the general setting of smaller
figures within a dominant landscape it bears some comparison with the earlier
Saint Anthony Abbot and Saint Paul the Hermit, which also allows the light ground
to make a significant contribution to the dilute applications of greens and blues
that make up the distant landscape and sky.[57] The silvery tonality and translucent
effect of the landscape is also enhanced by some of the pigment mixtures employed:
largely colourless smalt particles were included with the azurite in the sky, and
relatively transparent yellow lake pigments were routinely included within the
green foliage mixtures (fig. 60).[58]

In spite of his manifest ability with a variety of subject matter, the majority
of Velázquez's output was still concerned with portraiture.[59] His powers of obser-
vation were such that being portrayed by him was not always a particularly
comfortable experience, as Philip himself admitted in 1653: 'It is nine years since
any portrait was made, and I am little inclined to subject myself to Velázquez's
phlegm, nor thus find further reason to witness how I grow old.'[60] The probable
result of that process is the bust-length *Philip IV* (fig. 110) now in the Prado (made
some nine years after the so-called Fraga portrait now in the Frick), which is
indeed merciless in the depiction of the rapidly ageing king. Yet he was to be
portrayed at least once more by Velázquez. The *Philip IV of Spain* (cat. 44) in the

National Gallery, generally dated to the late 1650s, is closely based on the Prado portrait on page 85. yet clearly shows the further effects of time in the sagging, puffy flesh of the monarch. The familiar brown-black brushed drawing and under-modelling are just visible under the left side of the chin and in the hair, eyes and lips.[61] The flesh paint contains deliberate additions of high-quality smalt pigment, which provides a rich tonal contrast with the pinker tones of the general carnation.[62] It is also mixed with vermilion to create the deep mauve shadows of the eye sockets, and is used within the eyes to create an intentionally rheumy, foggy appearance (fig. 61).[63] The handling is characteristically varied between dilute applications and thick impasto, blended transitions and strongly differentiated juxtaposed brushstrokes – perhaps the most striking of which can be seen in the downward slashing brown strokes at the outside edge of the shadowed eyelid. In fact the picture now appears more blended and sedate in its handling than it actually is, due to the severe old glue lining and surprisingly discoloured varnish, which have the cumulative effect of flattening the surface texture and suppressing the local variations in colour within the flesh painting.

The National Gallery portrait is technically very similar to the earlier Prado image – especially in the layout of the modelling, the shifts in colour temperature, and the details of hair – yet still shows the subject's advancing years. It is therefore interesting to speculate as to whether it was also made from live sittings, or if Velázquez instead used the experience of his everyday contact with the king to 'age' the 1653 portrait in a studio reinterpretation, as it is well known that he had a pragmatic attitude to the reuse and recycling of life studies for the production of royal portraiture.[64]

In considering this question it is instructive to look at the images of *Pope Innocent X*, made during his second trip to Italy in 1650–1. Contemporary accounts describe a painting made from very limited live sittings, the final painting now in Rome (fig. 28), and a version brought back by Velázquez to Spain – which is most likely the picture now in Apsley House (cat. 39); it remains an open question as to

whether the initial study was also the same painting brought to Madrid. The chronological status of the Apsley House painting therefore remains unclear – it is either the initial study made from the life or an autograph replica produced for the king. While extremely close in execution, the brushwork of the modelling of the face in the Rome version seems more streamlined compared to the London painting, with a more gestural and almost calligraphic abstraction. Is the Rome version a bravura reprise of the harder-won brushwork achieved in the live sittings behind the London version, or should the London picture be thought of as a less spontaneous, slightly dutiful copy made for his royal employer? (It is interesting to think of *Juan de Pareja* (fig. 29) in this context as a benchmark for a picture that must have been done entirely from the life and with no restrictions on the desired sitting time.) Whatever their relationship, both *Pope Innocent X* images are autograph, made in Rome away from his workshop,[65] and therefore provide an example of Velázquez reinterpreting his work that seems relevant to our understanding of the National Gallery *Philip IV*.

The suggestion that Velázquez could more or less recreate stroke by stroke a head such as *Innocent X* or *Philip IV* implies that he had, like many of his contemporaries

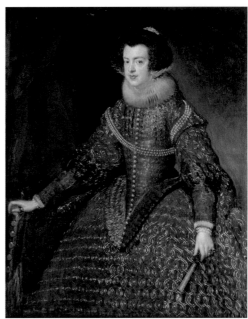

64

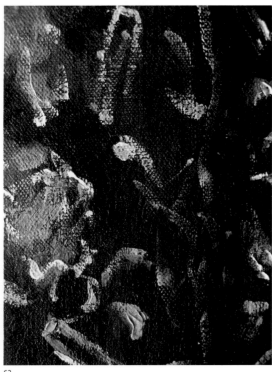

62

63

65

66

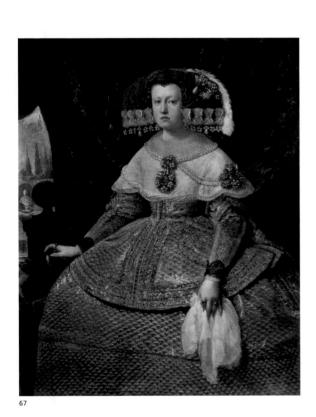

67

who ran large studios, developed a systematised method of painting to facilitate workshop production. This is true to a certain extent in that his approach became ever more terse, his application of paint more economical. Whether intended or not, such a method would have been useful in achieving a relatively uniform look for the portraiture output of his studio. Workshop examples are often superficially convincing imitations of the master's basic methods, particularly so in the rendering of costume. But, however outwardly similar, such works also provide an unintentional key to the unique genius of Velázquez's technique. The studio assistant responsible for the costume of the *Isabella of Bourbon* (fig. 64) used much the same materials and build-up as did Velázquez in his roughly contemporary *Philip IV in Brown and Silver*, but the assistant's swirls are dull and mechanical (fig. 63) against the slashing brilliance of the master's work (fig. 62). In the 1650s the workshop *Mariana of Austria* (fig. 67, detail fig. 65) comes closer to that standard, but again comparison with *María Teresa* (cat. 43, detail fig. 66) mercilessly exposes the shortcomings of the studio work. *Mariana's* flesh painting lacks the easy interplay of warm and cool tones,[56] while the loose brushwork in the hairstyle creates a slightly nervous surface pattern, appealing but not fully convincing in communicating the structures and textures of hair, fabrics and jewels. By contrast, *María Teresa's* brushwork is both more open in its handling and entirely persuasive in its representation. The 'miraculous' ability to conjure substance from paint ascribed to Velázquez by Palomino was not reducible to any studio formula, but was the result of a masterful control of his materials and a keen awareness of how the brushstrokes would be read. And although ultimately based on optical phenomena, this facility was used for broader and more expressive purposes than mere 'impressionistic' bravura; the liquid application, rough impasto, and shimmering effects of the *Mercury and Argus* (fig. 103, detail pp. 68–9), for example, have nothing to do with conveying the splendour of royal finery, but speak to deeper narrative truths. Attractive as it is, Velázquez's broken brushwork was not an end in itself, but was the vehicle for a way of depicting based on a profound understanding about how we see, and why we value the very act of painting.

I would like to acknowledge the following people for their invaluable help in allowing close access to pictures, sharing technical information and providing helpful criticism: Denise Allen, Ronni Baer, George Bisacca, Dawson Carr, Gabriele Finaldi, Charlotte Hale, Rhona MacBeth, Wolfgang Prohaska, Ashok Roy, Xavier Salomon and Robert Wald.

1 Quoted in Wilson-Bareau 2003, p. 231, and note 93, p. 236.

2 Dedicated technical studies of Velázquez are a fairly recent phenomenon: the first major examples are McKim-Smith et al. 1988, and Garrido Perez 1992. This essay is largely based on the recent investigation of the nine paintings by Velázquez in the National Gallery, as well as on comparative material, both published and observed, from other collections. For other technical studies see McKim-Smith and Newman 1993, Veliz 1996, Brown and Garrido 1998, McKim-Smith 1999, Hale 2005, Zuccari, Veliz and Fielder 2005, and McKim-Smith et al. 2005.

3 Serrera 1996, p. 37.

4 The relationship was both professional and personal, as Velázquez married his daughter Juana.

5 Pacheco 1649 (ed. and trans. Veliz 1986), pp. 30–106; see also the translator's note 6 on subsequent Spanish editions, p. 200.

6 Pacheco 1649 (trans. Harris 1982), p. 191.

7 See Brown 1986, p. 4, on Italian influences in Spanish art beginning from roughly 1570 (the time of the decoration of the Escorial); Serrera 1996, pp. 37–43 on the importance of northern artists such as Campana and Hemessen; and McKim-Smith et al. 1988, p. 9 and note 55, p. 134, on the relationship between Italianate theory and Flemish-derived practice in Spain.

8 'When they have some figure or history to paint, they should choose things from prints, drawings or paintings – a head from one, a half-figure or two from another, arms, draperies, buildings, and landscapes – and unite them in such a way that at the least they form a single composition, making a pleasing whole from many varied parts': Pacheco 1649 (ed. and trans. Veliz 1986), p. 35. See also Veliz 1996 and Veliz 1998.

9 See Pacheco 1649 (trans. Harris 1982), p. 194, and Davies 1996, pp. 53–7.

10 Pacheco 1649 (trans. Harris 1982), pp. 194–5.

11 As investigated by the Scientific Department of the National Gallery, the material is essentially iron oxide in composition, with significant calcium carbonate and silicon dioxide inclusions bound in linseed oil. See Pacheco 1649 (trans. Veliz 1986), pp. 68–9, for his description. See Garrido 1992, Veliz 1996, Brown and Garrido 1998, Hale 2005 and McKim-Smith et al. 2005, for other similar examples.

12 See Veliz 1996, p. 80 and fig. 9.4, for her suggested example of such a compositional study drawing by Pacheco; also reproduced on p. 161 as no. 35.

13 This feature was first described by Veliz 1996, and has since been noted by McKim-Smith 1999, Hale 2005, Zuccari 2005 and McKim-Smith et al. 2005 among others on several paintings from the Seville period. The technique is difficult to identify with precision, and cannot be verified without careful comparison of the X-radiograph and the painting itself. Most of the fine white lines visible in X-rays are the result of a relatively thick extrusion of paint along the edges of brushstrokes applied with a broad, stiff brush, and are not at all preliminary in nature. Such ridges are often created by Velázquez's characteristic late reinforcement of outlines and contours, which in X-ray alone are easily confused with preliminary design indications. Also, the seemingly low atomic density of the ground allows relatively dark and thick paint to show a surprising degree of X-ray opacity, for example the raised thin dark brown line along the bottom of the window in the *Kitchen Scene with Christ in the House of Martha and Mary* or the ridges of dark landscape foliage paint at the lower left of the *Immaculate Conception*, neither of which is preparatory and both of which show nearly white in X-radiographs.

14 The infrared absorbency of the ground makes the technique of IR reflectography of limited use in the determination of carbonaceous underdrawing, although brushy black-painted correction strokes have been noted in the Metropolitan Museum of Art's *Supper at Emmaus* (see Hale 2005) and the National Gallery's *Immaculate Conception*. The generally thick and comprehensive subsequent paint application also potentially obscures much preliminary work; see the discussion of the National Gallery's *Christ after the Flagellation contemplated by the Christian Soul* below.

15 Veliz 1996, p. 83.

16 Pigments identified by the Scientific Department of the National Gallery on Seville-period pictures included lead white, carbon black, various ochres, cochineal, vermilion lake, azurite, smalt and umber, which is in accord with findings on other Seville paintings published by Garrido 1992, Garrido and Brown 1998, Veliz 1996, Hale 2005 and Zuccari 2005.

17 The generally accepted reading of the painted date of 1618 is not sustained by close examination; the final digit is impossible to read with certainty.

18 Both pictures follow the iconographic programme carefully laid out by Pacheco in the *Arte de la pintura*; see Davies and Harris 1996, p. 156.

19 The blue drapery is particularly visible in the X-radiograph because it is worked up with a grisaille underpainting of black and white with a little red earth, onto which the blue paint was glazed. While the grey underpaint allows us to see clearly the change in the lower drapery, it also shows the more careful planning of the reserve around the proper left forearm, which is more typical of Velázquez's practice at this time. For other examples of grey underpainting of blue drapery

in early works see also the *Adoration of the Magi* and the *Coronation of the Virgin* – while such practice is not present in the much later *Spinners*, where a pentimento of the leg of the woman at near right shows through a single application of blue drapery paint.

20 See further p. 132 (cat. 10).

21 See Brown 1986, p. 25, on his suggested print source by Jan Sadeler. See also Pacheco : 'And in the case of my son-in-law who follows this course one can also see how he differs from all the rest because he always works from the life' in Pacheco 1649 (trans. Harris 1982), p. 194. It seems likely that the same model was used in other paintings.

22 Whatever the cause, the problem is evident in many of the Seville paintings, for example the Prado *Portrait of a Man with a Ruff* (1209). See also Garrido 1992, pp. 96–101, Veliz 1996, Hale 2005 and Zuccari 2005.

23 Identified by the National Gallery Scientific Department with HPLC-GCMS. The paint medium in both pictures was identified as linseed oil, in almost all cases heat-bodied; see White et al. 1998, p. 95.

24 Palomino 1724 (1982), p. 198, and Davies 1996, pp. 53–7.

25 See Brown 2005, p. 45.

26 See further p. 144. The painting closely follows techniques employed in Seville, and may have been painted on a canvas primed there and brought to Madrid. See McKim-Smith et al. 2005, pp. 83–7.

27 See p. 144 (cat. 15) in this catalogue.

28 See Brown 1986, p. 60, on Carducho's rivalry with Velázquez.

29 Destroyed in a fire in 1734. See Brown 2005, pp. 45–6.

30 See Garrido 1992, pp. 167–79, and Brown and Garrido 1998, pp. 27–39 for documentation of other examples of this ground. The x-radiograph of the National Gallery picture shows clear signs of palette knife application, a feature found on many works throughout his career.

31 A similar-looking red ground is clearly visible in the Hispanic Society *Olivares* (fig. 14) through thinly painted sections of the grey background and along the outer figural contours, especially the lower leg.

32 For example, there is a carefully planned reserve around the column base at the left side, yet no evidence of any brushed or painted dark underdrawing is visible through the thinly applied paint layers.

33 Bayerische Staatsgemäldesammlung, Alte Pinakothek, Munich (518). See López Rey 1999, pp. 120–1.

34 The cochineal lakes in the sleeves of the angel have faded significantly and would have been effectively set against the intense verdigris pigment used in the green sash, while the intended deep purpley blue of the fabric at the lower left has sunk and darkened to an indistinct colour. The use of verdigris, while also found in the depiction of the pottery in *Christ in the House of Martha and Mary*, appears to have been rather unusual – the pigment is not included in the list of pigments used by Velázquez given by Brown and Garrido 1998, p. 17, or in the description of his practice on p. 18.

35 Palomino 1724 (trans. Harris 1932), p. 201.

36 His copy of the *Rape of Europa* has a strongly coloured grey ground, while his version of the *Temptation of Adam* has, among other more subtle changes, a prominently displayed red parrot not found in Titian's version. On Rubens and Velázquez see also Vergara 2002, p. 627.

37 See Brown 1986, pp. 69–79, Brown and Garrido 1998, p. 10, and Brown 2002, pp. 30–47.

38 Garrido 1992, pp. 218–33, and Brown and Garrido 1998, pp. 40–5, on *Joseph's Bloody Coat brought to Jacob*; Garrido 1992, pp. 234–45, and Brown and Garrido pp. 46–56, on the *Forge of Vulcan*. See Bonfait 1994 for roughly contemporary Roman practice, including examples of lighter grounds.

39 For example, in the *Forge of Vulcan* the warm brown underlayer visible to the left of Apollo's right foot does not accord with the cooler grey ground visible in cross-sections taken elsewhere from the painting (Garrido 1992, pp. 242–4), but suggests the presence of a warmer preliminary translucent modelling layer.

40 This layer is for the most part comprised of semi-translucent earth pigments.

41 Pacheco 1649 (1982), p. 191, and Brown 1986, p. 45, referring to a portrait made of the king on 8 August 1623. *Infanta Dona Maria, Queen of Hungary*, Museo del Prado, Madrid (1187). Full-length studio portraits based on the Prado bust are now in the Staatliche Museen, Preussischer Kulturbesitz, Berlin, and the Národní Muzeum, Prague. See López-Rey 1999, pp. 80–1, 114–17. Something of the scale of the portrait-making operation is indicated by a 1633 reference to Velázquez and Carducho being asked to inspect the quality of a batch of 37 recently completed royal portraits; see Brown 1986, p. 88.

42 It is interesting to compare their condition with similarly depicted fabrics in the Hispanic Society's *Olivares* (see fig. 14), where the lakes were laid over the typically pre-Italian opaque red ground, and hence remain comparatively vivid.

43 Palomino 1724 (1982), p. 204. McKim-Smith et al. 1988, p. 33, and note 143, p. 149, quotes a witty reference to free brushwork from a contemporary *refran*: 'la pintura y la pelea desde lejos me la otea' ('I keep my distance from paintings and fights').

44 See McKim-Smith et al. 1988, pp. 34 and 38–45.

45 Bellori's citation of Federico Zuccari's description of Caravaggio as a Giorgionesque painter would today seem quite a stretch, for example. See Keith 1998, p. 37, and notes 4 and 5, p. 50.

46 McKim-Smith et al. 1988, p. 49. It is worth remembering that although clearly stating Velázquez's interest in Venetian painting, Palomino also refers to his drawing after Raphael and Michelangelo in the Vatican; see Palomino 1724 (1982), p. 203.

47 McKim-Smith et al. 1988, p. 46.

48 *The Buffoon Don Cristobal de Castenada y Fernia (Barbarroja)*, Museo del Prado, Madrid (1199). The figure's outer cloak has been completed by another hand. See López-Rey 1999, pp. 210–11, and Garrido 1992, pp. 410–17.

49 The handling appears broadly similar – from visual inspection within the museum – in the bodice of the central maid of honour in *Las Meninas*.

50 See note 36.

51 This superior form of copying is contrasted by Palomino with the more literal, self-effacing copying practised by Mazo of works by Velázquez. See Alpers 2005, p. 194.

52 An additional factor of undoubted importance was Velázquez's ever increasing curatorial duties within the Spanish royal collection; see Brown 1986, pp. 183, 188.

53 See Alpers 2005, pp. 133–218.

54 Although the canvas has a horizontal strip added across the top/bottom, continuous strokes from the application of the ground across the canvas seam, visible in the X-radiograph, show the format to be original.

55 Made with azurite and red lake, the purple colour is just apparent in the darkest tones such as the brushstrokes where the upper contour of the bed meets Venus' lower leg, especially where the fabric has been drawn over her foot and toes, and in a part near the left edge (now hidden by the frame) which was covered by restorer's putty. Something of the picture's intended general chromatic relationships is suggested by the play of red and purple fabrics in the *Coronation of the Virgin*, a picture which is unusually well preserved; see Garrido 1992, pp. 446–57, and Brown and Garrido 1998, pp. 117–24.

56 See, for example, the Munich *Rape of the Daughters of Leucippus*, where red thighs have a deliberate narrative intent.

57 The ground of *Philip IV hunting Wild Boar* has been identified by the Scientific Department as lead white with slight amounts of Kassel earth. On the *Saint Anthony Abbot* see López-Rey 1999, pp. 212–14; Garrido 1992, pp. 298–307, and Brown and Garrido 1998, pp. 102–8. For Brown 1986, p. 96, its silvery tonality is a deliberate evocation of fresco; Van Eikema Hommes 2004, pp. 24–5, citing Pacheco, suggests a more general awareness of the possibility of compensating for the darkening of the oil medium through the use of lighter colours.

58 Brown and Garrido 1998, pp. 18, 60, 102–4, refer to the practice of deliberately adding calcite to paint mixtures to increase their transparency. Chalk has also been found in some pigment mixtures within the *Philip IV hunting Wild Boar*, although it may in some cases be the remaining substrate of degraded yellow lake and should be interpreted with some caution.

59 His painting output was significantly reduced at this time as the result of his increasing official responsibilities at court; see Palomino 1724 (1982), p. 213, and Brown 1986, p. 183.

60 Cited by Perez Sanchez 1989, p. 54, without documentation, from a letter to a nun who had been the governess of his daughter María Teresa. See also Harris 1990, p. 289.

61 One must distinguish between the delicate rubbing back of paint done by Velázquez (visible in the proper left eye socket and the line of shadowed hair along the proper left cheek) and abrasion (present in the perimeter of the collar and the upward curl of hair at the shadowed side of the head). The reserve of the background paint as visible in infrared reflectography confirms the original intention of the amorphous blob at the lower right as an upward curl of hair – the present smoky grey shape is not foggy varnish, but presumably largely abraded cursory treatment of the shadowed lock of curling hair.

62 This is also apparent in the flesh of the *Margarita in Blue* (cat. 45) It is interesting to speculate whether the practice could be another example of Velázquez simulating an effect he would have seen in Rubens – where the blue flesh tones are generally created by the optical qualities of the layer structures and do not contain blue pigment – without reproducing the actual techniques he employed to create them.

63 There is also a tiny blue blob of pure smalt in the shadowed side of the upper lip, which may be an accidental 'splash', like the streaks of bright blue sky paint visible within the hunting enclosure of the *Wild Boar* picture.

64 See note 41, and cats 31 and 24 for more on studio repetitions of portraits.

65 Some scholars have suggested that the costume of the Apsley version was finished by assistants; see p. 222 in this volume. See also Coliva in Rome 1999–2000, pp. 60–7, and Madrid 1996, pp. 41–60.

66 Velázquez's use of blue pigment within flesh mixtures is not apparent in the studio piece; see Hanzer 1992 on the technique of *Mariana*.

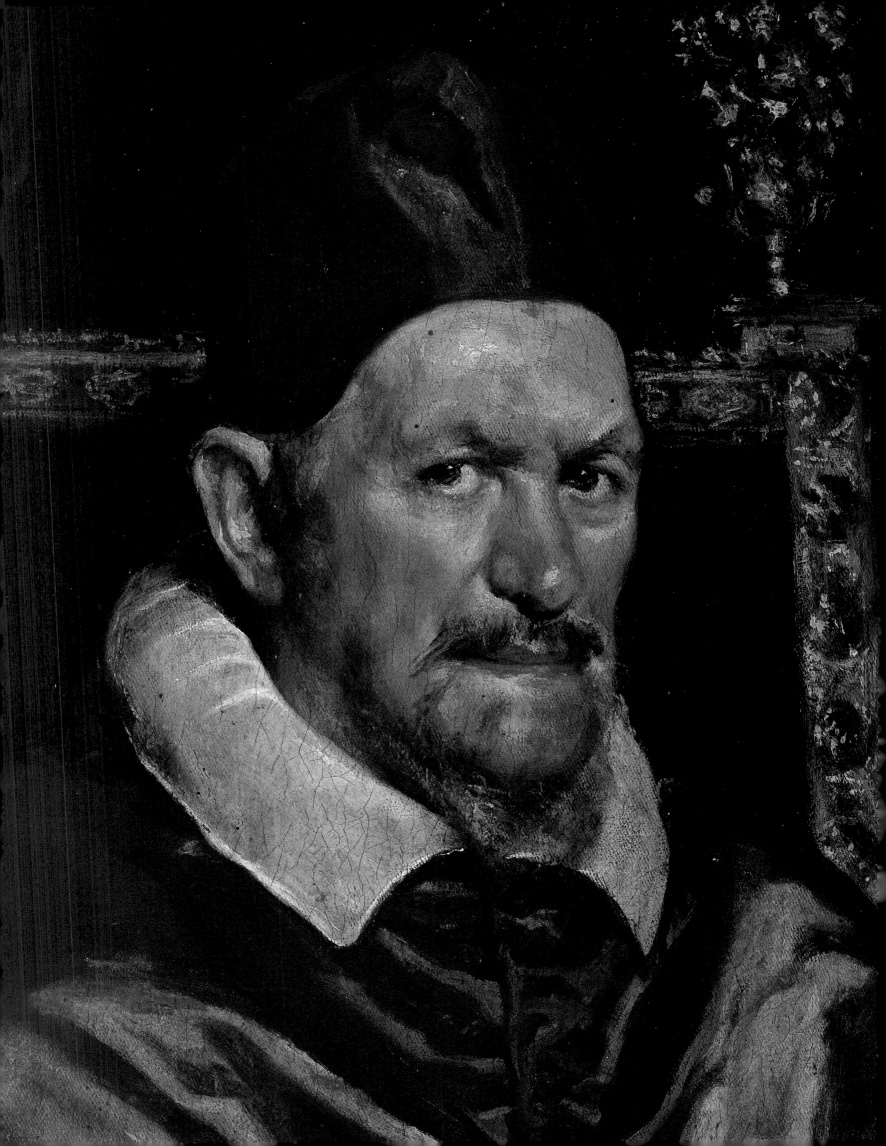

Velázquez and Britain

XAVIER BRAY

'What we are all attempting to do with great labour, Velázquez does at once' (Sir Joshua Reynolds)

WHEN VELÁZQUEZ DIED IN 1660, the painted legacy that he left behind was divided between four different cities: Seville, his birth place; Madrid, where he spent the bulk of his career; Rome, where he travelled twice and painted his master-piece of portraiture *Pope Innocent X* (fig. 28); and lastly the Habsburg court at Vienna, where some of his most beautiful late portraits of the Spanish royal family were sent. Two centuries later, the situation had changed dramatically – for those wishing to see and study the art of that most celebrated of Spanish artists, Britain came second only to Madrid as the essential port of call.

In his catalogue of Velázquez's oeuvre published in 1848, Sir William Stirling-Maxwell, the Scottish collector and art historian, identified more than seventy paintings in Britain as being by Velázquez's hand – out of a total of 226 worldwide.[1] The large majority of these paintings are today no longer accepted as autograph and others have since been sold abroad. However, Britain still boasts eighteen paintings by the master, nine of them in the National Gallery in London. Remarkably, nowhere else outside Spain can such a comprehensive view be had of Velázquez's stylistic development from his early career in Seville to his final years in Madrid as court painter to Philip IV.

This essay will trace the increasing enthusiasm for Velázquez in Britain and the determined efforts of collectors to obtain paintings by him. While a significant number of works attributed to Velázquez had arrived in Britain before the end of the eighteenth century, most came following the Spanish Peninsular War (1808–13). It was largely as a consequence of this exodus that Velázquez's work became better known outside Spain. However, until the middle of the nineteenth century, Velázquez's work in Britain was mainly displayed privately in stately homes across the country, and he was primarily known to a specialist audience of connoisseurs, dilettantes and artists. But from the 1840s onwards, it was the National Gallery's active and successful attempts to acquire paintings by Velázquez (notwithstanding some mistakes along the way) which established his reputation and made him known to a wider public.

The first known contact between an Englishman and Velázquez involved no less a personage than the future King Charles I. As Prince of Wales, Charles travelled to Spain in 1623 on a 'secret' mission to woo Philip IV's seventeen-year-old sister, the Infanta María.[2] After a six-month stay, Philip organised farewell festivities for Charles at El Escorial and it was probably there that Charles met Velázquez.[3] At the time, the artist was twenty-four years old and his career as court painter had just

68.
Studio of Velázquez
Infante Baltasar Carlos,
1638–9
Oil on canvas, 211 × 110 cm
Royal Collection,
Hampton Court Palace

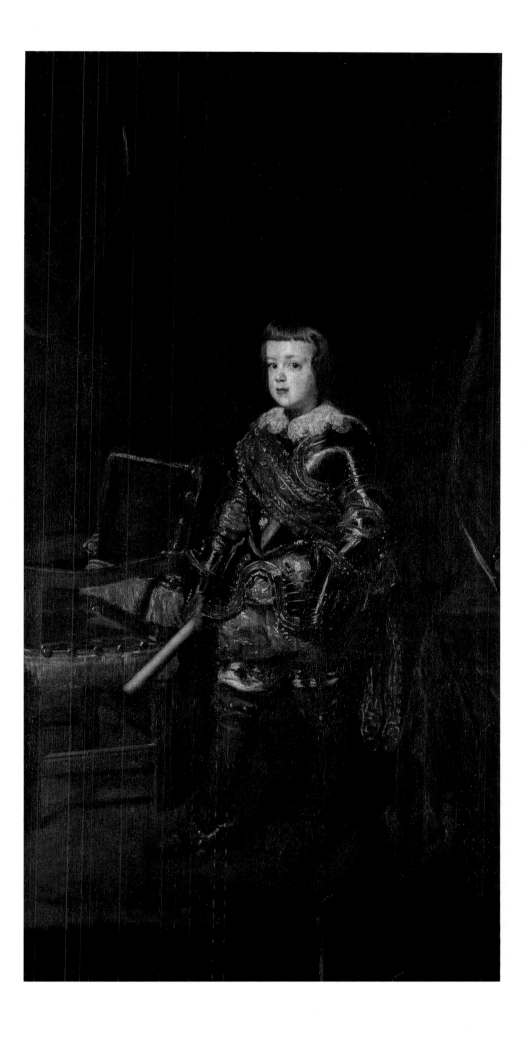

begun. According to his father-in-law, Francisco Pacheco, he had just painted his first portrait of Philip IV, 'which was a great success', and we learn from Pacheco that he 'made *en passant* a sketch [*bosquejo*] of the Prince of Wales, who gave him a hundred escudos'.[4] What subsequently happened to the portrait is unclear as it is not recorded in any inventory of Charles I's collection.[5]

The first 'Velázquez' paintings known definitely to have reached London were the portraits of Philip IV, Isabella of Bourbon and Infante Baltasar Carlos (fig. 68) dispatched from Madrid in December 1639 as gifts, in exchange for the portraits of the English royal family sent the previous year.[6] However, these paintings are now regarded as studio works. The possibility of future exchanges of diplomatic gifts came to an end with Charles I's execution in 1649, and few paintings by Velázquez or his studio left Spain during the remaining years of the seventeenth century. In contrast to his contemporary Murillo, whose paintings were collected as far away as Antwerp and London, Velázquez had painted almost exclusively for the Spanish court. In order fully to appreciate Velázquez in the seventeenth century it was necessary to go to Madrid, but Spain unlike Italy was never part of the Grand Tour. Even for those who did tour the Iberian Peninsula, permission to visit the Royal Palace in Madrid was not easy to obtain and access to Velázquez's work was hard to secure. The Neapolitan artist Luca Giordano (1634–1705), who had been invited to Madrid in 1692 as court painter to Charles II of Spain, was one of the few allowed into the king's private apartments to see *Las Meninas* (fig. 30). The painting he made inspired by this visit is today in the National Gallery (see fig. 79).

Perhaps one of the most important touchstones for the early appraisal of Velázquez's art came in 1724 when Antonio Palomino (1653–1726), painter and art theorist, published his lives of Spanish artists.[7] He dedicated a large section to Velázquez, whose life he had compiled from a lost biography by the artist Juan de Alfáro (1643–1680), who had known Velázquez personally and made a drawing of him on his deathbed (fig. 69).[8] Palomino provided colourful anecdotes about Velázquez's career at court, his relationship with Philip IV and his travels to Italy. It was essential reading for anyone wishing to know more about Velázquez and consulted by most visitors to Spain as a 'catalogue' to his work. Proof that there was some British interest in Spanish art at this period is attested by the publication of an abridged English edition of Palomino's book in 1739.[9]

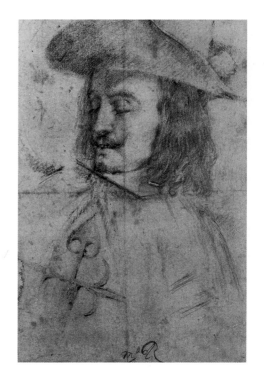

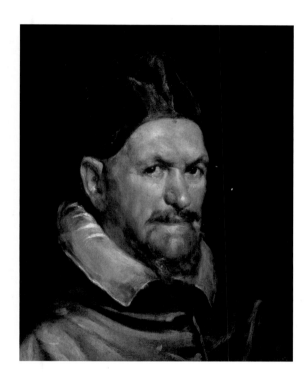

Early acquisitions of Velázquez's work

The publication of Palomino's biography coincided with some of the first recorded purchases of Velázquez's paintings in Britain. The first acquired by a British collector was a head of Pope Innocent X, bought for eleven guineas in 1725/6, probably in London, for Sir Robert Walpole, Prime Minister to King George III.[10] His 'Velasco', as he called it, first hung in his London house before being sent to his country estate at Houghton Hall, Norfolk (fig. 70).[11] Today, the portrait is considered to be a copy after the original in Rome, but Walpole probably believed it to be the autograph version or, more likely, the preparatory sketch brought back by Velázquez to Madrid as described by Palomino (see cat. 39).[12]

A rare opportunity to buy Velázquez paintings in Madrid presented itself in 1733 when the collection of the Duke of Arcos was put up for sale. Among the pictures inventoried in the collection as by Velázquez were two versions of his celebrated portrait of the Spanish admiral, *Don Adrian Pulido Pareja*.[13] It is not clear who bought the paintings at that time but they both eventually made their way to Britain. One was acquired by the 4th Duke of Bedford before 1771 when it is recorded as hanging in Bedford House, Bloomsbury.[14] The other version, now attributed to Mazo, and no doubt the better one admired by Palomino, had reached Britain by 1788 when it was sold to the 2nd Earl of Radnor, of Longford Castle, Salisbury (fig. 71). Palomino's description that 'near-hand, one does not know what to make of it; but afar off, it is a Master-piece' no doubt gave the picture extra value and increased its fascination for British collectors.[15]

While paintings by Murillo appear frequently in British picture sales between 1721 and 1759, paintings by Velázquez were harder to come by, the majority being acquired by aristocrats on their Grand Tour to France and, particularly, Italy.[16] The 4th Earl of Carlisle, for example, purchased on one of his two trips to Italy (1714–15 and 1738–9) a version of Velázquez's *Juan de Pareja*, as well as the portrait of *Baltasar Carlos with a Dwarf* (cat. 23), which he thought represented the Prince of Parma by Correggio.[17] Around these dates, the 3rd Earl of Burlington acquired the *Lady in a Mantilla* for his Palladian villa at Chiswick, outside London (fig. 72).[18] In 1784 Welbore Ellis Agar bought *Baltasar Carlos in the Riding School* (cat. 27), and in 1798 the 5th Earl of Carlisle acquired the *Finding of Moses* at the sale of the Orléans Collection – a painting hugely admired at the time and only much later recognised as the work of Orazio Gentileschi (1563–1639).[19]

The first true masterpiece by Velázquez to enter Britain was the prime version of his portrait of *Juan de Pareja*, purchased in Naples by Sir William Hamilton while serving as British envoy there between 1764 and 1798 (fig. 29). After his return to England, in 1801, Hamilton, heavily in debt, put the portrait up for auction at Christie's where it sold for £42.[20] Ten years later, it was purchased by the 2nd Earl of Radnor, who already owned the portrait of *Don Adrian Pulido Pareja*.

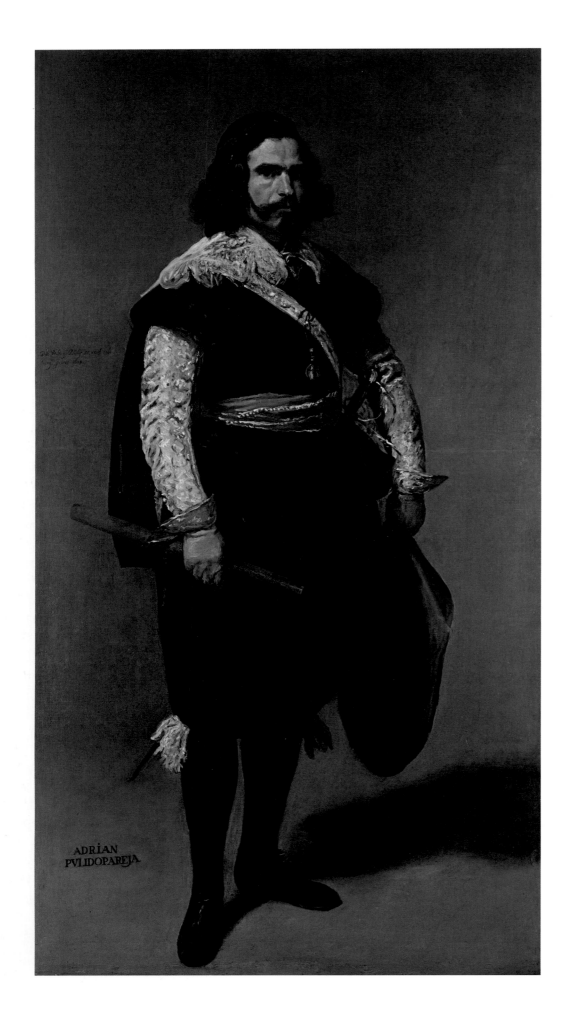

ADRiAN
PVLIDOPAREJA

71.
Attributed to Juan Bautista
Martínez del Mazo
(about 1612/16; died 1667)
Don Adrián Pulido Pareja,
after 1647
Oil on canvas,
203.8 × 114.3 cm
The National Gallery, London
(NG 1315)

The Velázquez mania seemed to be in full swing, with around 108 paintings sold as by him on the market between 1801 and 1808. However, only two of these were autograph works: the rest had little to do with Velazquez.[21]

By the later part of the eighteenth century, British visitors had begun to travel to Spain, specifically to see Madrid collections and, in particular, paintings by Velázquez.[22] Conditioned by their overwhelming interest in Italian art, however, they concentrated mainly on works inspired by Italian painting, neglecting the pictures regarded today as his masterpieces such as *Las Meninas* and the *Surrender at Breda* (figs 30 and 22). *Joseph's Bloody Coat brought to Jacob* (cat. 17) at El Escorial was 'esteemed the best picture of Velasquez' by the diarist Henry Swinburne, and hailed by the art collector William Beckford as 'the loftiest proof in existence of the extraordinary powers of Velasquez'.[23] Similarly, the equestrian portrait of Olivares (Prado, Madrid) was judged by Swinburne to be 'the best portrait I ever beheld: I know not which most to admire; the chiaroscuro, the life and spirit of the rider, or the natural position and fire of the horse.'[24] Such comments may perhaps be explained by the Rubensian quality of the Olivares portrait and by the fact that *Joseph's Coat* was very much an essay in the Italian style of painting.

Diplomats and ambassadors were also influential in spreading word of Velázquez.[25] Lord Grantham, British ambassador to Spain between 1771 and 1779, and his brother Frederick were so enthusiastic that they commissioned a German painter, Wenceslaus Pohl, to make small-scale copies of the most important works by Velázquez in the royal collection, while they embarked on a catalogue of his works.[26] In 1778, Grantham became aware of another series of copies after Velázquez: the etchings on which Francisco de Goya was at work during that year. He bought five sets and dispatched them to London, with one set destined for Sir Joshua Reynolds.[27]

Lord Grantham and other visitors no doubt benefited from the expert knowledge of the contemporary Spanish art historian Antonio Ponz, whose guidebook *Viaje de España* was published in 1775–6. Not only could they have visited the Royal Palace with him in person, but they would have read his detailed description of the palace room by room. In addition, Ponz had published a letter he had received from Anton Rafael Mengs (1729–1779), a painter much admired in Britain. Mengs, who had been in Spain since 1761 as court painter to Charles III, extols in this letter his ideas on art almost like an art-history lecture, using many of the works in the royal collection as examples. When he comes to Velázquez he categorises him as a practitioner of the 'natural style' and praises his 'intelligent use of light and shadow, and of aerial perspective'.[28] Mengs was also one of the first to comment on Velázquez's stylistic development, from his realistic *Water-Seller* (cat. 8) to the loosely painted and freer style found in the *Spinners* (fig. 31), which he says was 'made in such a way that it seemed that the hand played no role in the execution.'[29]

73.
Studio of Velázquez,
retouched by Sir Joshua
Reynolds (1723–1792)
Infante Baltasar Carlos,
about 1640
Oil on canvas, 154 × 108.3 cm
The Wallace Collection,
London

Apart from copies after Velázquez, few pictures actually by him left Spain in the second half of the eighteenth century. Indeed, Spain imposed strict controls on the export of important Spanish paintings in 1779.[30] The only record of a Velázquez exported to Britain from Spain in this period was a version of Velázquez's *Jerónima de la Fuente* brought back in the diplomatic bag of Lord St Helens, ambassador in Madrid between 1791 and 1794.[31]

Velázquez and British eighteenth-century artists

For those travellers who did not make it to Spain, Rome offered the opportunity to view Velázquez's celebrated portrait of *Pope Innocent X* (fig. 28) at the Palazzo Doria Pamphilj. For Reynolds, setting eyes on it between 1750 and 1752, it was a revelation. As an artist who had based his technical knowledge of portraiture on Van Dyck, considered Velázquez's painting as the closest to truth of any work that he had seen. It was said that the portrait of Innocent X was one of only two pictures Reynolds ever condescended to copy. Reminiscing some thirty years after his visit, he said it was 'one of the first portraits in the world'.[32] British artists and tourists were so enthralled by it that any painting thought to be a variant by Velázquez, or a copy after, was eagerly purchased.[33]

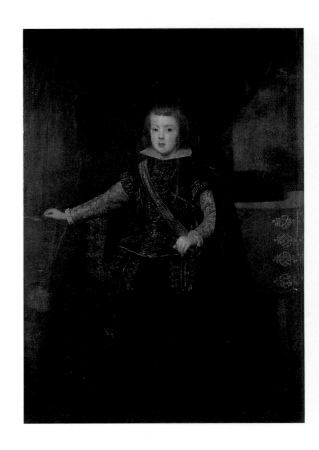

In order to understand a painter's technique better, Reynolds had the curious habit of 'dissecting' paintings by scraping down paint layers and then retouching them. One painting subjected by Reynolds to this treatment is the portrait of Baltasar Carlos (fig. 73) which he bought in the early 1770s.[34] Reynolds worked on the face so much that his pupil James Northcote, unaware that the original painting was by Velázquez, complimented him by saying 'and how exactly it is in your own manner, Sir Joshua'.[35] However, it was perhaps Northcote who had more respect for Velázquez's artistic technique. On seeing a full-length portrait by Velázquez (whose identity and whereabouts are unknown), he recalls how 'it seemed done while the colours were yet wet; everything was touched in, as it were, by a wish; there was such a power that it thrilled through your whole frame, and you felt as if you could take up the brush and do any thing.'[36]

Another leading English painter to be deeply impressed by Velázquez was Thomas Gainsborough, who on seeing the portrait of *Baltasar Carlos in the Riding School* (cat. 27) impulsively offered to buy it for £1000.[37] In the end, Gainsborough could not afford such a sum, and it was purchased by the 2nd Earl of Grosvenor, later 1st Marquess of Westminster.[38] Gainsborough's admiration for this painting is not surprising and is perhaps reflected in some of his own portraits. Reynolds, in a posthumous tribute to Gainsborough in his *Fourteenth Discourse*, not only recognised the brilliance of his brushwork but also praised, in comments that

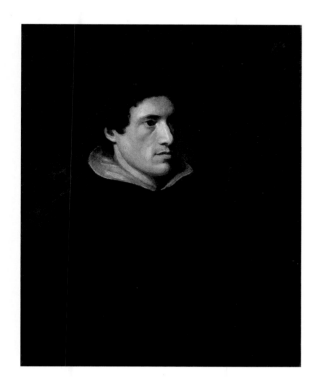

74.
William Hazlitt (1778–1830)
Charles Lamb, 1804
Oil on canvas, 76.2 × 62.2 cm
The National Portrait Gallery,
London

could equally apply to Velázquez's technique, the way in which 'all those odd scratches and marks . . . by a kind of magick, at a certain distance . . . seem to drop into their proper places'.[39]

Despite the awareness of Velázquez's reputation as a portrait painter, few British eighteenth-century portrait painters actually painted in his style. Henry Raeburn's *Archers* (1789–90) at the National Gallery has a light painterly touch that echoes Velázquez in sentiment, but a rare example of a portrait directly inspired by Velázquez is William Hazlitt's *Charles Lamb* (fig. 74). Reminiscent of the Spaniard's early portraits of Philip IV (fig. 4), Hazlitt portrays his sitter in black wearing the Spanish *golilla* ruff and adopts the tight and polished technique typical of Velázquez's early work.

Nineteenth-century collectors

The opportunity for profit and plunder offered by the Napoleonic Wars in Europe was grasped quickly by picture dealers and collectors in Britain. Before the French had even entered Spain, a young Scotsman, William Buchanan, who had already made extensive acquisitions in Italy, sent an agent to the Peninsula to look for paintings. He knew that Velázquez's paintings fetched 'very high prices in England – there is that colouring about them which pleases the present taste of the English, and a freedom of pencil that the English artists all cry so much about.'[40] His agent, the landscape painter George Augustus Wallis, arrived in Madrid in the spring of 1808 and remained there until 1813.

Among the pictures Wallis acquired was *The Toilet of Venus* (see cat. 37), sold by Buchanan for £500 almost immediately to John Bacon Sawrey Morritt of Rokeby Hall in Yorkshire, who had been advised to purchase it by the portrait painter Sir Thomas Lawrence. A Member of Parliament and classical scholar, Morritt was a close friend of Sir Walter Scott, with whom he frequently corresponded. In one his letters to Scott, he describes his hanging of the Velázquez: 'I have been all morning pulling about my pictures and hanging them in new positions to make room for my fine picture of Venus's backside which I have at length exalted over my chimney-piece in the library. It is an admirable light for the painting and shows it to perfection, whilst raising the said backside to a considerable height, the ladies may avert their downcast eyes without difficulty and connoisseurs steal a glance without drawing the said posterior into the company.'[41]

Elsewhere in Spain, the British diplomat Bartholomew Frere, Minister Plenipotentiary to the Spanish government in Seville in the winter of 1809–10, acquired two of Velázquez's early masterpieces, *Saint John the Evangelist* and the *Immaculate Conception* (cats 9–10). These remained with his heirs until they were bought by the

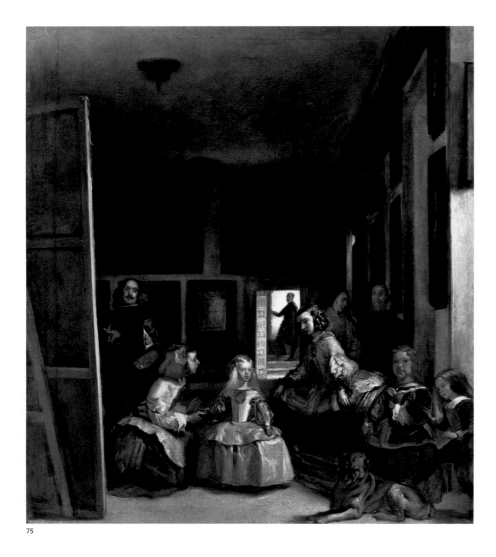

75

75.
Attributed to Juan Bautista
Martínez del Mazo
(about 1612/16; died 1667)
Copy after 'Las Meninas',
after 1656
Oil on canvas, 142 × 122 cm
Kingston Lacy, The Bankes
Collection (The National Trust)

76.
William John Bankes
(1786–1855)
**Sketch showing the
'Spanish Picture Room' at
Kingston Lacy**, after 1814
The National Trust,
Kingston Lacy, Dorset

National Gallery (with generous contributions from The Art Fund, then the National Art Collections Fund, and the Pilgrim Trust) in the twentieth century. Likewise, Velázquez's *Kitchen Scene with Christ in the House of Martha and Mary* (cat. 4) was probably bought in Spain in about 1810 by Lt. Col. Henry Packe, who had it hanging at his home at Twyford Hall, Norfolk, by 1833.[42]

One of the most impressive collectors operating in Spain during the Peninsular War was William John Bankes who travelled with the express idea of collecting Spanish pictures, which he later brought together in his 'Spanish picture room' at Kingston Lacy, his country seat in Dorset.[43] Among the pictures he acquired was one that he believed to be the sketch for *Las Meninas* (fig. 75). In a letter from Spain, Bankes refers to it as 'the glory of my collection', adding that 'I was a long while in treaty for it and was obliged at last to give a high price.'[44] He designed the frame himself and gave it pride of place in his hang (fig. 76). Despite the fact that the picture is probably by Velázquez's son-in-law, Juan Bautista del Mazo (Velázquez was not in the habit of painting preliminary drafts), it was admired throughout the nineteenth century.[45] However, the jewel of Bankes's Spanish collection, acquired in Bologna in 1820, is Velázquez's portrait of *Cardinal Camillo Massimo* (cat. 40).[46] Painted on Velázquez's second visit to Italy, it was perceived by Bankes as having a 'richer tone of colour than the generality of his works in Spain'.[47]

It was in the aftermath of the Spanish War of Independence that some of the finest examples of Velázquez's work came to Britain. In the French retreat from

76

the army of the Duke of Wellington, Joseph Bonaparte left behind at the Basque town of Vitoria in northern Spain, a number of rolled-up canvases, including Velázquez's *Water-Seller* (cat. 8), *Two Young Men at a Table* (cat. 7), *Portrait of a Man (José Nieto)* (cat. 29), and a version of *Innocent X* (cat. 39), all from the Spanish royal collection. The Duke of Wellington intercepted 'Joseph's Baggage' and brought the contents to London for safekeeping.[48] When he offered to return them to Ferdinand VII, who was proclaimed King of Spain in 1815, they were officially donated to the Duke in recognition of his role in freeing Spain from French domination.[49] It is noteworthy that by the end of the first quarter of the nineteenth century over sixty per cent of Velázquez's early oeuvre could be found in Britain.

Access to Velázquez's masterpieces in Spain was made easier in 1819 when Ferdinand VII decided to open up the royal collection to the public, in the form of the Prado museum. Visitors began to appreciate pictures such as *Las Meninas*, not just those with a marked Italianate influence.[50] Sir David Wilkie was one of the first British artists to visit the collection in 1827,[51] writing with excitement to Thomas Lawrence that 'Velázquez is all sparkle and vivacity' and 'does at once what we do by repeated and repeated touches ... this master is one that every true painter must in his heart admire.'[52] Wilkie felt that there was already a stylistic affinity between Velázquez and the British school and that the Spanish painter had strongly influenced 'Reynolds, Romney, Raeburn, Jackson, and even Sir Thomas Lawrence', who seemed to him 'whether from imitation or instinct ... powerfully imbued with his style'.[53]

While in Madrid in 1827–8, Wilkie also took the opportunity to acquire paintings attributed to Velázquez for clients back in Britain. For the politician Robert Peel, he bought the *Portrait of Archbishop Fernando de Valdés* (cat. 30), which he had seen in the collection of the painter José de Madrazo, later director of the Prado.[54] Also owned by Madrazo was a second version of *Baltasar Carlos in the Riding School* about which Wilkie wrote enthusiastically to Peel.[55] The picture was purchased on his recommendation for the banker and collector Samuel Rogers and sold in 1856 to the 4th Marquess of Hertford (fig. 93).[56] Wilkie's discovery of Velázquez coincided with the London art world's first real opportunity to appreciate his greatness. The Duke of Wellington kept his paintings at Apsley House, and therefore out of sight for most members of the public, but three of them, *The Water-Seller*, *Pope Innocent X* and *Portrait of a Man* (see cats 8, 39, 29), were shown publicly for the first time at the British Institution in 1828.[57] A contemporary critic wrote enthusiastically – if somewhat misguidedly – that 'the Exhibition at the British Gallery enables us to form so complete a judgement of the excellences of that truly great master.'[58]

In the 1840s scholars such as Richard Ford and Stirling-Maxwell made conscientious efforts to introduce Velázquez to a British audience. Ford wrote one of

the first biographies of the artist in English in the *Penny Cyclopaedia* (1843) and published his reflections in his *Hand-Book for Travellers in Spain* and *Readers at Home* (1845). Soon after, in 1848, Stirling-Maxwell published the first catalogue raisonné of the artist in his *Annals of the Artists of Spain*, and then in 1855 brought out a revised edition in his *Velázquez and his Works*. Not only did Stirling-Maxwell discuss Velázquez's role and status as both artist and courtier, a pioneering approach to the artist, but he attempted in 1873 to bring together visual records of his oeuvre in the form of prints and talbotypes (an early type of photographic reproduction), thus producing the first art-history publication illustrated photographically.[59]

Velázquez at the National Gallery, London

The history of collecting Velázquez at the National Gallery is one of great coups and occasional misattributions. In 1824, soon after it was founded, the Gallery acquired the Angerstein collection which included a double portrait of a king and queen, thought to be Philip IV and Isabella of Bourbon by Velázquez. It was catalogued as such until 1859, when it was realised that the portrait was by Justus Sustermans (1597–1681) and represented the Grand Dukes of Tuscany (NG 89).

The National Gallery made its first deliberate purchase of a Velázquez in 1847. This was a large canvas depicting *Philip IV hunting Wild Boar* (cat. 33) which it had first contemplated acquiring in 1839, in consultation with the dealer Buchanan. Buchanan wrote to Lord Calborne: 'pictures by Velasquez of this class, are nowhere to be found out of Spain . . . and I am not aware of any picture by that master in this country which could be placed in competition with that now in question [which is] full of character, most scientifically treated, and of powerful execution.'[60] This was an important acquisition and it remains today one of Velázquez's rare landscapes and depictions of court entertainment, the only example of this strand of his art in this country.

In 1853 an unexpected opportunity arose to buy Spanish paintings when the Spanish collection of the deposed French King Louis-Philippe was put up for sale at Christie's in London. Velázquez's *Portrait of Baltasar Carlos in Silver* was purchased by the 4th Marquess of Hertford,[61] while the National Gallery decided to buy what it believed to be a fine early Velázquez of the *Adoration of the Shepherds*, for the not immodest sum of £2060 (fig. 77). The attribution was accepted by most Spanish scholars, including Stirling-Maxwell, who saw 'the models … taken from the vulgar life … full of truth and nature' as characteristic of Velázquez's early style.[62] Shortly afterwards, however, the Gallery was forced to reconsider the attribution. In a letter to *The Times*, the collector of Italian Renaissance paintings William Coningham wrote contemptuously of what he called the 'disputed Velázquez',

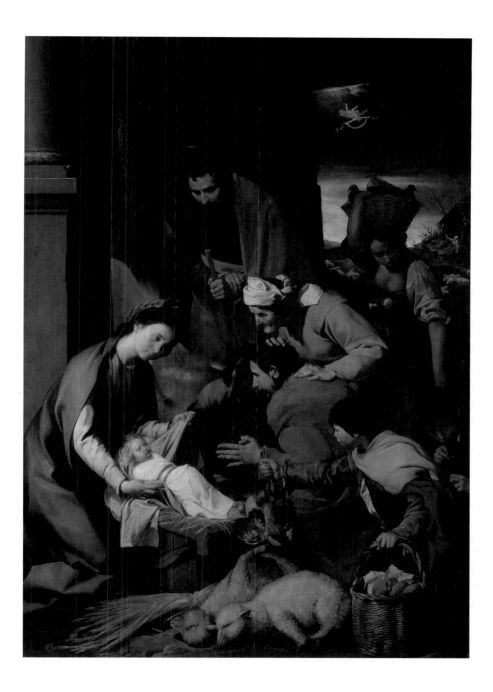

which he referred to as an 'inferior picture'.[63] The attribution was debated by the French critic Louis Viardot who believed it to be by Zurbarán, while others thought it a copy after Ribera.[64] Although the true authorship of the picture still remains a mystery, most agree on its excellent quality.[65]

Velázquez featured prominently at the Manchester Art Treasures Exhibition of 1857, with some twenty-five paintings by, or purporting to be by, his hand. All the pictures came from British private collections and the exhibition presented an ideal opportunity to see them in a public context, including the young James Abott McNeill Whistler. The Bedford version of *Don Adrian Pulido Pareja* was much admired, and it was there too that the *Toilet of Venus* received the nickname by which it is better known today, the 'Rokeby Venus'.[66] An example of how British painters had taken to heart the story of Philip IV painting the cross of the Knights of Santiago on Velázquez's self portrait in *Las Meninas*, was A. J. Herbert's *Philip II* [sic] *conferring Knighthood on Velázquez* (1856) in the section devoted to British contemporary art.[67]

In 1859 Sir Charles Eastlake, director of the National Gallery and one of the most discerning connoisseurs in Europe, set out for Madrid to look at the availability of Spanish paintings. While there he met John Savile Lumley, later Lord Savile, a passionate admirer of Velázquez whose enthusiasm was such that he painted copies of Velázquez's work, and commissioned others from the artist Charles Maloney.[68] The year before Eastlake's visit Lumley, who was attached to the British Embassy in Madrid, had acquired *Christ after the Flagellation contemplated by the Christian Soul* (cat. 16). Eastlake much admired the picture and offered to buy it for the National Gallery. (He did not get it on this occasion but Lumley later, in 1883, gave the painting to the Gallery.) When it was exhibited at the British Institution in 1860, the painter Edwin Landseer (1802–1873) declared that he would rather have 'the detail of the child's head' than 'the great picture of Murillo in the Louvre'.[69] The *Athenaeum* commented on the 'originality and solemnity' of the picture, adding that the 'resignation of the saviour and the silent awe of the child ... cannot fail to leave a deep and yet painful impression on all who have beheld it.'[70] Prince Albert was equally enthusiastic, praising the sculptural effects achieved by the artist in his treatment of the human body.[71]

A few years later, in 1865, Eastlake was in Paris bidding on behalf of the National Gallery for two paintings by Velázquez. The first was at a sale of one of the most admired collections in Paris, that of Count James-Alexandre de Pourtalès-Gorgier. Among its contents was a picture known as the 'Dead Roland' or 'Dead Soldier', showing the corpse of a youthful warrior in black silk, lying surrounded by skulls (fig. 78). Edouard Manet had been deeply affected by it a few years earlier, although he may have not seen it in the flesh but through a print, and had based his *Dead Matador* on it (1863–4, National Gallery of Art, Washington).[72] Because of the painting's restricted palette, macabre realism and startling composition, it was thought to be by Velázquez, and Eastlake, convinced by the attribution, as was Stirling-Maxwell, bid more than £1500 for it.[73] The attribution to Velázquez, however, did not survive the test of time. Today the painting is catalogued as by an unknown artist.

On a more successful note, in June 1865 Eastlake acquired for £1200 an extremely fine late portrait by Velázquez, *Philip IV of Spain* (cat. 44), which he had seen in Prince Demidoff's collection in Florence in 1862.[74] The Gallery then had to wait a further seventeen years before purchasing another great Velázquez, this time from a British private collection. The portrait of *Philip IV in Brown and Silver* (cat. 24) had been acquired by William Beckford in 1828 at a French sale and had later passed to his son-in-law, the 10th Duke of Hamilton. The whole of the Hamilton collection came up for sale in 1882 and the portrait of Philip IV was singled out by the Gallery and bought for £6300.[75]

A much higher price was paid for the *Portrait of Don Adrian Pulido Pareja*, acquired for £55,000 from the 5th Earl of Radnor in 1890. The painting attracted great public

attention with *The Graphic* praising the sitter's 'extraordinary vigour and force' and describing it as 'the finest Velázquez out of Spain'.[76] Artists who came to see it in the Gallery admired its 'intensity' and the execution of details such as the glove and sword hilt.[77] Although considered a great acquisition at the time, the attribution came under scrutiny in 1909 by the Spanish artist and authority on Velázquez, Aureliano de Beruete, who consigned the picture to Mazo.[78] Most scholars since then have preferred to see it as a copy after a lost original.[79]

Generous bequests also enriched the National Gallery's holdings of Velázquez. His early masterpiece, *Kitchen Scene with Christ in the House of Martha and Mary* (cat. 4), was given in 1892 by Sir William J. Gregory. Three years later, Lord Savile presented what he thought was a self-portrait of Velázquez wearing the cross of the Knights of Santiago with his family (fig. 79). The National Gallery had been offered the picture as early as 1845, but had rejected it. Indeed it did not take long

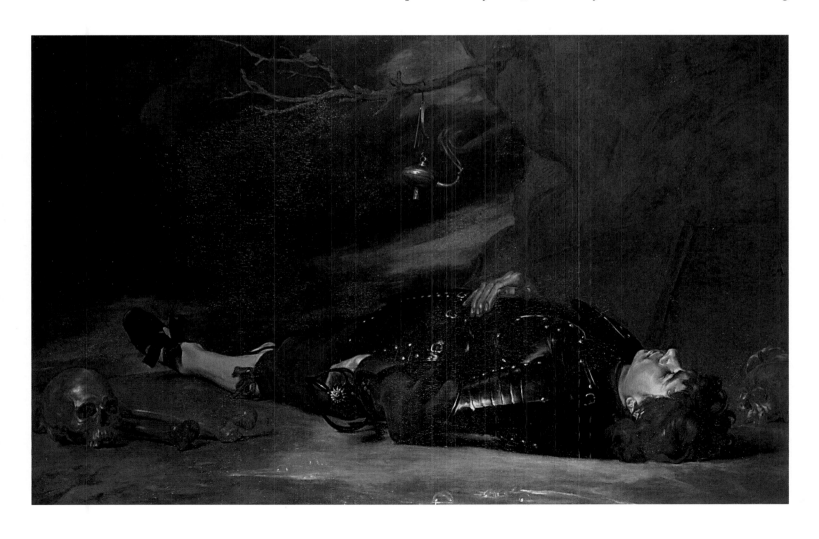

to realise that the picture was actually by Luca Giordano, painted when he was in Madrid in the 1690s, and the picture was re-titled *A Homage to Velázquez*.[80]

The opportunity for the National Gallery to acquire the 'Rokeby Venus' came in 1905. The painting had largely remained out of the public eye since its acquisition by Morritt and its sudden emergence into the public arena was sensational, with 30,000 people visiting Agnew's to see it.[81] The *Daily Express* called it 'the Nation's Venus'. The Gallery was eager to acquire it, but the Louvre, the Kaiser Friedrich Museum in Berlin and many American collectors were all ready to pay the asking price of £45,000. It was the newly founded National Art Collections Fund (now The Art Fund) who came to the rescue, with distinguished subscribers, including Roger Fry, Henry James and R. Norman Shaw, contributing to an appeal fund.

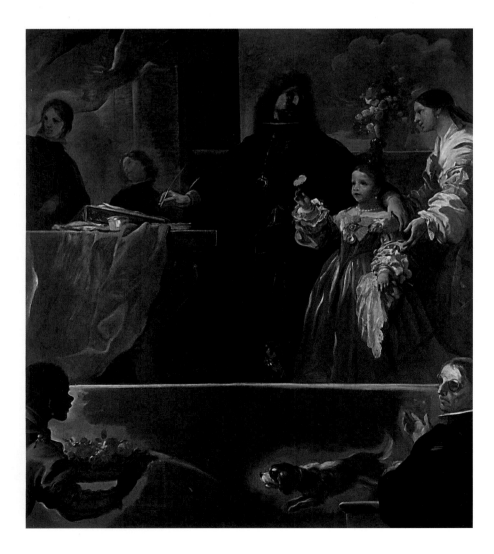

80.
Bernard Partridge
(1861–1945)
Desirable Aliens
Punch, 31 January 1906
('The *Verus and Cupid* of
Velasquez, and Mr. Sargent's
Ellen Terry as Lady Macbeth,
were both last week secured
for the National Collection')

The bid almost failed, but a last-minute anonymous donation, rumoured then (and recently confirmed) to have come from King Edward VII, was to save the painting.[82] On 14 March 1906, the *'Rokeby Venus'* was officially presented to the Trustees of the National Gallery by The Art Fund. The event is commemorated in a cartoon in *Punch*, entitled 'Desirable Aliens'. It shows Velázquez arriving at the National Gallery, with his picture under his arm, in the company of John Singer Sargent, whose *Ellen Terry as Lady Macbeth* (now in Tate Britain) was acquired at the same time (fig. 80).

Throughout the twentieth century, the National Gallery and The Art Fund continued to buy other works by Velázquez, all of which had been in the country for more than a century. The portrait of *Archbishop Fernando de Valdés* (cat. 30) that had belonged to Wilkie was bought in 1967 for the relatively high price of £100,000. And in 1974 the *Immaculate Conception* (cat. 9) joined its pendant, *Saint John the Evangelist* (cat. 10), which had been acquired in 1956. However, despite considerable efforts to raise the funds, the National Gallery failed to acquire one of Velázquez's greatest portraits, *Juan de Pareja*. After 150 years with the Earls of Radnor it was put up for auction at Christie's in London on 27 November 1970 and fetched a then world record price of £2,310,000, bid on behalf of the Metropolitan Museum of Art, New York.

Declared of national importance, the picture was stopped from export by the Reviewing Committee and the National Gallery had three months to raise the funds. Public response was strong and led many to review the presence of Velázquez in Britain. Lord Clark, former director of the National Gallery, was, surprisingly, not in favour of the acquisition, telling the *Evening Standard* that he was against 'spending gigantic sums of money on pictures which are fetching ... such inflated prices', and he reminded the reader that 'London is richer than any other city except Madrid in Velázquez: how many people visit the Wellington Museum to see the three Velázquez's there?'[83] But a handful of artists such as Barbara Hepworth, Graham Sutherland, Francis Bacon and David Hockney were adamant that the picture should remain. Ultimately the government decided not to support the National Gallery's application – a misguided decision according to *The Times*, which pointed out later that almost seventy per cent of the purchase price would have gone straight back into the Treasury as part of the death duties payable on the estate of the 7th Earl of Radnor.[84]

81.
Sir John Everett Millais
(1829–1896)
**A Souvenir of
Velázquez**, 1868
Oil on canvas, 102.7 × 82.4 cm
The Royal Academy of Arts,
London

82.
James Abbott McNeill Whistler
(1834–1903)
**Brown and Gold
(Self Portrait)**, 1895–1900
Oil on canvas, 95.8 × 51.5 cm
Hunterian Art Gallery,
University of Glasgow
Birnie Philip bequest

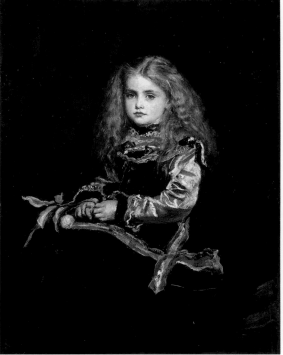

81

Velázquez and the avant-garde

Despite the authority and esteem in which Velázquez was held by British artists in the second half of the nineteenth-century – Ruskin described him in his *Modern Painters* as 'the greatest colourist' and 'the most accurate portrait painter of Spain'[85] – it was in no way comparable to the French response to Velázquez and Spanish painting as a whole at this time. Velázquez had inspired the avant-garde art scene in Paris, and in particular Manet, whose *Philosopher* (1865–6, Art Institute of Chicago) revealed his admiration for the Spaniard's technique and his ability to paint nature as he saw it, without academic constraints.[86] Although there were many more examples of Velázquez's work in Britain than in France, Britain never produced a 'British Manet'.

Perhaps the painter who came closest to emulating Velázquez was Sir John Everett Millais, founder member of the Pre-Raphaelites, who in 1868 presented *A Souvenir of Velázquez* (fig. 81) as his diploma piece for the Royal Academy. It shows a little girl as an infanta in seventeenth-century Spanish dress, sitting informally and holding an orange on a branch. The manner in which the dress is executed is reminiscent of Velázquez, yet the final effect is more that of a pastiche. The painting fails to resurrect Velázquez's spirit and is Victorian in mood, despite Millais's attempt to engage with the Spaniard's innovative approach to portraiture.

Best able in Britain to 'quote' Velázquez and yet retain their own individuality were James McNeill Whistler (1834–1903) and John Singer Sargent (1856–1925), both of whom were American but spent most of their working lives in Britain.[87] Sargent's *The Daughters of Edward Darley Boit* (1882, Museum of Fine Arts, Boston) is not only a homage to *Las Meninas* but brings Velázquez back to life again in a nineteenth-century context and Whistler instilled the spirit of Velázquez into a number of his compositions.[88] His last full-length self portrait, *Brown and Gold* (fig. 82) of about 1896, offers one of his most explicit and profound tributes to Velázquez by adopting the pose of Pablo de Valladolid (fig. 2).

The importance of Velázquez for British artists is well documented in Robert Stevenson's enormously influential *The Art of Velasquez*, published in 1895, which pays homage to Velázquez in written form rather than in paint.[89] As a painter who had studied in Paris under Carolus-Duran, a strong advocate of Velázquez, Stevenson provided an illuminating and accessible pocket-size book that was read by almost every British artist of the period.[90] In it, Stevenson describes Velázquez from the artist's perspective, discussing his training and style, and hailing him as the 'great Spanish impressionist'.[91]

In the twentieth century British artists have continued to show their admiration for Velázquez by selectively borrowing from or alluding to his work. In 1913, for example, the Irish-born society painter Sir John Lavery looked to Velázquez

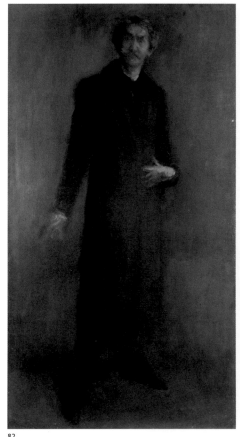

82

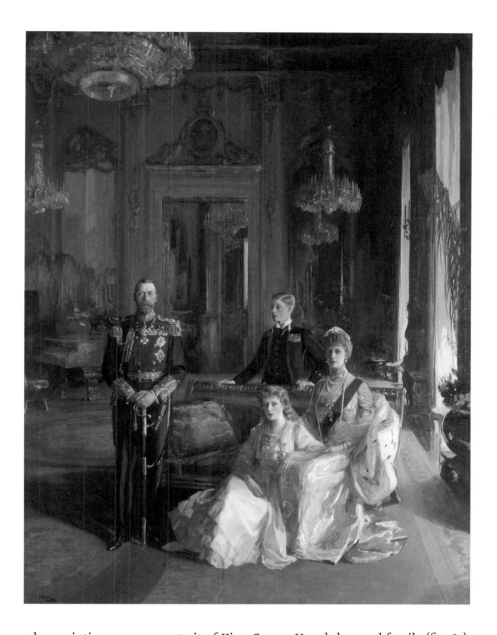

83.
Sir John Lavery (1834–1903)
The Royal Family at Buckingham Palace, 1913,
1913
Oil on canvas,
340.3 × 271.8 cm
The National Portrait Gallery,
London

when painting a group portrait of King George V and the royal family (fig. 83). He chose as a location the White Drawing Room at Buckingham Palace, a room similar to Baltasar Carlos's apartments where Velázquez painted *Las Meninas*, arranging the lighting in the same way as in Velázquez's painting.[92] When George V visited Lavery at work on the picture, he asked, harking back to the moment when Philip IV daubed the cross of the Knights on Santiago on the figure of Velázquez in his painting, to be allowed to contribute with his own hand: 'Thinking that royal blue might be an appropriate colour,' Lavery recalls, 'I mixed it on the palette, and taking a brush he applied it to the Garter ribbon.'[93] For a moment, the spirits of Velázquez and Philip IV hovered over a painter's studio in England.

With the increasing interest in cubism, and expressionist and abstract art, it was painters like El Greco on whom more attention began to be focused as the century advanced.[94] But the extraordinary hold that Velázquez had over painters is exemplified by Francis Bacon's lifelong relationship with Velázquez's portrait of *Innocent X*. On his visit to Rome in the early 1950s, Bacon made the deliberate decision not to go and see the portrait in the flesh. Instead, he bought reproductions and from these worked up a series of paintings, which today have become icons of British art (fig. 84). In an interview with the art critic David Sylvester, Bacon sought to

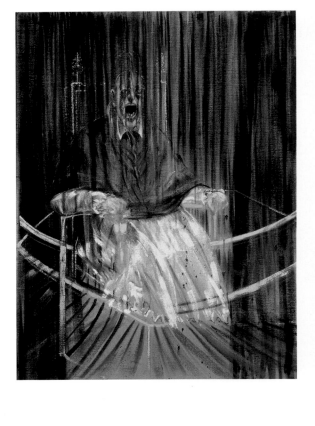

84.
Francis Bacon (1909–1992)
**Study after Velázquez's
Portrait of Pope Innocent X**,
1953
Oil on canvas, 153 × 118.1 cm
Purchased with funds from
the Coffin Fine Arts Trust;
Nathan Emory Coffin
The Des Moines Art Center,
Iowa

explain his fascination with the picture: 'Because I think it's one of the greatest portraits that has ever been made, and because I became obsessed by it . . . it opens up all sorts of feelings and areas of – I was going to say – imagination, even, in me.'[95]

Directly or indirectly therefore, the art of Velázquez has become engrained in the consciousness of British artists in the twentieth and twenty-first centuries. Mark Gertler's early *Artist's Mother in her Kitchen* (about 1910, Tate) was a direct tribute to Velázquez's *Kitchen Scene with Martha and Mary*, which he later said was his favourite painting in the National Gallery.[96] Later in the century, when Pop Art and Minimalism dominated the art scene, painters such as Frank Auerbach, Leon Kossoff and Lucian Freud, whose main emphasis in their art is on 'brushwork', showed a profound respect for Velázquez's art. Kossoff is particularly fascinated by Velázquez's *Aesop* (cat. 35),[97] while Freud keeps a reproduction of a detail from *Las Meninas* in his studio.[98] And even today, in the twenty-first century, Mark Wallinger commented: '[*Las Meninas*] seems particularly modern to me because it's the first great self-conscious painting.'[99]

The story of Velázquez in Britain is essentially one to be proud of. Despite note-worthy losses, such as the *Juan de Pareja*, Britain is today the best place outside Spain to view his work thanks to the diligence and connoisseurship of scholars, collectors and artists over the past two centuries. One of the most valuable scholarly contributions has been that of Enriqueta Harris (who died in April this year):[100] her monograph *Velázquez*, and her many articles, remain seminal works for students and scholars today. It is entirely fitting that the National Gallery's *Velázquez* exhibition of 2006, as well as marking the centenary anniversary of the nation's acquisition of the 'Rokeby Venus', should be dedicated to her.

I am grateful to the following for their assistance while researching this essay: Richard Dorment, Pierre Géal, Charlotte Gere, Nigel Glendinning, Enriqueta Harris, Tim Knox, Alastair Laing, Nicholas Penny, Daniel Robbins, Francis Russell, Alison Smith, Nicholas Tromans, Richard Shone, Zahira Véliz and Juliet Wilson Bareau. The Reynolds quote is taken from Reynolds (1856), p. 212.

1 Stirling-Maxwell 1848, vol. III, pp. 1391–411.
 See also Harris 1999b, pp. 23–30.
2 For more on this see Brown and Elliot 2002, p. 57.
 See also Jenkins 1989.
3 De Andrés 1974, pp. 1–20.
4 Pacheco 1649, lib. I, ch. VIII. Trans. in Harris 1982, p. 191.
 See also Huxley 1959, pp. 111–12, and Harris 1967, pp. 414–19.
5 Enriqueta Harris, in her personal (unpublished) notes, suggests that the picture was with the Duke of Buckingham and then in the collection of the Earl of Fife (d. 1809) in Whitehall, where 'A head of Charles I when prince of Wales' is described by Thomas Pennant in 1790.
6 Cust 1928, pp. 151–3.
7 Palomino 1724 (1982), vol. III, pp. 321–54.
8 At one time owned by Stirling-Maxwell, see Tatsakis 2003, p. 110, no. 43.
9 Palomino 1724 (1739), pp. 49–56.
10 See *Sale Catalogues 1711–59*, vol. 1, p. 19. See also Pears 1988, p. 87.
11 See 'George Vertue Notebooks', vol. IV, *Walpole Society*, 1951–2, Oxford 1955, p. 175. Walpole also acquired a 'Velasco' of 'S. Joseph', recorded in 1736 in his drawing room in London (see Hermann 1972, p. 81), which was engraved as by Velázquez (see Harris 1987, p. 151). Both paintings were sold by Walpole's grandson to Catherine the Great in 1779.
12 For the *Innocent X* at the National Gallery of Art, Washington, see Brown and Mann 1990, pp. 124–6, and, most recently, Kagané 2002, pp. 284–6, no. 187.
13 Varona 1999, pp. 330–1 and p. 338.
14 My thanks to Chris Gravett, Marilyn Buckley and Lavinia Wellicome for this information.
15 See Palomino 1724 (1739), p. 52.
16 Only two paintings attributed to Velázquez, besides Walpole's *Innocent X*, are recorded as being sold between 1711 and 1759 on the British Art Market: Dr Bragge's sale of 1757, 'The Education of Achilles by Chiron the Centaur, D. D. Velasquez', and Sir L. Schaub's sale of 1758, 'An Old Woman's Head – Diego Velazquez'. See *Sale Catalogues 1711–59*.
17 Both pictures are recorded at Castle Howard in 1758. The *Baltasar* was recognised as a Velázquez by Waagen (see Waagen 1854, vol. III, p. 322). The *Juan de Pareja* was sold to the Hispanic Society of America, New York in 1925. See Du Gué Trapier, pp. 51–4.
18 The *Lady in a Mantilla* is now generally considered to be by Mazo. For the first mention of the picture see Dodsley 1761, vol. II, p. 119. Another highly acclaimed picture, also thought to be by Velázquez, was a portrait of Philip IV at Fraga now in Dulwich Picture Gallery,

where it is catalogued as studio of Velázquez. See Murray 1980, p. 131.

19 Glendinning et al. 1999, p. 604. See also Finaldi in London 1999. The *Finding of Moses* is now on loan to the National Gallery from a private collection.

20 Christie's, London, 28 March 1801, no. 59.

21 See *The Provenance Index of the Getty Art History Information Program*, vol. 1 (1988), pp. 773–8, and vol. 2 (1990), pp. 1027–9.

22 Richard Cooper, for example, visited the Duke of Alba's collection in 1767, which contained, among other Velázquez paintings, the *Toilet of Venus*, see Bull and Harris 1986, pp. 646–7. Another English traveller, Richard Twiss, saw what he described as 'An Army Marching' (presumably *The Surrender at Breda*) and 'Three Children playing with a dwarf' (*Las Meninas*), see Twiss 1775, pp. 146 and 150.

23 Swinburne 1787, p. 227; Beckford 1834, p. 310.

24 Swinburne 1787, p. 174.

25 Grantham went so far as to say 'Velasquez and his paintings are with us the "Electrical Eel" of the day'. See Glendinning, Harris and Russell 1999, pp. 598–605.

26 While only thirteen of these copies have survived, there is no sign of the catalogue. Grantham also bought a painting attributed to Velázquez of *The Conspirators*, today entitled a *Group of Men under an Archway* (Lucas Collection), based on three figures in the foreground in *Philip IV hunting Wild Boar*, NG 197. Although now considered a pastiche (see Glendinning, Harris and Russell 1999, p. 609), it was admired by Gainsborough who copied it in 1785. See Whitley 1915, p. 249.

27 See also Glendinning, Harris and Russell 1999, p. 601.

28 Ponz (1947), pp. 569–70.

29 See Ponz (1947), p. 574.

30 *Almanak mercantile o Guía de comerciantes para el año de 1798*, Madrid, p. 157.

31 See Brigstocke in Oviedo 1999–2000, p. 6 (and no. 6)

32 Reynolds (1928), p. 152.

33 John 3rd Earl of Bute, for example, bought in Rome what he considered one of the best versions of the original. See Russell 2004, pp. 192, 195, illus. no. 91. For another copy admired by Wilkie see further Irwin 1974, p. 353.

34 Ingamells 1985, I, P4, pp. 415–16.

35 Quoted in London 1986, p. 68.

36 Hazlitt (1949), p. 59.

37 Hazlitt (1949), p. 59.

38 Christie's, London, 2 and 3 May 1806, lot 22.

39 Reynolds (1959), pp. 257–8.

40 See Brigstocke 1982, p. 183.

41 Letter dated 9 December 1820. See Johnson 1970, vol. I, p. 715.

42 I am grateful to Philip McEvansoneya for providing me with this information. The National Gallery of Scotland's *Old Woman cooking Eggs* (cat. 3) also came to Britain at about this time, and was included in the John Woollett sale, London, 8 May 1813, lot 45.

43 See Maclarnon 1990, pp. 114–25.

44 Harris 1990b, p. 127. See also Laing 1995, pp. 137–9, no. 51.

45 It was exhibited in 1823 and 1864 at the British Institution and at the Royal Academy in 1870 and 1901–2. For an analysis of the picture's influence in Britain see Brooke in Stratton-Pruitt 2003, pp. 47–79.

46 See Harris and Lank 1983, pp. 408–15.

47 For Bankes's other 'Velázquez' acquisitions see Crawford Volk 1985, pp. 23–35.

48 Kauffmann 1982, pp. 5–10.

49 At first, the realism of the *Waterseller* and the *Two Men at a Table* led them to be catalogued as Caravaggio. See Seguier in Wellington 1901, vol. I, pp. xvii, xx.

50 See Quin 1824, p. 309 and p. 305.

51 Wilkie's trip probably inspired other younger artists to visit Spain, including John Frederick Lewis (1805–1876) and John Philip (1817–1867), both of whom copied some of Velázquez's works. See Sweetman 2005, pp. 310–15, and Brooke 2003, pp. 59–60.

52 See Cunningham 1843, vol. II, p. 486 and p. 472.

53 Cunningham 1843, vol. II, p. 458–71.

54 See Tromans 2002, p. 38, note 20. See further Tromans 2006, forthcoming.

55 Letter dated 28 January 1828. See Ingamells 1985, p. 41, note 15.

56 *Christie's*, 3 May 1856, lot 710. Now Wallace Collection, London.

57 See Tromans 2000, pp. 44–55. See also Tromans 2006.

58 Quoted in Tromans 2002, p. 40. On this exhibition see Tromans 2000, pp. 51–2.

59 See Harris 1987, pp. 149–50, and Brooke 2003, p. 56.

60 Letter dated 6 May 1839, National Gallery archives (NG538/1839).

61 Bought at the Standish sale, 30 May 1853, London. See Ingamells 1985, P12, pp. 407–10.

62 Stirling-Maxwell 1855, ch. ii, pp. 37–8.

63 See *The Times*, 10 and 14 May 1853.

64 Viardot 1860, p. 50. Curtis later, however, still believed the National Gallery picture to be by Velázquez. See Curtis 1883, p. 4, no. 8.

65 At least ten different artists, some Spanish and some Italian, have since been proposed. Today it is catalogued as Italian, Neapolitan (NG 232).

66 See Manchester 1857, pp. 74–5, and p. 134.

67 The story is told in the 'Handbook to the Paintings by Ancient Masters', Manchester 1857, pp. 66–7. See also Brooke 2003, p. 55.

68 Maloney made 60 copies in all, which in 1888 were given to the National Gallery for 'young artists and students to copy'. Six remain in the Gallery's history collection: H193 *Don Diego de Acedo*, H194 *Francisco Lezcano*, H195 *Queen Mariana of Austria*, H196 *A Sibyl*, and two copies (H197 and H198) after *A Girl* by José Antolínez (but formerly attributed to Velázquez).

69 He was presumably referring to the Soult *Immaculate Conception*. Quoted in Glendinning 1989, p. 123.

70 *Athenaeum*, 23 June 1860, vol. I, p. 859.

71 Glendinning 1989, p. 123, note 40.

72 See Portús in New York 2003, p. 459, no. 81.

73 See *Report of the Keeper of the National Gallery*, appendix no. 1, p. 4, no. I (National Gallery archives): ' examined the picture well yesterday forenoon when I was admitted quietly & satisfied myself of the authenticity of every part.'

74 See *Report of the Keeper of the National Gallery*, appendix no. 1, p. 4, no. III (National Gallery archives).

75 Christie's, London, 17 June 1882, lot 1142 for 6000 guineas.

76 *The Graphic*, 28 June 1890, p. 734.

77 See McConkey 2005, p. 192.

78 See Beruete 1916, pp. 1–25.

79 Although other versions of the picture exist (such as those sold in the Altamira Sale in 1833 and the Aston Hall Sale in 1862), the National Gallery painting is the best version so far known.

80 Recognised in Beruete 1898, pp. 187–8. See Levey 1971b, pp. 113–14. For the correct interpretation of this picture see Aterido 1994, pp. 396–400.

81 See Haskell 1999, p. 229, note 18.

82 See Nead in London 2003–4, pp. 74–9.

83 See the *Evening Standard*, 31 December 1979, p. 10.

84 Geraldine Norman, 'Taxing problems for art benefactors', *The Times*, 27 September 1972.

85 Ruskin 1903–12, vol. 7, p. 419.

86 See Wilson-Bareau in Paris-New York 2002–3, pp. 203–57.

87 See Ormond and Pixley 2003, pp. 632–40.

88 Whistler owned nine prints after eight paintings by Velázquez; see Thorp 1987, pp. 88–9.

89 Stevenson 1895, pp. 1–3 and 101–10.

90 McConkey, 2005, pp. 193–6.

91 Stevenson 1895, p. 124. See also McConkey 2005, pp. 193–6, who discusses British artists' interest in Velázquez at the turn of the nineteenth century.

92 The royal portrait was actually commissioned by the publisher W.H. Spottiswoode and presented by him to the National Portrait Gallery in 1913.

93 Quoted in McConkey 1993, p. 122.

94 See Alvarez Lopera 1999, pp. 259–71.

95 Interview with David Sylvester, May 1966: exhibition catalogue, *Important paintings from the estate*, Tony Shafrazi Gallery, New York, October 1998 – January 1999.

96 I am grateful to Richard Shone for this information.

97 *The Guardian*, 1 June 1996, p. 29, published an exchange of letters between Leon Kossoff and John Berger in which they discuss their shared passion for Velázquez's *Aesop*.

98 I am grateful to Martin Gayford for pointing this out to me.

99 Martin Gayford, 'Mark Wallinger on Las Meninas', *Daily Telegraph*, 'Art and Books', 3 March 2001.

100 See obituaries in *The Guardian* (16 May 2006, p. 35) by Michael Kauffmann, and *The Times* (20 May 2006), by Nigel Glendinning.

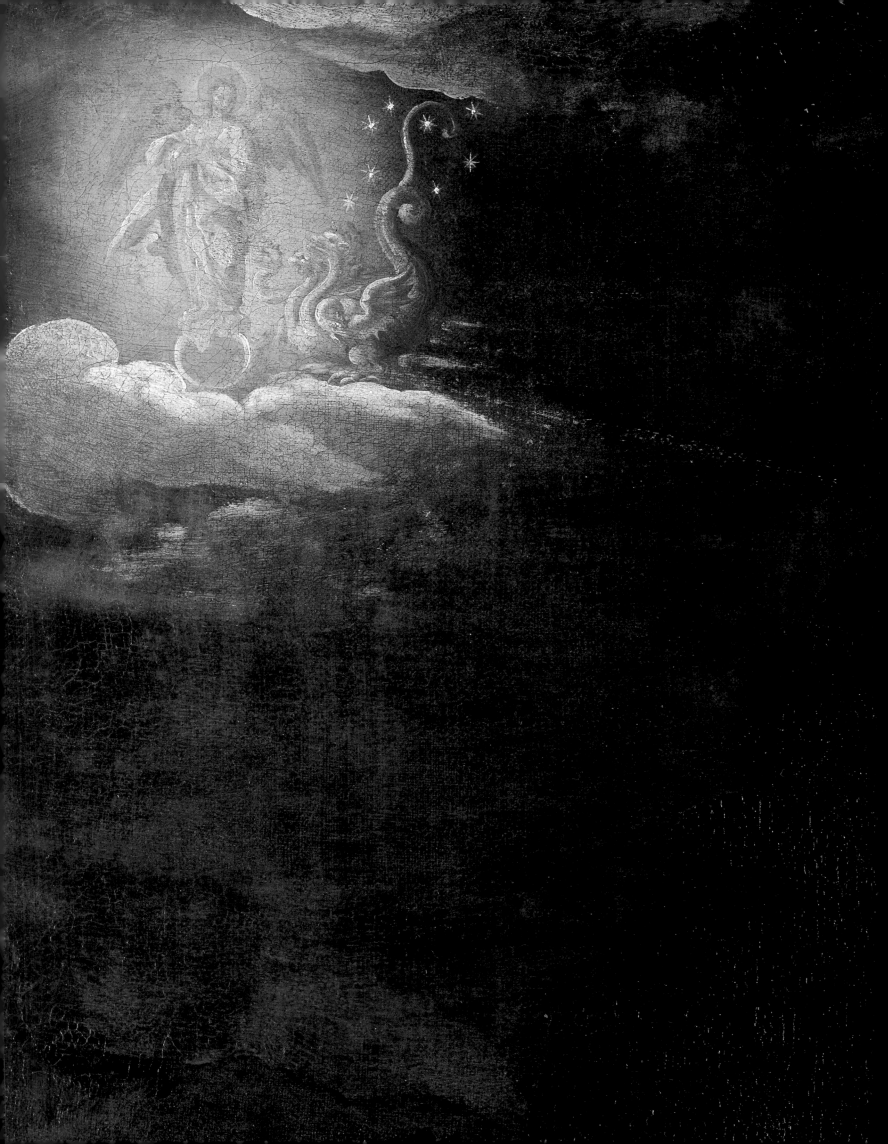

Catalogue

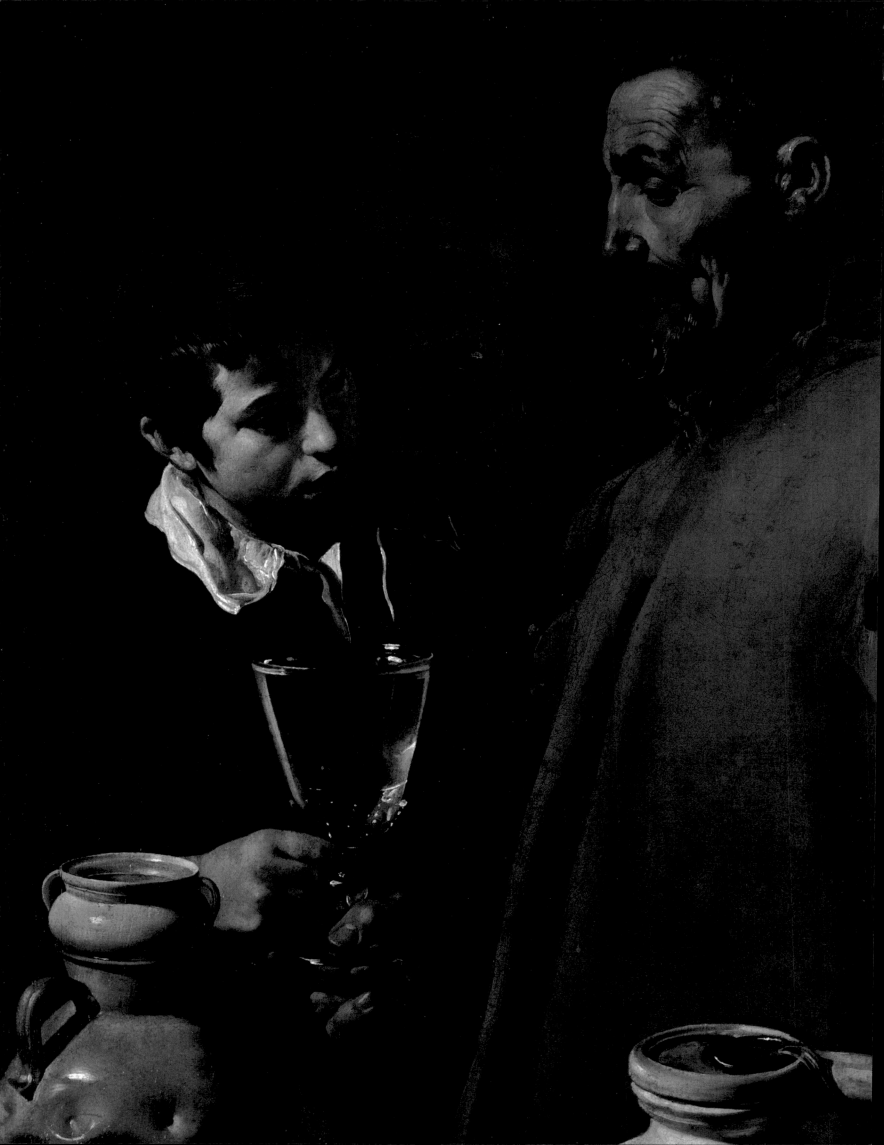

VELÁZQUEZ IN SEVILLE

Seville, where Velázquez was born in 1599, was an ideal training ground for a young artist. Strong trading links with other parts of Europe and with Spain's colonies in the Americas made it a wealthy, cosmopolitan city with a rich and varied artistic culture. Merchants from Flanders and Italy brought with them prints, drawings and paintings. Francisco Pacheco, Velázquez's teacher, owned a collection of Italian drawings and prints by Dürer and Lucas van Leyden, while a celebrated collection of Roman antiquities at the Casa de Pilatos was open to artists and connoisseurs. In addition, the churches of the city were full of religious paintings and sculptures.

Pacheco's workshop, 'a gilded cage of art, the academy and school of the greatest minds of Seville,'[1] as Palomino later described it, was at the centre of this cultural ferment. It was there, on 17 September 1611, that Juan Rodríguez, Velázquez's father, signed a document committing his son to a five-year apprenticeship with the man who was then the city's leading painter. The contract was conventional in its terms – Velázquez was to live as a servant in Pacheco's home and be fed and clothed. In return he was to be taught the art of painting.

Pacheco's Arte de la Pintura (1649), one of the most important Spanish treatises on the theory and practice of painting, gives us an idea of the schooling that Velázquez would have received. A connoisseur of both antique art and contemporary painting Pacheco gave his students an all-round technical training, from grinding and mixing colours and preparing and priming canvases, to drawing from prints and plaster models. As the official 'censor and inspector of all sacred subjects' on behalf of the Inquisition, he also instilled in them his ideas on religious decorum and iconography.

Velázquez was also probably taught to paint sculpture, an art form in which Pacheco particularly prided himself. The realism and tangibility of Velázquez's early paintings, especially religious works such as the Immaculate Conception (cat. 9), may well have found inspiration in the life-size painted wooden sculptures carved by Juan Martínez Montañés. The celebrated sculptor

often brought his carvings to Pacheco's workshop, where they were painted in a realistic manner, to give them life, as Pacheco said.[2] Training in the art of polychroming these wooden figures enhanced Velázquez's awareness of the visual impact and physical presence of sculpture, enabling him to translate the same sensation into paint on canvas in what may be called a 'sculptural style'.

On 14 March 1617, Velázquez passed his examination for the Guild of Saint Luke, on the strength of a practical demonstration and his answers to questions posed by the guild's officials, Pacheco and Juan de Uceda. This enabled him to begin his career as a 'master painter of religious images and in oils and in everything related thereto'.[3] At eighteen years of age, he was now licensed to practise his art in Seville or anywhere else in the kingdom, to set up shop and to employ assistants and apprentices. So impressed was Pacheco, as he later recalled, by his student's 'virtue, integrity and excellent qualities, and also by the promise of his great natural genius' that he gave him his daughter in marriage. Velázquez married Juana Pacheco on 23 April 1618.

Velázquez was no slavish follower of his master, however. From his surviving paintings of this period, we see that he was already beginning to take a very different direction from that of Pacheco. Velázquez set out not to idealise the world around him, but to paint it as realistically as possible. Although Pacheco later claimed to have trained his pupil in 'the true imitation of nature', it was Velázquez who made him see how that was possible. He probably began, as Pacheco tells us, by paying a country lad 'to adopt various attitudes and poses' and different expressions and 'thereby gained assurance in his portraits'. None of these studies have survived, but paintings such as the Three Musicians and Tavern Scene (cats 1–2), contain figures surely studied from life.

The source of Velázquez's realism – in terms of the novelty of his subject matter and of his execution, both of which set him apart from his Sevillian antecedents – has long been considered to be an acquaintance with the Caravaggesque style of painting. Velázquez may have been familiar with copies after Caravaggio, whose

innovative manner spread throughout Europe with amazing rapidity. The strong contrasts between light and dark in paintings such as the Old Woman cooking Eggs, dated 1618, or the Water-Seller (cats 3 and 8), for example, have been attributed to the influence of Caravaggio. However, there is no evidence that Velázquez saw original paintings by Caravaggio, and he may well have known of his work by reputation only.

Perhaps the most startling innovation of Velázquez's early career are his bodegones. These were paintings following a style imported from northern Europe and Italy, showing a kitchen or a tavern with a prominent still-life motif. For his bodegones, Velázquez chose subjects from his own immediate environment to demonstrate his growing mastery of his art. Using a palette of earth tones, the young painter set out to imitate visual reality with aplomb. Later, he began to add a spiritual dimension with works such as Kitchen Scene with Martha and Mary, dated 1618, and Kitchen Scene with the Supper at Emmaus (cats 4–5), in which a domestic scene is contrasted with a representation of a biblical episode.

Velázquez's skill at portrait painting, a more established genre, also attracted the attention of patrons. Portaits such as that of the Poor Clare Jerónima de la Fuente (cat. 14) and the poet Luis de Góngora (cat. 15) demonstrate the unidealising manner that Velázquez strove for, unlike the more sugary and naive style of his contemporaries. The precocious young artist soon outgrew his native city. In 1623, he travelled to Madrid (perhaps taking with him a bodegón such as the Water-Seller as a demonstration piece) in the hope of obtaining patronage at the court of the King of Spain. According to Pacheco, he painted his first portrait of Philip IV on 30 August 1623 at the age of 24. It was, his father-in-law reported, 'a great success'. XB

1 Palomino 1724 (1987), p. 140.
2 Pacheco 1649 (1990), pp. 494ff.
3 Varia Velázqueña 1960, II, p. 217, doc. 10.

The Water-Seller of Seville
(detail of cat. 8)

1

Three Musicians, 1616–17?

Oil on canvas, 88 × 111 cm
Staatliche Museen, Gemäldegalerie, Berlin (413 F)

PROVENANCE

La Touche Collection, Ireland;
R. Langton Douglas, London;
Staatliche Museen, Gemäldegalerie,
Berlin (since 1906)

ESSENTIAL BIBLIOGRAPHY

Berlin 1975, pp. 448–9, no. 413 F;
Bock 1986; López-Rey 1996, vol. I,
pp. 35–7, and vol. II, pp. 10–11, no. 1;
Davies and Harris in Edinburgh 1996,
p. 140, no. 25 (entry on a version
after Velázquez); Marini 1997,
pp. 42–3; Navarrete Prieto in Naples
2005, p. 48, no. 2; Navarrete Prieto
in Seville 2005–6, pp. 202–4, no. 35

'He used to bribe a young country lad who served him as a model to adopt various attitudes and poses, sometimes weeping, sometimes laughing, regardless of difficulties. And he made numerous drawings of the boy's head and of many other local people.'[1] In *Arte de la Pintura* Francisco Pacheco tells his readers of the young Velázquez's keen interest in capturing the emotions of ordinary people in and around Seville. These may have included the three musicians portrayed here, who illustrate the painter's fascination with the study of lively facial expressions. On the left, a boy looks straight at us with an open smile;[2] in the centre, a man is so absorbed that he turns his gaze heavenwards, as though striving for the highest notes;[3] on the right, a violinist tilts his head and leans forward in an effort to tune his instrument to his companion's singing.

The three figures are in a dimly lit room, almost certainly a tavern, standing by a table set with bread, a glass of wine and a round of cheese. On the left edge of the composition, the spirited eyes of a monkey emerge from the shadow. Monkeys have often been interpreted as allusions to lust or, in a broader sense, man's slavery to the lower instincts, but it seems more likely that here the animal, holding a pear, has a less symbolic role: exotic pets imported by Portuguese merchants from the New World were carried around by street artists to attract the attention of passers-by. The light mood of the picture, and its portrayal of the world of wandering entertainers, is typical of the so-called *pintura de risa*, those *bodegones* or tavern scenes that showed merry characters drinking, singing and playing music.[4]

The picture was added to Velázquez's oeuvre in 1906,[5] shortly after it was acquired by the Gemälde-galerie (then the Kaiser Friedrich Museum). Some scholars have raised doubts as to its authenticity, arguing that it may be a good copy after a lost original.[6] Indeed, when compared to Velázquez's other *bodegones*, the *Three Musicians* seems somewhat awkward, mainly because of the absence of a clearly defined space. The asymmetrically disposed figures are crammed into a room that lacks depth; in fact the landscape painting on the wall is the only element that creates a background.[7] The other noticeable weakness of the painting is the unsuccessful attempt to portray the laughing face of the boy. The heavy shadows around the nose and mouth render his features stiff, almost frozen, betraying the artist's inability to convey the movement of facial muscles.

Yet, of the four existing versions of this composition, the painting in Berlin is generally considered to be the only autograph work.[8] Most modern critics believe that the picture's limitations can be attributed to Velázquez's inexperience, rather than to another hand. This may be Velázquez's earliest known work, executed when the Sevillian was an apprentice in Pacheco's workshop, possibly as early as 1615. Despite its tentative quality, the work possesses beautifully painted passages. These would later develop into the artist's distinctive traits: the rendering of volumes through the bold modelling of faces and hands (visible especially in the figure on the right); the use of chiaroscuro to accentuate gestures and expressions; the naturalistic rendering of details such as the beady-eyed monkey, and the folded tablecloth on the silver plate. SDN

1 Pacheco 1649, Lib. III, ch. VIII, pp. 144–6.
2 Some suggest that this is the same boy, although younger, featured in the *Tavern Scene* and the *Old Woman cooking Eggs*. Davies 1996; Seville 1999, p. 182, no. 84; Rome 2001, p. 147.
3 Radiographs have revealed that the costume of this figure was originally lighter and his collar smaller. It is not clear whether the changes were made by the artist himself, or if they were carried out at a later stage. Lying underneath Velázquez's *Head of a Young Man in Profile* in the Hermitage there is a face almost identical with that of the singer here.
4 Jordan and Cherry in London 1995b, p. 39.
5 Beruete 1906, p. 8.
6 Du Gué Trapier 1948, pp. 76–7; Pantorba 1955, p. 72, no. 15; Camón-Aznar 1964, I, pp. 200–1.
7 López-Rey observes that 'spatial depth is principally achieved by the multiplicity of points of distance marked off by hands, faces and inanimate objects', López-Rey 1996, p. 36.
8 One version is in the collection of Art Hispania, S.A. (Carlos Ferrer), Barcelona. The whereabouts of the two other versions are unknown. See Edinburgh 1996, p. 143, no. 25.

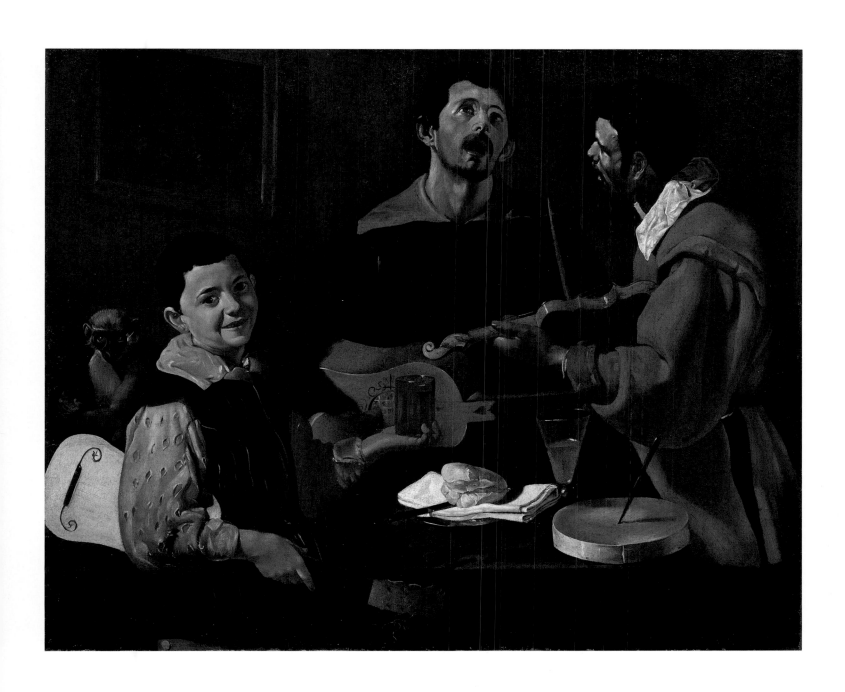

Tavern Scene, 1616–17?

Oil on canvas, 108.5 × 102 cm
The State Hermitage Museum, St Petersburg (389)

PROVENANCE

The State Hermitage Museum,
St Petersburg (before 1774)

ESSENTIAL BIBLIOGRAPHY

Kemenov 1977, pp. 28–33; López-Rey
1996, vol. II, p. 14, no. 3; Davies and
Harris in Edinburgh 1996, p. 142,
no. 26; Kagané 1997, pp. 255–6,
no. 139; Marqués in Seville 1999,
p. 182, no. 84

This painting is probably one of the artist's earliest *bodegones*, produced when Velázquez was still an apprentice in Pacheco's studio, or shortly after he graduated from it. Although not mentioned by Velázquez's early biographers, the work's status as autograph has been undisputed since Bode attributed it to the Sevillian painter in 1895.[1] A comparison with the more ambitious *Old Woman cooking Eggs* (cat. 3), signed and dated 1618, suggests that this picture was painted earlier, possibly in 1616–17. However, as so few of Velázquez's early paintings have survived it is difficult to judge the distance from later works with any certainty. Several roughly contemporary imitations surviving today attest to the fact that *Tavern Scene* must have quickly become well known.[2]

Three figures sit around a table with food and drink. A stern old man is about to eat a simple meal; an amused boy raises a decanter of wine while looking out towards the viewer; a youth eyes the spectator and points to his companion with a knowing smirk. The table, painted close to the picture plane, is covered with a bright white tablecloth. Interestingly, the frugal meal appears to cater for one person only: a bowl of fish (mussels or sardines), two pomegranates, a glass of wine and a loaf of bread. In a daring attempt at bravura, a knife is placed at the edge of the table, but the curve of the shadow shows that the young painter cannot yet fully command the effects of light. The still life continues in the background, where a cap, a collar and a sword are seen against the wall.

The interest of artists in so-called 'lowly subjects', or the depiction of humble people in markets and taverns, surrounded by food and cooking utensils, was not a novelty. However, Velázquez's exceptional ability to reproduce on canvas the physical reality around him must have had an extraordinary impact on his contemporaries. Here he has portrayed the world of the seventeenth-century Spanish lower classes. The rough physicality of the protagonists is expressed in their broad facial features; their poverty by the heavy material and plain colours of their clothes, as well as by details such as the torn tablecloth.

Yet, in *Tavern Scene* Velázquez did not merely record what he saw. The telling gesture of the figure on the right, and the laughing expression of the young boy, reveal the existence of a narrative. It has been argued that the old man is a traveller who has come to the tavern to eat and rest from his journey.[3] This hypothesis is lent credibility by the objects on the wall, as well as by the fact that he is the only one eating. Perhaps the two adolescents have joined him at his meal, and are smiling at the thought of some trick they are about to play on him.[4] Their mischievousness would have been in tune with the spirit of the Spanish *picaresque* novels, in particular with the burlesque types whose misadventures entertained contemporary readers.[5] Others have suggested that the gesture of the figure on the right refers to the Latin expression '*collateraliter mostro*' ('monster is he who sits next to me'), which was used by actors to poke fun at fellow characters.[6]

It is also possible that Velázquez intended this painting to be a representation of the Three Ages of Man.[7] The allegory is conveyed not only by the different ages of the figures, but also by the characterisation of their personalities: from the playfulness of the boy, to the more measured gaze of the youth, and finally to the weariness of the old man. The artist's rendition of this traditional theme is a deeply personal one, and shows the desire of the young painter to adapt a well-established artistic motif for a contemporary audience. Rather than portraying the Three Ages of Man using characters from the classical world,[8] Velázquez turned his attention to the people and places of his immediate surroundings. SDN

1 According to the Hermitage catalogue of 1899, see Kagané 1997, p. 255. In the 1774 Hermitage catalogue it is given as 'Unknown, a meal'.
2 *Peasants at Table* in the Budapest Museum of Fine Arts is sometimes regarded as the artist's own variant on this composition. Edinburgh 1996, p. 142, no. 26.
3 Kemenov 1977, p. 28.
4 A similar scene is described in *Vida del buscón Don Pablo* by Francisco Gómez de Quevedo. Kemenov 1977, p. 29.
5 Most critics have made the association with this literary genre. Du Gué Trapier referred to specific novels: 'The ugly, grinning boy... seated between an old man and a rascally looking young one, might have posed for *Lazarillo de Tormes*, or *Pablo de Segovia*.' Trapier 1948, p. 63.
6 See Seville 1999, p. 182.
7 This interpretation has also been given to *The Water-Seller of Seville*. In this context, the theme has been linked to Pacheco's discussion of 'the three ages of the painter's profession: *principiantes, aprovechados, y perfectos*', Moffit 1979, pp. 5–23.
8 See *The Three Ages of Man* by Titian (National Gallery of Scotland, Edinburgh).

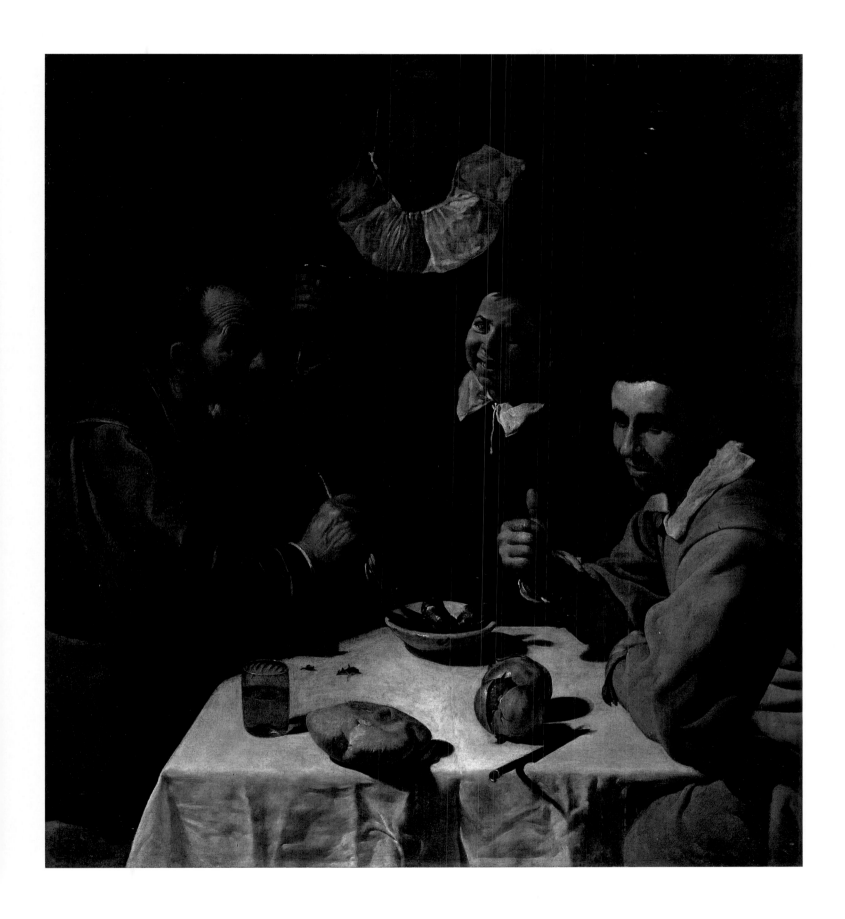

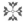

An Old Woman cooking Eggs, 1618

Oil on canvas, 100.5 × 119.5 cm
Dated 16.8 in the bottom right corner
National Gallery of Scotland, Edinburgh
Purchased with the aid of The Art Fund, 1955

PROVENANCE

Recorded in 1698 in the collection of Nicolás de Omazur; John Woollett sale, 8 May 1813, lot 45; Samuel Peach; Peach's sale (Elgood & Sons) 23 April 1863, lot 239; bought by 'Smith', presumably the London dealers John Smith and Son; Sir Francis Cook; by inheritance to Sir Frederick Cook; and then in 1939 to Sir Francis Cook and the Trustees of the Cook Collection; acquired by the National Gallery of Scotland in 1955

ESSENTIAL BIBLIOGRAPHY

Madrid-New York 1990, pp. 74–9, no. 4; Brigstocke 1993, pp. 191–3, no. 2180; London 1993, p. 41, no. 7; Edinburgh 1996, p. 128, no. 16; Seville 1999, p. 186, no. 86

Dated 1618, this is one of the earliest documented works by Velázquez. Painted when he was nineteen, in the year of his marriage to Juana Pacheco and a year after his admission into the Guild of Saint Luke in Seville, this sober and dignified kitchen scene may have served as a demonstration piece to show his skills to potential clients. It displays his ability to capture in paint objects and people as we see them with our own eyes.

Velázquez sets the scene in a dark room, lighting it from the top left to bring the foreground into sharp focus. An old woman sits at a kitchen table, tending to two eggs cooking over a brazier. On the table, forming a line in the front of the picture plane, are a white dish with a knife casting a shadow on its concave surface, a pestle and mortar, two ceramic pitchers, a red onion and some cloves of red garlic.

A young boy enters the scene from the left, holding a bruised melon (or pumpkin) tied round with string, and a glass carafe containing wine or vinegar. On the wall on the right two oil lamps hang from nails while in the upper centre of the picture our eye is captured by a basket with a white cloth. This is a painting of great refinement in whose shadowy stillness we are invited to explore the tactile qualities of form. Although at first sight apparently a spontaneous snapshot of a typical kitchen scene, it is in fact a cleverly constructed studio piece in which Velázquez uses a tightly knit, rhythmical design characterised by a hyperbolic curve. The curve begins with the boy's head at the left, descends through the melon to the dish of eggs, and ends with the objects on the table in the foreground. The viewpoints have been adjusted so that we see the table and the objects from above while looking straight at the figures of the old woman and the boy. These different viewpoints could be interpreted as awkward spatial inconsistencies, but they allow us to see how skilfully Velázquez has painted the eggs coalescing in hot oil and the fall of light on the variety of surfaces.

No doubt this was the kind of *bodegón* to which Pacheco was referring in 1625 when defending Velázquez's artistic honour at court in Madrid against a jealous rival who dismissed such subjects as unworthy of a painter. 'Well, then are *bodegones* not worthy of esteem? Of course they are, when they are painted as my son-in-law paints them, rising in this field so as to yield to no one … they are deserving of the highest esteem … he hit upon the true imitation of nature.'[1]

We do not know for whom or why Velázquez painted this picture. It has been suggested that he may have been inspired by a contemporary picaresque novel, *Guzmán de Alfarache* by Matheo Alemán, in which there is a description of a woman cooking eggs for a young *pícaro* (urchin), but the encounter depicted by Velázquez is quite different from that of the novel.[2] Others prefer a religious interpretation, suggesting that the picture shows an old woman committed to good works and feeding the hungry.[3]

However, it may simply be a virtuoso piece aimed at an educated audience from Pacheco's circle, some of whose members may have been familiar with Pliny's story of the painter Peiraikos, who won fame with humble subjects of shops, food and the like.[4] Palomino cites a similar story in Baltasar Gracián's *El Heroe*: when an artist who took to painting rustic subjects with great bravado was asked why he did not paint more serious subjects with delicacy and beauty like Titian, he replied that he preferred to be first in that kind of coarseness than second in delicacy.[5]

An indication that such a picture was prized by connoisseurs is suggested by the fact that Velázquez's *bodegón* was acquired before the end of the seventeenth century by Murillo's most important private patron, the sophisticated Flemish merchant Nicolás de Omazur: in his inventory of 1698 it was described as 'An old woman frying a couple of eggs, and a boy with a melon in his hand'.[6] X B

1 Pacheco 1649 (1990), pp. 11 and 137.
2 Matheo Alemán, *The Rogue*, or *The life of Guzmán de Alfarache*, trans. by James Mabbe, 1623 (ed. London 1924, vol. I, pp. 98–9). See London 1993, p. 41, and Davies in Edinburgh 1999, p. 62.
3 Delenda 1993, pp. 21–2.
4 Pacheco 1649 (1990), p. 159 (Pliny, *Natural History*, XXXV, 112).
5 Palomino 1974 (1982), p. 197, cited in note 2. Gracián cited in *Varia Velázqueña* 1960, vol. II, pp. 52–3.
6 'Una vieja friendo un par de huebos, y un muchacho con un melón en la mano.'

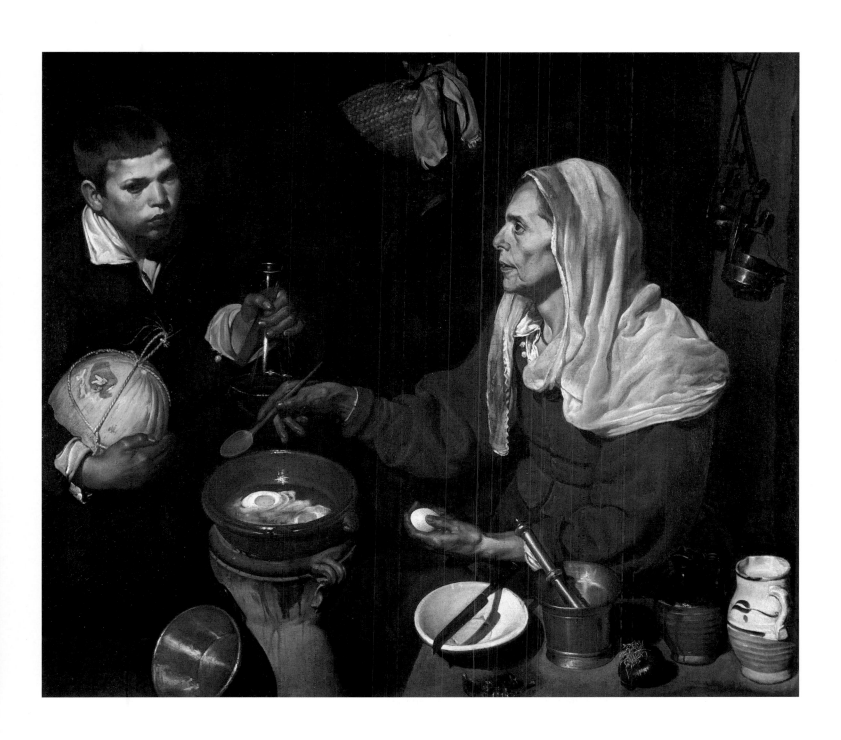

Kitchen Scene with Christ in the House of Martha and Mary, 1618

Oil on canvas, 60 × 103.5 cm
Inscribed at right with fragmentary date: 161[8]
The National Gallery, London (NG 1375)

PROVENANCE

Possibly listed in the 1637 inventory of the 3rd Duke of Alcalá, Seville; acquired by Lt Col Henry Packe (?1786–1859);[1] inherited by his son William Packe (1837–1880);[2] sold at Christie's London, 18 June 1881, lot 18; Sir William H. Gregory; bequeathed to the National Gallery in 1892

ESSENTIAL BIBLIOGRAPHY

Maclaren 1970, pp. 121–5; Fort Worth 1985, pp. 83–5; Madrid 1990, pp. 62–4, no. 2; Edinburgh 1996, p. 132, no. 21; Seville 1999, p. 180, no. 83; Dulwich 2001, pp. 80–2, no. 2

85.
Jacob Matham (1571–1631) after Pieter Aertsen (1508/9–1631)
Kitchen Scene with Christ at the Supper at Emmaus, about 1600
Engraving, 24.5 × 32.7 cm
The British Museum, London (Bartsch, III, 165)

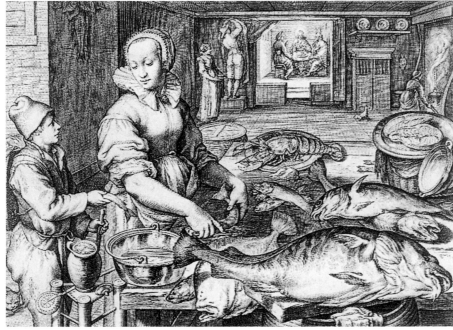

85

Velázquez shows us an everyday kitchen scene in which a maid pounds garlic in a mortar while an elderly woman (possibly the same woman as in cat. 3) either encourages or scolds her. On the table are four fish and two eggs on blue plates, an earthenware jug probably holding olive oil and, in the foreground, garlic cloves and a shrivelled red pepper – the ingredients for a Lenten dish of fish with *alioli* mayonnaise, all observed with precision. It is beyond this scene, however, that the real subject of the painting is revealed through what appears to be a serving hatch.[3]

Painted in a more sketchy style and illuminated from the right, this scene shows Christ sitting in the house of the two sisters, Mary and Martha (Luke 10: 38–42). While Mary 'sat at Jesus' feet and heard His Word', Martha grumbled that she was obliged to do all the work, but Jesus answered her: '"Martha, Martha, thou art careful and troubled about many things. But one thing is needful, and Mary has chosen that good part, which shall not be taken away from her."'

The pointing gesture of the old woman perhaps suggests that we are being invited to think about the activities going on in the foreground in the light of the moral commentary provided behind. Velázquez creates a deliberate ambiguity. Is this the reverie of two women meditating on the life of Christ during Lent, or a recreation of the biblical scene in which Christ extols the contemplative over the active life?

The story was often used in sermons and exegetical literature as a reminder of the transience of life and the importance of spirituality. Whether 'good works' or 'faith alone' was the most effective way to salvation had been a matter of debate since the fifth century, when Saint Augustine interpreted Martha as the 'type' for the *vita activa* (temporal life), and Mary as the 'type' for the *vita contemplativa* (spiritual life).[4] The two poles were seen, not as good and bad, but rather as good and best.[5]

During the Counter-Reformation the debate between action and contemplation took on renewed intensity. While the Catholic Church stressed the importance of good works, such as helping the poor, it also acknowledged the importance of the contemplative life. The Augustinian friar Pedro de Valderrama (1550–1611), for example, glorified Martha and Mary in his sermons as the embodiments of action and contemplation.[6] A fellow Spaniard, the Jesuit Antonio Cordeses (1518–1601), hailed 'the active life, if exercised with perfection, [as being] of great excellence' and 'necessary for the provision and preparation for the contemplative life'.[7] As for a *vida mixta*, which combined action with contemplation, this was a 'very noble' way of imitating the apostles in spreading the word of God.[8]

Combining representations of a Gospel story and contemporary life was not uncommon, and Velázquez was almost certainly familiar with engravings after paintings by Pieter Aertsen (fig. 85) and Joachim Beuckelaer. Like contemporary meditation manuals for lay people, such pictures helped the faithful to integrate the world of work with that of the spirit.[9]

Whether Velázquez received a specific commission for this picture is not known. It may have been intended for a domestic setting such as the home of the wealthy 3rd Duke of Alcalá, whose inventory of 1637 lists a painting by Velázquez of 'a kitchen where

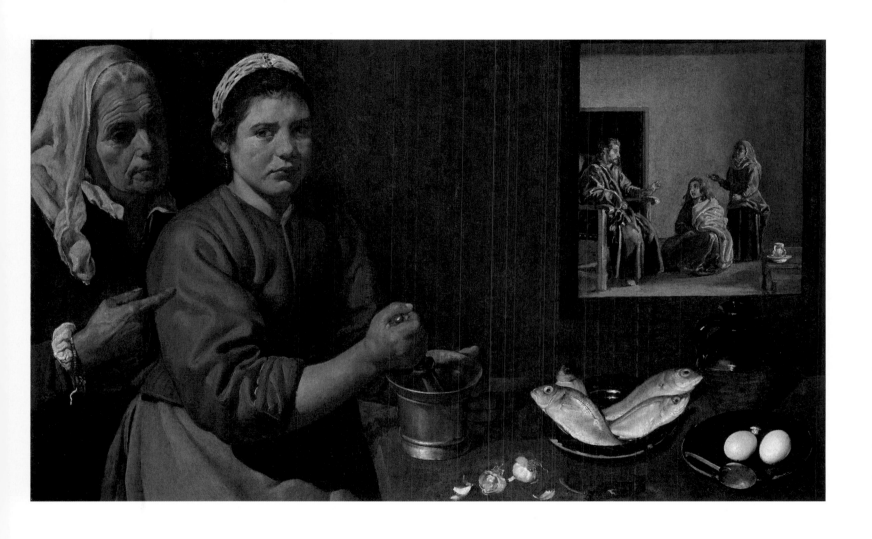

a woman is pounding garlic',[10] though there is no reference to a religious subject in the background. The picture's subject matter and format have prompted some to suggest that it may have hung near the serving hatch of a convent refectory or reception room.[11] Recently, for example, it has been proposed that the Hospital de Santa Marta in Seville, whose principal function was to feed the poor, may have provided Velázquez with the inspiration for his painting, and may even have commissioned it.[12]

It is possible, too, that Velázquez conceived this painting as part of a series. If so, it could have been a pendant to a picture such as cat. 5. The subject matter and mood of these pictures suggest that they may have been conceived together. Nevertheless, contemporary scholars, mindful perhaps of Saint Teresa of Avila's words, 'the Lord walks even among the kitchen pots, helping you in matters spiritual and material',[13] would have appreciated the allusions to the theological debate that the picture presents.

XB

1 Probably in Spain while fighting in the Peninsular War; or on his return to England. According to P. McEvansoneya (oral communication) possibly first recorded in 1833 at Twyford Hall, near Elmham, Norfolk (a bill from a Mr Freeman, carver, from the period March–October 1833 records: 'Oct. 16 Restoring Picture by Valest -12-').

2 William Packe records in his diary (December 1876–November 1877): 'Dutch or Spanish picture representing two Women given to Velasquez purchased by H. Packe £20.0.0.'

3 See Fort Worth 1985, p. 85, notes 9–10, for the debate whether the scene in the background is a view through a wall into another room, a small framed painting hanging on the wall, or a mirror. Recently Boyd and Elser 2004 have proposed that Velázquez used a mirror to paint the whole composition.

4 Steinberg 1965, p. 289, and Craig 1983, pp. 25–39.

5 Fort Worth 1985, p. 83.

6 Tiffany 2005, pp. 439–40.

7 Quoted in Tiffany 2005, p. 441.

8 Tiffany 2005, p. 441.

9 Cherry and Brooke 2001, p. 80, citing Terence O'Reilly.

10 'Un lienco Pequeño de un cocina donde esta majando unos ajos una muger es de Dieº Velasquˢ.' See Brown and Kagan 1987, pp. 238 and 249.

11 Harris 1982, p. 44, and Mulcahy 1988, p. 81.

12 Tiffany 2005, p. 439.

13 Soria 1949, p. 127.

Kitchen Scene with Christ at Emmaus, about 1618

Oil on canvas, 56.5 × 113.2 cm
The National Gallery of Ireland, Dublin

Kitchen Scene, about 1618

Oil on canvas, 55.9 × 104.2 cm
The Art Institute of Chicago
Robert Waller Memorial Fund (1935.380)

CAT. 5 PROVENANCE

According to a label on the reverse in
the collection of Rev. Swiney; thought
to be in the possession of Sir Hugh
Lane by 1909; Sir Otto Beit by 1913;
by inheritance to his son, Sir Alfred
Beit, in 1930; collection of Sir Alfred
and Lady Beit, Russborough, county
Wicklow, 1953–87; presented to the
National Gallery of Ireland in 1987

ESSENTIAL BIBLIOGRAPHY

Harris 1982, p. 44–5; Mulcahy 1988,
pp. 79–82, no. 4538; Edinburgh 1996,
p. 134, no. 22; Seville 1999, p. 178,
no. 82

CAT. 6 PROVENANCE

First noted in a private collection in
Zurich; Goudstikker in Amsterdam;
acquired in 1935

ESSENTIAL BIBLIOGRAPHY

Mayer 1936, no. 105; Edinburgh 1996,
Seville and Bilbao 2005–6, pp. 206–7,
no. 36

If it were not for the New Testament story of the Supper at Emmaus visible through a window in the background of the Dublin painting, rediscovered during cleaning in 1933, the composition of these two paintings would be almost identical. Both show a maid at a table surrounded by kitchen utensils. In her left hand, she holds a white-and-blue glazed ceramic jug,[1] while her other hand rests on the side of the table. Her dark skin and facial features suggest that she is of Moorish or mulatto extraction.

We do not know which of these two pictures was painted first. Their worn surfaces and the fact that they have both been cut down at the sides make it hard to reach a firm conclusion. Velázquez's original intention may simply have been to provide a naturalistic representation of an everyday scene from the world that he saw around him, in which case the Chicago version may have been painted first.[2] Alternatively, the Dublin picture may have come first, with the Chicago one following as an improved, more confident version.

The face and headgear of the maid in the Chicago version show a sense of volume and detail that suggests that she may have been painted from life. The way in which her face catches the light coming in from the left provides Velázquez with the challenging exercise of reproducing her head in half-shadow. The objects laid out on the table transmit a real sense of presence. By comparison, the Dublin picture seems blander and less exciting.

In both compositions Velázquez takes delight in the visual contrasts between the different objects displayed. The soft glazes of the ceramic jug on the far left contrast with the bright reflections on the brass bowl. The jug that the maid holds upright (which also appears in cat. 3) stands behind one positioned upside down. Such details catch the viewer's attention and convey an atmosphere of quiet contemplation. Unlike the *Kitchen Scene with Christ in the House of Martha and Mary* (cat. 4) no food apart from the garlic on the far right is visible. The pile of inverted plates (a detail that reappears in cat. 7), the upturned jug and the foreground cloth look as though they have been laid out to dry. The maid has done her work and now seems lost in thought.

The Dublin painting links this scene from contemporary life with a significant moment in the Gospels. Through a window, Velázquez shows the scene of the Supper at Emmaus as told in the gospel of Luke (24: 13–32). According to this account, the risen Christ had appeared, unrecognised, to two of his disciples as they walked on the road from Jerusalem to Emmaus. On reaching Emmaus, the disciples asked Jesus to join them for supper. This is the moment represented by Velázquez: Christ 'took bread, and blessed it, and brake, and gave to them. And their eyes were opened, and they knew him; and he vanished out of their sight.'

As in cat. 4 the biblical scene is painted in a loose manner which gives it a dreamlike, unreal quality. Indeed, the maid seems to be more aware of the story in an abstract sense rather than of its physical presence in the background. The Supper at Emmaus, in addition to providing Christ's disciples with proof that he had risen from the dead, was seen as a confirmation of the sacrament of Holy Communion recalling his words at the Last Supper: 'This is my body which is given to you: this do in remembrance of me ... This cup is the new testament in my blood, which is shed for you' (Luke 22: 19–20).

The differences between the Dublin picture and *Christ in the House of Martha and Mary* in terms of size and surface texture make it difficult to imagine them as a pair, but it is possible that Velázquez and his workshop painted several versions of both themes, and that these two paintings are from different pairs. The suggestion of a possible connection is supported by a series of elements linking the two pictures as well as by the references to the active and contemplative life. In purely compositional terms, the idea that Velázquez may have conceived paintings like these as working pairs, perhaps to hang alongside or opposite each other, finds support in such details as the position of the two hatches, on the right in the London picture and on the left in the Dublin one: if hanging together the pair would 'speak' to each other. The foreground scene in the London version shows two women preparing Lenten food while in the background the living Christ provides spiritual sustenance to two female followers, Martha and Mary. In the Dublin picture, the empty dishes and vessels

5

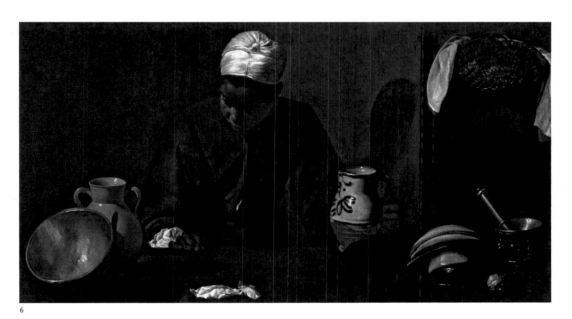

6

and the white cloth in the foreground may be seen as an allusion to the empty sepulchre, while in the background, the risen Christ joins two male disciples in a post-resurrection meal.

If the National Gallery painting is about the debate over the rival merits of 'good works' and 'faith alone', the Dublin picture emphasises the role of Christ's sacrificial death and resurrection for human salvation. The stories of Mary and Martha and the Supper at Emmaus are both taken from the Gospel of Saint Luke, which focuses on the teachings of Christ as a message of universal salvation and stresses his kindness and understanding and care for outcasts. Velázquez has chosen contrasting events from Christ's life: as mortal, during his

ministry, and as divine, after his resurrection. The prominence of women in these paintings suggests that they may have been intended for a feminine audience dedicated to acts of charity such as hospitality and feeding the poor. x B

1 Probably made in the ceramics factory attached to the Carthusian Monastery of Santa Maria de las Cuevas outside Seville.
2 Two copies attest to the popularity of the Chicago composition: a fragment in the Museum of Fine Arts, Houston (55.100, 86.3 × 73.7 cm), and a weak copy in the Antonio Baselga collection, Madrid, whose dimensions (68 × 118 cm), may give an indication of how much was cut from the Chicago picture.

Two Young Men at a Table, 1618–20

Oil on canvas, 65 × 104.4 cm
The Wellington Collection, Apsley House, London
English Heritage (WM 1593-1948)

PROVENANCE

Possibly the 3rd Duke of Alcala;
Marqués de la Ensenada, Madrid;
bought by Charles III in 1768;
Palacio Real Nuevo, Madrid, 1772;
captured by the Duke of Wellington
at Vitoria, 1813

ESSENTIAL BIBLIOGRAPHY

Palomino 1724 (trans. in Harris 1982,
appendix II, p. 197); Brown and
Kagan 1987, p. 238; Wellington 1901,
pp. 210–12; Kemenov 1977, pp. 34–7;
Kauffmann 1982, pp. 139–40, no. 182;
López-Rey 1996, vol. II, p. 56, no. 24;
Davies 1996, p. 138, no. 24

'Velázquez made another painting of two poor men eating at a small and humble table on which are some earthenware vessels, oranges, bread and other things, all observed with extraordinary meticulousness.'[1] Notwithstanding a few inaccuracies in the description, it seems certain that this extract from Antonio Palomino's biography of Velázquez refers to the picture now in Apsley House.[2] The Duke of Wellington took posession of the picture at the Battle of Vitoria, after Joseph Bonaparte abandoned his travelling carriage, leaving behind a number of paintings seized from the Spanish royal collection. On its arrival in London, it was catalogued as 'Boys Drinking', by Caravaggio.[3]

The quiet tone and frank realism of Two Young Men at a Table make this one of the most remarkable works of Velázquez's early career. In the foreground a man, his back turned to the spectator, drinks from a bowl; his companion sitting opposite him slumps over the table. It has been suggested that he is sleeping, perhaps 'taking a siesta after the meal and the washing up'.[4] The uncertainty about these figures adds to the charm of the picture – Velázquez seems to be playing a game of hide and seek with the viewer, concealing the men's faces and adding dark shadows on the little that is revealed. Unlike Tavern Scene (cat. 2) and the Three Musicians (cat. 1) no young boy grins out of the canvas and no picaresque character invites us into the picture space. It is as though the two men are unaware of the painter's presence. Despite their humble appearance (conveyed most noticeably by the torn sleeve), it is likely that the two figures are not, as has been suggested, intended to represent beggars,[5] but kitchen helpers.[6]

The table, with its carefully arranged kitchen utensils, could stand as a complete painting, comparable to the superb still lifes of Juan Sánchez Cotán. Through his masterly handling of light and shade, Velázquez skilfully conveys the subtle colour nuances of each object: the golden hue of the brass mortar and pestle, the shiny green glaze of the earthenware pitcher, the reddish clay that shows through the white finish of the upturned dishes. In a delightful detail, an orange is placed on the lip of a tall jug, its leaves casting a soft shadow. In sharp contrast with this well-lit area, the brown background seems to create an overall effect of restrained darkness. However, this may have not always been so. In 1787, when the picture hung in King Charles's Retiring Room in the Palacio Real Nuevo, it was described as having in the background 'a clear and beautiful landscape'.[7] This is not the case now, so it would appear that this area was painted over.

Like most of Velázquez's early works it is difficult to establish exactly when Two Young Men at a Table was painted, but scholars generally agree on a date of about 1618–20. The artist's increasingly confident technique places the work close to the Old Woman cooking Eggs (cat. 3) and Christ in the House of Martha and Mary (cat. 4), in which some of the same, beautifully painted objects appear. SDN

1 Palomino 1724 (1982), appendix II, p. 197.
2 Of the four bodegones described by Palomino, only Two Young Men at a Table and The Water-Seller of Seville are known today.
3 Catalogue of Principal Pictures found in the Baggage of Joseph Bonaparte, by William Seguier, published in Wellington 1901, vol. I, p. 201.
4 Justi 1889, p. 72.
5 Stirling-Maxwell 1848, vol. II, p. 581. In Wellington 1901, p. 211.
6 The two men are not sitting at the table, which they have just piled up with washed-up crockery, but appear to be leaning on a lower, side bench.
7 Cumberland 1787, p. 54, cited in Wellington 1901, p. 211.

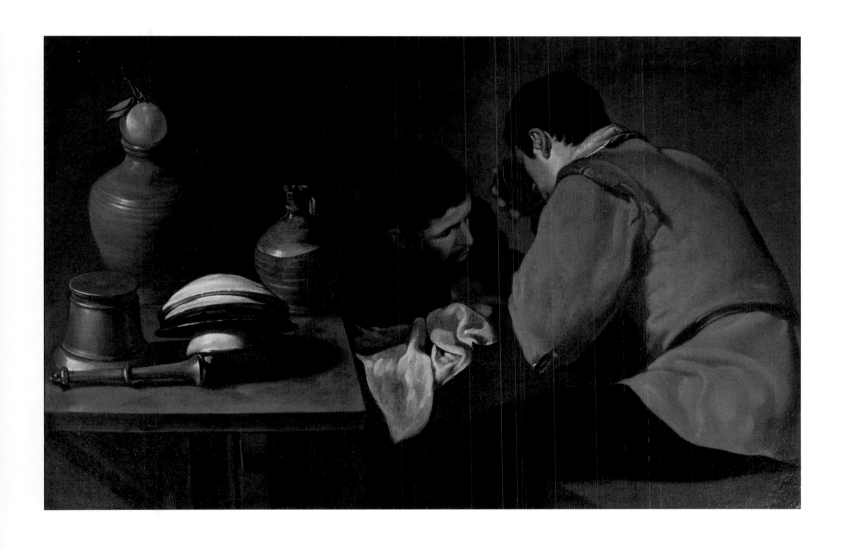

The Water-Seller of Seville, 1618–22

Oil on canvas, 107.7 × 81.3 cm (including a 4 cm strip added at the top)
The Wellington Collection, Apsley House, London
English Heritage (WM 1600-1948)

ESSENTIAL BIBLIOGRAPHY

Palomino 1724 (1987), p. 141; Wellington 1901, pp. 184–90; Kauffman 1982, pp. 140–2; Madrid and New York 1990, pp. 68–73, no. 3; Pérez Lozano 1993, pp. 25–40; London 1993, p. 43, no. 8; Davies in Edinburgh 1996, pp. 57–8, 152, no. 31; Seville 1999, p. 188, no. 87

The date of this picture is still uncertain, but most critics agree that it marks the peak of Velázquez's *bodegones*. It transmits a sense of physical reality striking in its refinement, simplicity and gravitas. Velázquez 'stage manages' in his studio a common street scene from Seville, such as he might have seen at the Fuente del Arzobispo on the Alameda.

The vertical format allows the main character the space to dominate. A man of stature and sobriety, he stands holding an earthenware jug that bulges into our space. He has just replaced the jug's wooden stopper after pouring water for the boy to whom he hands the glass. In the act of pouring, he has spilt some water which trickles down the sides of the jug. The detail is of no particular significance in itself, but Velázquez's ability to render it in paint, particularly the changes in texture from the dry terracotta to the recently wetted areas, is stunning.

His customer is well dressed and noble looking, and there is an older companion in the shadows behind him. The background area is very damaged, but a contemporary copy (Contini-Bonacossi Collection, Florence) shows this figure drinking from a white-and-blue glazed ceramic jug, giving us an idea of how the painting may have looked. On the table is another jar with a receptacle on top. Shapes and volumes play against each other, contrasting with the faces of the water-seller and his customers.

It is generally thought that Velázquez took this picture with him on his second trip to Madrid in 1623 and sold or gave it to Juan de Fonseca y Figueroa (1585–1627), in whose collection it is recorded in 1627. However, Fonseca was a Canon of Seville Cathedral from 1607, and resided in the city on and off until the Count-Duke of Olivares called him to Madrid to become the 'Chief Officer of His Majesty's Chapel' in 1622,[1] which leaves open the possibility that Velázquez painted the *Water-Seller* in Seville some time between 1618 and 1622.[2]

Fonseca, a man of great culture and an amateur painter, who wrote a now-lost treatise on ancient painting, was one of the first admirers of Velázquez's work. A member of the Sevillian intellectual elite, he was nicknamed 'Fabio' after the Roman patrician and amateur painter.[3] He took his painting seriously, at one point borrowing an easel from Velázquez, and

when Fonseca died Velázquez bought a large quantity of artists' materials from his estate.[4]

In 1622, when Velázquez made his first trip to Madrid, Palomino recounts how he 'was shown particular friendship' by Fonseca, whose 'keenness of intellect and great erudition … did not disdain the noble practice of painting and who was a great admirer of Velázquez's work'. A year later, when Velázquez returned to Madrid, he lodged with Fonseca and on this occasion painted Fonseca's portrait (now lost) 'which was … seen by all the grandees, by the Infantes Don Carlos and Cardinal Don Ferdinando, and by the king, which was the greatest distinction it could have had'.[5]

Velázquez's friendship with Fonseca y Figueroa has led some to speculate that the *Water-Seller* may be a visual pun on his name.[6] 'Fonseca' means 'dry fountain' and the fig (*higo*) that some see upturned in the glass of water could be a play on Figueroa. Such an ingenious theory has its attractions, but it loses persuasiveness if one sees the dark centre of the goblet not as a fig, but as a glass bubble forming part of an elegant design.[7] Indeed, there have been many different suggestions regarding the 'meaning' of the *Water-Seller*: it may be a straightforward genre scene, related to the world of contemporary picaresque novels,[8] or it may have symbolic or emblematic significance.[9] Part of the painting's potency is that it resists interpretation. When Fonseca died in 1627, it fell to Velázquez to value the pictures in his collection. When he came to this painting, he identified it simply as 'a picture of a water-seller, by the hand of Diego Velázquez' and gave it the highest value. XB

1 Palomino 1724 (1987), p. 144.
2 Joyce Plesters' observation that the picture was painted on canvas possibly cut from the same roll as other early paintings by Velázquez, including cats 3–4 and 9–10, would support this. See MacLaren and Braham 1970, p. 124, note 1.
3 Pacheco 1649 (1990), pp. 214–16; Pérez Lozano 1993, p. 32.
4 López Navío 1961, pp. 53–84.
5 Palomino 1724 (1987), p. 144.
6 Pérez Lozano 1993, pp. 9–10.
7 Ramírez-Montesinos 1991, pp. 397–404, and Cherry in Edinburgh 1996, pp. 35–8.
8 For example Estebanillo González, *Vida y hechos*, Antwerp 1646.
9 Moffitt 1978, pp. 5–23.

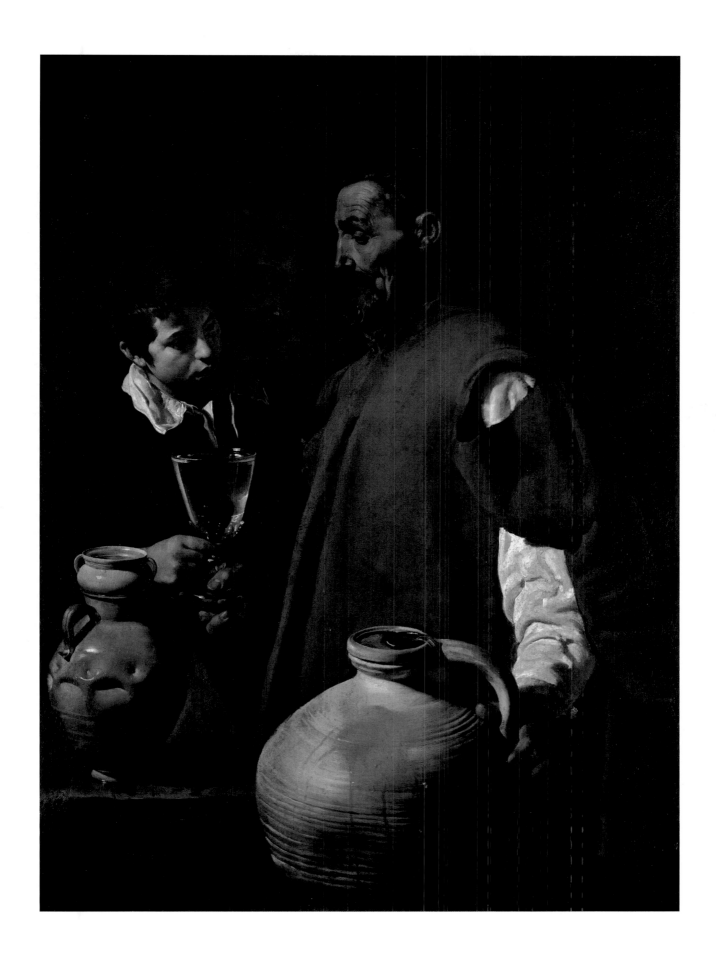

The Immaculate Conception, 1618–19

Oil on canvas, 135 × 101.6 cm
The National Gallery, London (NG 6424)
Bought with the aid of The Art Fund, 1974

Saint John the Evangelist on the Island of Patmos, 1618–19

Oil on canvas, 135.5 × 102.2 cm
The National Gallery, London (NG 6264)
Bought with a special grant and contributions from
the Pilgrim Trust and The Art Fund, 1956

PROVENANCE

Both recorded in the Chapter
House of the Convent of the Shod
Carmelites, Seville, 1800; bought by
Don Manuel López Cepero, Dean of
the Cathedral of Seville; 1809–10
sold to Bartholomew Frere; 1813
in London, Brunswick Square; on
Bartholomew Frere's death in 1851
stored until inherited by one of his
great-nephews, Laurie Frere of
Twyford House, Bishops Stortford;
NG 6264 bought in 1956 and
NG 6424 bought in 1974

ESSENTIAL BIBLIOGRAPHY

Maclaren and Braham 1970,
pp. 129–33; Martínez Ripoll 1983,
pp. 201–8; Delenda 1983, pp. 39–51;
Edinburgh 1996, pp. 156–8, nos 33–4;
Seville 1999, pp. 190–3, nos 88–9

Ignoring Pacheco's recommendation in his *Arte de la Pintura* that Saint John the Evangelist should be depicted as a grey-bearded old man, Velázquez has chosen a model in his late teens to sit for him.[1] The saint is shown on Patmos, his pen poised in the act of describing his vision of the Woman of the Apocalypse, who appears above left in small scale. Beside him is his customary attribute, the eagle. In the companion piece to *Saint John*, the Virgin of the Immaculate Conception is shown standing on a crescent moon surrounded by billowing clouds. Crowned with stars around her head, she floats above a landscape dotted with symbols alluding to her purity. Her hands are held in prayer as she looks down with humility.

We do not know who commissioned these paintings from Velázquez. They are first mentioned in 1800 in the chapter house of the Convent of the Shod Carmelites, Nuestra Señora del Carmen.[2]

As committed defenders of the dogma of the Immaculate Conception, the Carmelites might well have ordered such paintings as visual aids for their theological discussions. They may have been part of an altarpiece along with other pictures as well as polychrome sculptures, or displayed as paintings in their own right as we see them today.

Their similarities in size and style suggest that they were painted as a pair. Velázquez uses the same range of colours and tones, and places the figures centrally, lighting them both from the top left. To give his figures a sense of monumentality, Velázquez uses distinct contours and strong contrasts of light and shade. Such a treatment may have been inspired by Velázquez having seen, and possibly worked on, the wood sculptures of Juan Martínez Montañés, which were often polychromed by Pacheco (fig. 86).

As pendants these paintings would have played an effective role as propagandistic illustrations of the doctrine of the Immaculate Conception, the belief that the Virgin was conceived without the stain of Original Sin. This teaching was fervently supported in seventeenth-century Spain, and particularly so in Seville, where artists such as Pacheco and Velázquez played an important role in establishing an orthodox image.

The iconographic basis for representations of the Immaculate Conception was Saint John's description of the Woman of the Apocalypse as 'a woman clothed with the sun, and the moon under her feet, and upon her head a crown of twelve stars' (Revelation 12: 1–4 and 14). In the upper left corner of his painting of Saint John, Velázquez has represented the woman with wings and threatened by the dragon, in conformity with the scriptural texts. To give his painting further authority, perhaps on the advice of Pacheco, he has based the vision directly on conventional illustrations such as an engraving by the Jesuit Juan de Jáuregui, a friend of Pacheco's, in Luis del Alcázar's treatise on the Apocalypse. For the general composition, he may have drawn on Jan Sadeler's *Saint John on Patmos* print after Martin de Vos's painting (fig. 87).[3]

In his *Arte de la Pintura*, Pacheco codified this abstract vision and set down his own rules of representation. He recommended the Virgin should be

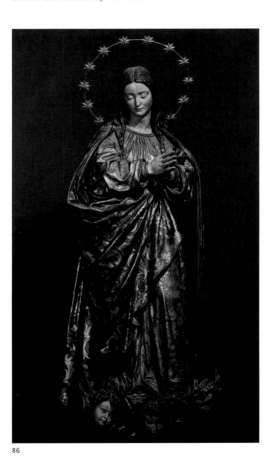

86.
Juan Martínez Montañés
(1548–1649) and Francisco
Pacheco (1564–1644)
**The Virgin of the
Immaculate Conception**, 1628
Polychromed wood, height 155 cm
Seville Cathedral

86

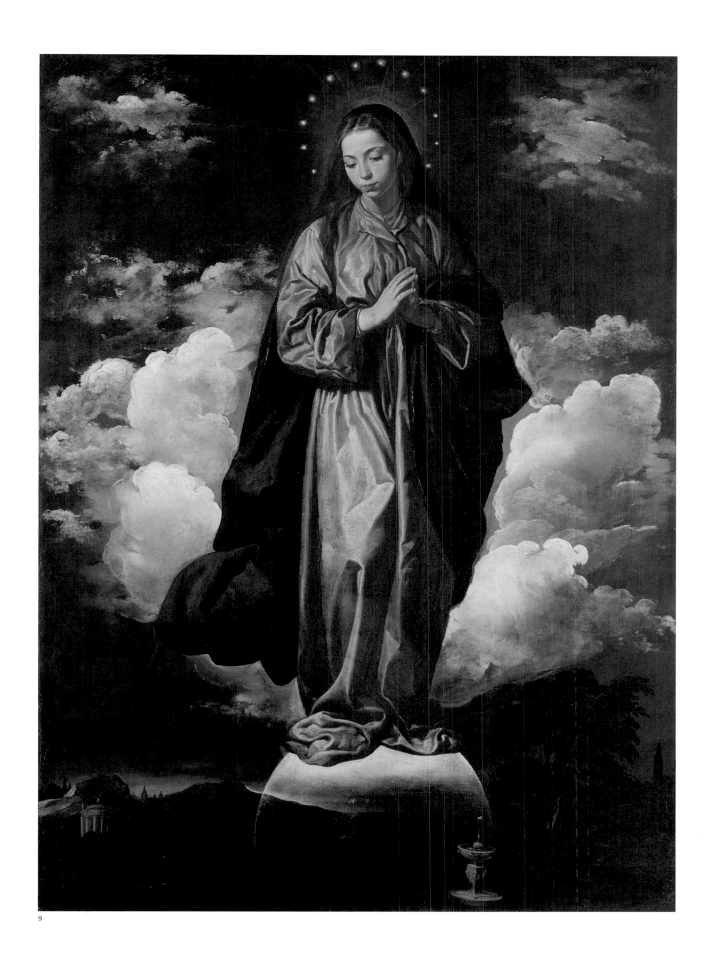

9

87

represented 'in the flower of her youth, twelve or thirteen years old, as a most beautiful young girl, with fine and serious eyes, a most perfect nose and mouth and pink cheeks, wearing Her most beautiful golden hair loose, in short with as much perfection as human brush could achieve'.[4] As for the moon, 'although it is a solid planet, I took the liberty to make it light and transparent above the landscape as a half-moon with the points turned downwards'.[5]

Velázquez's image of the Immaculate Conception corresponds to many of Pacheco's prescriptions, including the unconventional transparent moon. In addition to the attributes of the Virgin cited by Pacheco and derived from the Book of Revelation, Velázquez has included other traditional emblems, mostly taken from the Song of Solomon and Ecclesiastes and included in the Office of the Immaculate Conception: mountains; clouds; temple; palm; dawn; city; ship; sea; fountain; cedar; cyprus; and an enclosed garden.

Velázquez may have conceived these pictures in response to the 1617 celebrations in Seville of a papal decree defending the mystery of the Immaculate Conception and prohibiting public censure of the doctrine. The same year, Velázquez was examined as master painter and his examiners may have wished to see his skills in interpreting a complex subject such as the Immaculate Conception, as was done with Francisco Herrera in 1619.[6] A more fanciful suggestion, supported by the extremely sensitive portrayal of the figures, is that Velázquez painted himself as Saint John the Evangelist and Juana Pacheco, whom he married in 1618, as the Virgin.[7]

X B

1 Pacheco 1649 (1990), pp. 672–3 and 576–7.
2 Ceán Bermúdez 1800, vol. 5, p. 179. The Carmelite convent in Seville no longer exists.
3 Alcázar, Luis del, Vestigatio arcane sensus Apocalypsi, Antwerp 1614, p. 614. See also Martínez Ripoll 1983, pp. 201–8.
4 Pacheco 1649 (1990), pp. 576–7. A similar description of the Virgin's features can be found in Juan de las Ruelas, Hermosura Corporal de la Madre de Dios, Seville 1999, pp. 157–8, who was Prior of the Carmelites between 1618 and 1621 and may have been responsible for the commission.
5 Pacheco 1649 (1990), pp. 576–7.
6 See Cherry in Edinburgh 1996, p. 68.
7 On Saint John's likeness to an early portrait, possibly a self portrait, see Harris 1982, pp. 10–11.

87.
Jan Sadeler (1550–1600) after
Martin de Vos (1532–1603)
Saint John on Patmos, before 1600
Engraving, 23.5 × 20.1 cm
Bibliothèque nationale de France,
Paris

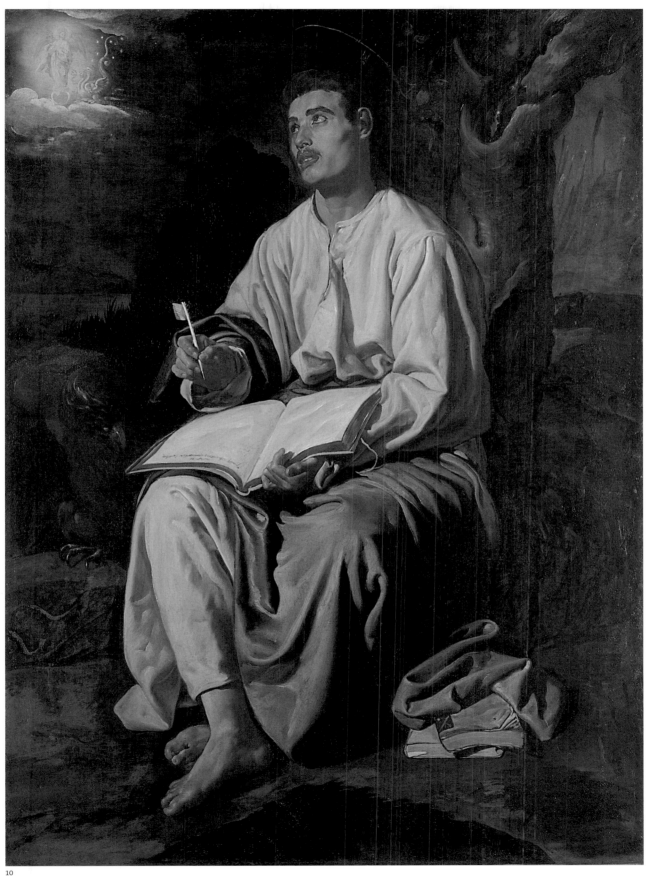

The Adoration of the Magi, 1619

Oil on canvas, 203 × 125 cm
Museo Nacional del Prado, Madrid (1166)

PROVENANCE

First recorded in about 1764 in the Jesuit Novitiate of San Luis, Seville; acquired by Francisco de Bruna after 1767 in whose collection it was seen in 1773 by Twiss; offered to Ferdinand VII in 1807, who gave it to the newly founded Museo Nacional del Prado in 1819

ESSENTIAL BIBLIOGRAPHY

Harris 1982, pp. 38, 40; Brown 1986, pp. 21–4; New York 1990, pp. 62–7, no. 2; Garrido Pérez 1992, pp. 67–77; Delenda 1993, pp. 52–61; Edinburgh 1996, p. 162, no. 36; Serrera 1999, pp. 351–60; Seville 1999, p. 194, no. 90

Compared to treatments of the Adoration of the Magi by other contemporary artists, notably Rubens, this is a sober and austere rendition. Velázquez has interpreted the Gospel of Saint Matthew in the most direct of ways: 'And when they were come into the house, they saw the young child with Mary his mother, and fell down, and worshipped him … they presented unto him gifts; gold, and frankincense, and myrrh' (Matthew 2:11). He has chosen the moment before the Magi open their gifts – the lids of their golden receptacles are sealed – leaving us to focus on the newborn Christ Child and the Virgin who, with a mixture of pride and meekness, holds him upright in his swaddling clothes.

Next to the Virgin, Saint Joseph looks up in admiration, while the three kings kneel and stand at the left. Caspar, the eldest, is in the middle; Melchior, the youngest, kneels in the foreground, and Balthazar stands behind wearing a flamboyant red cape, a red ruby earring in his right ear and a fine lace collar. Behind him, a young man peers over his shoulder to witness the event, a face we have seen before in Velázquez's earlier *bodegones*.[1]

The draperies provide a three-dimensional effect, their curves, shadows and swirls taking our eye up through the composition from Melchior in the foreground to Balthazar at the back and finally to the Virgin, whose headdress is a delightful example of Velázquez's skill in painting cloth. The faces all express profound veneration and concentration, and the atmosphere is still, almost rigid. Behind the group is an arch, barely visible today due to fading of the pigments, and a landscape which has lost much of its colouring. Originally, this background would have provided an area of visual repose.

The date, 1619, appears prominently on the stone on which the Virgin's feet are resting. From the subject, format and size of the painting, it seems likely that Velázquez painted this picture as an altarpiece. First recorded around 1764 in the Jesuit Novitiate of San Luis, Seville,[2] it may originally have been located in the nearby Chapel of the Novices, founded in 1609 but destroyed in 1695.[3] According to Ortiz de Zúñiga (1677), the chapel was the place where the novices practised their spiritual exercises and was independent of the church.[4]

Velázquez's painting contains subtle touches that would have served to educate and inspire young would-be Jesuits. The gifts brought by the Magi are seen as having symbolic significance: gold for Christ's kingship; frankincense for his divinity; and myrrh, used in embalming, foreshadowing his death. To emphasise this further, Velázquez has inserted branches of thorn in the foreground as a reminder of Christ's Passion.[5] XB

1 The lifelike appearance and apparent ages invite the suggestion that we have here a group of the artist's own family: Pacheco as the older Magus, Velázquez himself as the younger one (or possibly as Saint Joseph with a beard), the Virgin the likeness of his wife (similar to cat. 9), whom he married the previous year, and the child – a little older than usual in this scene – their daughter, Francisca, born in May 1619. But as Harris bluntly puts it: 'there is no evidence to support such an ingenious notion.' See Harris in Edinburgh 1996, p. 47. See also Serrera 1999, pp. 351–66.
2 Carriazo 1929, p. 176, and Ainaud de Lasarte 1946, pp. 55–60.
3 Serrera 1999, p. 353.
4 Ortiz de Zúñiga 1677, pp. 607–8, 732.
5 Brown 1986, p. 286, no. 49.

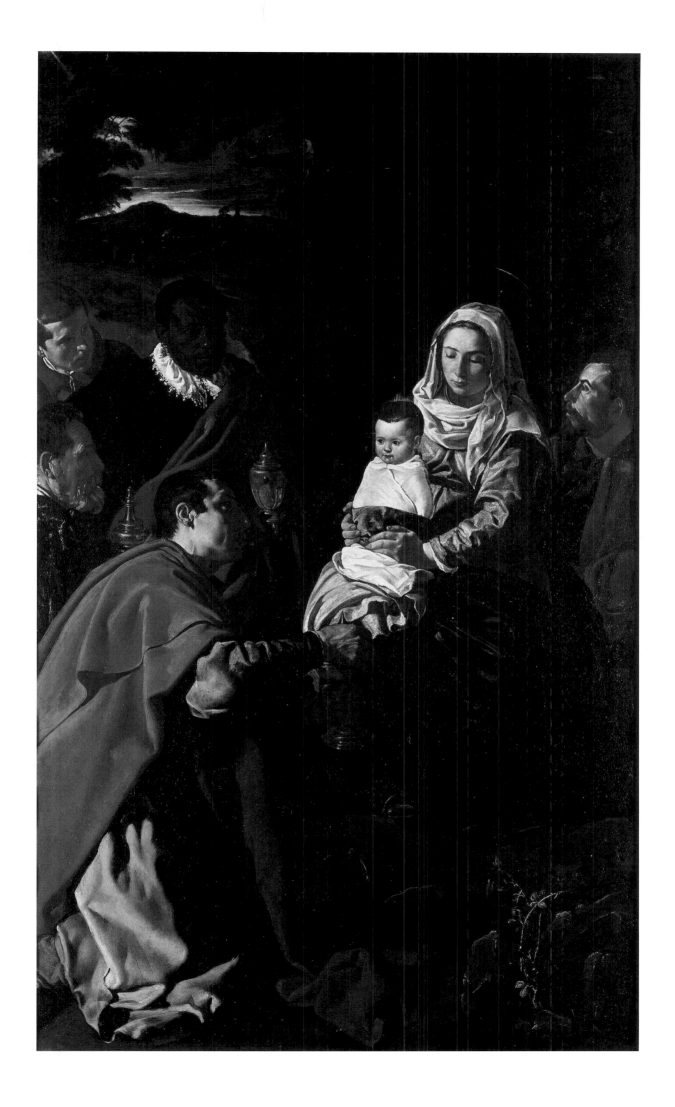

Saint Thomas, about 1619

Oil on canvas, 105 × 85 cm
Musée des Beaux-Arts, Orléans (1556 A)

PROVENANCE

First recorded in the Orléans
museum in 1843 as by Murillo

ESSENTIAL BIBLIOGRAPHY

Ponz (1947), p. 742; Gómez Moreno
1925, pp. 230–1; Longhi 1927, pp. 4–12;
Madrid 1990, p. 104, no. 10; Delenda
1993, pp. 62–5; Edinburgh 1996, p. 164,
no. 37; Seville 1999, p. 202, no. 94

The model for this Saint Thomas may be the same moustachioed character who posed for Saint John the Evangelist (cat. 10). In his right hand, the apostle grips a book, perhaps a Bible, which he balances against his hip, while his left hand holds a lance, creating a powerful diagonal across the composition. Against a neutral background, the folds of his dark yellow-ochre cloak are brought into a sharp focus by dramatic contrasts of light and shade.

The book alludes to Thomas's role as preacher of Christ's teachings and the lance to his martyrdom. According to the fourth-century apocryphal account of his life known as the *Acta Thomae*, Thomas was sent to evangelise India. When he converted the wife and daughter of King Misdai, he was put to death with a lance (another account claims that he was martyred in Mylapore, near Madras).

In the Gospels, Thomas comes across as an active, pragmatic person. In particular, he is remembered for his incredulous response on being told by his fellow disciples of Christ's Resurrection: 'Except I shall see in his hands the print of the nails, and put my finger into the print of the nails, and thrust my hand into his side, I will not believe' (John 20:25). When some days later, in the presence of the resurrected Christ, he accepted the evidence of his eyes, he earned a smarting rebuke: 'Because thou hast seen me, Thomas, thou hast believed: blessed are they that have not seen, and yet have believed' (John 20:29). His doubting and subsequent acceptance, none the less, made him an ideal figure to spread the word of Christ.

Nothing is known about this picture before it entered the Orléans museum in 1843 as by Murillo. With the exceptions of Saints Peter and Paul, the apostles were not often represented as individual figures, so Velázquez's *Saint Thomas* was probably part of a series of twelve. A painting of *Saint Paul* by Velázquez in the Museu Nacional d'Art de Cataluñya, Barcelona (fig. 88), has been proposed as also being part of this putative series, the rest of which has been lost. During the Counter-Reformation period, such series were popular, as evidenced by those of El Greco, Ribera and Rubens.

The measurements of the Barcelona painting (98 × 78 cm) are close to those of the present work and the inscriptions on both, whether original or not, are alike in form, indicating that they may have hung together. Although the manner of painting and the consistency of the paint are quite distinct from each other, the Orléans *Saint Thomas* being closer in execution to the National Gallery's *Saint John the Evangelist* (cat. 10), they may be the paintings believed to be early works by Velázquez that Antonio Ponz saw in the 1770s in the Carthusian Monastery of Nuestra Señora de las Cuevas in Seville.[1] However, if they were painted for this monastery, it is strange that Pacheco, who visited it in 1632, made no mention of them.[2] X B

88.
Saint Paul, about 1619
Oil on canvas, 98 × 78 cm
Museu Nacional d'Art de
Cataluñya, Barcelona

88

1 Ponz (1947), p. 742: 'varias pinturas que representan apóstoles, que, si son de Velázquez como allí quieren, puede ser que las hiciese en sus principios.'
2 Pacheco 1649 (1990), p. 456.

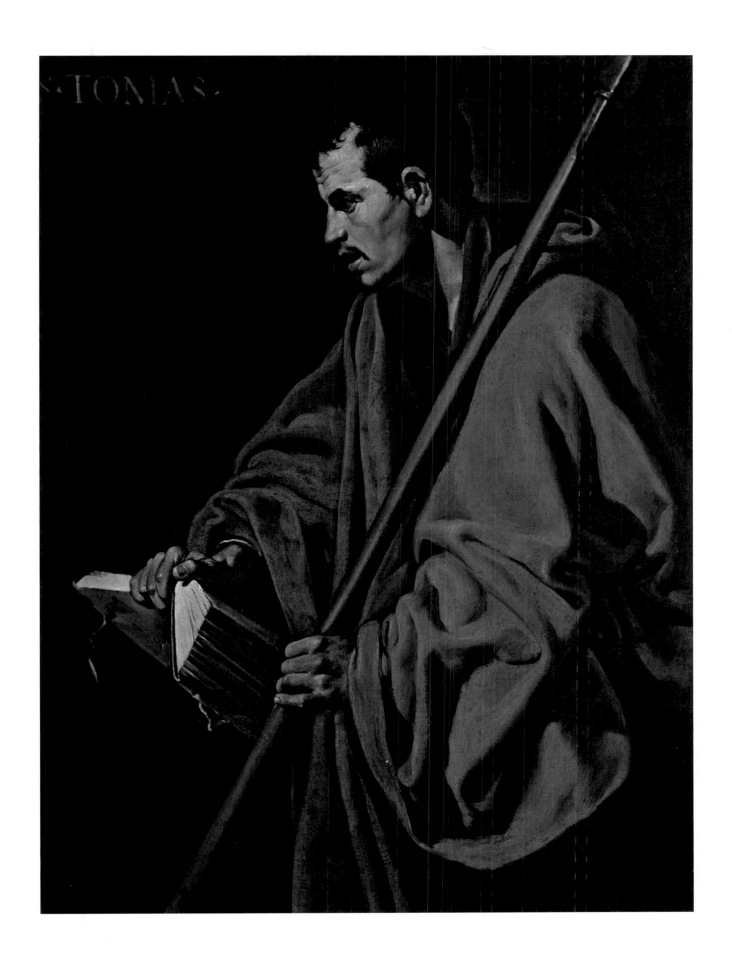

139

Portrait of Don Cristóbal Suárez de Ribera, 1620

Oil on canvas, 207 × 148 cm
Signed at lower middle right: DOVZ 1620
The Confraternity of San Hermenegildo, Seville
On loan to the Museo de Bellas Artes, Seville

PROVENANCE

From 1620 onwards in the
Chapel of the Confraternity of
San Hermenegildo, Seville; on loan
from the Confraternity to the Museo
de Bellas Artes, Seville, since 1970

ESSENTIAL BIBLIOGRAPHY

Loga 1913, pp. 281–91; Carriazo 1929,
pp. 157–83; Ainaud de Lasarte 1946,
pp. 54–63; Madrid 1960, p. 51, no. 38;
Brown 1986, pp. 29–31; Edinburgh
1996, p. 172, no. 41; Seville 1999,
p. 212, no. 99

This portrait of Cristóbal Suárez de Ribera (1550–1618), a priest and patron of religious art who had been a close friend of Pacheco, was painted two years after the subject's death. He and Pacheco had known each other at least since 1592, when Pacheco pledged security for a commission from Suárez de Ribera for a *Crucifixion* by the sculptor Juan Martínez Montañés (now lost).[1] In 1602, Suárez de Ribera became godfather to Pacheco's daughter Juana. It was probably thanks to Pacheco that Velázquez was commissioned to paint what is one of his earliest surviving attempts at portraiture.

The portrait was to be placed above Suárez de Ribera's tomb in the Chapel of the Brotherhood of Saint Hermengild, Seville. As was the custom for funerary sculptures, the subject is shown kneeling in a bare room dressed in his black priestly robes. He holds a book, perhaps a Bible, in his left hand while with his right hand he points out of the picture. The surface of the painting has suffered, particularly in the blacks of his cloak, but the paint of the hands is well preserved. The right hand is extremely realistic, creating a sense of three-dimensionality. Further suggesting depth, a window on the right looks out onto treetops, perhaps in a courtyard below or a garden beyond. The green of the trees and the blue of the sky have lost their intensity over time.

Suárez de Ribera's biretta, casually thrown aside, creates a sense of space between him and the wall behind. Rather than showing him as the old man he would have known, Velázquez depicts him as a young and dynamic priest. Strong focused light from the centre right illuminates his face and creates a play of shadows on the ground. Velázquez may have worked from an earlier likeness: a recently published fragmentary drawing of the upper part of the head (in reverse) is a possible candidate.[2] Strong in execution and bearing a resemblance to Velázquez's final portrait, this drawing, though sometimes attributed to Velázquez, seems closer to Pacheco's portrait drawings. If Velázquez did use it, that might explain the rigidity of the expression. The figure, though it has great presence, lacks the 'truth to nature' that Velázquez habitually instilled into his portraits.

A cartouche in the top left-hand corner explains why the picture was commissioned. Emerging from the royal crown, a martyr's palm, an axe and a cross with a crown of roses on top are the emblems of the Brotherhood of Saint Hermengild. The son of Leovigild, the Visigoth King of Spain, Hermengild (550–585) had been converted from Arianism to Catholicism by his wife. Rebelling against his father, he was defeated in 584 and imprisoned in Seville. He was beheaded in Tarragona after refusing communion from an Arian bishop. In 1585, at the instigation of Philip II, Pope Sixtus V authorised the cult of Hermengild in Spain. The Jesuits were strong devotees, dedicating their college in Seville to Saint Hermengild.

Suárez de Ribera's devotion was such that between 1606 and 1616 he built a chapel adjacent to the cell where Hermengild is said to have been imprisoned. On 26 April 1616, Hermengild's remains and the headquarters of the Brotherhood were transferred to this chapel from the church of San Julián, where Suárez de Ribera was parish priest. The procession was accompanied by a statue of the saint, probably the polychromed wood sculpture attributed today to Montañés.[3] This sculpture shows Saint Hermengild in Roman armour, standing in a classical posture reminiscent of the Apollo Belvedere, meditating on the crucifix. In his left hand, he holds the martyr's palm and his prison shackles, while the axe in his head gives a gruesome reminder of his destiny. Velázquez's portrait was positioned in such a way that it would have greeted the visitor on entering the chapel, Suárez de Ribera's pointing gesture would then have directed the viewer to the high altar where Montañéz's life-size effigy was positioned. XB

1 Hernández Díaz 1987, p. 100.
2 Morel d'Arleux 2004, pp. 32–6, *Fragment of the head of a clergyman*, 5.7 × 6.5 cm, black and red chalk on buff paper, Real Academia Española, Madrid.
3 Proske 1967, p. 16, fig. 2.

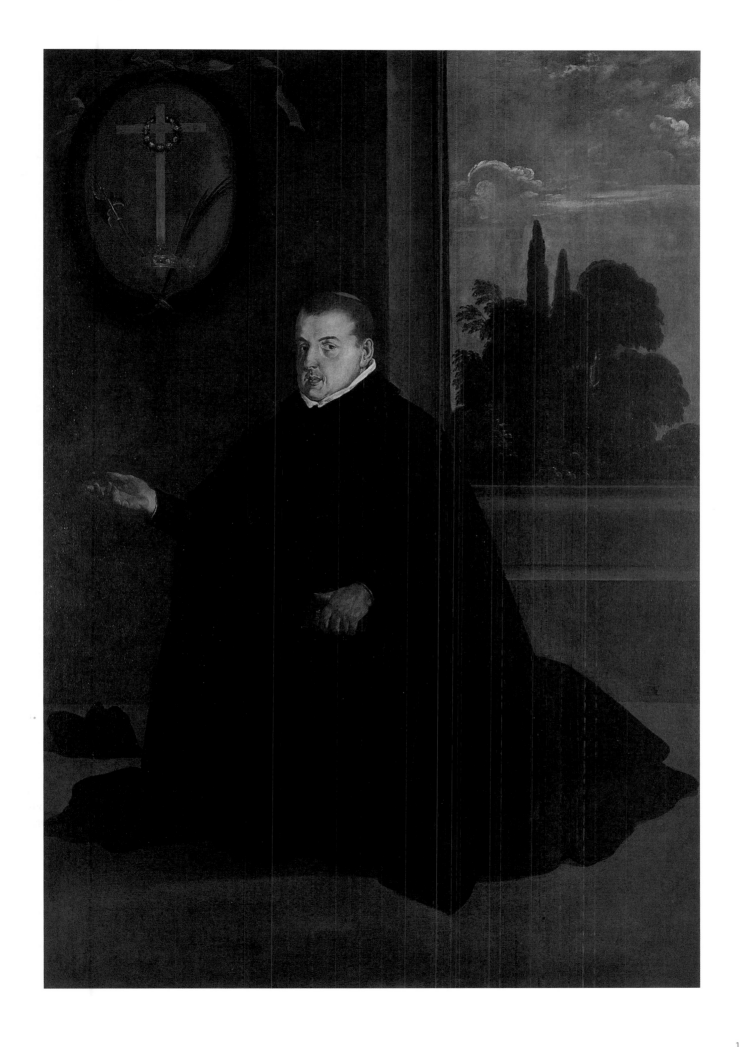

The Venerable Mother Jerónima de la Fuente, 1620

Oil on canvas, 162.5 × 105 cm
Private collection
Signature added at a later date above the inscription on the left: DIEGO VELAZQUEZ F. 1620

Inscribed: *Este es verdadero Retrato de la Madre Doña Jeronima de la Fuête relixiosa del Coñuento de Sancta ysabel de los Reyes de T̲. fundadora y primera Abadesa del Convento de S. Clara de la Concepcion de la primera regla de la Ciudad de Manila en filipinas. salio aesta fundacion de edad de 66 anos martes veinte y ocho de Abril de 1620 años salieron de este conuento en su compania la madre Ana de Christo y la madre Leonor de sanct francisco Relixiosas y la hermana Juana de sanct Antonio novicia Todas personas de mucha importancia Para tan alta obra*

PROVENANCE

Kept in the convent of Santa Isabel la Real, Toledo, and made public in 1931; sold by the nuns in 1944 to the Fernández de Araóz collection

ESSENTIAL BIBLIOGRAPHY

Garrido and Gómez Espinosa 1988, pp. 66–75; New York 1990, p. 68, no. 3; Delenda 1993, pp. 65–9; Edinburgh 1996, pp. 48–9 and p. 174, no. 43; Seville 1999, p. 208, no. 97; Veliz 1999, pp. 397–414; Oviedo 1999–2000, pp. 78–89, no. 6; Garrido 2004, pp. 4–6

Mother Jerónima de la Fuente (1555–1630), a Franciscan nun from the closed order of the Poor Clares, looks us in the eye with a penetrating gaze. In one hand she holds a crucifix; in the other, a Bible. Born in Toledo to a hidalgo family (her father was a jurist), she entered the convent of Santa Isabel de los Reyes in Toledo at the age of fourteen. Venerated for her holiness during her lifetime, she was also praised for her organisational skills, and won admiration for her austere programme of penitence and meditation. Her biographers tell how she achieved mystic communion with Christ through visions and revelations, re-enacting the Crucifixion by attaching herself to a cross and hanging unsupported for as much as three hours at a time.[1]

On 28 April 1620, she and three other members of her order left Toledo in order to sail around the world to set up a sister convent in Manila in the Spanish Philippines. On their way to Cádiz, where they were to embark, they stayed in the Franciscan Convent of Santa Clara in Seville, where they arrived on 1 June 1620. As Jerónima's companion, Ana de Cristo, subsequently recounted: 'We were in the convent for almost two months, in which time many people came from all parts to visit our Mother, attracted by the fame of her sanctity.'[2] It was there that Velázquez would have painted her portrait, commissioned perhaps by the nuns of the convent in Toledo. That Velázquez succeeded in capturing her likeness to the satisfaction of his patrons is shown by the fact that he painted at least two versions of this portrait. The present painting is an autograph copy of an earlier original re-discovered in the convent of Santa Isabel in 1927 and bought by the Prado.[3] The present version was found in the same convent in 1931.

To emphasise Jerónima's spiritual stature, Velázquez shows her in a pose that may have been based on a contemporary engraving of Father Simón, a similarly venerated figure from Valencia who is likewise shown holding a crucifix and book (fig. 89).[4] Velázquez, however, goes beyond religious propaganda to produce a work of great intimacy. This portrait of a Poor Clare famed for her piety and proselytising zeal, his first full-length portrait, marks a remarkable beginning to a brilliant career.

Pledged to silence under the rules of her order, Velázquez's Jerónima leaves it to the white banderol next to her to do the 'talking': 'I shall be satisfied when I awake, with Thy likeness' (Psalms 17 : 15). Those who dare to differ are reprimanded by the Latin quotation above: 'It is good that a man should both hope and quietly wait for the salvation of the Lord' (Lamentations 3 : 26). Combining word and image, Velázquez portrays the rugged features of the 66-year-old nun in a realistic and uncompromising fashion, creating a sense of physical presence accompanied by profound spirituality. The inscription below, recounting Jerónima's journey to the Philippines and probably added later, justifiably presents the picture as a 'true portrait'.

On 5 August 1621, Jerónima arrived in Manila after a journey lasting one year, three months and nine days. There she founded the Convent of Santa Clara, where she spent the remaining nine years of her life. While Philip IV expressed his regret at the loss of such a saintly woman from his kingdom, he emphasised that 'we have sacrificed her for the spiritual good of those souls'.[5] XB

89

1 Ruano 1993, p. 27.
2 Ruano 1993, p. 84.
3 *Sociedad Española de Amigos del Arte*, Madrid 1927, no. 18.
4 Ainaud de Lasarte 1957, pp. 86–9.
5 Ruano 1993, p. 35: 'sacrifiquémosla al bien spiritual de aquellas almas'.

89.
Michel Lasne (1590–1667) after Francisco Ribalta (1565–1628)
Father Simón, 1612–19
Engraving (detail)
Museu Nacional d'Art de Cataluñya, Barcelona

Luis de Góngora y Argote, 1622

Oil on canvas, 50.2 × 40.6 cm
Museum of Fine Arts, Boston
Maria Antoinette Evans Fund, 1932 (32.79)

ESSENTIAL BIBLIOGRAPHY

Pacheco 1649 (1990), pp. 203–4; New York 1990, pp. 75–7, no. 4; Edinburgh 1996, p. 180, no. 45; Seville 1999, p. 214, no. 100

Luis de Góngora y Argote (1561–1627) was one of Spain's greatest poets, renowned for his learning, acuity and caustic wit. He was 61 when Velázquez painted this portrait, with an illustrious career behind him. Ordained a priest in 1605, he had obtained an appointment as honorary chaplain to Philip III in 1617, through the influence of the Duke of Lerma. As a poet, praised in 1585 by Miguel de Cervantes in *La Galatea*, he wrote sonnets, odes, ballads, songs for the guitar and longer poems such as the *Soledades* and *Polifemo*. Along with his close friend Fray Hortensio Félix Paravicino y Arteaga, a Trinitarian preacher portrayed by El Greco (fig. 37), he practised a literary style that was brilliantly inventive, dense in visual images and rich in learned references, known as *gongorismo* or *culteranismo*.

Velázquez brings out his sitter's character in this sharply focused and subtly modelled portrait with broad and smoothly blended brushstrokes. Using simple visual tricks to create relief, he illuminates the right side of his sitter's face, toning down the lighting in the background and leaving the left side of his face in shadow. The transition from light to dark gives the portrait a sculptural quality reminiscent of the heads of saints carved by Juan Martínez Montañés and polychromed by Pacheco.[1]

Velázquez painted this portrait in Madrid in April 1622 at the request of Pacheco, who may have wished to make a drawing after the painting in order to include it in his *Libro de retratos*.[2] Although no drawing by Pacheco survives that corresponds to this painting, it is noteworthy that Velázquez originally represented his sitter crowned with a wreath of bay leaves, visible in X-radiography and just

discernible to the naked eye, similar to those in Pacheco's portraits of illustrious poets. Pacheco tells us that the portrait was much admired in Madrid, no doubt contributing to Velázquez's reputation and perhaps helping to win him an invitation to return to court the following year.

Góngora's satirical writings and his use of affected Latinisms, unnatural transpositions, strained metaphors and frequent obscurities earned him many enemies, among them his main rival, Francisco de Quevedo. The two poets composed bitter satirical pieces attacking each other, with Quevedo taking advantage of Góngora's weaknesses, including his susceptibility to flattery and passion for gambling, and even accusing him of sodomy, a capital crime in seventeenth-century Spain. Their enmity reached a climax when Quevedo bought the house in which Góngora lived, for the sole purpose of ousting him from it. In 1626, severe illness seriously impaired his memory and forced him to return to his hometown, Cordoba, where he died the following year.

Several painted copies of Velázquez's portrait were made and it served as a model for engraved portraits.[3] The earliest, by Juan de Courbes, appeared in a work on Góngora dated 1630[4] and in the poet's collected works published in 1633.[5] XB

1 See in particular *Saint Francis Borgia* in Proske 1967, p. 78, figs 89, 91.
2 Pacheco 1649 (1990), pp. 203–4.
3 For copies see López-Rey 1963, nos 497–9.
4 José Pellicer de Salas y Tovar, *Lecciones solemnes a las obras de Don Luis de Góngora y Argote*, Madrid 1630.
5 *Todas las obras de Luis de Góngora en varios poemas*, Madrid 1633.

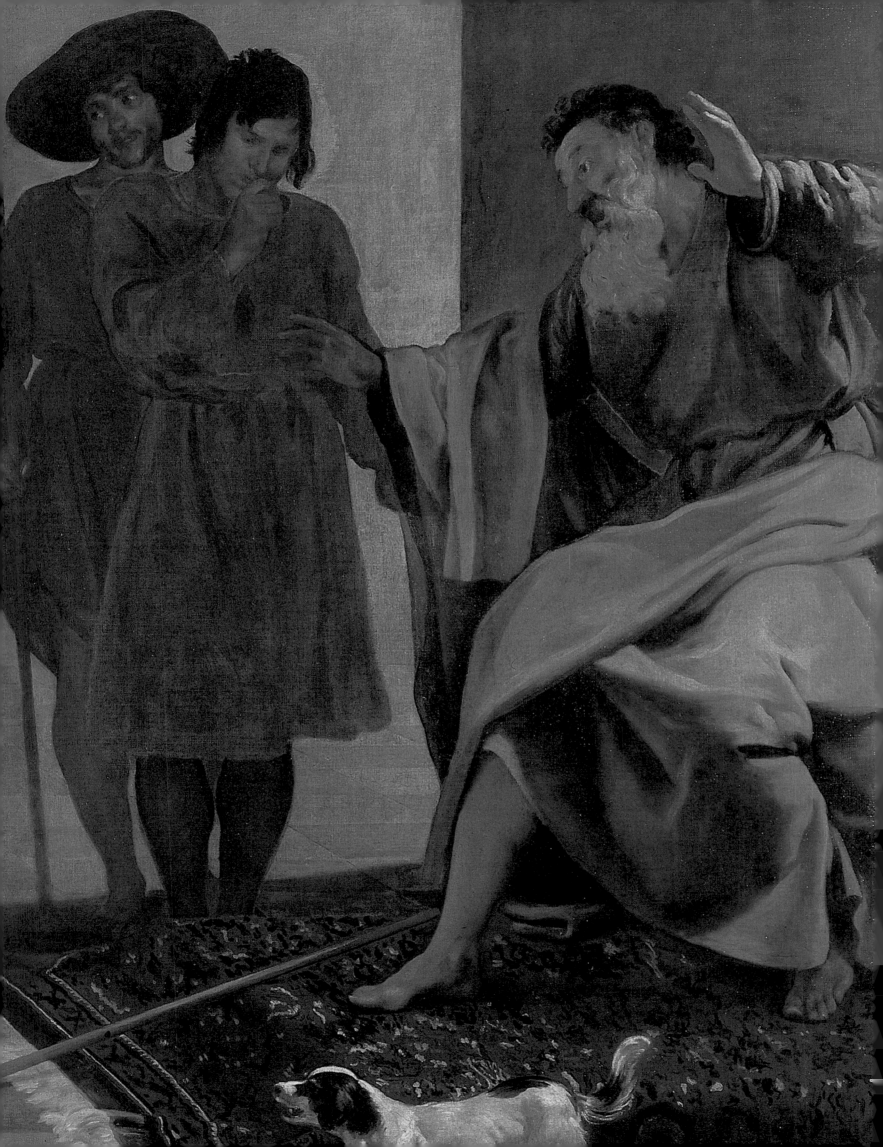

AT COURT AND IN ITALY:
PAINTER OF FAITH AND MYTH

Velázquez's appointment at court in 1623 altered his career forever. Had he remained in Seville, he would have been occupied mostly with making religious paintings and the promise shown in his early works would have brilliantly flourished in some of the noteworthy commissions given to Zurbarán and Murillo. Once in Madrid, he made only a few religious paintings, indeed far fewer than any other major painter in a Catholic country in this period. This does not represent a propensity for secular subjects because the number of his mythological paintings is equally small. The main factor in his limited production in these areas was his primary responsibility in the royal household, the creation of portraits. He was also notoriously slow, and as his career as a courtier developed, duties in the royal household took increasing precedence over painting. With a significant exception to be addressed below, he apparently only made religious and mythological paintings on commission, and it would seem that these were not generally what his patrons desired from him. The paintings that survive make it clear that he relished the challenges of depicting significant subjects and perhaps the deep consideration that he gave to each work also contributed to their scarcity.

This section considers Velázquez's development as a history painter in the years before, during and after his first trip to Italy. In this period of experimentation, he evolved more rapidly than at any other time in his career. While always able to describe natural appearances his command of space and expression with the figure was to progress quickly, so that by his return from Italy, he was unquestionably one of the best narrative painters in Europe.

His quest for a personal vision was literally from the ground up, because he tried different types of canvas and completely changed the colour and tone of the surface on which he built his compositions. Each painting in this section has a distinctive look that results from this experimentation and from his progress, but Velázquez is always recognisable in the affective humanity of his subjects.

Though Velázquez's early years at court were dominated by portraiture, in 1627 he established that he was the leading history painter as well by winning a competition among court artists, ordered by the king, to paint the Expulsion of the Moriscos by Philip III. His critics had accused him of only being able to paint portraits, so it must have been gratifying to see his painting installed along with Titian's representations of the Habsburgs as defenders of the faith in the Alcázar. This canvas was consumed by fire in 1734, and consequently, only one mythology and one religious painting survive from the period before his visit to Italy.

The Feast of Bacchus (fig. 15), the artist's first depiction of a classical myth, established that his primary goal was to endow such ancient tales with contemporary significance. In a similar vein, Christ after the Flagellation contemplated by the Christian Soul (cat. 16) attempts to give actuality and accessibility to a scene from the Passion. It is not clear if this painting was made before, during, or after Velázquez's first trip to Italy. In comparison with Bacchus, the greater command of space and the exceptional pose of Christ suggest that it was made after he had experienced contemporary art in Rome and Bologna, but the balance of evidence points to the period before he departed. Velázquez's adjustment of his compositions and technique to the subject at hand makes the problem of dating difficult.[1]

In Rome, Velázquez was not happy simply to study, but set about to prove himself as a history painter in two large canvases (cats 17–18), one drawn from the Bible and the other from classical mythology. Velázquez had never before worked on such a grand scale and he chose unusual subjects with complex drama that would challenge his ability to express with the figure. The results show an artist transformed into a mature and inventive narrator though it is difficult to point to any one source of influence, contemporary or ancient. It would seem that general exposure to Italian traditions of spatial definition, compositional organisation and rhetorical expression enriched his expressive clarity and range. While he enjoyed playing with newly observed classical models, as in his use of the Apollo Belvedere in posing his Apollo at the Forge of Vulcan, he remained clearly focused on telling his stories using everyday gestures and expressions with distinctive effectiveness. His palette, too, became richer and brighter, suggesting that neo-Venetian trends in contemporary Roman art might have pointed the way to a colour scheme he might well have learned at home.[2] His technique became more assured, though this did not depend on Italian lessons, and shows his development toward definition with ever greater economy.

The final painting in this section, The Temptation of Saint Thomas Aquinas (cat. 19), was probably made a year or two after his return to Madrid. This was Velázquez's first and last religious narrative set in an interior, which makes it an ideal point of comparison with the other works in this section. The lessons of Italy are evident in the clarity of spatial organisation and in the succinct and moving telling of the story, but here Velázquez takes another step on the road to his final style in the suggestion of forms and features. DC

1 On the visit to Italy see Salort Pons 2002, pp. 31–79, with pertinent documents, pp. 439–40.
2 On the Roman art scene at this time, see Bonnefoy 1970.

Joseph's Bloody Coat brought to Jacob
(detail of cat. 17)

by word and example, leads his neighbours to imitate Thee.'[5] While the Soul is not specifically mentioned, 'member' is surely meant to be every faithful Christian, and this sentiment was expressed in most meditations on the Passion.

The ancient and cherished belief in guardian angels found new life during the Catholic Reformation in keeping with the general trend to personalise religion. Though the cult of guardian angels had long existed, in the last quarter of the sixteenth century the churches of Toledo, Cordoba, and Valencia were granted feast days in their honour and in 1608 Pope Paul V extended the feast to the whole church. The following year Saint Francis de Sales stressed the importance of the guardian angel in personal spiritual development to the youth Philothea (a 'soul in love with God') in his *Introduction to the Devout Life*, one of the most eloquent and influential treatises of the period.[6] The Spanish edition did not appear until 1618, but it was published in French and Latin in the years preceding Roelas's painting, and may have influenced its creator.

The subject surely appealed to Velázquez's interest in exploring different levels of reality. In his early religious *bodegones* (cats 4–5), mundane contemporary scenes were counter-posed with moments of revelation from the Bible. Here, the flagellated Christ shares the same space with allegorical figures, but ones that seem so down to earth, their actions so recognisable, that they guide the viewer to the appropriate response. The space of the painting is conceived as contiguous with the viewer's and in a dark, meditative environment, the lighting and the dark mass of Christ's robe in the foreground would have emphasised the haunting actuality that Velázquez gives to this timeless, visionary scene.

The painting has been variously dated to the years immediately preceding Velázquez's first trip to Italy, to the time he was in Italy (summer 1629–1630), and to the period following his return to Madrid in January 1631. The greater command of composition, space and the figure in comparison with *The Feast of Bacchus* (fig. 15) and the more Italianate figure types suggest that the painting reflects his experience there, or that he was well on his way before he ever left Madrid. The painting was executed on a reddish-brown ground typical of Velázquez before his trip to Italy, but also used in *Joseph's Bloody Coat* (cat. 17) painted in Rome. Velázquez's other Roman work, *Apollo at the Forge of Vulcan* (cat. 18), employs the light greyish ground that he presumably used thereafter. This and the distinctly Spanish iconography argue in favour of a date of 1627–8.

Nothing is known of this painting before it was bought by John Savile Lumley in Madrid in 1858 from a 'poor old artist'.[7] The size as well as the content implies that it was made for a small chapel or place of devotion. We cannot preclude that an individual commissioned it for personal use, although the subject seems more appropriate for a convent setting, where, as Roelas's example demonstrates, it could have served for individual devotion, but also as an effective tool in the instruction of novices. DC

1 Matthew 27:26; Mark 15:15; Luke 23:16 and 22; John 19:1.
2 Pacheco 1649 (1990), p. 301.
3 Schneider 1905, pp. 157–8, identified the subject. On the theme, see Moffitt 1992, pp. 139–54.
4 Valdivieso and Serrera 1985, p. 158, no. 83, fig. 97.
5 Alvarez de Paz 1933, p. 193. See Moffitt 1992, p. 144.
6 Saint Francis de Sales 1972, p. 46. Moffitt 1992, pp. 146–9.
7 Glendinning 1989, pp. 123, 126 (Appendix II D).

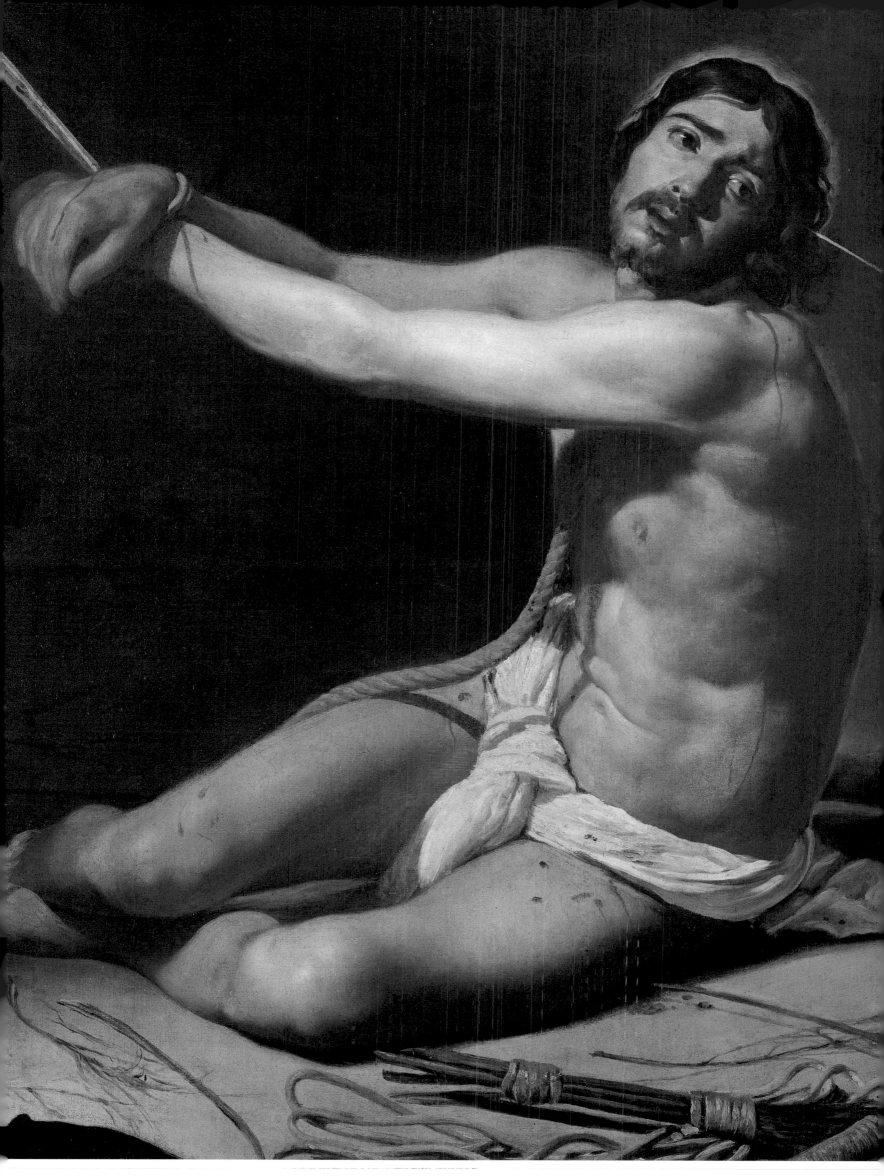

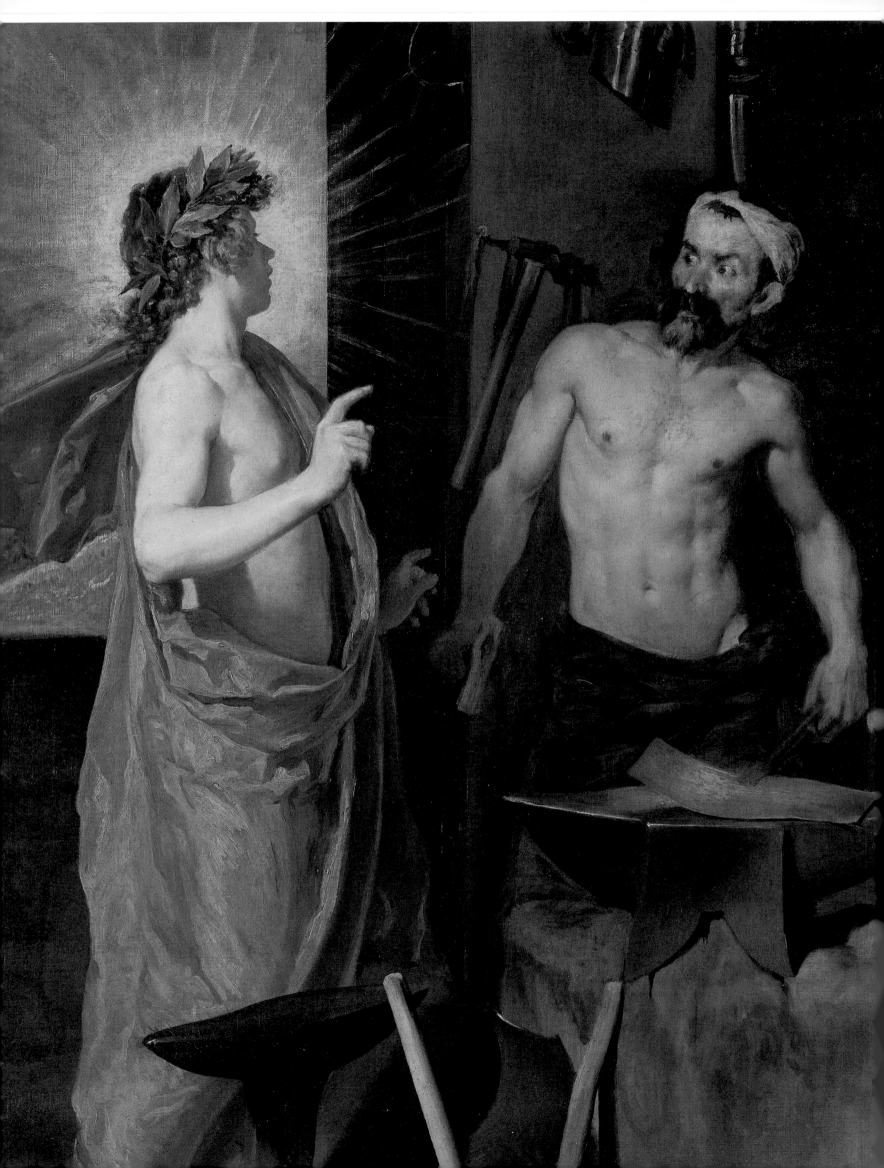

91

labour of craft. Standing before the painting, one might imagine this coming up in discussion, but Velázquez's primary intent was surely not allegorical but rather to depict his subject in an affecting way.

As in *Joseph's Bloody Coat brought to Jacob* the paint handling is adjusted according to the distance of an object from the picture plane, with sharply defined forms in the foreground ranging to the barely suggested features of the figure operating the bellows in the background. The forge and landscape are very sparingly brushed in, but the paint is generally more thinly applied, and where Velázquez uses thick impasto – the robe of Apollo and the glowing iron on Vulcan's anvil – it is to achieve the effect of incandescence. The exceptional condition of the painting allows us to study Velázquez's extraordinary variations in light as it plays across forms, revealing texture and establishing presence. The dilute washes of dark paint used to model the flesh are preserved intact and should inform assessment of more compromised paintings.

This is the first painting that Velázquez executed on a warm grey ground. Hitherto he had employed a dark reddish brown similar to the grounds used by Caravaggio and his followers, which results in a relatively sombre overall tonality. Perhaps Velázquez's observation of his Bolognese contemporaries, artists such as Guercino and Guido Reni, inspired him to try the lighter ground. In carrying out this work, he realised that it impacted greater luminosity and offered a greater range of tonal effects, so he used this type of ground thereafter.

Scholars debate whether this painting was conceived as a pendant to *Joseph's Coat*. The choice of a scene from classical mythology to balance one from the Old Testament can hardly be accidental, even if this was only to prove his abilities in both realms. However, as both show scenes of revelation, one calculated to deceive, the other to unmask deception, it is tempting to see them as intending to provoke comparison. The differing sizes of the canvases and conflicting evidence concerning the original dimensions of both make a definitive conclusion difficult. DC

The Temptation of Saint Thomas Aquinas, 1632–3

Oil on canvas, 244 × 203 cm
Obispado de Orihuela-Alicante
Museo Diocesano de Arte Sacro, Orihuela

PROVENANCE

Salón de Grados, Colegio de San
Domenico, Orihuela, from 1633(?);
Sacristy, Colegio de Santo Domingo,
Orihuela, in 1906; Museo de la Junta
Central del Tesoro Artístico, Palacio
del Marqués de Rafal, Orihuela,
1936–9; Chapel, Palacio Episcopal,
Orihuela, 1939–44; Museo Diocesano
de Arte Sacro, Orihuela, from 1944

ESSENTIAL BIBLIOGRAPHY

Sánchez Portas 1990; Gállego in
Madrid 1990, pp. 184–8, no. 29;
Garrido 1992, pp. 263–77; Delenda
1993, pp. 110–13; Brown and
Garrido 1998, pp. 62–8, no. 8; Mena
in Rome 1999–2000, pp. 76–8, no. 4

Velázquez's services were in demand by the king in the years following his return from Italy in 1631, yet he found time to create this painting for another patron. It was discovered in 1906 in the College of Saint Dominic in Orihuela, a town on the Segura River in the Kingdom of Valencia, not far from Murcia. Documents testify that in March 1633 'a painting of Saint Thomas' was delivered to the college, but unfortunately they do not indicate the artist, the specific subject, or even the origin of the shipment. No payment for the painting was recorded and Velázquez would probably not have accepted a commission from a remote college without incentive. The most plausible hypothesis is that the painting was the gift of the most influential Domincan at court, Fray Antonio de Sotomayor, the king's confessor, who was appointed to the authoritative position of Inquisitor General in 1631. Later that year, he was named protector of Orihuela's Dominican college in gratitude for having granted it exemption from paying tribute to the crown and it is possible that he commissioned Velázquez to paint this subject to express the seriousness with which he took his role.[1]

Based on Saint Dominic's calling to fight heresy, the special vocation of the Order of Preachers is saving souls by teaching the truth of faith. Underpinning their evangelism is a tradition of distinguished theological scholarship. The greatest of all Dominican theologians, Thomas Aquinas (about 1225–1274), addressed the full range of Christian doctrine, often in reference to non-Christian and heretical views. Though his works were not so influential in his own time, they became the standard for doctrinal orthodoxy during the Catholic Reformation and he was proclaimed a Doctor of the Church in 1567. Images of the 'Angelic Doctor' were customary in Dominican colleges, but if the Inquisitor General was indeed behind this commission, it is interesting that he chose not to show Aquinas as defender of the faith, but rather to present the young collegians with a moving depiction of the saint's fundamental religious vocation. If the painting was in fact his gift, it should be seen as reflecting the importance that Dominicans place on teaching to pass on the benefits of faith.

The story depicted by Velázquez was well known from contemporary compendia of saints' lives. Thomas Aquinas was born at Roccasecca to a noble family that was horrified by his decision to join a mendicant order. Not long after taking the habit, his brothers abducted and confined him, hoping he would renounce religious life. They sent a woman to his room to tempt him, but when she appeared, he grabbed a burning log from the fireplace, used it to draw a cross on the wall, and knelt to pray. Falling into a trance, he was visited by two angels, who tied a white belt around his waist to endorse his chastity.

Velázquez viewed this visionary, symbolic scene with tender realism. In his sweet sleep, Aquinas leans ever so gently on the kneeling angel, who supports him with an embrace, a potent gesture recognisable to anyone who has consoled an ailing friend. The other angel prepares to gird the saint, regarding him intently and holding the belt so delicately that it seems the task will be carried out without waking him. Through the open door, the temptress takes flight, though she cannot resist glancing back, her eyes and mouth conveying her bewilderment at a totally new experience. The stool made into a desk and the open books on the floor show that Thomas turned his palatial chamber into a cell. The smouldering log lies at his side, smoke rising like incense to sanctify the moment he offers himself completely to God.

Even though painted not long after Velázquez's return from Italy, the forms and especially the heads seem particularly idealised, which he apparently felt was appropriate to the depiction of the angelic characters. They appear to be based on posed models, but not the earthy characters of Velázquez's earlier religious works, even the quite recent, solid angel in *Christ after the Flagellation contemplated by the Christian Soul* (cat. 16). Some see the influence of Guido Reni, but if Bolognese classicism was indeed the source of inspiration it is thoroughly assumed into Velázquez's own idiom, in which even the ethereal is grounded in reality. For instance, Velázquez's religious figures always have distinctive human hair, and here he takes pleasure in defining the subtle stubble of the monk's tonsure. The main characters are recognisable as descending from the figure of

Apollo in cat. 18, particularly the standing angel with its arms held away from the body. The beauty of the faces, the way the facial features are suggested rather than defined, and the elegant hand gestures point toward the *Coronation of the Virgin* (Museo Nacional del Prado, Madrid), probably Velázquez's last religious work, made just a few years later.

Here, the narrative and spatial clarity that he had assimilated in Italy are in evidence. Similar to *Christ contemplated by the Christian Soul*, the composition is constructed around intersecting diagonals so that the heads of the saint and the supporting angel are at centre. However, now spatial diagonals are also at play through the central figure group, the log being counterposed with the fire and the saint's books with the fleeing temptress.

Before the cleaning and restoration of the painting in 1990, the attribution to Velázquez was sometimes questioned:[2] the idealisation of the figures, which today seems so fitting to the subject and in keeping with his later work, was troubling to some. It was assigned instead to his friend and classmate in Pacheco's studio, Alonso Cano (1601–1667), the only other artist capable of approximating Velázquez's style; and it was also seen as a collaboration between the two painters. Few doubted that Velázquez was responsible for the woman because she is executed in the abbreviated technique of the background figure in *Apollo at the Forge of Vulcan* (cat. 18) as well as of the smaller figures in *Baltasar Carlos in the Riding School* (cat. 45), the *Tela Real* (cat. 33), and, ultimately, *The Spinners* (fig. 31). However,

the precise delineation of the chimneypiece is unlike anything in Velázquez's oeuvre and it was seen as evidence of Cano's ability as an architectural draughtsman. Some still doubt that Velázquez made this architectural detail himself, but the attribution to him has won general approbation since the restoration.

The composition was carefully planned in advance and the only significant changes were made to the figure of the standing angel. Some of these are evident in the drapery as we see it today owing to the ageing of the thin paint employed by Velázquez. Most importantly, he eliminated a great sweep of drapery to the left on the floor. Interestingly, it was the lower drapery that was significantly altered in *The Immaculate Conception* (cat. 9). Here, it would seem that Velázquez originally conceived the train of fabric to echo the diagonal established by the outline of Thomas's cloak, changing his mind perhaps to situate the figures better in space. The more upright stance, repeating other vertical elements of the composition, better emphasises the pyramidal figure in the end. DC

1 For the documentation and the suggestion of Sotomayor as patron, see Sánchez Portas 1990. Mena in Rome 1999–2000, p. 76, suggested that Fray Tomás de Roccamora, who represented the college in Madrid, commissioned the work. It is perhaps not odd that no payment is documented. In any case, it would have taken Sotomayor's influence to gain such a painting from Velázquez.
2 Brown 1986, pp. 271–3, summarises the critical history of the painting before the restoration.

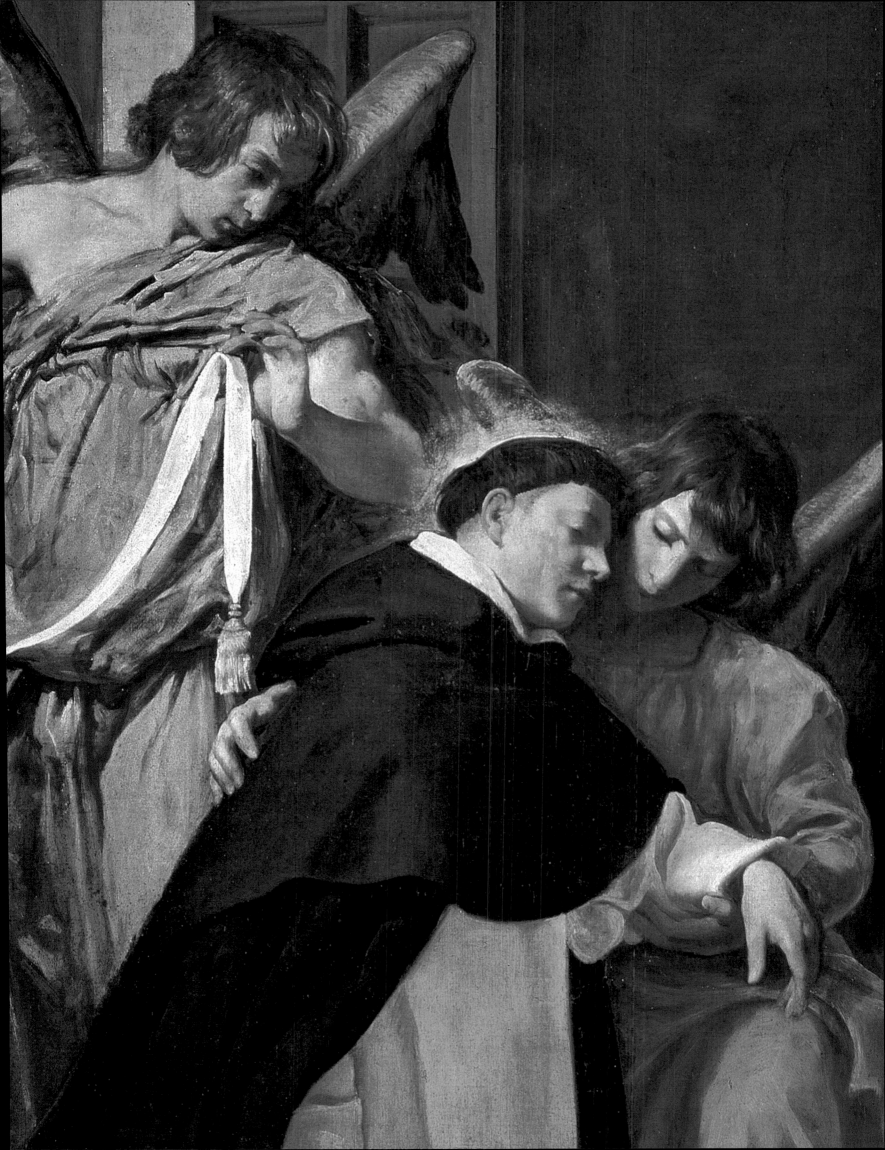

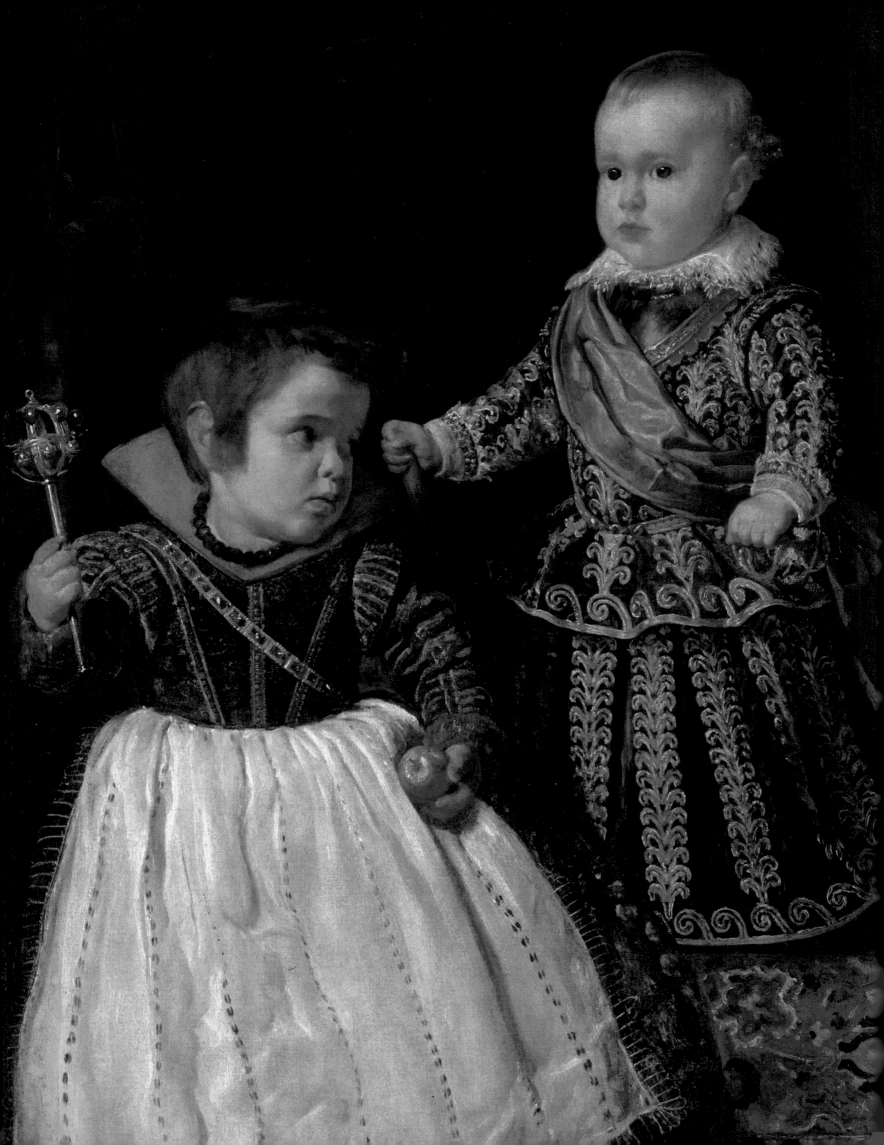

PORTRAYING THE COURT

Velázquez won his position as court painter though his skill as a portraitist, and fashioning likenesses of Philip IV and his family became his primary responsibility for the remainder of his career. Over the course of almost four decades, Velázquez portrayed the king, his only constant subject because those closest to him died one after one. In his portraits of the king, even as the toll of responsibility and personal loss began to tell, the artist achieved images of effortless and understated majesty that have come to typify the monarch and his reign.

While Velázquez's manner of painting evolved considerably over the course of this period, the basic qualities and structure of his formal portraits changed hardly at all. Already in Seville, he had shown that he would concentrate on the person, and particularly the face, by setting his subject against a neutral background, with minimal indications of space and use of props. At court, his approach was fundamentally conservative, following traditional formats developed by Titian, Anthonis Mor and Alonso Sánchez Coello in the sixteenth century. These had established that Spanish Habsburg self-presentation would be reserved, the richest and most powerful monarchs having no need of aggrandisement. This corresponded well with Velázquez's sensibilities and he made the pre-established portrait types even more spare, while creating a greater sense of presence and lending his subjects a particular reticent ease.

The likeness was apparently taken in sittings with the king in a head or bust-length study and then applied to virtually any costume or setting. Two full-length portraits of the king from the 1630s (cats 24 and 31) show that Velázquez used the same head for two very different portraits, one to record a splendid garment worn on a special occasion and the other to appeal to the king's love of the hunt. These were exceptional portraits made by Velázquez himself, but the majority were generated by his workshop from Velázquez's prime model.

The king was portrayed differently from other people, his visage more luminous, his manner more grave and detached. The regality of the image is demonstrated by comparison with portraits of courtiers, although these were not often done by Velázquez. *Don Pedro de Barberana y Aparregui* (cat. 22) was created around the same time as *Philip IV in Brown and Silver* and shows relatively uncompromising realism as well as an insinuation of personality in the upraised eyebrow that so enlivens his corporeal presence.

Velázquez's reputation as a portraitist is enhanced by a series of portraits of the royal children. Throughout the 1630s, Velázquez portrayed the heir to the throne, Infante Baltasar Carlos, in works following his development (cat. 23, fig. 17, cats 25, 27 and 32). Most of these were adaptations of adult portrait formulae to stress continuity of rule and, like his father, Baltasar's expression was required to be aloof, but Velázquez none the less managed to instil a hint of the spirit of a child.

Not all of Velázquez's sitters were high born. One of the more extraordinary aspects of his production is a small group of informal portraits of fellow courtiers, men at or near Velázquez's social level, or at least we presume this from the familiarity with which they are treated (cats 21 and 29, fig. 99). These were perhaps made for the sitters as tokens of friendship, and are often unfinished. None was intended for public presentation and the artist felt free to capture particularities of appearance and aspects of character that are suppressed in his more formal portraits. The marginal status of court dwarfs and buffoons allowed Velázquez even greater freedom to probe appearance and psychology and these portraits are today considered among his greatest achievements for their honest dignity. Thus, in the course of his career, Velázquez portrayed the whole range of the court.

Though the bulk of Velázquez's portraiture follows conventional formats and aims, he also created three paintings that purport to capture informal glimpses of court life. The first of these was probably *Philip IV hunting Wild Boar* (cat. 33), in which the artist tried to enliven a standard type of hunting scene by including not only portraits of the king and his grandees, but also a broader spectrum of courtiers and servants than was customary, though most of these figures do not seem to be portraits. It was perhaps his experience with this work, constrained though it was by having to fit into an ensemble, that gave Velázquez the idea of creating a seemingly informal portrait of the court that would seem more real. *Baltasar Carlos in the Riding School* (cat. 27) is an independent and highly novel picture that presages his ultimate court portrait in *Las Meninas* (fig. 30). Here, a recognisable palatial setting and familiar characters are combined to evoke a seemingly casual moment, though it was as carefully constructed as a history painting to reveal political and social relationships. In it, we see virtually the whole range of people captured in Velázquez's independent portraits, here acting their parts in the king's extended family. DC

Don Gaspar de Guzmán, Count-Duke of Olivares, 1624

Oil on canvas, 203 × 106 cm
Museu de Arte de São Paulo Assis Chateaubriand
São Paulo, Brazil

PROVENANCE

Commissioned in 1624 by Doña
Antonia de Ipeñarrieta (who later
married Don Diego del Corral);
Palacio Corral, Zarauz (Guipúzcoa),
1668; by descent to the Duques de
Villahermosa, Madrid; Duque de Luna,
Madrid, 1906; Agnew and Sons,
London, 1912; Duveen Bros; Lord
Cowdray, London; his sale, Sotheby's,
London, 11 June 1947; Museu de Arte
de São Paulo since 1948

ESSENTIAL BIBLIOGRAPHY

Mélida 1905; Mélida 1906; Allende-
Salazar 1925, pp. 25, 274; Mayer 1936,
p. 74, no. 316; Lafuente Ferrari 1943,
p. 19, no. 27; Trapier 1948, pp. 97–102;
Pantorba 1955, pp. 86–7, no. 26;
Harris 1982, p. 59; Brown 1986,
pp. 47–50; López Rey 1996, vol. II,
pp. 70–2, no. 30; Brown in Madrid
1999–2000, pp. 166–8, no. 18;
Mena in Rome 2001, pp. 166–9

As Philip IV's favourite during the first half of his reign, Don Gaspar de Guzmán (1587–1645), Count-Duke of Olivares, controlled the destiny of the Spanish monarchy.[1] He was also perhaps the most significant figure in Velázquez's career because, without his support, the painter might not have been given the opportunity to portray the king, nor have enjoyed such rapid advancement in the royal household.[2] Though Olivares was born in Rome – in Nero's Palace according to his enemies – he was from an Andalusian family and liked to surround himself with trusted countrymen. He surely recognised Velázquez's talent, but because he well understood the importance of art as a tool of propaganda his protection was not totally altruistic.[3]

Here, Olivares confronts the spectator in a nearly frontal pose that stresses his formidable bulk and the intensity of his gaze. Half of the face is cast into deep shadow (see also cat. 15), which only deepens our sense of being scrutinised. One hand grips the table, while the other is poised on his sword hilt, a stance which amplifies his massive form and animates its contours, reflecting his lively, tireless persona. The characterisation has been perceived as unflattering, but at this early stage in his consolidation of power Olivares surely relished, perhaps encouraged, this tough image. Here is the forthright reformer, ready to take on the special interests of the grandees, the failing economy, and the inflated, corrupt government bureaucracy; here is the enforcer of the king's will.

In his belt, Olivares wears the symbols of his power. The key is the emblem of the *sumiller de corps*, or groom of the stole, whose duties included dressing the king. The golden spurs pertained to the office of *caballerizo mayor*, or master of the horse, who was required to accompany the king whenever he left the palace. A regulation prohibited anyone from holding two offices, so this combination, which signified constant access to the king, was a sign of eminence that previously had only been granted to the Duke of Lerma, Philip III's favourite.

The simple starched collar, known as a *golilla*, was introduced in 1623 as one measure of Olivares' great reform programme because the ruff had grown so luxurious that it was seen as a symptom of the decline in public morality. Though Olivares was a diligent and well-meaning minister, his more significant policies eventually led to political and financial crisis and Philip IV was forced to relieve him of his offices and banish him from the court in 1643. He died a broken man two years later.

The painting is one of three commissioned from the artist by Doña Antonia de Ipeñarrieta, the wife of an important jurist. On 4 December 1624, Velázquez signed a receipt for 800 reales, presumably the final payment, for this painting, the *Portrait of Philip IV* (Metropolitan Museum of Art, New York), and a portrait of her first husband, Don García Pérez de Araciel (now lost).[4] The fact that the New York *Philip IV* is a version of a portrait made for the king (fig. 13) suggests that this image is a replica of a lost work. It certainly dates from before August 1624, when Olivares left the military Order of Calatrava, whose red cross insignia is emblazoned on his doublet, in favour of the Order of Alcántara, whose emblem was the green cross seen in the portrait made by Velázquez about a year later (fig. 14).[5]

The attribution to Velázquez has been accepted without reservation by most critics, but a few have questioned whether workshop participation is involved.[6] While the painting's compromised condition makes judgement difficult, since its restoration in 2000 the intensity of the expression and the physical presence of the great hulking body have been recovered. Likewise, Velázquez's economic handling of paint can be seen in the nuances of black tones, the distinct rendering of textures, and especially the modelling of the face. DC

1 Elliott 1986 is the classic study of Olivares.
2 Pacheco 1649 (1990), pp. 203–5, notes that Velázquez was called to Madrid by Olivares, and the elaborate strategy to bring the painter to the king's attention is worthy of the Count-Duke, who typically wanted to seem uninvolved.
3 See Brown and Elliott 2003, p. 12, for the Nero analogy.
4 See Melia 1906 and *Corpus velázqueño* 2000, I, p. 46. The receipt that accompanied the sale is now in the Metropolitan Museum, New York. Doña Antonia was apparently pleased with the results because Velázquez portrayed her and her second husband, Diego del Corral, after 1631 (both now in the Prado).
5 On the change of orders, see López-Rey 1996, II, p. 70.
6 Brown in Madrid 1999–2000, pp. 166–8, surveys the critical opinion on the painting.

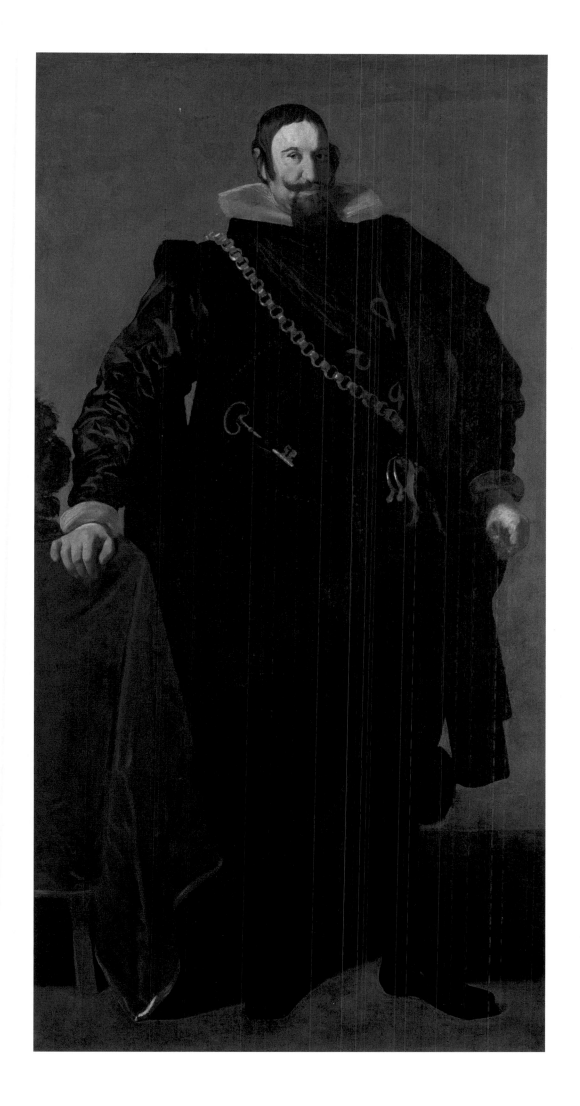

Portrait of a Young Man, 1625–9

Oil on canvas, 89.2 × 69.5 cm
Alte Pinakothek, Bayerische Staatsgemäldesammlungen, Munich (518)

PROVENANCE

Bought in Madrid in 1694 by Minister Heinrich von Wiser for Prince Elector Johann Wilhelm von der Pfalz; Sammlung des Kurfürsten, Düsseldorf; Hofgartengalerie, Munich, from 1806; Alte Pinakothek, Munich, since 1836

ESSENTIAL BIBLIOGRAPHY

Pantorba 1955, pp. 94–5, no. 35; Soehner 1963, pp. 195–9; Camón Aznar 1964, vol. I, p. 367; Brown 1986, p. 52; Madrid 1990, pp. 118–19, no. 14, López-Rey 1996, vol. II, pp. 120–1, no. 50

Though one of the finest likenesses captured by Velázquez, we do not know the identity of this handsome young courtier, nor the purpose of this unfinished work. Its half-length format suggests that it was intended as a formal portrait, but the pose and the characterisation set it apart. The frankness of the gaze, enigmatic though it may be, and the slight tilt of the head, give a casual aura, as does the hand on the hip. Animating and lending drama to his expression, the strong light casts shadows that accentuate his long, sinuous nose and even partially cover his piercing eyes, intensifying the focus conveyed by the catch lights.

The head is so present and alive that it seems fully finished, but the body is only filled in broadly. The hand on the sword and the right side of the collar are broadly sketched with just a few quick strokes. The other hand is also not resolved, but Velázquez was clearly trying a different, more dynamic and less formal pose from other contemporary portraits.

This is one of a small group of portraits that Velázquez made of his social peers at court. This must be deduced wholly from the attitude of this portrait, but two others can be identified with certainty: *Juan Mateos*, the Master of the Hunt (fig. 99), and *Juan Martínez Montañés* (fig. 50), the Sevillian sculptor, both colleagues and perhaps friends of the artist. As Brown as pointed out, these portraits and *A Little Girl* (Hispanic Society of America, New York) are also unfinished, which might indicate that they were created as tokens of friendship with no requirement that they be completed. For Velázquez, such likenesses provided the opportunity to explore portraiture beyond the strictures of decorum required in the presentation of noble subjects. A similar sense of personality is revealed in another portrait, also seemingly of one of Velázquez's equals, now at Apsley House (cat. 29), painted at least a decade later.

Pantorba suggested that the painting might represent Juan Fonseca, whose portrait by Velázquez was used to demonstrate Velázquez's excellence to the king, but the age of the sitter at the presumed time of execution contradicts this. Pemán identified the painting as a self portrait based on comparison with the supposed *Self-Portrait* (Pinacoteca Capitolina, Rome), but this suggestion has not met with acceptance because the man simply does not resemble Velázquez.[1]

Generally, critics have dated the painting to the last half of the 1620s mainly because of the strong shadow cast by the nose, which was a feature of his portraits of this time, such as the *Infante Don Carlos* (Museo Nacional del Prado, Madrid). This dating is perhaps confirmed by the brown ground, which would seem to preclude it having been made after Velázquez returned from Italy, though some have placed this painting in that period.

This painting offers an excellent demonstration of Velázquez's working method. The broad indication of the left hand and the inner part of the collar allow us to see how he established position and form by sketching directly on the canvas with a brush and fluid paint. This sort of sketching presumably underlies most of his paintings of this period.[2] The hand on the hip shows how he would hold areas in reserve, working around them so that the tone of the ground could be used whenever desired in creating form. Although the body seems only generally indicated, a pentimento around the right shoulder indicates that he was already revising to achieve just the right contour and, in this case, give torsion to the figure. The background colour is very lightly applied. As was his custom, Velázquez used the area at right to wipe his brush so that it was loaded with exactly the right amount of paint to achieve such delicate effects as the wisps of hair at his temple, the light moustache and goatee, and the highlights that give shape to his nose and lips. DC

1 César Pemán in *Varia Velazqueña* 1960, pp. 701–3.
2 See Keith in this volume, pp. 79–80.

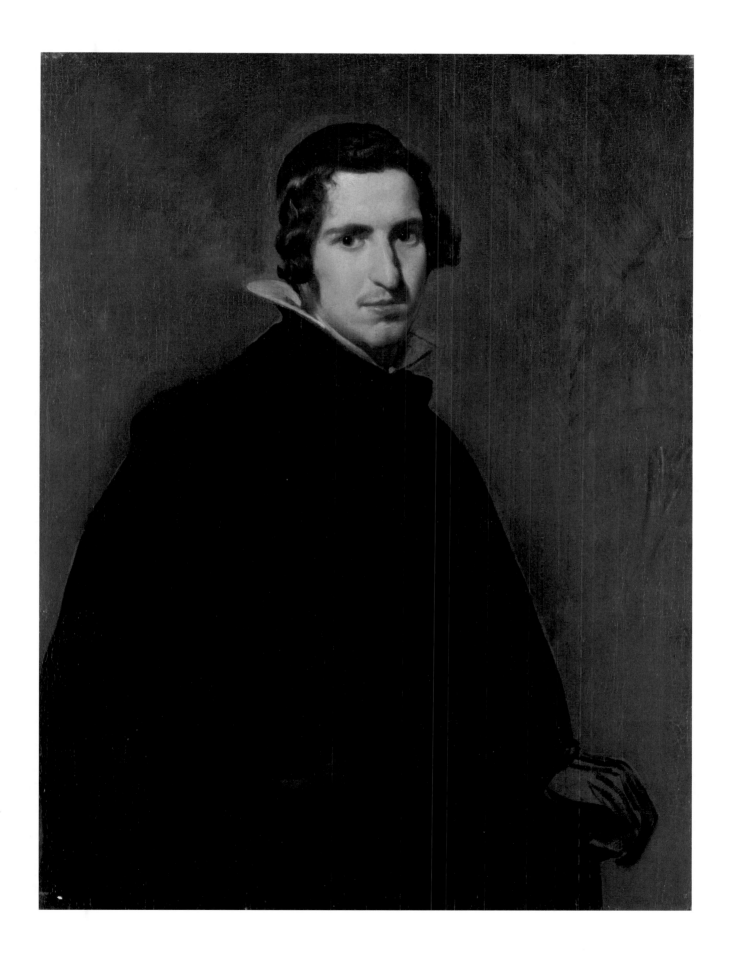

Don Pedro de Barberana y Aparregui, early 1630s

Oil on canvas, 198.1 × 111.4 cm
Kimbell Art Museum, Fort Worth, Texas (AP 1981.14)

PROVENANCE

Private collection, Spain, until 1950s;
Georges Wildenstein (d. 1963),
New York; (Wildenstein and Co.,
Inc., New York); purchased by
Kimbell Art Foundation, Fort Worth,
1981

ESSENTIAL BIBLIOGRAPHY

López-Rey 1972, pp. 61–70; Gudiol
1973, pp. 147–9, no. 87; López-Rey
1974, pp. 30–1; Jordan 1981, pp. 378–9;
Brown 1986, p. 141; Kimbell Art
Museum 1987, pp. 200–1; New York
1989, pp. 186–8, no. 24; López-Rey
1996, vol. II, p. 142, no. 57

This is the painting most recently attributed to Velázquez that has gained general acceptance. In 1972 López-Rey rediscovered the work in a private collection and published it as a portrait of an unidentified knight of Calatrava.[1] The following year Gudiol identified the sitter through an inscription found on the back of an old relining canvas, which bore the name and additional biographical information.[2]

Pedro de Barberana y Aparregui (1579–1649), a wealthy landowner of noble origin, held a number of offices for the Spanish crown: he was the governor of his native town of Briones, Rioja, auditor of the royal accounts and, most importantly, one of the members of Philip IV's Privy Council.[3] On 14 October 1630, Barberana was made Knight of the Order of Calatrava.[4] Named after a fortified castle in southern Castile, this was the oldest of the four medieval military orders whose mission was to recapture and defend Spanish towns from the Moors.[5] When founded in 1158 the order consisted of Cistercian monks and lay brothers, but over time membership became a privilege of the Spanish aristocracy, and was granted on the basis of a knight's social status. The emblem of the order, a red Greek cross with each arm ending in a fleur-de-lis, features prominently on Barberana's doublet and cape.[6] The portrait was probably commissioned to celebrate his admittance to the order, but as Velázquez was in Italy at this time, it is likely that it was painted shortly after his return to court in January 1631.[7]

Arguably the artist's greatest achievement is the three-dimensional rendering of the figure, attained through the three-quarter view, an outstanding definition of volume and, in particular, the foreshortening of the emblem's arms (both on Barberana's chest and on his cape) and the modelling of the left hand, the knuckles nearly touching the canvas.[8] In Gudiol's words, this is 'a work of incomparable realism, so much so that the sensation of life emanating from the figure is actually disturbing'.[9] The assured stance and stern, direct gaze – with the raised left eyebrow – convey a strong psychological presence, while the red nose, five o'clock shadow and high forehead – with a wisp of hair floating above – give a faithful rendering of the man's features.

In contrast to the portrait of *Don Diego del Corral* (Museo Nacional del Prado, Madrid), here the artist decides to concentrate solely on the human figure, avoiding any distracting object in the background. The brownish, empty background is interrupted only by the darker tone of Barberana's shadow on the floor and the lighter hue of the random strokes on the wall; these were caused by the painter cleaning his brush, or trying new colours but, as in many of his works, they seem to add immediacy to the picture. Velázquez overcomes the constraints of a sombre palette by introducing a variety of nuances to the black satin of the dress.

The technical 'tricks' used by Velázquez in *Don Pedro de Barberana y Aparregui* were not intended as a mere display of artistic virtuosity; instead they show the painter's complete mastery of the art of portraiture, and his ability to turn a formal, commissioned portrait – a potentially crippling subject for an artist – into a daring exercise. SDN

1 López-Rey 1972, pp. 61–70.
2 Gudiol 1973, pp. 147–9, no. 87. See full inscription in Jordan 1981, p. 378.
3 Kimbell Art Museum 1987, p. 200.
4 López-Rey 1974, pp. 30–1.
5 In 1147 the King of Castile, Alfonso VII, recovered the fortress of Calatrava from the Moors and, after the Templars abandoned the city, offered it to any knight who would be prepared to defend it. The Cistercian abbot Ramon Sierra – advised by a monk named Diego Velázquez – accepted the task and founded the Order of Calatrava in 1158.
6 This cross has been previously confused with that of the Order of Santiago, as worn by Velázquez in *Las Meninas* and in the *Portrait of Francisco de Quevedo* (copy of a lost original, Instituto de Valencia de Don Juan, Madrid). See López-Rey 1978, p. 71.
7 López-Rey dates the picture to the early 1630s through stylistic similarities with *Don Diego del Corral* and *Doña Antonia de Ipeñarrieta*, both in the Prado. He also argues further that the similarity between Barberana and an officer in *The Surrender of Breda* (fig. 22) is such that 'the face of *A Knight of Calatrava* is a starting point for the representation of the Spanish officer.' López-Rey 1972, pp. 61–3.
8 The lighter tones of brown around the head and left shoulder reveal changes in the figure's contours.
9 Gudiol 1973, pp. 147–9, no. 87.

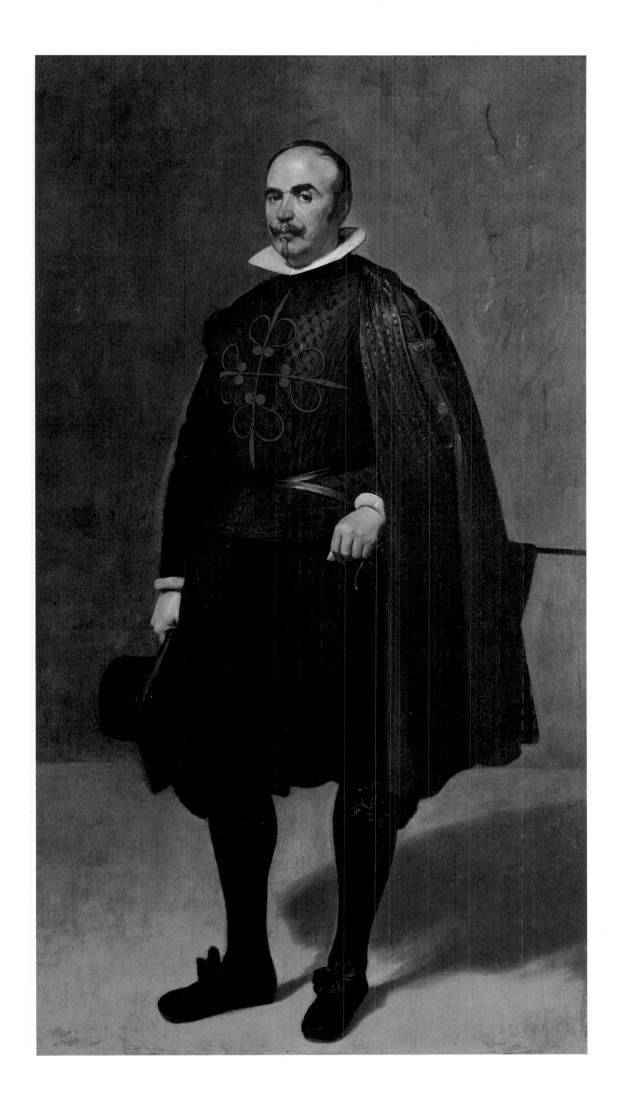

Infante Baltasar Carlos with a Dwarf, 1631–2

Oil on canvas, 128 × 101.9 cm
Museum of Fine Arts, Boston
Henry Lillie Pierce Fund (01.104)

PROVENANCE

Castle Howard, Earls of Carlisle
(acquired in Italy in the mid-
eighteenth century); Museum of
Fine Arts, Boston (since 1901)

ESSENTIAL BIBLIOGRAPHY

Camón Aznar 1964, pp. 437–40;
Brown 1986, pp. 82–3; New York
1989, pp. 166–70, no. 21; López-Rey
1996, vol. I, p. 84; vol. II, pp. 122–4,
no. 51; Wind 1998, pp. 73–7

This charming painting is thought to be the first in a series of portraits Velázquez made of Baltasar Carlos, son of Philip IV and Isabella of Bourbon. The birth of the long-awaited heir to the throne, on 17 October 1629, was received at court with jubilant celebrations. His untimely death at the age of sixteen, while on a military campaign with his father in Zaragoza, was not only a deep personal shock for the Spanish king, but also the beginning of a dynastic crisis.

Standing regally in the centre of the composition, the Infante is shown wearing a lavishly embroidered costume, his right hand gripping the baton of command and his left holding his sword hilt. Before him a dwarf, painted close to the onlooker, turns his head backwards, perhaps in a restless attempt to get a view of his master. Scholars are divided as to the identity of the young prince's companion: according to tradition, he was Francisco Lezcano, also known as El Niño de Vallecas, who would be immortalised in Velázquez's famous portrait (cat. 34).[1] However, official documents of the Royal Palace state that Lezcano did not enter the prince's service until 1634, when Baltasar was five years old.[2] Moreover, one cannot exclude the possibility that the dwarf is female, as suggested by the dress and bead necklace.[3]

This is the first time that Velázquez painted a dwarf, a subject he would return to numerous times in his career. More importantly, this is the only instance, aside from cat. 27 and Las Meninas, in which the artist depicted a royal sitter with this type of courtier. Velázquez stressed the authority of Baltasar Carlos by placing him on a raised step over his attendant. The prince's gorget (an armoured collar), sword, and red sash – the attributes of a captain-general – are indications of his future military powers as king of Spain. The dwarf is given the toys, a rattle and apple, allusions to the royal sceptre and orb.[4] His spontaneity counterbalances the stiffness of his master, and humanises an otherwise formal image.

The clean flesh tones of both faces stand out against the deep reds of the royal apartment: the velvet curtain drawn across the background, the soft red cushion on which sits a plumed hat, and the precious Persian carpet. Velázquez's newly acquired taste for vivid colours has rightly been linked to his trip to Italy of 1630–1, where he absorbed the lessons of the great Venetian colourists of the sixteenth century.[5]

The date of Infante Baltasar Carlos with a Dwarf is not resolved. The fragmentary inscription on the red curtain on the right (AETATIS AN … MENS 4) cannot be taken as evidence that, as was once generally believed, the prince was one year and four months old, dating the picture to February–March 1631.[6] The portrait could in fact commemorate the oath of allegiance sworn by the nobles of Castile to the heir to the throne the following year on 7 March 1632.[7] The debate is complicated further by a depiction of Baltasar Carlos in the Wallace Collection (fig. 17), in which the prince is shown in a similar pose and costume, but looks older and no longer has his child-dwarf attendant (most scholars believed this was the portrait made to celebrate the 1632 ceremony). Whatever the circumstances surrounding the production of the two pictures, it seems clear that, following the artist's experimentation in Infante Baltasar Carlos with a Dwarf, Philip IV demanded a more traditional portrait of his son from Velázquez. SDN

1 Moreno Villa 1939, pp. 107–9.
2 Moreno Villa 1939, p. 108.
3 Camón Aznar 1964, p. 437.
4 See Brown and Elliott 1980, pp. 253–4.
5 The painting was wrongly attributed to Correggio until Waagen 1854, vol. III, p. 322, no. 33: 'The portrait of two children in elegant dress, said to be a young Duke of Parma and his dwarf, and ascribed to Correggio. In my opinion … an admirable picture by Velázquez.'
6 This was shortly after Velázquez returned from his first trip to Italy, as in Pacheco's account. Pacheco 1649, Arte I, ch. 8.
7 Brown and Elliott 1980, pp. 253–4.

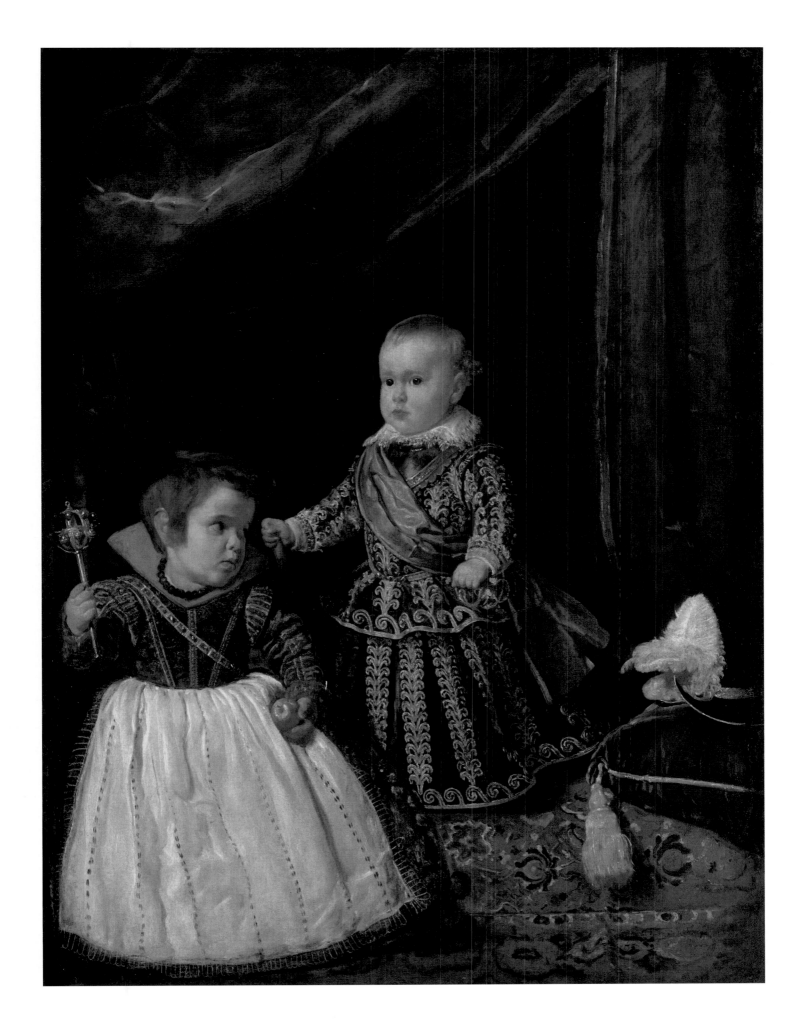

Philip IV of Spain in Brown and Silver, probably 1632

Oil on canvas, 195 × 110 cm
The National Gallery, London (NG 1129)
Signed on the petition the king holds in his right hand:
Señor. / Diego Velasqūz. / Pintor de V. Mg
(Sire, Diego Velázquez, Painter to Your Majesty)

PROVENANCE

Library of the Monastery of San
Lorenzo, El Escorial, from at least
about 1650 and possibly from the
time of its execution in the early
1630s; removed in November 1809
on the orders of Joseph Bonaparte
and given to General Augustin
Desolle (died 1828) in January 1810;
purchased from the latter's daughter
by the dealer Samuel Woodburn, and
sold to William Beckford; on Beckford's
death in 1844 the painting passed
to his son-in-law, the 10th Duke of
Hamilton, from whom purchased
by the National Gallery in 1882

ESSENTIAL BIBLIOGRAPHY

MacLaren and Braham 1970,
pp. 114–19; López-Rey 1999, pp. 124–7,
no. 52; Brown in Madrid 1999–2000,
pp. 126–9, no. 5

The painting, which has never been lined, is one of the best-preserved works by Velázquez outside the Prado. At some point in its history the canvas was transferred from its original stretcher (which measured 195 × 110 cm) and mounted on a smaller one (191.5 × 105.5 cm). At a much later date the painting was increased in size, with strips of canvas on all four sides, to the present dimensions and placed on yet another (its current) stretcher. The impastoed embroidery on the king's costume is beautifully preserved and the transparent glazes in the face, curtain and table covering are largely intact. Several pentimenti are visible, notably the lowering of the border of the cloak and the earlier positions of the right leg and left foot.

In general terms the image conforms to the portrait type established at the Spanish court several generations earlier by Alonso Sánchez Coello, which was itself an amalgam of the models of Titian and Anthonis Mor. Velázquez's contribution to the evolution of the type involved the stripping away of the remaining vestiges of regal paraphernalia in accordance with the notion that there is no more effective expression of majesty than the royal person himself. Philip IV stands in front of a plain wooden table draped with red velvet; his head is uncovered and he fixes his gaze impassively on the viewer. He is shown much as he appeared to foreign envoys when he gave audience in the Alcázar, immobile and inexpressive. He wears the badge of the Order of the Golden Fleece, of which he was the Grand Master, and rests his left hand on the hilt of his sword. Behind him there is a fall of red curtain trimmed in gold. None of these elements is in itself an attribute of royalty, but the image allows for no doubt as to the regal identity of the sitter.

Two features stand out: the first is the signed petition the king holds in his right hand, a motif which Velázquez appears to have introduced into royal portraiture and which he had already employed in the Prado portrait of the young Philip IV (fig. 13). Its presence here alludes to the attention paid by the king to official papers (generating com- parison with his grandfather, Philip II, who on account of this virtue became known – without irony – as 'el rey papelista'), as well as to his personal concern for his subjects' needs. The petition has the form of address that the king had imposed in a decree of 1623: 'We request and require that when writing to us, nothing more should be placed at the top of the letter or paper than "*Señor*"' (*Capítulos de Reformación*, Madrid 1623, p. 10v), and it bears the name of Velázquez, thereby acting as a vehicle for the natural inclusion of the artist's signature in the painting, as well as identifying his position as 'Painter to Your Majesty', although by this date he had already been appointed Gentleman of the Bedchamber. The petition declares the artist's allegiance to his monarch, but it also suggests that Velázquez's petition (whether for payment or advancement at court) will indeed be heard by the king. The painter rarely signed his paintings, seemingly putting his name (or leaving an unsigned fictive *cartellino*, which was a form of 'signature' in some paintings of the 1630s) only on those that he considered especially significant or successful.

The second notable feature is the extraordinarily rich costume that the king wears. His suit, composed of a sleeveless jacket and knee-length breeches, is of purplish-brown velvet (now faded to brown) embroidered in silver thread with a regular pattern of parallel bars and floral motifs. The white sleeves, probably silk, are embroidered with a dark thread and belong to an under garment. His short cloak appears to be edged with tufts of feathers like those that adorn his hat and he wears cream hose and chamois leather shoes of remarkable softness. The silver embroidery is painted with an audacious freedom using a dabbing impasto technique to convey the glint and relief of metal thread. The splendour and richness of the costume suggest (as Enriqueta Harris first observed) that the portrait may be commemorating the particular occasion on which the king wore it.[1] This was not uncommon in Spanish royal portraiture: Juan Pantoja de la Cruz (1553–1608) painted a portrait of Margaret of Austria with the dress she wore when she was married, and the celebrated portrait by Van Dyck of Philip IV's brother, the Cardinal-Infante Ferdinand (Museo del Prado, Madrid), as well as Velázquez's own so-called 'Fraga Philip' (fig. 7), show their respective sitters in the outfits they wore on particular occasions.

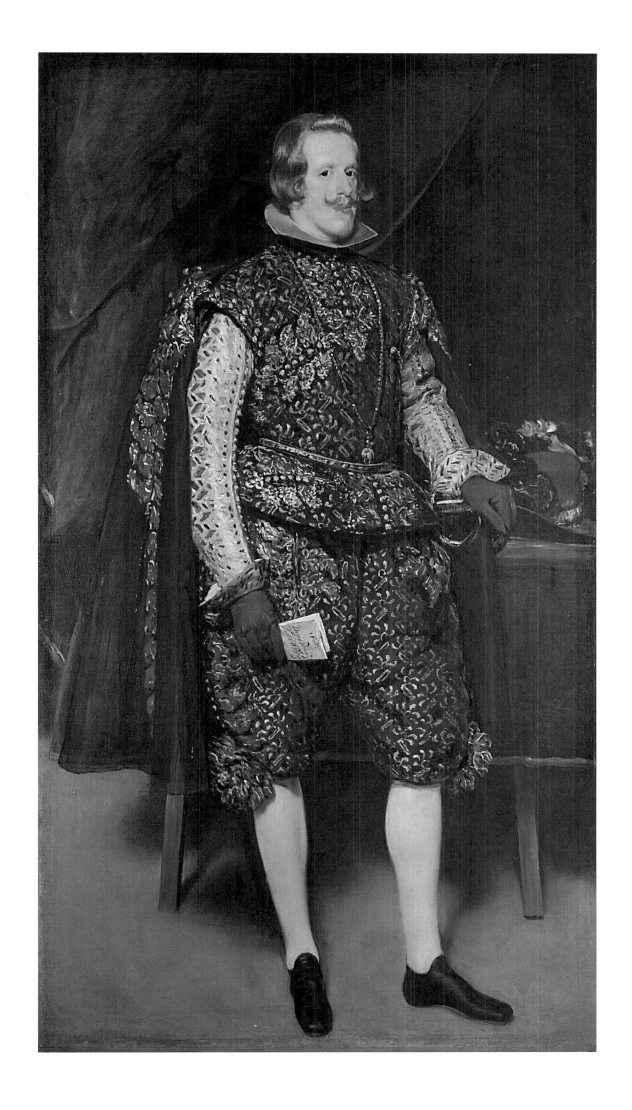

The portrait is usually dated to shortly after Velázquez's return from Italy in early 1631. The king had been portrayed several times by Velázquez between 1623 and 1628, and then by Rubens who was in Madrid between September 1628 and June 1629. Philip's physical development from youth to manhood, which spanned the second half of the 1620s, meant that during the first decade of his reign no portrait image of the king was definitive for very long, and Pacheco records that no portrait was executed during Velázquez's absence in Italy. A new prototype was required for at least two reasons. Firstly, the king's appearance had changed. A comparison between this portrait and those that precede it shows that he had lost weight around his jowls and that his moustache (of which a trace is visible in Rubens's portraits) had grown to a respectable length and could be curled up; he even sported a little beard. Secondly, he had produced a male heir. Baltasar Carlos was born on 17 October 1629 (see cats 25 and 27), and since he was healthy, unlike the previous children, five girls, none of whom had survived more than twenty months, the succession seemed secure and the swearing of the oath of allegiance to the crown prince by the Cortes of Castile could be prepared.

This was undoubtedly one of the most important ceremonies of Philip's reign and took place amid great splendour in the church of San Jerónimo el Real in Madrid on 7 March 1632. In one account of the event, the description of the king's apparel runs as follows: Philip was 'dressed in smooth dark brown velvet, embroidered with gold thread, all adorned with motifs in the form of Fs, a cape trimmed with embroidered bands and an edging made of tufts of feathers, black shoes, adornments and hatband of rubies, a gold and enamelled sword to match.'[2] Although the description does not match exactly, if one assumes a certain licence either on the writer's or on the painter's part, the similarity is intriguing. The dating of the work to the early 1630s, based on the appearance of the king and on stylistic evidence, would be compatible with a portrait commissioned to mark this significant event. The portrait was known to have been in the Escorial Library from before 1764[3] but a recently published anonymous

manuscript report on the paintings in the Escorial in the Biblioteca da Ajuda in Lisbon, dating from between 1649 and 1656, indicates that it was there from much earlier and raises the possibility that it might have been conceived for that location.[4] Interestingly, in the Library it formed part of a group of four portraits that included the king's three predecessors, Charles V, Philip II and Philip III (all painted by Pantoja de la Cruz), making up a dynastic series. If Velázquez's portrait does indeed commemorate the oath of allegiance to his heir, one can conceive of it being part of a pictorial series that marked the continuity of the Habsburg line.

Presumably the painting was based on one or more sittings given by the king (who seems actually to have sat to Velázquez relatively few times). The head is the prototype for at least one other autograph portrait, the *Philip IV as a Hunter* (cat. 31), and for a three-quarter-length portrait painted by Velázquez with studio participation in the Kunsthistorisches Museum in Vienna (probably the work for which Velázquez received a payment in September 1632), which itself spawned a sub group of bust portraits not recorded in the literature. The likeness of the king in the National Gallery painting was reproduced in the bookplates of several Madrid publications dating from the 1630s to the 1650s by the engravers Herman Panneels and Juan de Noort.

The painting was always held in high regard and when in 1810 Joseph Bonaparte decided to donate it to one of his most loyal generals, Augustin Desolle, an unidentified Spanish civil servant filed a plea to the king requesting that an alternative work should be chosen because it would be wrong to 'deprive oneself of this work since it is the best portrait in Spain of the monarch who most promoted the fine arts, to whom the capital owes its culture, its library and theatres, and to whom Velázquez owed the great honours he received.'[5] Had he been heard the painting would not be where it is today. G F

1 Harris 1982, p. 87.
2 A. Hurtado de Mendoza, *Convocación de las Cortes de Castilla … y juramento del Principe Señor Don Baltasar Carlos*, Madrid 1632.
3 See Ximénes 1764, p. 206.
4 See Bouza Álvarez 2000 and Bassegoda 2002, p. 329.
5 Quoted by Brown in Madrid 1999–2000, p. 129.

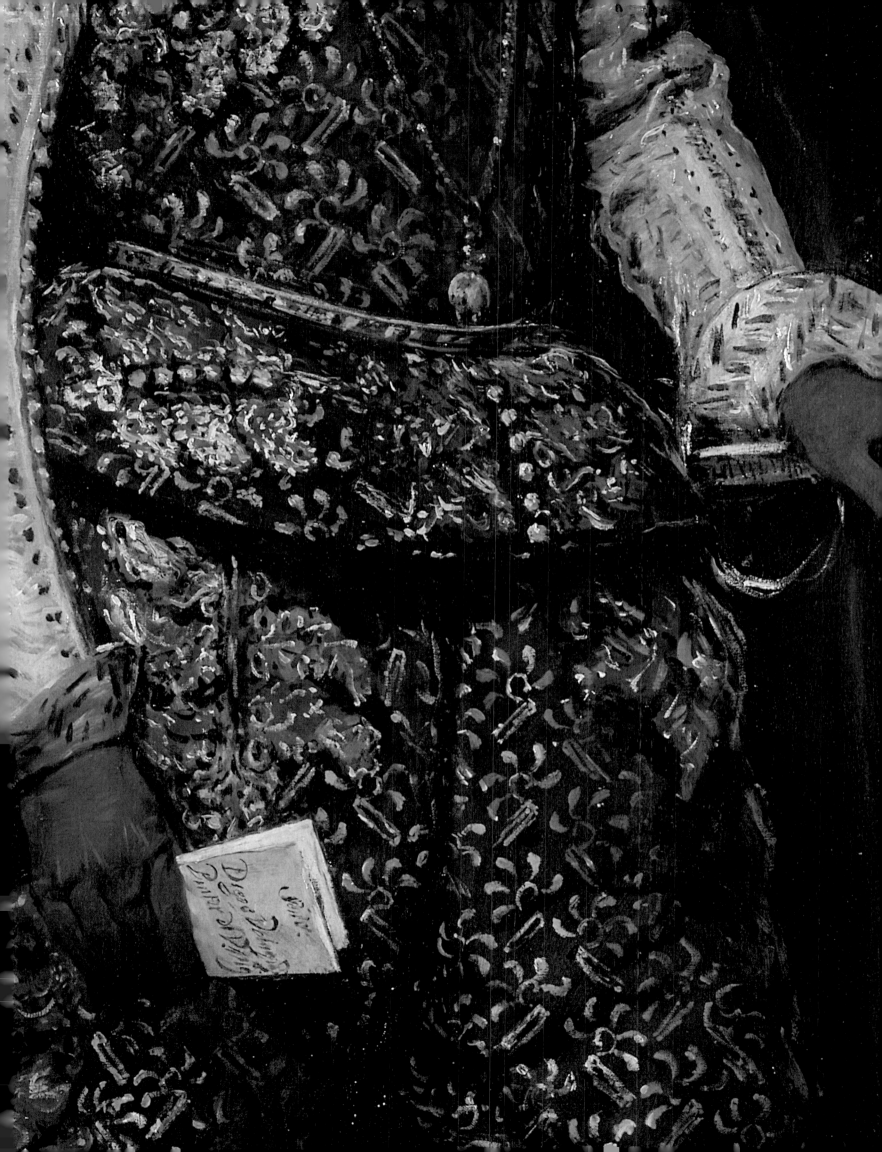

Infante Baltasar Carlos on Horseback, 1634–5

Oil on canvas, 209 × 173 cm
Museo Nacional del Prado, Madrid (1180)

PROVENANCE

Palacio Real del Buen Retiro, Madrid; Palacio Real Nuevo, Madrid (first recorded in 1772); Museo del Prado, Madrid (since 1819)

ESSENTIAL BIBLIOGRAPHY

Palomino 1724 (translation in Harris 1982, appendix II, p. 205); Du Gué Trapier 1948, pp. 207–10; Camón-Aznar 1964, pp. 543–8; Brown 1986, p. 116; Madrid 1990, pp. 240–4, no. 40; López-Rey 1996, vol. I, p. 101; vol. II, p. 178, no. 72; Portús in Madrid 2005, pp. 120–1, no. 13

This is one of five royal equestrian portraits that hung in the Salón de Reinos (Hall of Realms) in the Buen Retiro Palace. The decorative scheme of the Salón, completed in April 1635, was a highly ambitious programme of political propaganda: it consisted of two long walls hung with twelve large battle scenes, depicting celebrated victories under Philip IV;[1] these were interspersed between ten pictures representing the Labours of Hercules, painted by Francisco de Zubarán (see fig. 6). On the two short walls at each end of the room were Velázquez's equestrian portraits of Philip III, Margaret of Austria (east wall), and Philip IV, Isabella of Bourbon, and the Infante Baltasar Carlos (west wall).[2]

Infante Baltasar Carlos on Horseback hung above a door between the portraits of the prince's parents (see reconstruction, fig. 92).[3] Like his father (fig. 20), the six-year-old prince is seen confidently mastering a rearing horse, in the guise of a military leader: right hand raising the baton of command, sword attached to his hip and sash of the captain-general across his chest. Although some of these insignia also appear in other portraits of the Infante (see cats 23 and 27), the strongly political dimension of the Salón de Reinos endows them with an even greater significance. The prince's horse is, in the words of Antonio

Palomino, 'galloping with great impetus and speed as if, impatient with pride and breathing fire, he is anxiously urging on the battle and anticipating his master's victory'.[4] In contrast to the docile mounts of the two queens, the prince's mare has a fiery energy and is clearly intended as a symbol of youth. Baltasar is represented not only as an accomplished rider, but also a strong ruler.[5] Velázquez's choice of landscape is also significant: the beautifully painted hills and mountains in the background show the northernmost area of El Pardo, the grounds of the royal hunt since the fifteenth century. Portús identifies the snow-covered peaks on the right with the Maliciosa and Cabeza de Hierro (part of the Guadarrama range), and those on the left with the Hoyo mountains.[6]

Scholars believe that only this painting and *Philip IV on Horseback* (fig. 20) are entirely by Velázquez's hand, while the three other equestrian pictures in the Salón were executed at least in part by workshop assistants. *Infante Baltasar Carlos on Horseback* possesses a vitality and energy absent from the other portraits. Its sense of movement is primarily conveyed by the three-quarter angle of the horse, which gives the illusion of animal and prince advancing forward.[7] To a contemporary viewer this effect would have appeared even more pronounced: a border of about six centimetres that seems to have been added to the canvas[8] indicates that the landscape was originally smaller, with the horse and rider closer to the picture plane. As Lafuente points out, the exaggerated curve of the horse's belly might be explained by a deliberate calculation that the portrait would have been seen from below.[9] Velázquez may have also chosen to compensate for the viewer's distance from the picture by using a particularly vibrant palette, seen especially in the dazzling pink sash, the shimmering gold dress, and the luminous blue sky. His astounding painting technique ranges from the thick impasto of the costume's embroidery to the loose, fluid strokes of the landscape. The free handling of paint in the background perhaps led the author of the 1828 Prado catalogue to state that the picture was painted without a preparatory sketch.[10] However, a work described as '*Prince our lord on Horseback, sketched in colours*' in the inventory drawn

92.
Reconstruction of the west wall of the Hall of Realms after Carmen Blasco (fig. 6).

92

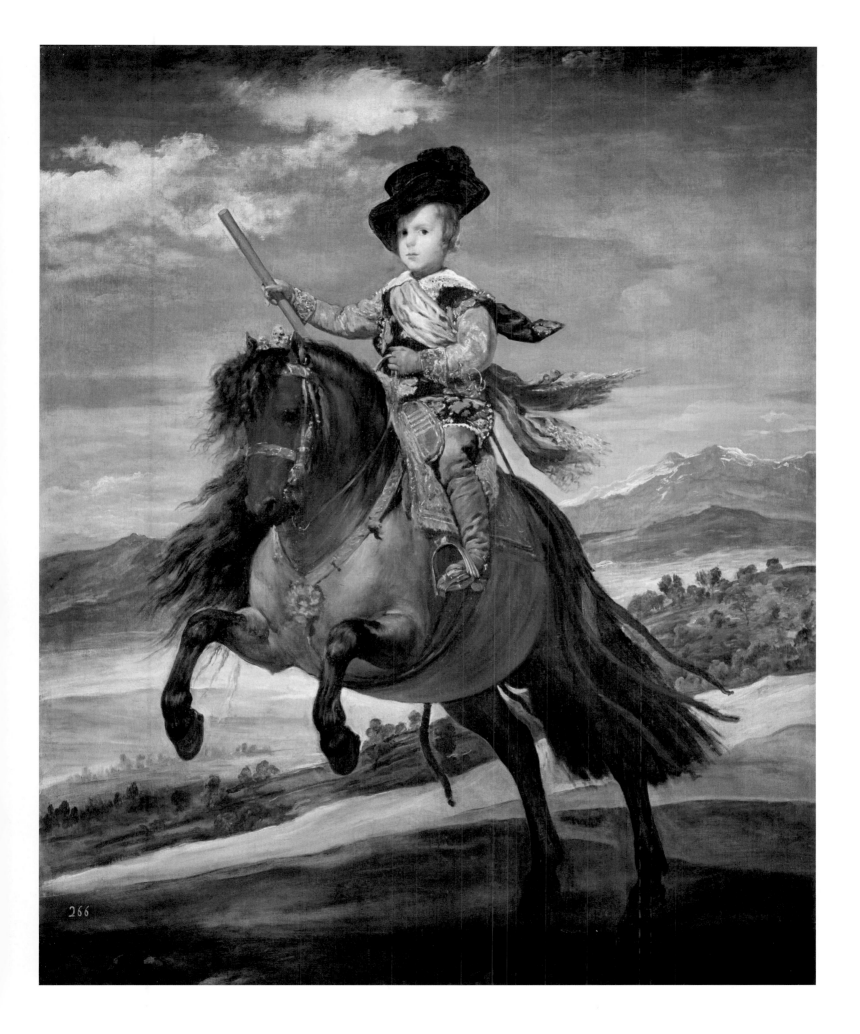

266

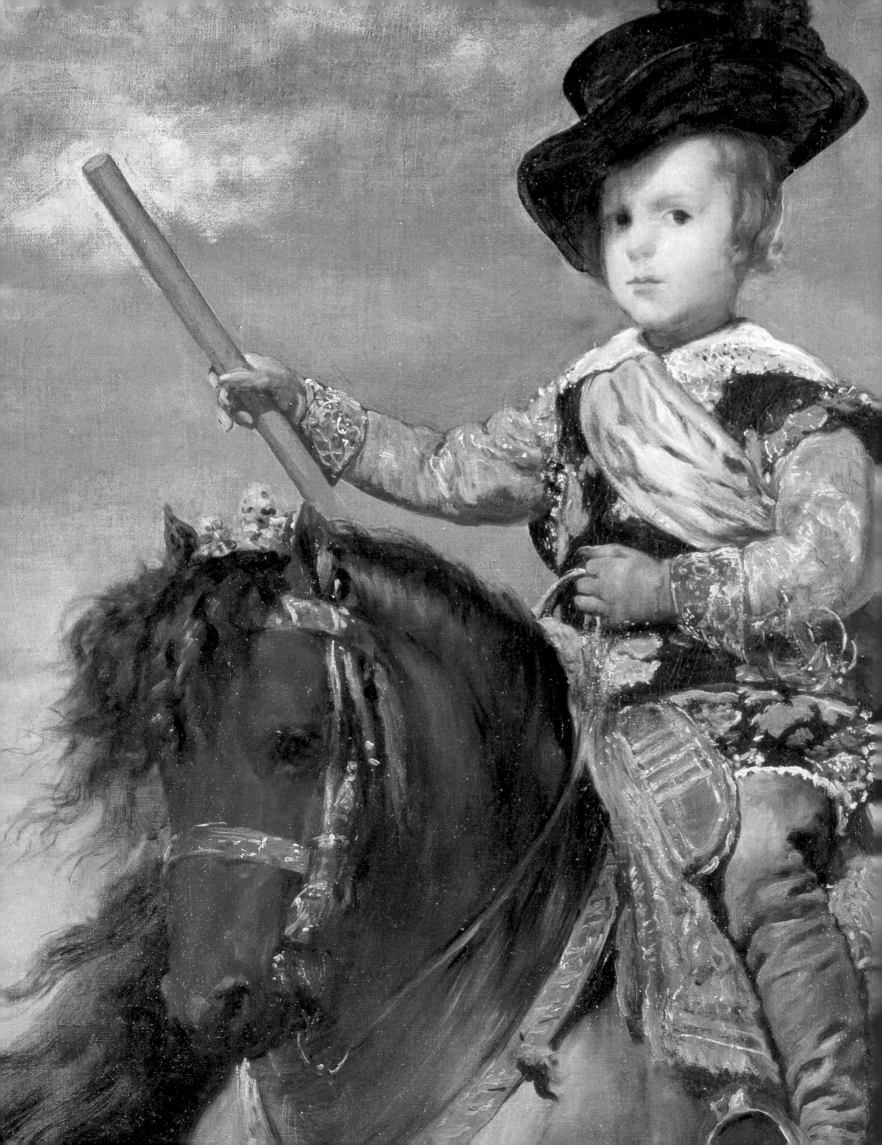

up at the artist's death points to the possibility that Velázquez might have made a preliminary study.[11]

This portrait would have left seventeenth-century visitors entirely persuaded as to the longevity of the Spanish reign and the continuity of the Habsburg dynasty. But the promise of power and glory Velázquez so successfully conveyed in this magnificent painting would never be realised: Baltasar lived only to the age of sixteen, dying on a military campaign with his father in 1646. SDN

1 Of these Velazquez painted *The Surrender of Breda* (fig. 22).
2 Brown and Elliott place this decorative cycle within the tradition of the Hall of Princely Virtue. This was the official room which, since the Renaissance, artists decorated with illustrations of events or ideas demonstrating the ruler's virtues. Brown and Elliott 1980, pp. 147–56.
3 Scholars have proposed different reconstructions of the original installation of the Hall of Realms. For a detailed summary see Lopera in Madrid 2005, pp. 91–111.
4 Palomino 1724 (1982), vol. 3, ch. IV.
5 The rearing horse also appears in Titian's *Charles V on Horseback at Mühlberg* in the Prado (fig. 19). Velázquez would have seen this painting in the Alcázar and possibly used it as a model. This pose was frequently found in sixteenth- and seventeenth-century prints. See note 7.
6 Madrid 2005, p. 116, no. 11, and p. 120, no. 13. Portús observes that this setting is similar to the landscape of *Philip IV on Horseback* (fig. 20), but has more precise topographical references.
7 This exact angle appears in a print of *Nero on Horseback* by Antonio Tempesta, which has been identified as a source. Madrid 1990, p. 243, no. 40.
8 Except for the top, where there are two strips of added canvas: the lower one – starting just above the prince's hat – is thought to have been added by Velázquez, while the second strip was most probably added after the painter's death (possibly when the picture was moved to the new Royal Palace in the eighteenth century).
9 Lafuente Ferrari 1943, no. 65.
10 In other words 'a la primera vez', see Madrid 2000, p. 243, no. 40.
11 López-Rey 1996, vol. I, p. 236, no. 100. Of course it is virtually impossible to establish the author of this now-lost sketch.

Don Gaspar de Guzmán, Count-Duke of Olivares, about 1635–6

Oil on canvas, 127.6 × 104.1 cm
The Metropolitan Museum of Art, New York
Fletcher Fund, 1952 (52.125)

PROVENANCE

Colonel Lemotteux, Paris (by 1806; probably removed from Spain during the Peninsular War); sold for £15,000 to Elgin; Colonel Thomas Bruce, 7th Earl of Elgin and 11th Earl of Kincardine, Broomhall, Dunfermline, Fife (1806–41); Earls of Elgin and of Kincardine, Broomhall (1841–1917); Edward James Bruce, 10th Earl of Elgin and 14th Earl of Kincardine, Broomhall (1917–52); sold through Agnew's, London, to the Metropolitan Museum of Art, New York

ESSENTIAL BIBLIOGRAPHY

Justi 1889, p. 315; Waterhouse 1951, pp. 27–8, no. 37; Harris 1951, pp. 314, 317; Soria 1954, pp. 95, 98–9; Gerstenberg 1957, p. 102; Liedtke and Moffitt 1981, pp. 529, 532; Brown 1986, pp. 125–6; Moffitt 1988, pp. 207, 212; Gállego in New York 1990, pp. 154–9; López-Rey 1996, vol. II, p. 164

Everything in this image conveys the authority of the Count-Duke of Olivares, the most powerful figure at the Spanish court and Philip IV's favourite and *alter ego*.[1] He wears gleaming black armour with a sumptuous red sash, ensign of the captain-general, like the baton in his right hand. Velázquez captures the horse as it is performing a *levade*, raising its forelegs from the ground and tucking them inwards, while bending deeply on its hindquarters. The *levade* is the peak of equestrian ability, which demands the utmost skill and concentration from both horse and rider. Olivares is shown as a confident, brave commander, ready to lead his troops to join the battle roaring in the distance.

This painting is a reduced replica, with variations, of the equestrian portrait of Olivares in the Prado (fig. 21), the most magnificent of Velázquez's portraits of Philip IV's first minister.[2] It has been suggested that one of the figures in the *Relief of Breisach*, painted by Jusepe Leonardo for the Buen Retiro Palace by April 1635, is based on Velázquez's painting in the Prado. If this is true, the latter should be dated before 1635. However, the conventional pose of horse and rider in the two pictures might derive from a common source.[3]

Although the circumstances of its commission are unknown, this powerful equestrian portrait has sometimes been associated with Olivares' greatest triumph, Spain's victory over France at Fuenterrabia in 1638, to which the battle scene in the background might refer. However, most critics argue that in this painting Velázquez portrayed the Count-Duke as the architect of Philip IV's military success, rather than as a victorious general during a specific battle.

Olivares' portrait in the Prado is related to the series of equestrian portraits of kings and queens painted by Velázquez for the Salón de Reinos of the Buen Retiro Palace. It is stylistically very close to *Philip IV* (fig. 20) and *Prince Baltasar Carlos on Horseback* (cat. 25), both dateable to around 1634–6. In contrast to these two rather static images, Velázquez creates a more dynamic composition here, foreshortening the three-quarter profile of the Count-Duke, who turns his confident gaze to the viewer. This bold representation may have been motivated by Velázquez's gratitude to Olivares, who had always favoured him, but also possibly by the Count-Duke's notorious vanity.[4]

Of the different versions of this portrait, the present replica is the closest to Velázquez. Some scholars have ascribed it to Velázquez, considering it either a study for the painting in the Prado or an autograph replica.[5] Others attribute it to Juan Bautista Martínez del Mazo, including, among others, López-Rey, who identified this portrait with one of identical size listed in the 1651 inventory of the 6th Marquis of Eliche.[6] GM

1 The political meaning of Olivares' equestrian portrait has been thoroughly investigated by Liedtke and Moffitt 1981 and Moffitt 1988.
2 The variations are in the colour of the horse (white rather than chestnut, and with a gala beribboned crupper), and in the tree, the foreground, the sky and the battle scene in the background.
3 Possible sources are the *Julius Caesar* from the *Twelve Caesars* by Antonio Tempesta (1596), the *Otho* from the *Twelve Caesars* by Stradanus (about 1590) and the emblem 35, 'In Adulari Nescientem' from Andrea Alciati's *Emblematum Liber* (1631), see Liedtke and Moffitt 1981, p. 532, and Moffitt 1988, pp. 212–15.
4 Pérez Sanchez 2004, p. 168.
5 A summary of the different opinions is in New York 1990, pp. 154, 156 (entry by J. Gállego).
6 The entry reads: 'A painting on canvas of the portrait of the Count-Duke, in armour, with a baton in his hand, on a white horse, copy after Velázquez by the hand of Juan Bautista Mazo, one vara and a half square more or less', Pita Andrade 1952, p. 230, translated by López-Rey 1979, p. 354.

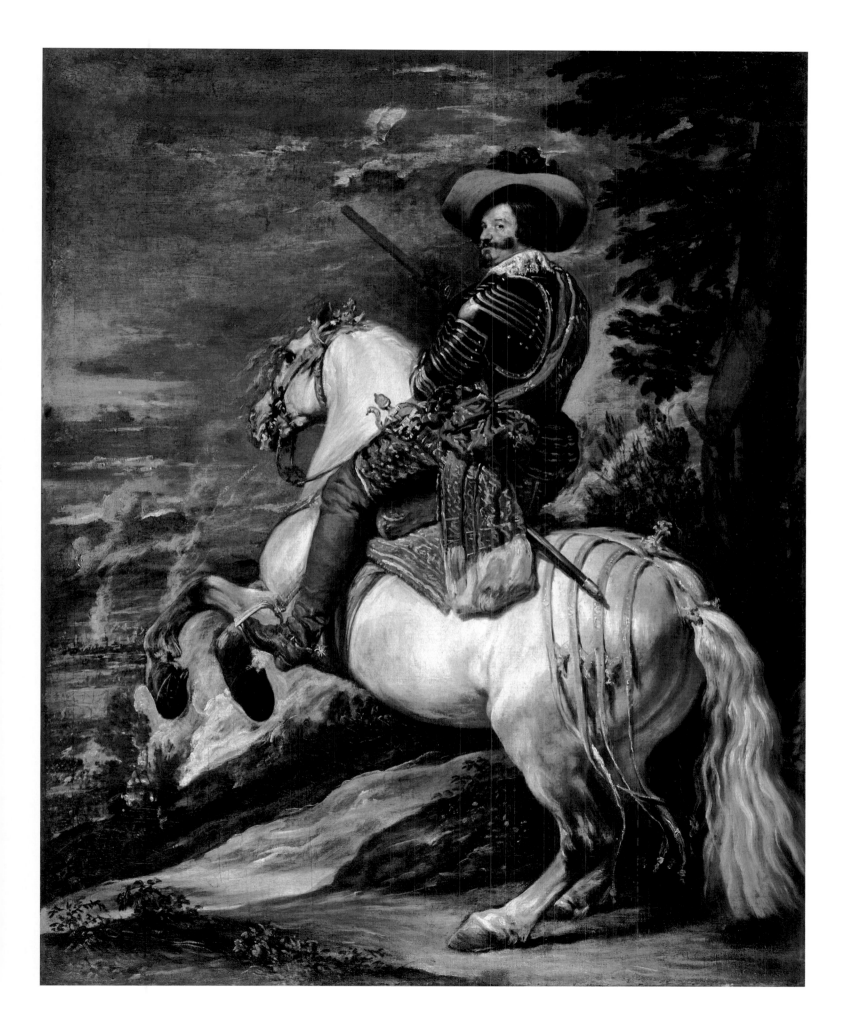

Infante Baltasar Carlos in the Riding School, 1636–9

Oil on canvas, 144.2 × 97 cm
Private collection

PROVENANCE

Cardinal Valenti Gonzaga, Rome;
Welbore Ellis Agar, London; Lord
Grosvenor, London (since 1806); by
descent to the Duke of Westminster

ESSENTIAL BIBLIOGRAPHY

Palomino 1724 (trans. in Harris 1982,
appendix II, p. 205); Levey 1971,
pp. 142–4; Harris 1976, pp. 266–75;
Harris 1982, pp. 99–103; Brown 1986,
p. 125; New York 1989, nos 23 and 41; López-Rey 1996,
vol. II, pp. 192–5, no. 78; Lopera in
Madrid 2005, pp. 75–7, no. 2

After completing *Infante Baltasar Carlos on Horseback* (cat. 25) for the Salon de Reinos of the Buen Retiro Palace, Velázquez set out to paint a less formal image of the Infante that would stress his mentoring by the Count-Duke of Olivares. Here he becomes part of a wider scene, giving the viewer a glimpse of life at the Spanish court. The daring juxtaposition of an 'official' pose with an informal setting led the eminent nineteenth-century scholar Karl Justi to state that this painting offered a foretaste of *Las Meninas*, thereby raising the status of this singular picture.[1]

The scene takes place in one of the courtyards of the Buen Retiro Palace. In the foreground, Baltasar Carlos is represented as an accomplished horseman, as he is about to run at the ring with the tilting lance that Alonso Martínez de Espinar, valet to the prince, is seen handing to the Count-Duke of Olivares. The man standing behind them with his hands clasped may be Juan Mateos, Master of the Hunt.[2] On the left edge of the canvas is an attendant dwarf, his pointing finger indicating the prince's mastery of the horse.[3] Of the sketchily painted figures watching the prince from the balcony, only the king and queen

can be easily distinguished. It has been suggested that the little girl on the right is the short-lived Infanta Maria Antonia,[4] but it is also possible that she is a dwarf. The woman standing between the monarchs has been identified as the king's sister[5] and also as the Countess of Olivares.[6]

Like *Infante Baltasar Carlos on Horseback*, this work acts as a manifesto on the prince's riding talents, incorporating a metaphor to his future grip on the reins of power. However, as Brown has rightly noted, 'this picture pays tribute to Olivares as mentor of kings'.[7] The ambitious Olivares, who earlier in his career had guided the young Philip IV in the art of government, was now trusted by the king with the education of the prince. Furthermore, it is significant that the Buen Retiro Palace, the brainchild of the Count-Duke, was chosen as a setting for this scene. The present picture appears therefore not only to be an exaltation of the heir to the throne, but also a subtle yet powerful statement about the political importance of the Count-Duke. It is most likely that it was made for Olivares, or a member of his family, probably between 1636 and 1639;[8] in 1647, a picture with this subject was recorded in the collection of Luis de Haro, nephew of the Count-Duke of Olivares.[9]

The painting is one of Velázquez's most extraordinary demonstrations of capturing likeness with great economy. The importance of the prince and his proximity to the viewer are indicated with dense paint application, but the rest of the work is very thinly painted. The features of Olivares and the others in the middle ground are barely defined, but the truly amazing renderings are of the king and queen, just a few strokes in each case, but they are completely recognisable, presaging *Las Meninas*. The unique status of the painting in Velázquez's oeuvre has led some scholars to question his authorship, pointing to his assistant, Juan Bautista del Mazo. Comparison with Mazo's figures in the *View of Zaragoza* (fig. 102) show that he did not possess the ability to paint these figures, nor is it possible that any other shop assistant achieved this masterly and unusual portrait of the court.[10]

The high quality of the *Riding School* is all the more apparent when compared to the version in the

93.
Studio of Velázquez
**Infante Baltasar Carlos in
the Riding School**, after 1636
Oil on canvas, 130 × 102 cm
The Wallace Collection, London

93

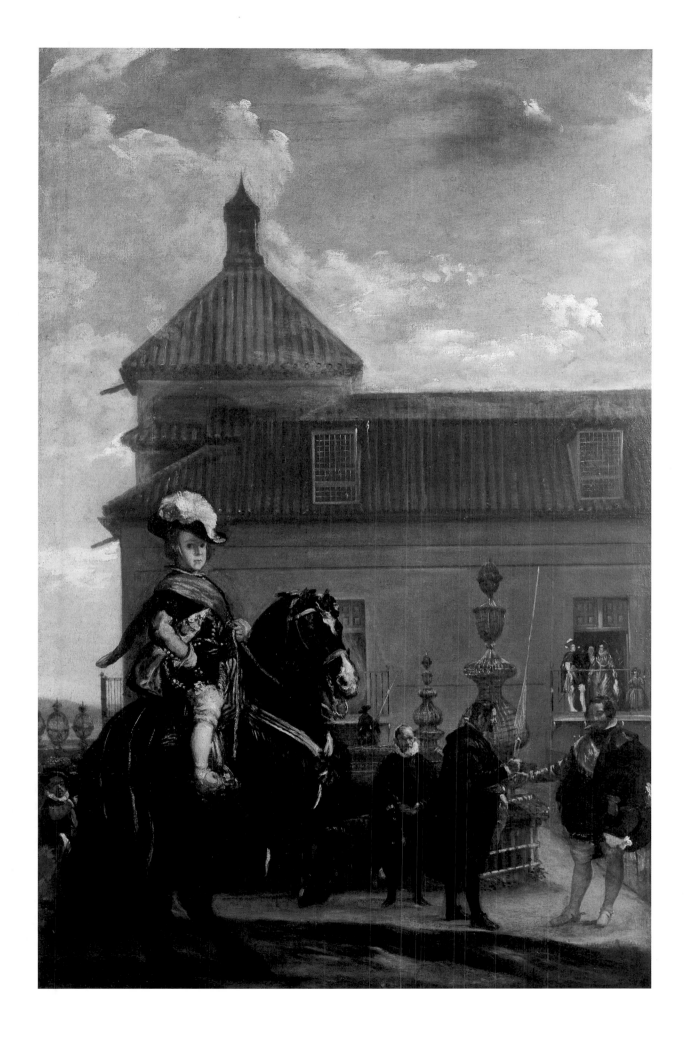

Wallace Collection, thought to be a workshop copy (fig. 93). Although that picture retains some of the liveliness of the Westminster painting, it is, as Harris perceptively observes, a 'shadow of the original':[11] apart from the colourfully dressed dwarf on the left, none of the sketchily painted figures in the background is recognisable. In fact, each of them seems to be the result of a single, quick brushstroke of black paint. Most importantly, the figure of Olivares, so crucial for the historical and political significance of the scene, has now disappeared, suggesting that this version was probably painted after his fall from power in 1643.[12] S D N

1 Justi (1953), p. 470.
2 Harris identified Juan Mateos on the basis of the engraved portrait in his *Origen y Dignidad de la Caça*, 1634, as well as the portrait in the Gemäldegalerie Alte Meister, Dresden (fig. 99). However, the sketchiness of the figure in the present painting does not allow a firm identification. The Prado *Portrait of Alonso Martiñéz de Espinar* from the studio of Velázquez provides a reliable image for the identification of the prince's valet. See Harris 1976, p. 271.
3 The dwarf bears a very close similarity to Sebastián de Morra who, however, is said to have entered the prince's service only in 1643 (Harris 1976, p. 271); according to Gallego, the dwarf may be Francisco Lezcano (cat. 34). See New York 1989, p. 184.
4 Maria Antonia died on 6 December 1636, about a month before her second birthday. Allende Salazar 1925, pp. 284–5.
5 Levey 1971, p. 142. The king's sister was a nun, and the figure in the painting appears to be wearing a black dress with a white veil.
6 Harris 1976, p. 271.
7 Brown 1986, p. 125.
8 Barbeito proposes a date of 1642 and Lopera dates it to 1639–40. Barbeito 1995, pp. 443–57, Lopera 2005, p. 76.
9 More precisely, it was in the inventory of the collection left by Doña Catalina, Luis de Haro's wife, on her death (Marqués del Saltillo 1953, pp. 233–4). This is very probably the same painting that appears in Panini's *Picture Gallery of Cardinal Valenti Gonzaga*, signed and dated in Rome in 1749. The large collection of the cardinal included five paintings attributed to Velázquez (see Olsen 1951, pp. 21–2 and 90–103). For further provenance history see Harris 1976, pp. 269–70.
10 Mayer and Gaya Nuño attribute the painting to Mazo (Mayer 1936, no. 267; Gaya Nuño 1960, *Varia Velazqueña* 1960, vol. I, pp. 475–6). According to López-Rey 'it is more likely to be a workshop painting' (López-Rey 1996, p. 195). For an attribution to Velázquez see, for example, Harris 1982, p. 99; Brown 1986, p. 125.
11 Harris 1976, p. 275.
12 Harris 1976, p. 275.

Portrait of a Man (José Nieto?), 1635–45

Archbishop Fernando de Valdés, about 1640–5

Oil on canvas, 63.5 × 59.6 cm
The National Gallery, London (NG 6380)
Bought with a contribution from The Art Fund, 1967

PROVENANCE

Probably bought by Sir David Wilkie
in Madrid in 1882 from Don José de
Madrazo, Keeper of the Royal
Collection; Wilkie sale, Christie's,
30 April 1843 (683); Sir George I.
Campbell of Succoth sale, Christie's,
19 July 1946 (20); acquired in 1950
by Mr Hugh Borthwick-Norton;
acquired by Mr Angus Bainbrigge by
1959, when deposited at the National
Gallery; the National Gallery from 1967

ESSENTIAL BIBLIOGRAPHY

Crombie 1960; Ainaud de Lasarte
1960; De Sambricio in Madrid 1960,
pp. 66–7, no. 62; Braham 1968;
MacLaren 1970, pp. 133–7; López-
Rey 1996, vol. II, pp. 138–41; Brown
1986, pp. 273–4

Fernando de Valdés y Llanos was born in the Asturias, a member of the family of the Counts of Toreno. After studying theology at Salamanca, he was appointed Bishop of Teruel in 1625 and Bishop Elect of León in 1632. The following year he came into prominence at the Spanish court, after his appointments as Archbishop of Granada and President of the Council of Castile, a post comparable to that of Lord Chancellor. During his seven-year stay in Madrid, Valdés commissioned a full-length seated portrait from Velázquez, a record of which survives in a copy in the Count of Toreno collection, Madrid.[1] The lost original was probably among the most ambitious portraits painted by Velázquez in the 1630s, a compelling representation of a high dignitary of state seated in an armchair, with an opulent red curtain in the background.[2]

The present painting is considered a fragment of a larger autograph portrait, probably full-length, from which another fragment, of a hand holding a letter signed by Velázquez, also survives (present whereabouts unknown, in the Palacio Real, Patrimonio Nacional, Madrid, until 1989).[3] Both fragments correspond to the copy in the Toreno collection. The relationship between this bust-length portrait and the copy in Madrid, as well as the existence of a lost original, has been the subject of much debate.[4] It was first suggested that the hand and bust fragments belonged to a full-length portrait by Velázquez, which, before being cut, was copied in the picture in the Count of Toreno collection. The depiction of a younger man in the latter painting runs against this argument.

The older face of the sitter in the portrait in London, based on an earlier likeness, suggests that Valdés was unable to pose for it. Since he died in 1639, this later portrait is presumably posthumous. It seems most likely that the two fragments belonged to a larger composition painted by Velázquez after Valdés's death, based on the lost full-length portrait.[5] The extremely drawn expression, the flattening of the moustache and the unnatural pressure of the lips suggest the use of a death mask. Yet the texture and lighting of the face are remarkably realistic. A strong three-dimensional effect is achieved with the light falling from the left, by means of which the head emerges from the rather flat areas of the black robe and red curtain and neutral wall behind. The free brushwork in this picture and in the hand fragment is consistent with that of works from the 1640s. GM

1 A three-quarter-length version of this composition is in
 the Archiepiscopal Palace, Granada.
2 The traditional composition adopted by Velázquez closely
 resembles that of Cardinal Roberto Ubaldini's portrait,
 painted by Guido Reni in 1627 (County Museum of Art,
 Los Angeles), which the Spanish artist might have seen
 during his first trip to Italy.
3 Brown 1986, pp. 273–4, has questioned the attribution of
 this portrait to Velázquez.
4 See López-Rey 1996, vol. II, pp. 139–41.
5 The existence of a copy of the present painting in the
 Museo Nacional de Arte de Cataluña in Barcelona
 (74 × 61 cm), dating apparently from the seventeenth
 century, suggests that Velázquez's picture was cut down at
 an early date. For this copy see Madrid 1960, pp. 65–6, no. 61.

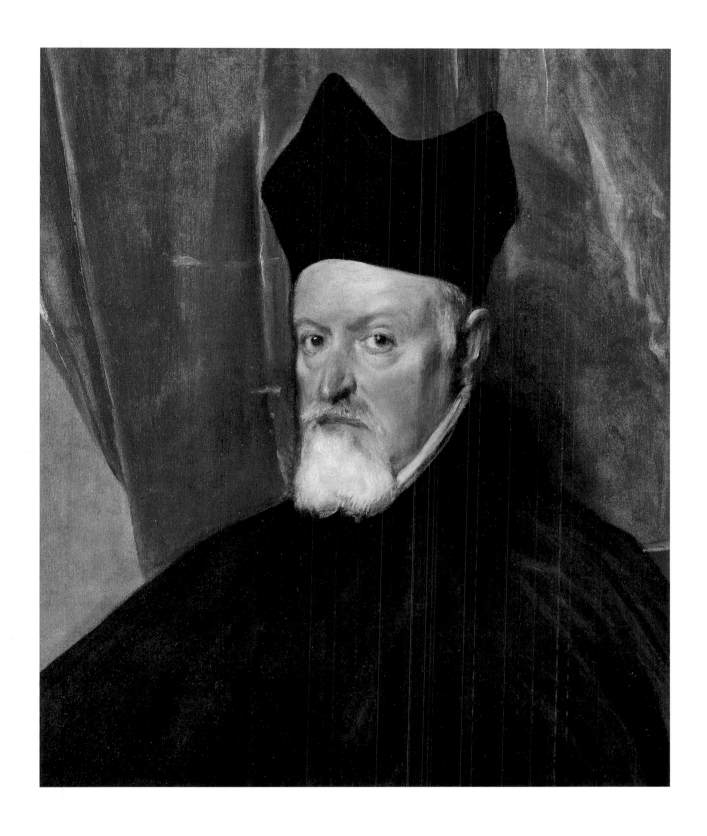

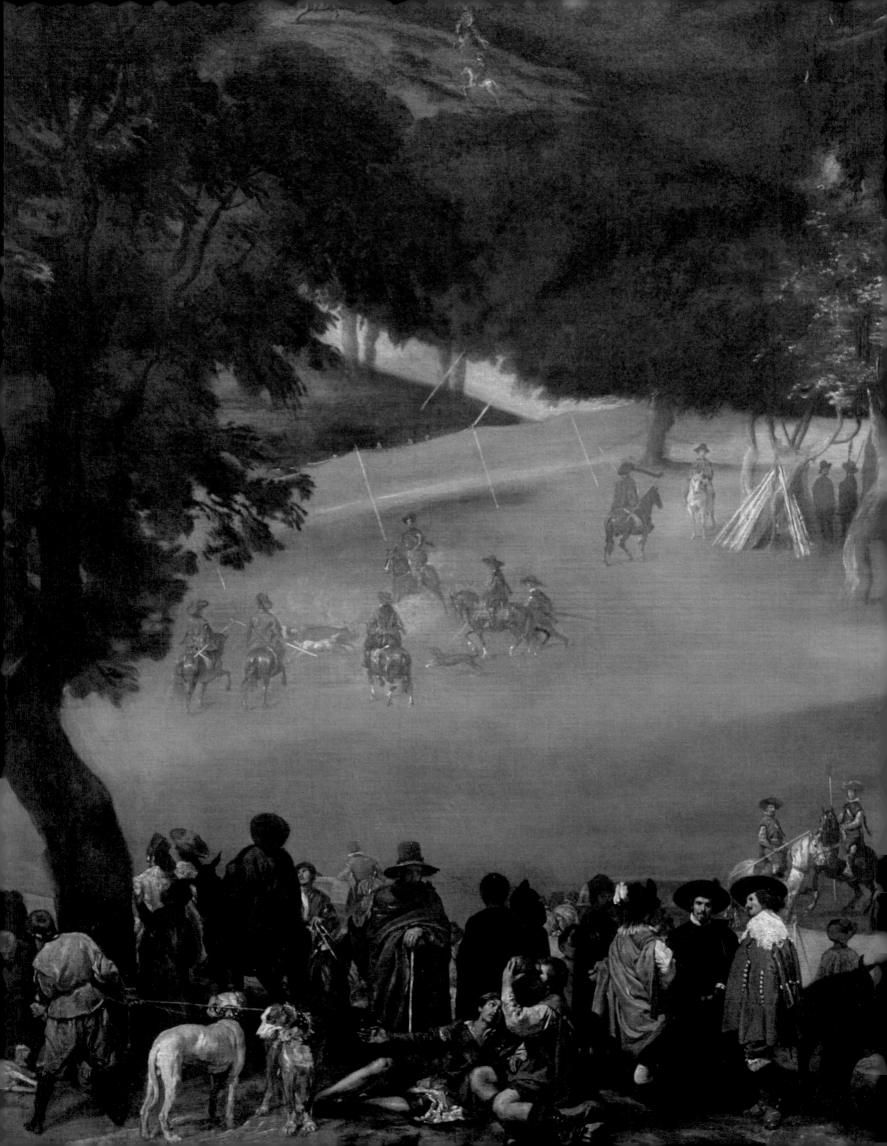

VELÁZQUEZ AND THE HUNT

The Habsburgs were by tradition enthusiastic and expert hunters. Emperor Maximilian I stated that he would have presumed his son, later Charles V, a bastard if he had not been a fine huntsman and Philip IV turned out to be his true heir as well.[1] While Philip's lifelong identification with hunting represented genuine enthusiasm, it also reflected a long-established principle in the education of a prince. Philip's hunting master, Juan Mateos (fig. 99), wrote that the principal dignity of hunting derived from its pursuit by kings, stressing its role as the best teacher of the theory and practice of the miliary arts: 'The forest is the school, the enemies are the beasts, and thus with reason hunting is known as the living image of war.'[2]

The qualities of a good hunter – courage, patience, and cunning – were equated with those of a leader, and Philip's boyhood zeal and skill at the hunt were seen as signs of his aptitude for rule. While this did not follow, hunting and art were to become true, lifelong passions, and around 1635, Philip IV took on a project that would indulge both by creating a hunting lodge for his personal use in the grounds of the Pardo Palace. He already possessed several palaces used seasonally for hunting, including the Pardo, but his new retreat was to be small, secluded, and very private. In contrast to the Buen Retiro Palace, a project dominated by Olivares to parade the public face of the monarchy, the lodge was to be truly Philip's undertaking and for his own enjoyment.[3]

The site selected was well known to the king. The Torre de la Parada, literally the 'Tower of the Stopping-Place', had been a gamekeeper's watchtower and, as its name suggests, had long served as a place for the royal party to rest during hunts, or on the way to and from Valsaín, a palace high in the Sierra de Guadarrama also used for hunting.[4] Standing on high ground, the Torre offered fine views in all directions, and relative isolation not a day's ride from Madrid. Around the tower, the king had a simple two-storey 'hoop-skirt' constructed, to use the analogy of Count Harrach, one of the few visitors ever taken there (fig. 95).[5] While the Torre was modest by royal standards, the small scale ensured a degree of privacy not possible in any other of the king's

dwellings, and stays there must have represented a welcome break from routine.

The king commissioned paintings for his humble lodge on a royal scale. The interiors were decorated principally with mythological paintings, the most extensive cycle ever created by Rubens and his workshop, as well as animal and game pictures by Frans Snyders. Velázquez provided eleven paintings and it would seem that the isolated, informal nature of the lodge gave him not only the cause, but also the licence to create some of his most individual works.

The bulk of the decoration was probably complete by the autumn of 1638, when Francesco I d'Este, Duke of Modena and Reggio Emilia (cat. 28), was taken there. The first inventory of the Torre was made in 1701 and, while we cannot be sure, it would appear that the placement of the paintings had not been substantially altered since the days of Philip IV.[6] This enables us to imagine Velázquez's works in context.

The main reception room of the lodge was known as the Galeria del Rey, or King's Gallery, and its decoration was distinct from the mytho-logical paintings that dominated the other rooms. Game and animal paintings were placed over the doors and windows as in the rest of the house, but otherwise this was truly a family room. Velázquez's principal role was to create three portraits of the male members of the royal family in hunting garb and these became the focal points of the decoration (cat. 31 and fig. 97). They were set amid four large, panoramic scenes illustrating distinct types of court hunts led by members of the royal family, including Velázquez's *La Tela Real* (cat. 33), the only painting certainly in this series to survive. Two paintings in another format focused on Philip's feats as a hunter. All of the other scenes were made by a specialist in hunting pictures, Pieter Snayers (1592–1667), under the direction of Cardinal-Infante Ferdinand who was serving as Governor of the Low Countries in Brussels. Because access to the Torre was restricted, it would seem that this celebration of the royal family as hunters was fashioned for the king, his intimates, and perhaps his successors. Apart from his royal portraits for the Galeria del Rey, Velázquez's contributions are multifarious:

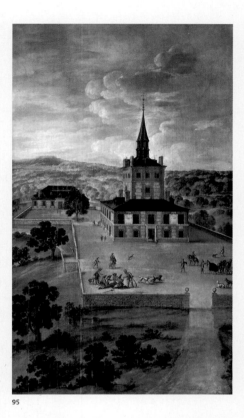

95

a series of dwarfs (one not added before 1643), a pair of ancient writers (cat. 35 and fig. 104), and a single mythological figure (cat. 36). This suggests that he was filling gaps after all the imported paintings were installed, which could have been accomplished at any time. DC

1 Alpers 1971, p. 102.
2 Mateos 1634, preface.
3 Justi (1933), p. 368.
4 On the Torre de la Parada and its decoration, see Alpers 1971. On the architecture, see Martínez Martínez 1992.
5 Alpers 1971, p. 27.
6 For the inventory, see Alpers 1971, appendix II, pp. 289–301 with an English translation pp. 302–14.

95.
Unknown artist
Torre de la Parada, about 1636
Oil on canvas, 214 × 113 cm
Musec Municipal, Madrid

Philip IV as a Hunter, about 1636

Oil on canvas, 189 × 124 cm
Museo Nacional del Prado, Madrid (1184)

Velázquez created his most novel independent portrait of the king by showing him at the hunt. While court culture had long attached great importance to hunting in the making and proving of a ruler, Philip's forebears had not been routinely depicted in such an informal context. It is not surprising that Philip IV would commission or countenance such an image because no monarch since Charles V had been so passionate a hunter.

The hunting theme gave licence to explore new territory in the tradition of understatement in presenting the Habsburgs. Philip is shown wearing an unpretentious hunting outfit, pausing beneath a sturdy oak while out shooting. An accomplished marksman, Philip carries, not a bejewelled regal weapon, but a fine arquebus, no doubt the most accurate of the day. A Spanish mastiff, surely the

likeness of a valued companion, sits patiently awaiting his command and regards the viewer with the same dispassionate gaze as his master. There are no trophies, nor trappings of honour. While no recognisable topographical features are quoted, the chalky patches and old oaks clearly evoke the king's beloved hunting reserve in the Pardo forest, not far from Madrid.

Although the painting is not documented, its genesis is probably tied to the king's creation of a small hunting lodge, the Torre de la Parada, on the Monte del Pardo (fig. 95). Work on the lodge began in 1635 and, by the end of 1638, it is likely that this painting and Velázquez's hunting portraits of the king's brother, Cardinal-Infante Fernando (Museo Nacional del Prado, Madrid), and heir (see cat. 32 and fig. 97) were hanging in the main room, the Galeria del Rey.[1] The decoration was a celebration of family hunting prowess and these full-length portraits served as focus points amid panoramic scenes of court hunts (see cat. 33). In this ensemble, the image of Philip as a hunter at rest served as a counterpart to the portrayals of him in action.

Velázquez employed virtually the same pose as that used in formal portraits of the king, including *Philip IV in Brown and Silver* (cat. 24), which was made a few years before. However, here a slightly more profile position enabled a seemingly off-handed glance. The relaxed stance and hand on hip transform the stiff formal portrait type required by court etiquette into an image of effortless, kingly assurance.

Velázquez did not establish this balance between solidity and ease immediately. Significant changes to the contours of the lower part of the figure have become evident as the thin paint used to cover them has become more transparent with age. The proper right leg was moved slightly, as one often finds in full-length portraits by the artist, but the leg at ease was considerably shifted back toward the figure's centre of gravity, perhaps because it seemed ungainly or too relaxed.

The characterisation – and execution – of the head is close to that in *Philip IV in Brown and Silver*. The king seems slightly older here, but the likeness appears to have been based either on the earlier

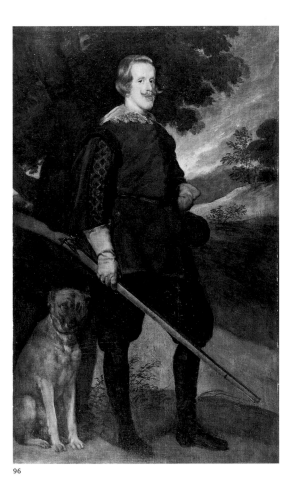

96.
After Velázquez
Philip IV as a Hunter, after 1636
Oil on canvas, 200 × 120 cm
Musée Goya, Castres (on deposit
from the Musée du Louvre, Paris,
since 1949)

96

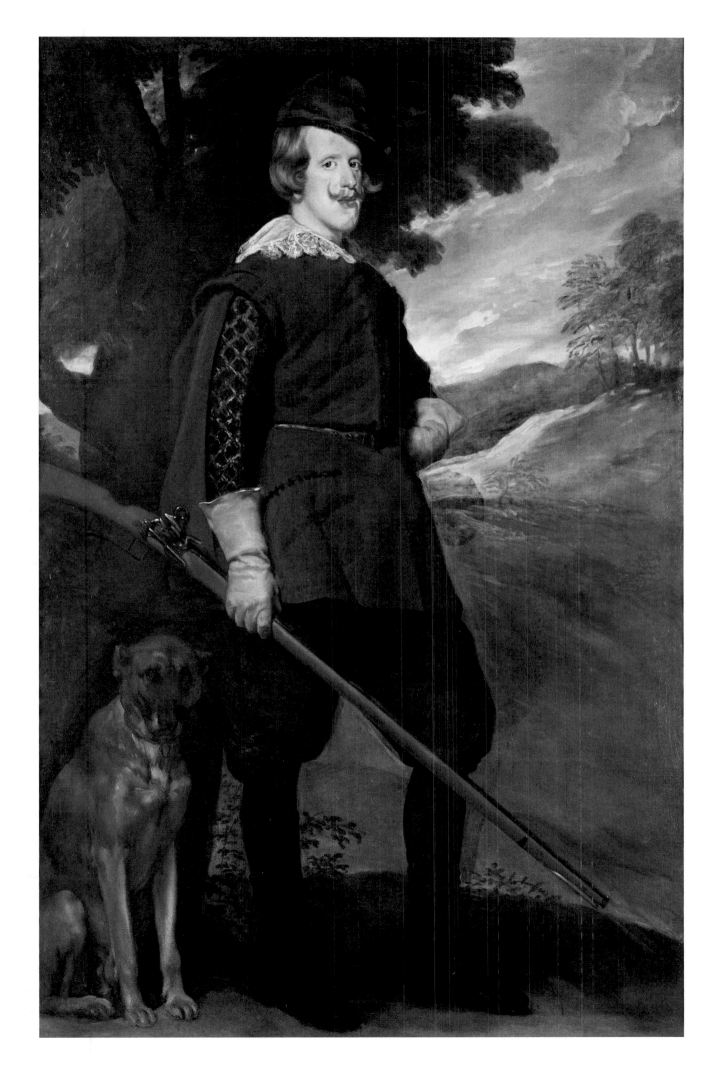

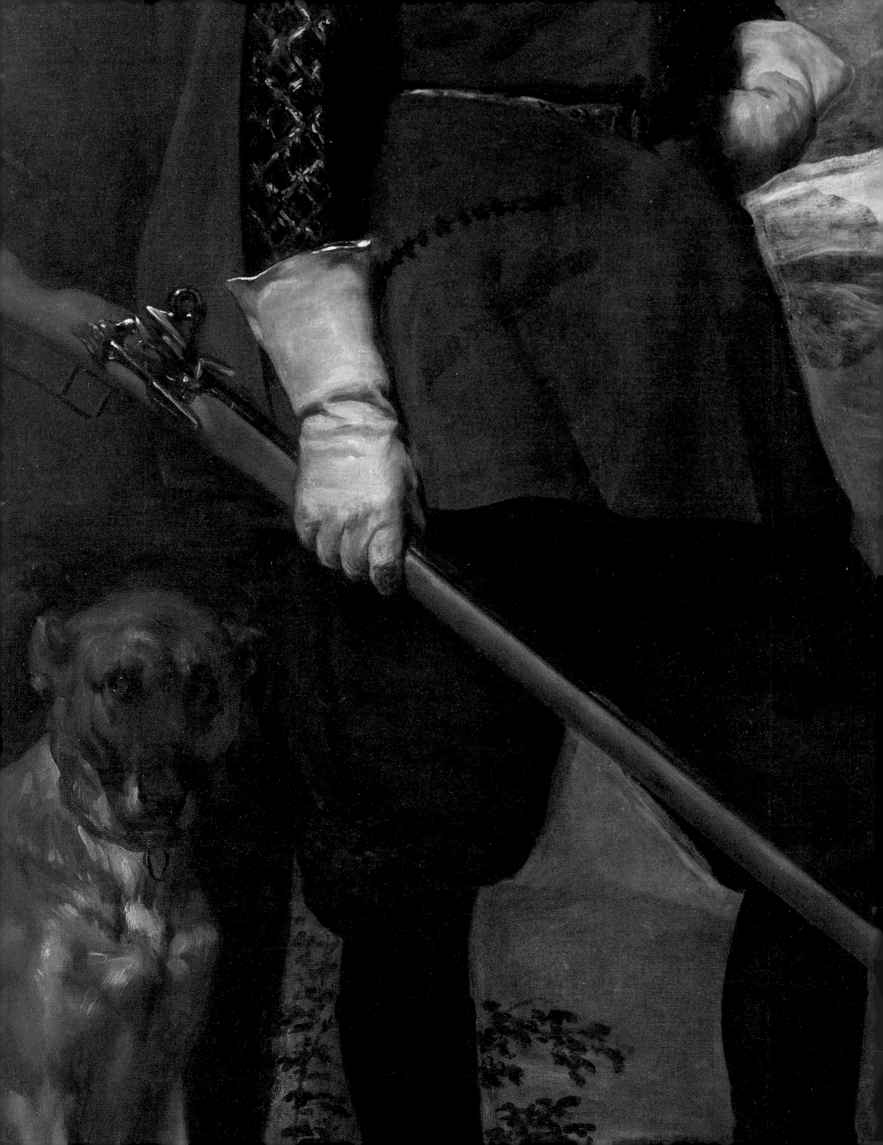

portrait or on a common model now lost. The idealised visages in the two paintings once seemed even more similar because Velázquez conceived the hunting portrait with the king 'uncovered', holding his hat rather than wearing it. The original position is evident in the dark pentimento below the hand on his waist. Velázquez apparently considered the painting finished in this state because a workshop copy was made (fig. 96).[2] Moving the hat certainly humanised the king's customary inscrutable expression and allowed for the long, neat sweep from waist to knee, but the change may also have been obliged by the evolution of the other hunting portraits with their prominent hats. The painter also reduced the length of the barrel of the arquebus after the copy was made.

The understated presentation of the king is echoed in the restrained technique. Overall the paint is very thinly, broadly and rapidly applied. Concise, brilliantly modulated brushstokes evoke the play of light across heavy wool, supple leather and lace, and the lifelike quality of the dog's expression is achieved with the barest suggestion of its features. The palette is largely restricted to earth colours – rich browns, greens, and ochres – handsomely keyed to the king's jacket. The open-air situation allowed Velázquez to frame the king's luminous head in dark, dappled green, and to compose the

landscape and sky to emphasise his strong presence. The trees and clouds show the freedom and economy with which pictorial effects were achieved. Some parts, such as the hill behind the king, were so thinly painted that we can presume some loss of definition based on the increased transparency of the paint revealing the pentimenti.

The painting was probably made about 1636, when Velázquez petitioned the king for moneys owed to him and mentioned works he was making for the Torre.[3] Based on the inscription of the portrait of the king's son made for the same room (see cat. 32), that work can be dated between October 1635 and October 1636. One would envisage the king's portrait being made first and this is perhaps confirmed by the alterations, which are not as evident in the other hunting portraits. DC

1 On the Torre and its decoration, see Alpers 1971; on the Galeria del Rey, see pp. 122–8. It would seem likely that the room was substantially complete by the time of the visit of Francesco d'Este in October 1638.
2 The Castres copy was made directly from the Prado painting using a tracing or other transfer method, as Joseph Padfield of the National Gallery's Scientific Department has confirmed with an overlay of the two images. It makes clear that Velázquez's changes to the legs and to the position of the pocket on his tabard were made before the Castres copy.
3 Harris 1982, p. 96, and Brown 1986, pp. 92–3, no. 41, where the scarce documentation is fully considered.

ATTRIBUTED TO VELÁZQUEZ

Infante Baltasar Carlos as a Hunter, about 1636

Oil on canvas, 154 × 90.5 cm
Ickworth, The Bristol Collection
(The National Trust, accepted in lieu of tax by HM Treasury in 1956)

PROVENANCE

Spanish royal collection(?); acquired in France by Frederick William, 5th Earl and 1st Marquess of Bristol (1769–1859); first recorded in an undated list in the Marquess's hand, drawn up about 1837; thence by descent, until surrendered with Ickworth and the contents of the state rooms to HM Treasury, in lieu of the death duties payable on the estate of the 4th Marquess (1863–1951), and given to the National Trust in 1956

ESSENTIAL BIBLIOGRAPHY

Justi 1903, vol. II, p. 51; Mayer 1936, p. 65, no. 272; López-Rey 1963, pp. 70–2, 267, no. 306; Camón Aznar 1964, vol. I, p. 564; Bardi 1969, p. 96, no. 63A; Brown 1986, p. 138; Gállego in New York 1989–90, p. 176, no. 22; Laing in London 1995, pp. 134–6, no. 50

In his treatise *Origen y dignidad de la caça* (1634) Juan Mateos, Philip IV's master of the hunt, wrote that Baltasar Carlos lanced wild boar from his early childhood, with a skill admired by all who saw him in action. The exercise of hunting was considered an essential part of the prince's education, since 'in it youth develops, gains strength and lightness, the military arts are practised, the lie of the land is understood … the sight of the spilled blood of wild beasts … creates generous spirits which constantly scorn the shadows of fear.'[1]

In this painting the young prince is represented wearing a hunting costume, with a green woollen tabard and breeches, amber gloves and a visored cap. A fine lace collar and sleeves made of a silvery fabric embellish this simple outfit. With a confident attitude, he holds an arquebus by its barrel, addressing the viewer with a serene gaze. Next to him are a sleeping partridge-dog and two alert Spanish greyhounds. The landscape in the background shows the Monte del Pardo, on which the Torre de la Parada (the royal hunting lodge) stood, and the mountains of Guadarrama in the distance.

Most critics consider this picture to be a workshop copy of the original in the Prado (fig. 97). The Prado painting must date to late 1635 or 1636, since an inscription in the left bottom corner states that the prince was six years old when Velázquez portrayed him (he was born in October 1629). This picture is one of the artist's most charming portraits, and, judging from the number of old copies, it was among the most popular images of the young prince.

Alastair Laing has suggested that the present painting might be an earlier and autonomous portrait of the prince by Velázquez, from which the artist derived an expanded variant for the Torre de la Parada. According to Laing, this argument is supported by various pentimenti and by the way the gun and tabard are painted over the landscape. In the portrait in the Prado only one greyhound is shown; since there is no evidence that the picture has been cut down, the absence of the second dog might be explained by its death between the execution of the

two versions. Another element in favour of Laing's hypothesis is that, like the Baltasar Carlos picture, both the hunting portraits of the king and the Cardinal-Infante have been reworked to suit the context of the Torre de la Parada.[2] It is hoped that some light on the attribution of this picture might be shed by its juxtaposition with the *Philip IV as a Hunter* from the Prado (cat. 31) in this exhibition. GM

1 Saavedra Fajardo 1640, trans. Mena Marques 2005, p. 354.
2 London 1995, p. 136 (entry by A. Laing). Although the original setting of this picture is unknown, the unusual narrowness of the canvas seems to suggest that it was once inserted into panelling, rather than in a frame.

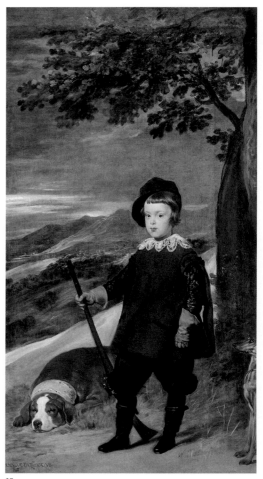
97

97.
Infante Baltasar Carlos as a Hunter, 1635–6
Oil on canvas, 191 × 203 cm
Museo Nacional del Prado, Madrid

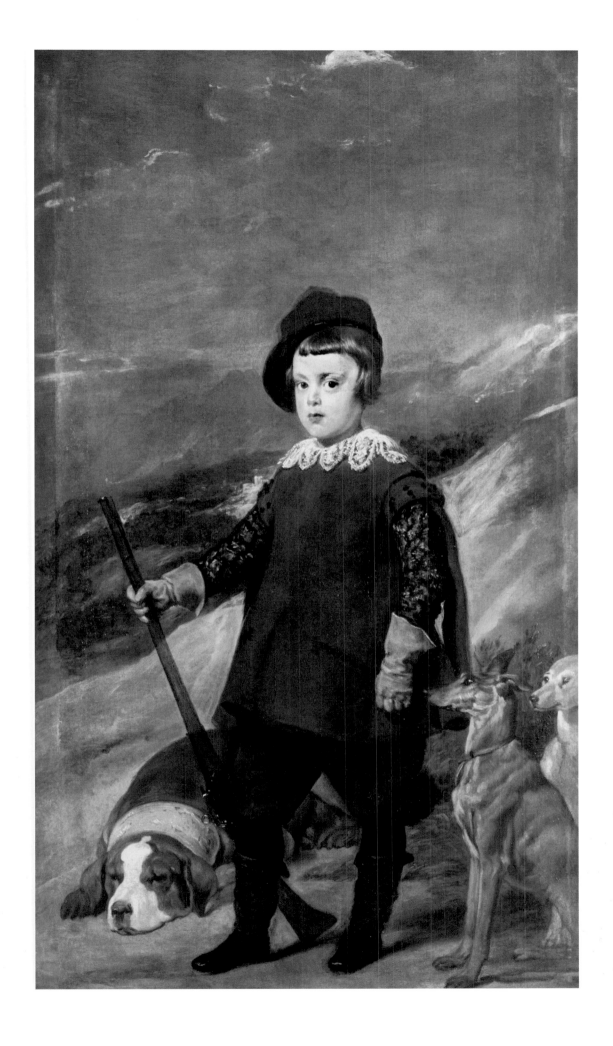

Philip IV hunting Wild Boar (La Tela Real), 1636–8

Oil on canvas, 182 × 302 cm
The National Gallery, London (NG 197)

PROVENANCE

Torre de la Parada; El Pardo Palace, from 1714; Royal Palace, Madrid, by 1747, until at least 1814; presented by Ferdinand VII to Sir Henry Wellesley, later Baron Cowley (British Minister in Spain 1811–22), between 1814 and 1818; exhibited at the British Institution in 1819 and 1838; sold by Lord Cowley to Henry Farrer, London; purchased from him in 1846

ESSENTIAL BIBLIOGRAPHY

MacLaren and Braham 1970, pp. 101–8; Alpers 1971, pp. 122–8; Harris 1982, pp. 130–1; Brown 1986, pp. 129–32

98.
Pieter Snayers (1592–1667?)
Philip IV hunting, about 1638
Oil on canvas, 181 × 576 cm
Museo Nacional del Prado, Madrid

Like *Baltasar Carlos in the Riding School* (cat. 27), this painting purports to document a moment in the life of the court. Not an everyday incident, but a type of 'boar hunt' that was staged occasionally at great expense and labour on feast days and to honour special guests. Introduced to Spain by Charles V, the sport involved the engagement of wild boar by horsemen in an arena formed of canvas in a forest clearing. Velázquez's scene inevitably reminds modern viewers of *rejoneo*, the equestrian form of bullfighting, which was also practised in the reign of Philip IV. 'Boarfighting' permitted the king to take the starring role and we see him just left of centre engaging a charging animal, watched by the queen and her guests from the safety of their carriages.

Among the king's favourite quarry, boar were fierce and daring, and their pursuit lent a bit of danger to his protected life. This was particularly remembered in the decoration of the Galeria del Rey in the Torre de la Parada, where male members of the royal family were celebrated as hunters. This painting was produced to accompany three others of equal size depicting different types of court hunts by Pieter Snayers, including one, now lost, that was a perfect foil as it showed the king leading a boar hunt in the wild. Also part of the ensemble were a pair of paintings by Snayers commemorating the king's feats as a hunter, one showing a famous incident in

which he pursued and killed an enormous boar single-handedly.[1]

The representation of court hunts had certain long-established conventions. Cranach's *Hunt in Honour of Charles V at the Castle of Torgau* (Museo Nacional del Prado, Madrid) illustrates the basic type with its panoramic, bird's-eye view of a land-scape into which are inserted many small portraits of hunters slaughtering game on a vast scale. The basic principle of reserving the front plane for the most important portraits was still honoured in the seventeenth century by specialists like Snayers, as can be seen in an enormous painting he made for another room in the Torre (fig. 98). It illustrates a different type of hunt using a canvas enclosure, this one designed for shooting boar, deer, wolves and foxes, and the king and his brothers are depicted front and centre rather than in action.

Velázquez departs from tradition by foregrounding behind-the-scenes activity, reversing the expected as was his predilection (cats 4–5 and figs 30–1). Some people scurry about playing their supportive roles, while others watch the action or rest. This reflects a role reversal at such events because here the grandees toil while courtiers and servants enjoy a period of leisure on the fringes. For Velázquez and his patrons, this would have carried no social signifi-cance and the foreground figures would have been

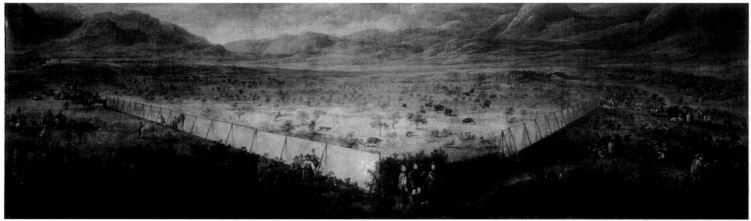

98

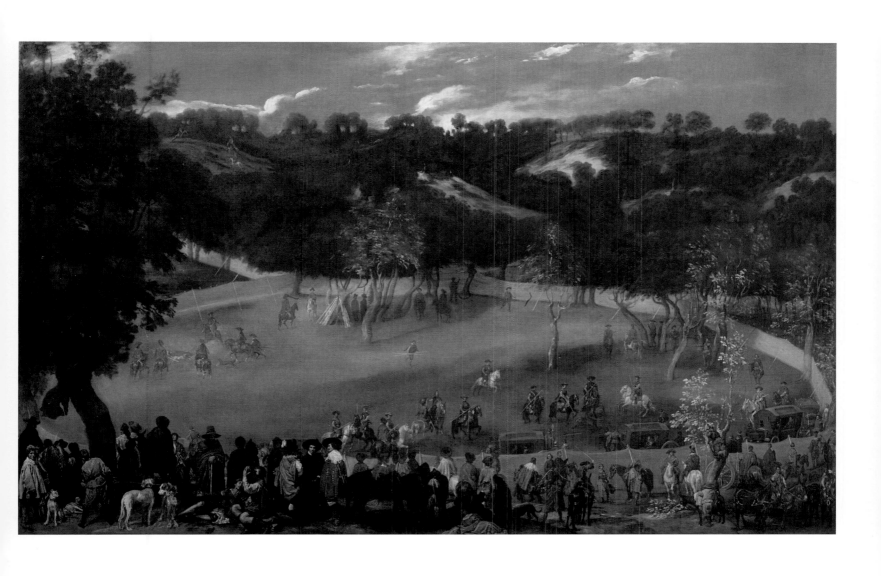

99.
Juan de Mateos, before 1634
Oil on canvas, 109 × 90.5 cm
Staatliche Kunstsammlungen
Dresden

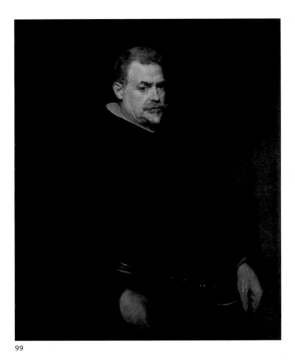

99

100.
Pieter Snayers (1592–1667?)
A Court Hunt, about 1638
Oil on canvas, 195 × 302 cm
Museo Nacional del Prado,
Madrid

101.
Francisco Collante
(1599–1656)
Boar Hunt
Engraving for Juan de Mateos,
Origen y dignidad de la caça,
published in Madrid 1634

read as ingenious use of staffage that gives the scene a greater sense of actuality and makes it possible to show the king in an arena.

To emphasise the king and his party, Velázquez had the terrain drop away so that the scale of the foreground figures is diminished in the area before him. The hill rises up to the left and as one moves away from the action, people become increasingly disengaged. The left side is taken up with a frieze of figures deftly formed with paint that is more thickly applied because of their proximity. The most prominent is the group of three richly dressed courtiers conversing to the left of centre who take no interest in the proceedings. To the left of the courtiers, the foreground is devoted to vignettes involving the grooms attending the dogs.

The features of most of the horsemen in the arena seem to be portraits; they are particularised in a way that the figures outside the area generally are not. As Master of the Horse, the Count-Duke of Olivares is at the king's left side. The condition of the painting does not allow for certain identification of the other two horsemen in the king's group, but they seem to represent his brothers, Carlos to the left of the king, and Ferdinand to the right of Olivares. While the brothers hunted together, we do not know if they ever participated together in such an event. Carlos had died in 1632 and Fernando left Madrid the same year, but as both were represented in other paintings in the Galería del Rey, it is not surprising to find them here.

Queen Isabella of Bourbon is probably represented, but again, the condition of the painting does not allow for certain identification. The lady in the third carriage looks most like the queen and perhaps her

identity is confirmed by the man on a white horse beside the carriage, Juan Mateos, the Master of the Hunt, who is identifiable from his portrait by Velázquez (fig. 99). None of the other horsemen have been identified, but participants were restricted to favoured grandees and those with offices pertaining to the hunt.

Hunting treatises describe the exacting preparations and process of this type of hunting, making it possible to understand the scene laid out by Velázquez.[2] The elusive boar were first trapped by encircling them with a vast fence of heavy canvas or *tela* strung between trees and supported by stakes. The arena that dominates Velázquez's composition was called the *contratela* or counter-*tela* and was limited in size for the main event. The *tela* itself encompassed a much larger area, up to a league – more than 2¼ miles or 4 km – in circumference. Velázquez depicts it branching off behind the *contratela*, seemingly taking in the whole upper part of the composition. In theory, the enormous size allowed for the *tela*'s deployment without sending the boar scurrying. The trapped animals were driven to a smaller holding area for culling and later admission to the *contratela* via a chute. The horsemen in the clearing at upper right are presumably just beginning the long journey and one arm of the pen or the chute can be seen branching off at centre. The huge enterprise was obviously costly and limited this type of hunting to the royal house, hence the name '*Tela Real*'.

Like bulls, boar were ideal for such sport because they would repeatedly charge when cornered.[3] The horsemen used a special tool called a *horquilla*, which consisted of a long pine shaft with a U-shaped iron

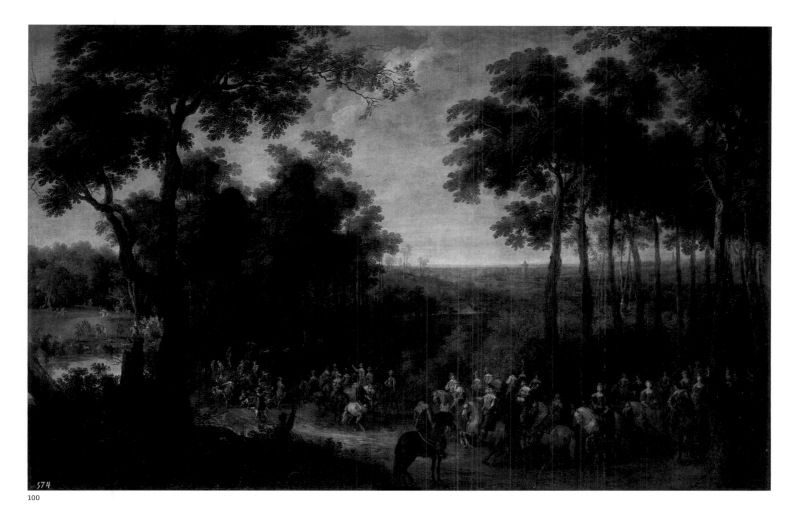

100

fork designed to fit a boar's muzzle. The sport entailed precisely placing the fork to divert the boar's charge. Success required strength, agility, and perfect control of a mount confronted with a raging beast large and fearless enough to disembowel it. Velázquez's depiction of the setting and basic process are confirmed by Francisco Collante's illustration

101

(fig. 101) for the book published by Juan de Mateos (fig. 99), in 1634. Velázquez was almost surely present at such events and we can see details not shown in the book illustration. The *horquillas* often cracked, as is evident on the floor of the arena, and the resulting spear could be used fend off an attack. As in bullfighting, the goal was to tire the animal in anticipation of the kill. When it was totally spent, a pack of dogs was released to dispatch the defeated creature, as Velázquez depicts toward the left side of the arena.

Contemporary hunting specialists and casual observers make clear that the main entertainment was not the killing of the boar, but the display of fine horsemanship. Philip IV takes his amusement, but as in his equestrian portrait (fig. 20), his abilities as a horseman, and here hunter, inevitably suggest his natural dominion. Seeing the king taking on his prey might conjure up images of Saint George and the dragon, or Meleager pursuing the Calydonian boar, with further allusions to his role as defender of the faith, and his people.

It seems probable that Velázquez sought to illustrate this type of hunting rather than represent a specific event because the painting was designed to go with three others by Snayers illustrating different kinds of hunts, and because the king's long-departed

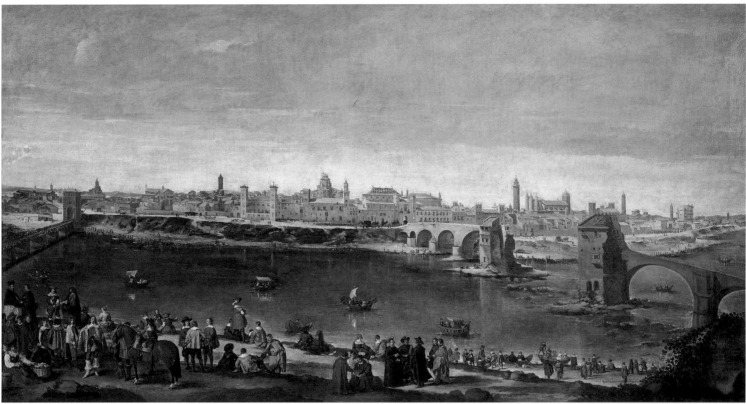

102

brothers appear. Only a few accounts of specific hunts exist, but they make clear that each was different in the number of boar used and dispatched. At the hunt organised for the Princess of Carignan on 19 January 1637, only one boar was killed, by the king, in front of the carriage with the queen and the princess.[4] Could Velázquez have been trying to evoke that recent incident here, while also including the killing of the boar at left so that the more usual outcome was shown?

The only surviving painting by Snayers (fig. 100) of similar dimensions to the *Tela Real* does not match the inventory descriptions of the other three hunts in the Galeria del Rey, which are now presumed lost.[5] This raises the possibility that Snayers provided four canvases for the series and that Velázquez's painting replaced this one. However, it seems strange that the most regal of hunts, as depicted by Velázquez, would be added as an afterthought. Perhaps he chose to take on one of these paintings, so different from anything that he had painted before, simply to explore the boundaries of portraiture in the casual depiction of court life.

The precise location of Velázquez's boar hunt has never been determined and may be largely invention, but the terrain is recognisable to anyone who has visited the Pardo Palace. The canvas and stakes for the hunt were kept at the Torre de la Parada, so one would presume that such hunts were staged within a reasonable distance.[6] The word 'Pardo' is inscribed

on the back of the original canvas, which could refer to the location of the hunt, but probably indicates that the palace was the destination for the painting when it was removed from the Torre.

This painting was the first work by Velázquez purchased by the National Gallery. After its acquisition in 1846, it was discovered that the painting was very damaged and this became the subject of a parliamentary investigation.[7] Testimony suggested that the paint had been burned off in discrete parts, particularly at the top, from the use of excessive heat and pressure in lining the canvas before 1833, when the painter George Lance restored it. Fortunately, the foreground figures on which Velázquez lavished so much attention are relatively well-preserved, in part because of the density of the paint. Many of the portraits in the arena show Velázquez's ability to record appearance with a few strokes and dabs, but some of the subsidiary figures, particularly toward the back of the *contratela,* are only ghosts of their former selves. The damage to the arena is minor by comparison with that to the top third of the painting, where his thin, impressionistic manner of forming trees has been virtually ruined. The forms of most of them can still be perceived, but in the upper left corner around the figures of the horsemen, very little original paint remains. The recent restoration was undertaken to remove a very discoloured varnish, but also the heavy retouching of 1950–2, which resulted in smothering what remained

102.
Juan Bautista Martínez del Mazo
(about 1612/16; died 1667)
View of Zaragoza, 1647
Oil on canvas, 181 × 331 cm
Museo Nacional del Prado,
Madrid

of Velázquez's work and left the painting looking unlike any other of his landscapes in its density.

The virtually unique status of this painting in Velázquez's oeuvre and the condition issues have combined to undermine the attribution for some scholars, although mostly before the restoration of 1950–2.[8] Mazo has been suggested as the author, largely because of the similarity of the composition of his *View of Zaragoza* (fig. 102), which depends on Velázquez's invention in this work rather than the other way around. Close comparison of the figures in that painting with those in *La Tela Real*, whether in the foreground or in the arena, show that Mazo defines form in a distinct manner with no trace of Velázquez's bold and knowing hand. Likewise, he is not capable of orchestrating figures across a broad area, so they tend to exist as fine, but independent, figure groupings. Mazo's rather dark and dense painting of trees in other works did bear some resemblance to the overly restored trees in this painting before the most recent restoration. What remains suggests that Velázquez's abbreviated style was at play, but it is now impossible to judge.

The painting does not seem to have been cut down, but there is a copy in the Prado (1230), which was in the Buen Retiro Palace from 1747, that shows slight additions at the sides and bottom. This painting is sometimes attributed to Mazo, but the figures are not worthy of him. It is a faithful, but uninspired copy and, since its recent cleaning, the colours seem to indicate that it was made in the eighteenth century. A reduced copy (61 × 107 cm) of undetermined later date was formerly in a Swedish collection.[9] Another reduced copy (68 × 110 cm) in the Wallace Collection, London, is damaged and lacks many of the figures.

The painting was clearly popular as there are also many derivations, mostly focusing on the foreground groups.[10] DC

1 Museo Nacional del Prado (1736).
2 On this type of hunt, see Mateos 1634, pp. 39r–41v, and Martínez de Espinar 1644, pp. 42v–54r, 153r–156v.
3 Comparison of boar and bull is made by Martínez de Espinar 1644, p. 156r.
4 See Rodríguez Villa 1886, p. 71.
5 Alpers 1971, pp. 122–8, with inventory descriptions on pp. 254 and 306, which describe Snayers's subjects as Philip IV and his brothers chasing wild boar, a hunt of wolves with nets, and a bird hunt with nets.
6 Mateos 1634, pp. 39r–40r.
7 *Report from the Select Committee on the National Gallery*, London 1854, pp. 346–53 reprinted in Bomford and Leonard 2004, pp. 460–72, with pertinent remarks from the art critic and restorer, Henry Merritt, pp. 458–9.
8 These opinions are summarised in MacLaren and Braham, pp. 103–4.
9 Madrid 1961, no. 108.
10 MacLaren and Braham, p. 105, lists these derivations.

Francisco Lezcano, 1638–40

Oil on canvas, 107 × 83 cm
Museo Nacional del Prado, Madrid (1204)

PROVENANCE

Torre de la Parada in 1701; El Pardo
Palace from 1714; Royal Palace,
Madrid, from 1772; Museo Nacional
del Prado, Madrid, from 1819.

ESSENTIAL BIBLIOGRAPHY

Harris 1982, p. 108, fig. 101; Brown
1986, pp. 148, 153–4, 274–7; Gállego
in Madrid 1986, p. 19; Mena in Madrid
1986, pp. 94–5, no. 26; New York
1989, pp. 218–23, no. 30; Madrid
1990, pp. 316–21, no. 52; Brown and
Garrido 1998, pp. 142–6, no. 21;
Portús 1999, pp. 172–3

We cannot identify this man with certainty, but he is traditionally thought to be Francisco Lezcano, a dwarf who came to court from Vizcaya in 1634. He served Baltasar Carlos until 1645, resurfaced at court in 1648, and died a year later; and that is virtually all we know of him. The greatest support for the identification stems from Velázquez's characterisation, which makes it easy to envisage this gentle little person being chosen as a playmate for the prince.

Dwarfs and fools were exploited by court culture for reasons that might seem contradictory today.[1] As curiosities, they served as a foil to the beauty and superiority of the monarchy (cat. 23), but they were also revered as special expressions of the wondrous variety of creation. Deliberately exempted from the strict code of court conduct, they were selected for the humour that their uninhibited expression might provoke. It was also recognised that their mental detachment could express ideas more visionary than humorous. The attitude that they were closer to God was not just in evidence at court, but was part of the fabric of society, as reflected in the tradition of care and veneration for the village *bobo*, a recurrent theme in Spanish literature of the period.

Velázquez frankly portrayed the things that make Lezcano different, but also endowed his sitter with monumentality, equalising his usual relationship with the full-sized world. He looks slightly down on us, having crawled up on a rock, leaving his hat below to suggest that his perch is higher than it might seem. By posing him sprawled like a child Velázquez accentuated his stunted and bowed legs, and that he is not only limited in stature. He seems to be at the entrance to a cave, a symbol of the unknowable, the bright light of day illuminating his face except for his eyes, which are virtually shadows as dark as the background behind. His outward gaze is at once penetrating and lacking in focus, which is achieved through the indistinctness of Velázquez's technique and by emphasising the contrast between the two sides of his face, one almost asleep, the other alert. The vague connection with the viewer is echoed in the unsteady tilt of the head back and to the side, and in the open mouth that drifts between smile and stupor. He shuffles a deck of cards, a traditional symbol of idleness and a natural attribute of jesters. More than denoting profession, the cards are used by Velázquez as a metaphor for mindlessness, the blind action of shuffling softly underscoring the still vacancy of the expression.

This is one of four portraits of virtually the same size that depict three dwarfs and a fool (figs 24–7). Nothing is known of their early history, but they were probably created for the Torre de la Parada, where they seem to be recorded together in 1701.[2] This painting and *Diego de Acedo* (fig. 24) are paired by their landscape backgrounds, which show the Sierra de Guadaramma in the vicinity of the Torre.

The airy vista is described with consummate brevity. On a greyish layer, Velázquez laid down highly diluted washes of paint, defining forms with varying concentrations of pigments, to achieve the sensation of a hazy day. Colour is restrained and keyed to the figure, the foliage being created from the same pigments as the costume. This is the best preserved of Velázquez's landscapes in the Torre de la Parada paintings and it should be used as a benchmark for other more compromised background scenes.

The paint handling bears many similarities with the royal hunting portraits, especially if one takes into account the added freedom afforded by the social standing of the sitter. Brown noted that the breadth of the technique must, at least in part, result from the probable position of the paintings over doors.[3] As we know that Velázquez was working on the Torre de la Parada decoration in the late 1630s and that one of the dwarfs depicted, Calabazas, died in 1639, it seems likely that three of the portraits were made in the years 1636–40. The royal portraits for the Galeria del Rey were surely given priority, so we might push this date to the end of that period.
DC

1 On dwarfs and fools at the Spanish court, see particularly
 Gállego in Madrid 1986, pp. 15–24, and Bauza 1991.
2 Alpers 1971, pp. 290, 302.
3 Brown 1986, p. 276–7.

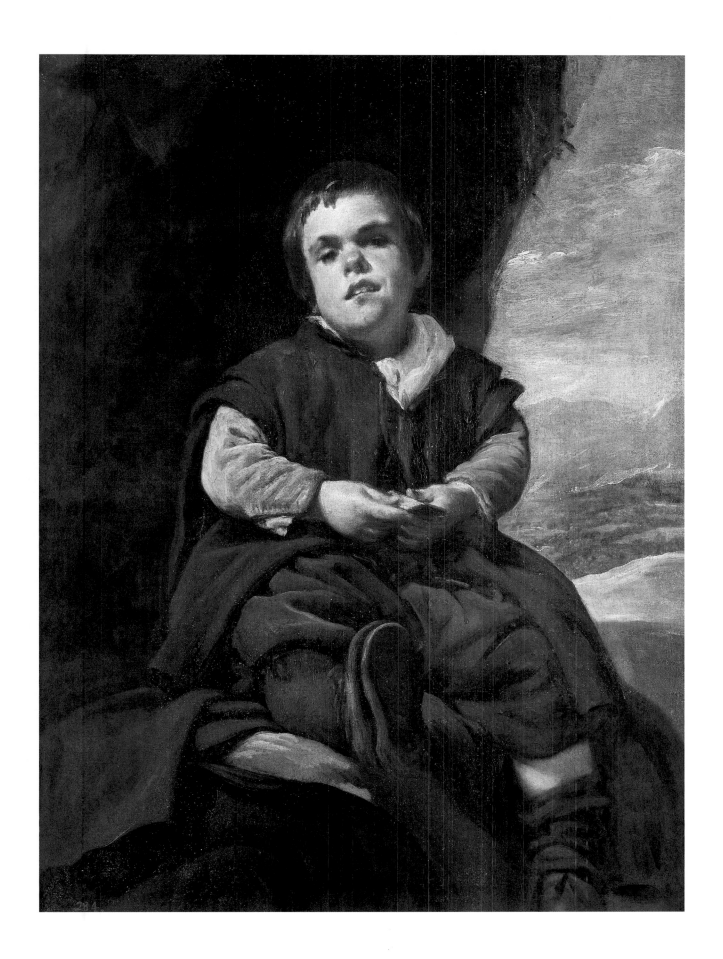

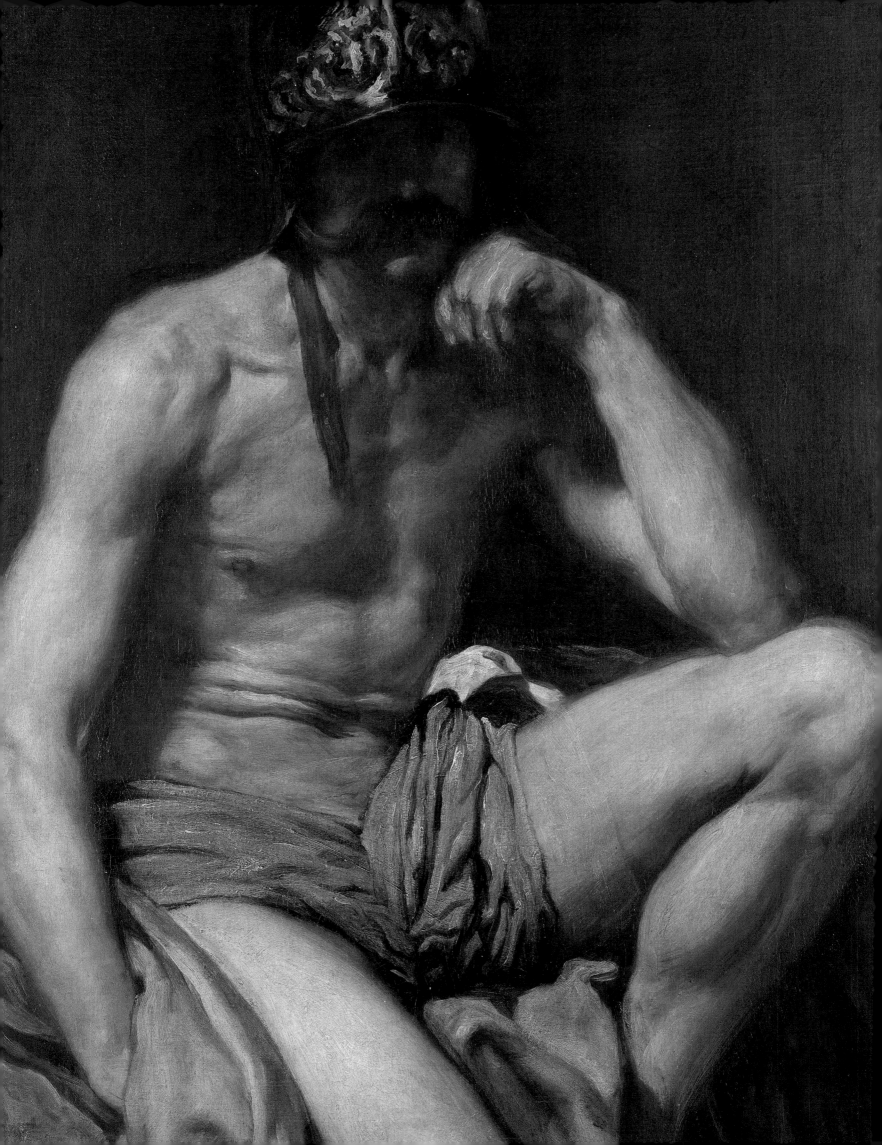

PORTRAYING THE ANCIENTS

103

Velázquez's reputation as one of the great interpreters of subjects from antiquity rests on few examples. Only four mythological narrative paintings survive: *The Feast of Bacchus* (fig. 15), *Apollo at the Forge of Vulcan* (cat. 18), *The Fable of Arachne* (fig. 31), and *Mercury and Argus* (fig. 103), each a masterwork of pictorial storytelling. The last, painted at the very end of his career, was saved from the flames of the 1734 Alcázar fire, but three companions perished: *Apollo and Marsyas*, *Venus and Adonis*, and *Cupid and Psyche*, depriving us of what was surely a brilliantly interlaced ensemble of adversaries and lovers. They were designed for the Hall of Mirrors in the Alcázar, one of the principal state rooms, to hang with works by Titian, Veronese, Tintoretto and Rubens, and were Velázquez's final statements of his relationship to the great tradition of Habsburg patronage and collecting. Virtually all of Velázquez's later mythologies are meditations on this relationship, seen most notably in his free use of paint and rich use of colour, with the artist seeking to surpass his predecessors on his own terms.

In addition to these depictions of mythological stories, Velázquez created several characterisations of individual gods, sibyls and writer-philosophers that contribute significantly to his fame as a painter of ancient subjects. The character of each is acutely considered and conveyed with a distinctive pose, expression and technique that bring them to life. The portrayals are tuned so finely that they have a kind of definitiveness about them because Velázquez understood his subjects so well and found visual means to convey great subtlety of characterisation. After seeing *Aesop* (cat. 35), Hans Christian Anderson declared that he had found his ancient counterpart, and could not picture his face in any other way. Aesop's wise, ironic and intelligent countenance has been interpreted as a reflection of Velázquez's own ability to observe and comment on the human condition. Certainly, his casting of mythological figures in human terms in his narrative paintings follows in these characterisations, though in a variety of ways.

The Rokeby Venus (cat. 37) can be included in this small group, in spite of Cupid's presence, because the artist so clearly focused on the goddess of love. Another reclining Venus was recorded in Velázquez's studio after his death and his depictions of *Venus and Adonis* and *Cupid and Psyche* for the Hall of Mirrors also surely referenced Titian's great mythological nudes in the royal collection, but the London *Venus* is the only one to survive. As the most important work by Velázquez in the National Gallery the *Rokeby Venus* suggested this section of the exhibition, which will consider such 'individual' depictions of ancient figures. These works are not numerous.

Velázquez first showed an interest in portraying figures from antiquity by painting a sibyl (fig. 107), one of the ancient seers of Christ's coming. Such imaginings of lovely women with visionary expressions dressed in exotic costumes had become popular in Italy in the early seventeenth century, and Velázquez probably painted this shortly after his first trip there. Typically, he downplayed the exotic and the erotic, humanising his portrayal and engaging the viewer in her grave gaze into the distance. It would seem that he was fascinated with depicting quasi-divine inspiration, as he returned to the theme more than two decades later (cat. 38), about the time he painted *Venus*, this time showing her more actively inspired as she utters some truth, gazing beyond the blank tablet before her.

Three paintings of individuals from the ancient world were made for the king. *Mars* (cat. 36), *Aesop* (cat. 35) and *Menippus* (fig. 104) were apparently designed to hang in the ensemble at the Torre de la Parada (see p. 193), where they vied with Rubens's depictions of individual gods and philosophers. The ancient writer of fables and an obscure cynic philosopher, both former slaves, confront the viewer with greater intensity and life than most works of this type, even those of Velázquez's distinguished compatriot, Jusepe de Ribera, who had popularised depictions of 'beggar-philosophers' in Naples. These humble men, leading lives devoted to pursuing the truth of human nature, free from the affectations of society, were perfect subjects for the hunting lodge, where the king sought the simple life to escape the artificiality of court etiquette.

Mars and *Venus* are the paintings in which we can most clearly perceive a true homage to Rubens and Titian, not only in the rich use of colour and the seductive rendering of flesh, but in the improvisational approach to working on the canvas. This is especially true of *Mars* (see detail opposite), where it is clear that originally the blue drapery covered more of his upraised leg, something the artist adjusted when he introduced the pink sheet. Even though *Mars* was painted perhaps a decade or more before *Venus*, Velázquez's suggestive technique was already in evidence. DC

103.
Mercury and Argus, about 1659
Oil on canvas, 128 × 250 cm
Museo Nacional del Prado, Madrid

Mars
(detail of cat. 36)

Aesop, about 1636–8

Oil on canvas, 179 × 94 cm
Museo Nacional del Prado, Madrid (1206)

PROVENANCE

El Pardo, Torre de la Parada, Madrid
(by 1701); El Pardo, Palacio Real,
Madrid (1714–72); Palacio Real
Nuevo, Madrid (inventoried in
1772 and 1794); Museo del Prado,
Madrid, since 1819

ESSENTIAL BIBLIOGRAPHY

Gerstenberg 1957, pp. 221–4;
Palm 1967; Alpers 1971, pp. 133–6;
Gállego in New York 1989–90,
pp. 203–9, no. 27; Berger 1991;
Rico 1991; López-Rey 1996, vol. II,
p. 226; Tromans 1996; Cruz
Valdovinos 1999; Portús Pérez in
Madrid 2004–5, pp. 343–4, no. 31

Aesop, a Greek writer who lived in the sixth century
BC, is famous for his fables illustrating truths about
life and human nature. After having been a slave
to two masters, Xanthus and Jadmon, he was freed
by the latter as a reward for his wit and wisdom,
and rose to prominence as a philosopher. Velázquez
represents Aesop as a tired old man wearing shape-
less clothes, who stares out at the viewer with a
serious intelligent expression and great dignity.
At his feet is a bucket with a rag on the edge, which
probably hints at his slavery.[1] On the right there
appears to be a sack with a curved object on it, which
might allude to one account of Aesop's death: after
he insulted the citizens of Delphi, they hid a golden
cup in his baggage and accused him of theft, before
throwing him off a cliff as punishment.[2]

In 1636 the Cardinal-Infante Ferdinand of
Austria commissioned Rubens to paint hunting
and mythological scenes for the Torre de la Parada,
a private royal lodge in the hunting reserve of
the Pardo Palace, near Madrid, and it seems that
Velázquez was also involved in its decoration; the
inventory made of the building in 1701 lists eleven
pictures by him. *Aesop* was displayed in the 'eighth
room of the high floor' of this building in 1701, with
two other paintings representing *Mars* (cat. 36) and
Menippus (fig. 104).

The painting of Menippus, a Greek philosopher
who lived in the third century BC, was a pendant of
Aesop. Both men were freed slaves who made fun of
the supposedly wise. It is likely that the two paintings
were conceived as counterparts to *Heraclitus* and
Democritus by Rubens (both Museo Nacional del
Prado, Madrid), which hung in the Torre de la Parada
from 1638. As exponents of stoicism, Heraclitus and
Democritus would have made a telling group with
Velázquez's pendants, the first laughing at the
ridiculousness and vanity of the human condition,
like Menippus, the other despairing of it, like Aesop.
While there is no evidence to prove definitively the
existence of a coherent decorative programme for
the Torre de la Parada, it is possible that the four
philosophers were placed in this context of leisure
as a reminder to the members of the court that
happiness is not always to be found in worldly
things, and that the search for truth and wisdom
is the real aim of life.[3] GM

104

104.
Menippus, about 1636–8
Oil on canvas, 179 × 94 cm
Museo Nacional del Prado,
Madrid

1 The bucket might also allude to Aesop's fable of the rich
 man and the tanner, or to an episode from his apocryphal *Life*,
 see Gerstenberg 1957, p. 224, and Tromans 1996, pp. 334–5.
2 This object has also been seen as a stone with some sort of
 pasteboard crown on it, or a piece of a harness, see Gállego
 in New York 1989–90, p. 209, and De Beruete 1906, p. 96.
3 But see Cruz Valdovinos (1999, pp. 166–7), who has suggested
 that the writer Francisco de Quevedo devised an iconographic
 programme for the Torre de la Parada. The presence of the
 philosophers within a programme devoted to the hunt and
 the gods of antiquity has also been interpreted as a satire
 of classical culture, quite prevalent in the Golden Age, see
 Gállego in New York 1989–90, p. 203.

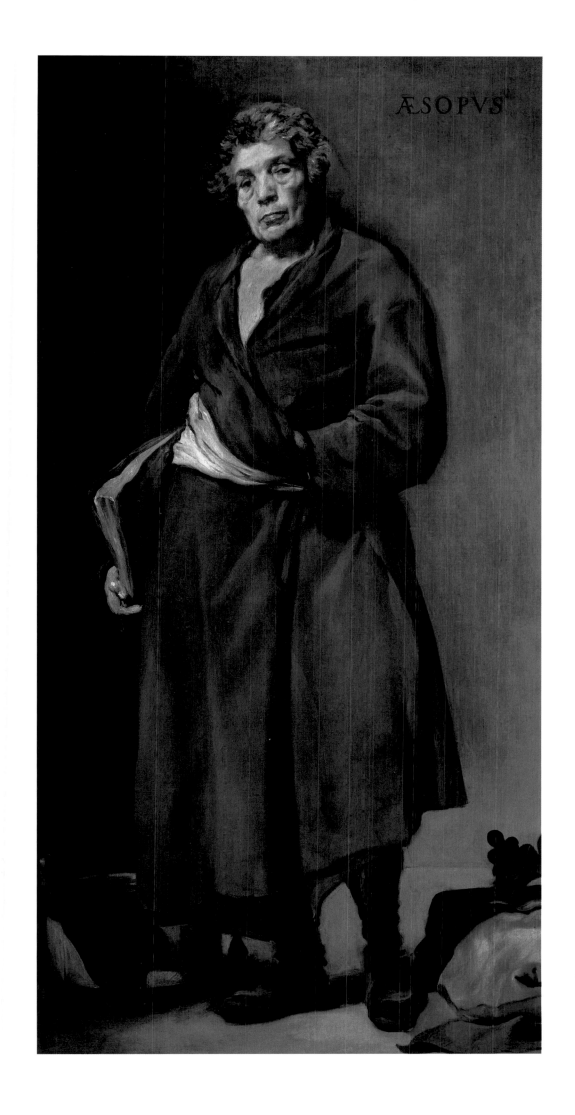

Mars, about 1638

Oil on canvas, 179 × 95 cm
Museo Nacional del Prado, Madrid (1208)

PROVENANCE

Torre de la Parada by 1701 to 1747;
Madrid, Royal Palace; taken to France
in the so-called 'Baggage of King
Joseph', 1808–14; Madrid, Royal
Palace, 1815; Madrid, Real Academia
de San Fernando, 1816-1827; Madrid,
Museo del Prado, from 1827

ESSENTIAL BIBLIOGRAPHY

Justi (1933), pp. 654–9; Camón
Aznar 1964, II, p. 703; Alpers 1971,
pp. 133–6; Harris 1982, pp. 132–5;
Brown 1986, pp. 167–8; New York
1989, pp. 210–15, no. 28; Madrid
1990, pp. 310–15, no. 51; Garrido
1992, pp. 475–83; Brown and
Garrido 1998, no. 26, pp. 168–73

105

105.
Roman copy after a Greek original
The Ludovisi Mars,
second century AD?
Marble, height 160 cm
Museo Nazionale Romano, Rome

Velázquez's incisive humanisation of the gods of antiquity is epitomised by this singular characterisation of Mars. One would expect the god of war to be a burly soldier, the embodiment of brute strength and manly fortitude that Venus found completely irresistible. Yet Velázquez substituted a veteran, perhaps ready and willing, but past his prime. We recognise him principally from his attributes, the armour made for him by Vulcan and his commander's baton. But rather than robust and belligerent, he appears deflated, peering out enigmatically through the shadow cast by a helmet that seems one size too large. Luxuriant facial hair was equated with virility and Mars was often shown bearded, but this unkempt, oversized moustache conjures up stock figures of libertines from comedy.

The painting would not have been appropriate in the Buen Retiro Palace, where war triumphs were celebrated, but it was apparently made for the king's retreat at the Torre de la Parada, where it is first recorded in 1701.[1] There the decoration was principally mythological and this painting was probably created to fill a vacant space after Rubens's paintings were installed. Rubens's individual heroes and heroines for the Torre were always shown in action, which would have emphasised Mars' repose. In the context of a royal hunting lodge, a depiction of Mars at rest was most appropriate because the hunt was considered the peaceful equivalent of war. As Alpers put it, at the Torre 'Mars is at rest in respect to the hunt'.[2]

This painting was possibly intended to hang with Velázquez's *Aesop* (cat. 35) and *Menippus* (fig. 104), which would suggest that *Mars* was meant to be seen within a tradition of scepticism and sarcasm. This might be true, but the colouring and handling of *Mars* are so entirely different that it seems an autonomous image. This is perhaps confirmed by the quasi-narrative quality of the painting.

Mars was not often painted as an independent figure. When depicted at peace, he was usually accompanied by Venus and Cupid to illustrate Strife tamed by Love. By showing him sitting on the edge of a rumpled bed, his loins hastily covered (partially by a pink bedcover), and his baton at rest, Velázquez alludes to the moment after Mars and Venus have been caught in the act by her husband Vulcan. This

painting represents the result of the episode depicted by Velázquez in cat. 18, showing Apollo visiting Vulcan's forge with the news of his wife's illicit love. Furious, Vulcan forged a net so fine that it was invisible, entrapping the hapless lovers for the ridicule of the other gods. Here, Venus has been whisked away by Vulcan and the gods have departed. The great and powerful Mars is left alone to ponder his chagrin, not defeated in battle, but by lust. It has been suggested that Velázquez was emulating the Greek satirist Lucian, who told ancient myths with comic overtones at the expense of the gods.[3]

The painting is replete with allusions to the art of the past. Velázquez based the pose on the *Ludovisi Mars* (fig. 105), an ancient statue that no doubt enjoyed some celebrity at the time of Velázquez's first trip to Rome as it was only acquired for the renowned collection in 1622 (on his return to Italy in 1650, Velázquez ordered a cast of it for Philip IV). Mars is shown as a young, strong god with his arms resting on a raised leg as Cupid plays with his armour at his feet. Velázquez altered the pose by introducing the head propped up on a bent arm, a traditional way of representing melancholy.

In executing the painting, Velázquez declares himself the heir to Titian and Rubens with particular boldness of colour and brushwork. There are faint echoes of their favoured blues, reds and golds, and their sensuous skin tones, to which Velázquez lends his own vibrancy. The contours are blurred and the overall effect is of a figure enveloped in a sultry air. Velázquez particularly sought to exceed his mentors in the economy with which he achieved his realism. His understanding of the suggestive effects of paint is already acute and is perhaps best appreciated in the creation of the armour, and in the two or three tiny dashes that define the toenail that gives form to the foot. The advanced technique has caused some scholars to date this painting in the 1640s or 50s, but it was probably produced towards the end of the 1630s along with other paintings for the Torre. DC

1 Alpers 1971, pp. 295, 307.
2 Ibid, p. 136.
3 Brown 1986, p. 168, Brown and Garrido 1998, pp. 170–2.

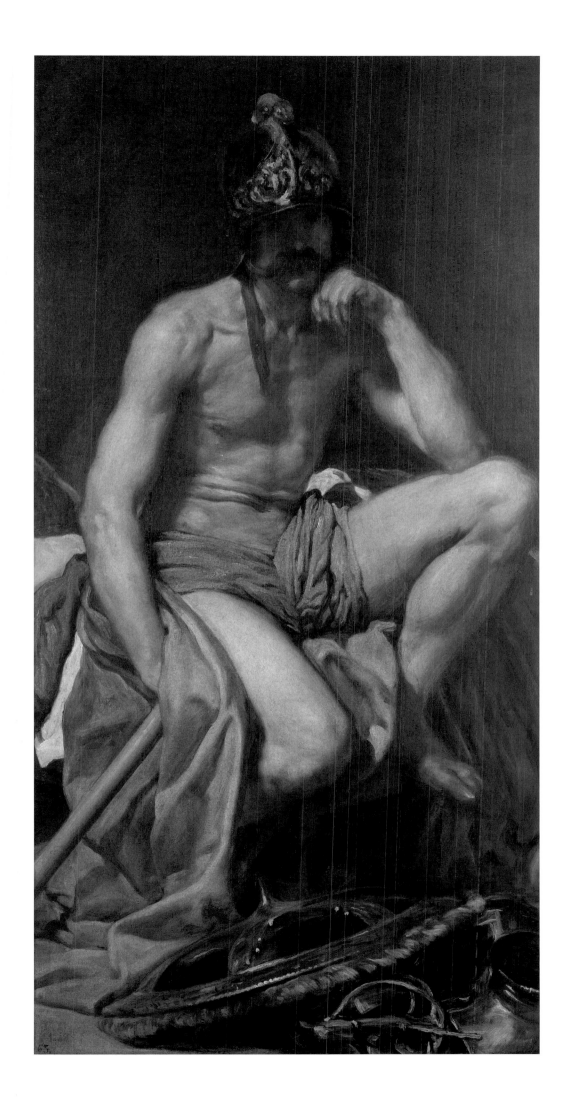

The Toilet of Venus ('The Rokeby Venus'), 1647–51

Oil on canvas, 122.5 × 177 cm
The National Gallery, London
Presented by The Art Fund, 1906 (NG 2057)

PROVENANCE

Domingo Guerra Coronel, Madrid, by November 1651; Gaspar Méndez de Haro, Marqués del Carpio and de Heliche, from 1652; inherited in 1687 by his daughter, Doña Catalina Méndez de Haro y Guzmán, who married the Duke of Alba in 1688; thence by descent in the Alba collection until 1802; sale ordered by Charles IV to Don Manuel Godoy, Principe de la Paz, who retained it until 1808; purchased by George Augustus Wallis after October 1808 for William Buchanan, who imported it to England in September 1813; sold in 1814 to John Bacon Sawrey Morritt, Rokeby Hall, Yorkshire; sold in 1905 by H.E. Morritt to Thos Agnew & Sons Ltd; the National Gallery, London, 1906

ESSENTIAL BIBLIOGRAPHY

Curtis 1883, no. 34; Justi (1933), pp. 660–3; MacLaren 1943; Tolnay 1960; Sánchez Cantón 1960; Madrid 1961, no. 76; MacLaren and Braham 1970, pp. 125–9; Braham 1976; Harris 1982, pp. 136–40; Brown 1986, pp. 181–5; Bull and Harris 1986; Harris 1990; Harris and Bull 1990; Bernal 1990; Bull and Harris 1994; Haskell 1999; Aterido 2001; Prater 2002; Morán Turina 2004; Pérez Sánchez in Naples 2005, pp. 104–7, no. 23; Portús, pp. 56–67

Velázquez's only surviving female nude depicts the goddess of love reclining languidly on her bed. She is identifiable because Cupid is present, but when the painting was first recorded it was described simply as 'a nude woman', reflecting the sense of a real, living being that it communicates.[1] Though we cannot be certain that he used a model, this has always been assumed because of her seeming individuality, but in depicting Venus, Velázquez took on the challenge of representing true beauty. The balance he achieved between real and ideal, between sensuality and decorousness, makes this a wholly new and compelling representation of the goddess who embodied not only profane but sacred love.

Velázquez's painting is one of the rare depictions of a nude by a Spanish painter. While the portrayal and display of unclothed people was officially discouraged, in aristocratic circles the aims of art overwhelmed questions of morality and mythological nudes were abundant in contemporary collections, none more so than the king's. The complex and fascinating moral and artistic context for the creation of *The Rokeby Venus* is fully considered in this volume by Javier Portús (pp. 55–67).

Velázquez conflates two distinct traditions for depicting Venus, both popularised by Titian. The most important showed her recumbent on a bed (for example Titian's *Venus and Cupid with an Organist*, Museo Nacional del Prado), while the other depicted the goddess at her toilet, usually sitting upright admiring herself in a mirror (fig. 106). Historians have posited numerous works from ancient to contemporary art as Velázquez's source of inspiration, and he surely knew many of them, but it is fruitless to focus on one.[2] The concentration on the perfection of the female form by Venetian artists determined his point of departure, but the freshness of this Venus makes it seem that the tradition is evidenced mainly in the way he posed his model.

The viewer is given privileged access to an intimate scene, but is not allowed to remain a voyeur. Cupid props up a mirror and, although the reflection of Venus's face is foggy, it is clear enough that she is not primping, but looking out at the viewer. She shows no sign of alarm, so perhaps the mirror does not signify an interrupted morning ritual, but preparation for bed. Intertwining ribbons

are knotted at the top of the mirror to suggest that it was suspended on a wall, and to allude to the fetters Cupid used to bind lovers. Venus had previously been portrayed at her toilet gazing outward via a mirror, but Velázquez was the first to use the motif in bed and to blur the reflection.[3]

The indistinctness of the reflected image is not solely the result of distance or the light scattering of an old mirror. As the depiction of Venus aspired to represent ideal beauty, perhaps this was Velázquez's metaphor for the idea that perfect beauty is unrepresentable, immaterial and, ultimately, spiritual.[4] Venus' vague beauty is also consistent with his introduction of ambiguity into his compositions to encourage the imagination of the viewer and, consequently, interpretations of her expression, such as it is, have ranged widely. Some see 'come hither', while others perceive a forbidding Venus, not pleased with the incursion into her chamber. Enriqueta Harris succinctly captured this quality: 'there is an ambivalence about this woman, an uncertainty whether she is a human being or goddess of myth. We are all, each one of us, left to fill in the features of the face in the mirror.'[5]

The model for Venus has been the subject of many flights of fantasy, though not of the kind Velázquez intended. Her sensuous realness has impelled ultimately futile attempts to establish her identity, even though painting from the model does not require slavish adherence to individual features to attain a sense of veracity. It has been suggested that Venus' face, however indefinite, resembles that of the woman seen in cat. 38, in *The Coronation of the Virgin* (Prado), and in the left foreground of *The Spinners* (fig. 31). Though perhaps based on a common model, the similarity more likely demonstrates the artist's ideals of female beauty applied to superior women.

Venus' bedchamber was usually described with richly embroidered fabrics and feminine finery, but Velázquez achieves opulence only with colour and brushwork. The folds of the fabric pay homage to her form, framing, echoing and emphasising its beautiful planes and sweeping curves. As often noted, one of the most distinctive features of the painting is the way the creamy flesh tones are enhanced by the austere, slate-grey sheet on which

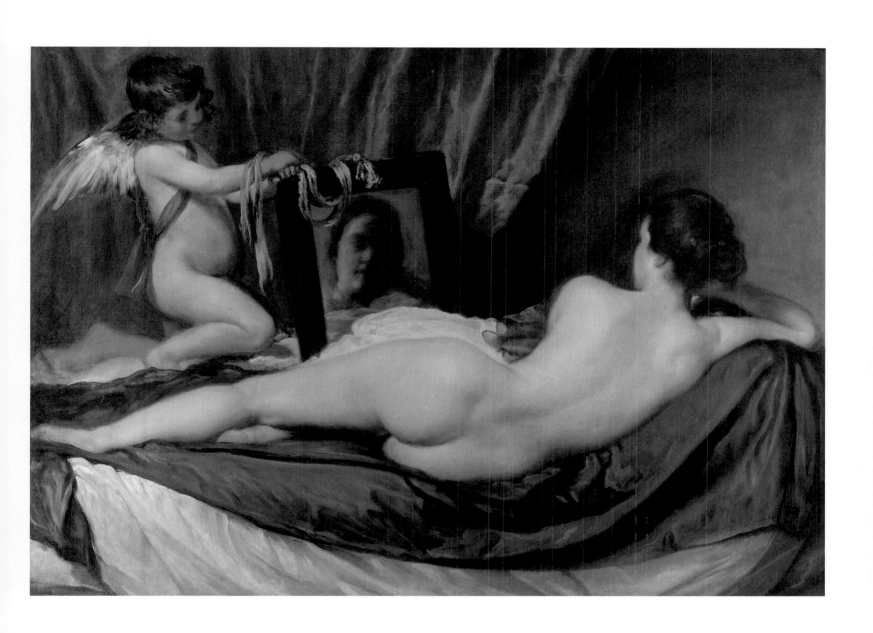

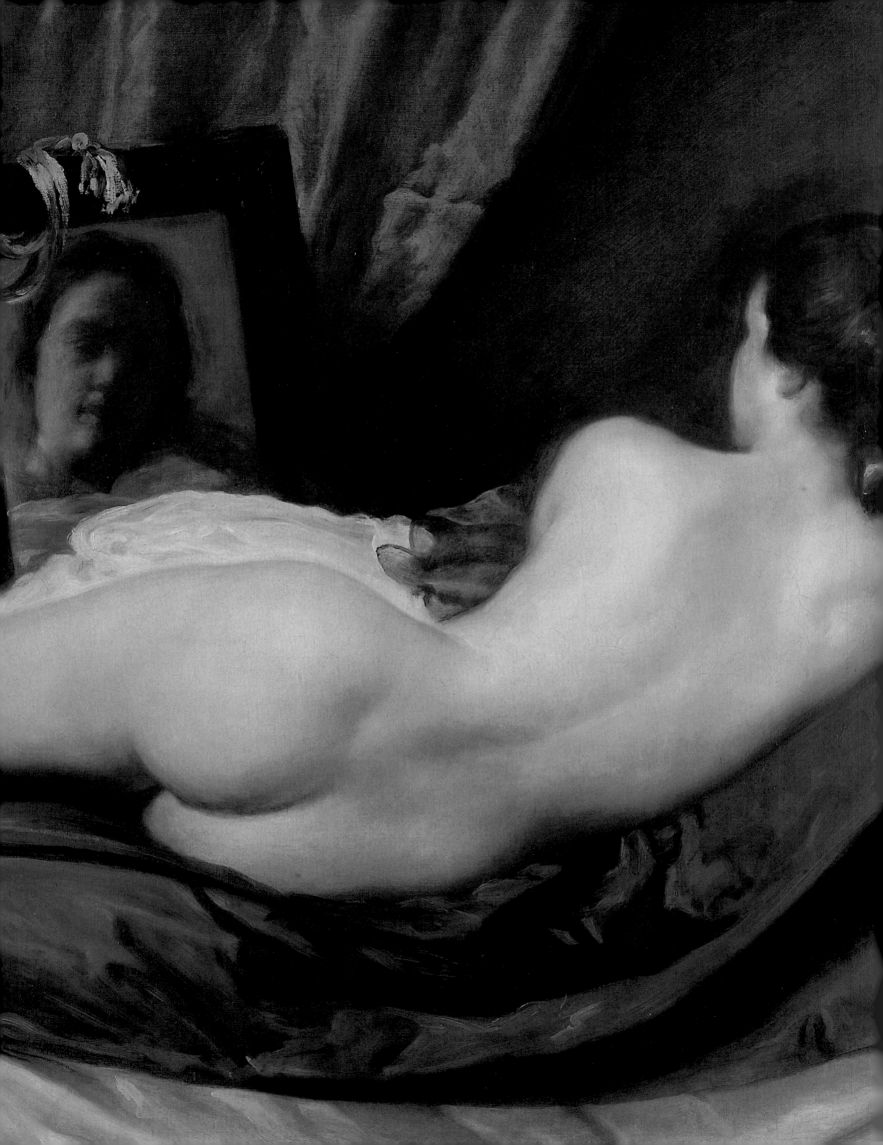

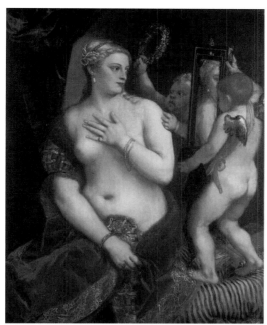

106

106.
Titian (active about 1506;
died 1576)
Venus with a Mirror,
about 1555
Oil on canvas,
124.5 × 105.5 cm
National Gallery of Art,
Washington DC
Andrew W. Mellon Collection

she reclines. Recent examination has shown that this was not intended and that the sheet was originally a deep mauve colour, so that the subtle play of warm and cool tones in the modelling of Venus' back can now be understood as the naturalistic rendering of reflected light.[6]

The contours of the figure are softly defined with modulated loadings of the brush, sometimes using flesh tones, sometimes an incursion of surrounding fabric, and this gives the figure a vibrant lifelikeness. Her flesh convincingly sinks into the satiny sheet and she seems to exist in the kind of vaporous, perfumed air that enveloped Mars in Venus' bed-chamber (cat. 36). The figure is virtually imperceptibly modelled in pearly tones, while the fabrics are rendered with some of Velázquez's most beautiful passages of painting, much of it executed *alla prima*, the ribbon scumbled and dashed on with a few well-controlled strokes. Velázquez's suggestive technique is here used to establish Cupid's relatively short distance behind, his facial features being barely defined and his back foot almost non-existent. This, as well as Venus' summarily formed foot near the edge of the painting, has been taken as evidence that the painting was left unfinished or has been overcleaned.[7] They are rather the artist's evocations of the effects of low light and distance from the centre of focus, as employed in *Mars*, which was perhaps made a decade or more before.

The figure was slightly, but significantly adjusted. Pentimenti can be seen in the head, particularly near the face, in the upraised arm and elbow, and in the position of the left shoulder. The X-radiograph shows that she was originally more upright and her head turned more to the left so that her nose was visible. These changes and the artist's adjustments to the mirror at top and along the left edge would seem to indicate that he was trying to establish just the right relationship between the two.[8]

The Rokeby Venus was long thought to be among Velázquez's latest works until it was spotted in an inventory made after 1651 of the paintings of Gaspar Méndez de Haro, the Marqués de Heliche, the great-nephew and namesake of the Count-Duke of Olivares.[9] Haro was a notorious libertine who loved paintings almost as much as women and it seemed perfectly logical that the commission would come from him. However, in 2001, Aterido confirmed that the painting first belonged to the Madrilenian painter and art dealer Domingo Guerra Coronel, who died in November 1651, and that it was sold from his estate to Haro only in 1652.[10] Thus, we are left to ponder what occasioned the painting of this nude, and when. The painting technique offers no assistance in dating as it might have been executed at any time during the 1640s or early 50s, in Spain or in Italy. On the one hand, it might be the exceptional nude that Velázquez painted abroad, especially as it appears not long after his return. If it was painted in Italy, was it inspired by renewed exposure to Italian art or does it more reflect the finding of new love in middle age, which resulted in the birth of an illegitimate son? Was it perhaps given to a middle man once back in Madrid to distance its creation by Velázquez? As Portús points out in his essay in this volume, the king's painter need not have feared painting a nude and, as one of the classic subjects of his greatest mentors, Titian and Rubens, it need not carry any biographical connection. DC

1 Aterido 2001, pp. 91–2.
2 Prater 2002 illustrates many of these. On the issue of sources see particularly Tolnay 1960.
3 For instance, Paolo Veronese, *Venus at her Toilet* (Joselyn Art Museum, Omaha), illustrated in Prater 2002, p. 26.
4 Ibid, p. 73, considers this idea.
5 Harris 1982. p. 140.
6 See Keith, pp. 70–91 in this volume.
7 For instance, MacLaren and Braham 1970, p. 125.
8 The accuracy of the photographic reconstruction of the scene by Gavin Ashworth, which suggested that the mirror would not reflect her face, has been rightfully questioned by Prater 2002, p. 24.
9 Pita Andrace 1952, pp. 226–7.
10 Aterido 2001. On Coronel see Saltillo 1944–5.

Female Figure (Sibyl with Tabula Rasa), about 1648

Oil on canvas, 64 × 58 cm
Meadows Museum
Southern Methodist University, Dallas, Texas
Algur H. Meadows Collection (74.01)

PROVENANCE

Private Collection, Milan; Julius
Böhler, Munich; Reinhardt Gallery,
New York; Edward Drummond
Libbey, Toledo, Ohio; John Willys-
Mrs Isabel van Wie Willys, Toledo,
Ohio; Mrs Isabel van Wie Willys'
collection sale, New York, Parke-
Bernet, 25 October 1945, lot 20, to
Wildenstein; Meadows Museum of
Art, Southern Methodist University,
Dallas, since 1974

ESSENTIAL BIBLIOGRAPHY

Jordan 1974, pp. 20–1; Brown 1986,
pp. 178–81; New York 1989, p. 225,
no. 31; López-Rey 1996, vol. 2,
pp. 268–9; Salort Pons in Naples
2005, p. 110, no. 25

107

107.
**Sibyl (Portrait of Juana
Pacheco?)**, about 1631–2
Oil on canvas, 62 × 52 cm
Museo Nacional del Prado,
Madrid (1197)

Sibyls were the prophetesses of classical mythology
who, according to Christian tradition, foretold the
coming of Christ to the Roman pagans. Although
this enigmatic picture is generally known as
Sibyl with Tabula Rasa, that is only one of the myriad
interpretations given to its subject. This reading
is based on the similarity with the *Sibyl* from the
Prado (fig. 107); both pictures represent half-length
female figures seen in profile holding a tablet.[1]
Large tablets or open books were the customary
attributes of these divinatory figures. Doubts have
been raised, however, because the dishevelled hair
and simple dress of the woman in Velázquez's
painting do not match the flowing robes and head-
dress of Renaissance and Baroque iconography.[2]

This painting has also been studied in relation
to *The Fable of Arachne* from the Prado (fig. 31):
according to some, Velázquez may have used the
same young model for the figure of Arachne (the
weaver in the right foreground) and the woman
in *Sibyl with Tabula Rasa* and, more importantly,
he possibly conceived both as personifications of
Painting.[3] In fact, it is difficult to discern a similarity
between the two women, as Arachne's face is
completely concealed from the viewer. One further
element that complicates this interpretation is the
absence of canvas and brush, essential features in
an allegory of Painting. Brown thus suggests an
identification of the figure with Clio, the muse of
History, but adds that traditionally she would hold
a pen.[4] Lastly, in an attempt to name the mysterious
sitter, it has also been hypothesised that she was
Flaminia Triunfi, the 'excellent painter' Velázquez
met and portrayed during his second stay in Italy.[5]
It should be said, however, that among those who
have attempted to explain this painting there are
also some who do not consider it to be autograph.[6]

In the absence of a firm identification of both
theme and sitter, the sibyl remains the most
convincing interpretation. Velázquez's diversion
from the traditional iconography does not refute
its validity, and is in fact hardly surprising. As in
his *Aesop* (cat. 35), the Spanish master gives an
original rendering of a classical theme, and enhances
its unconventionality by using real people as models.
As has been noted before, Velázquez may have also
intended this image to be a subtle reference to the
theme of the artist's inspiration and his power to
create the world on the blank surface of the canvas.[7]

Whereas the Prado picture (fig. 107), thought to
be a portrait of the painter's wife, gives a rather rigid
vision of the prophetess, the seductive quality of
this small picture lies precisely in the spontaneous
rendering of the theme.[8] The sibyl appears to have
been portrayed in the fleeting moment when she is
uttering her prophecy: her index finger pointing to
the tablet, and her lips parted, as if she is whispering
the truth that she alone can see. The same immediacy
is found in the exuberant painting technique which,
one can argue, anticipates the freedom of the French
Impressionists. The rapid brushstrokes, especially
visible in the chemise, may suggest that this work
was an unfinished sketch. A tentative date of about
1648 is based on the stylistic resemblance with *The
Rokeby Venus* (cat. 37): both pictures share a fluid and
loose application of paint that is greatly indebted
to Titian. SDN

1 Jordan 1974, pp. 20–1.
2 See, for example, Michelangelo's sibyls in the frescoes for
 the Sistine Chapel, and Guercino's *The Cumaean Sibyl with
 a Putto* in the National Gallery, London.
3 Mayer 1936, no. 570, and López-Rey 1996, p. 266, no. 107.
 According to López-Rey 'the two figures are quite close in
 regard to motion, setting in space, and modelling'.
4 Brown 1986, p. 181. In Cesare Ripa's *Iconologia* (Rome 1603)
 History is a winged woman, dressed in white, holding a book
 (or a tablet) in which she writes. See New York 1989, p. 225,
 no. 31.
5 Palomino in Harris 1982, p. 209. This woman has also been
 named Flaminia Trivia, see Naples 2005, p. 110, no. 25.
6 Pantorba, Camón Aznar and Harris do not include this work
 in their Velázquez monographs.
7 According to Jordan 1974, p. 20, the analogy between prophet
 and artist can also be found in *Saint John the Evangelist on
 the Island of Patmos* (cat. 10), the *Portrait of the Sculptor
 Martínez Montañéz* (fig. 50) and *Las Meninas* (fig. 30).
8 The *Sibyl* from the Prado is described as Doña Juana Pacheco,
 the artist's wife, in the inventory of Isabella Farnese, 1746.
 López-Rey 1996, p. 118, no. 49.

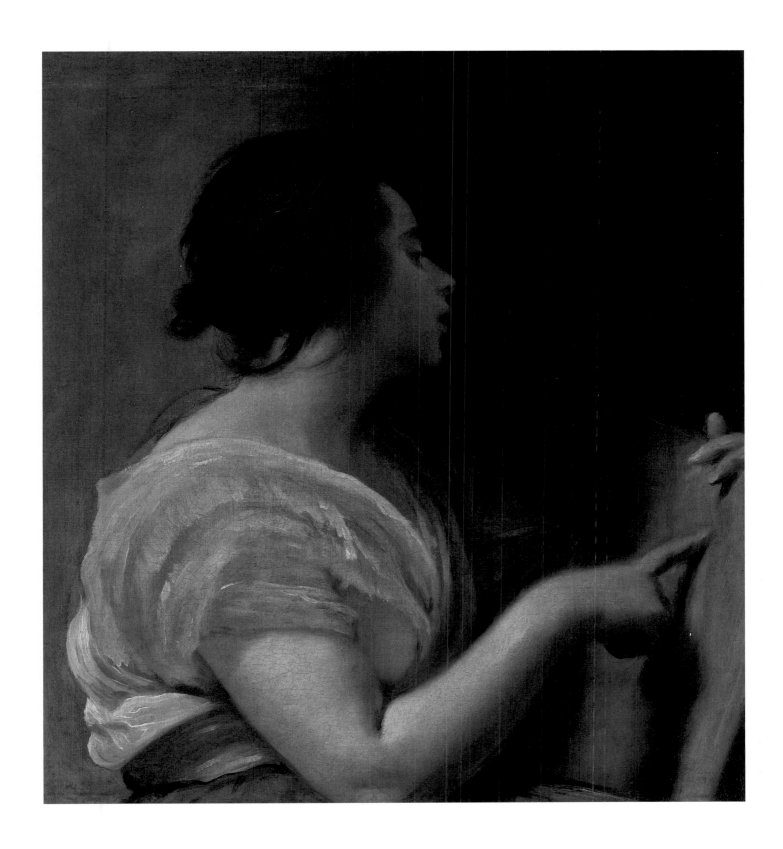

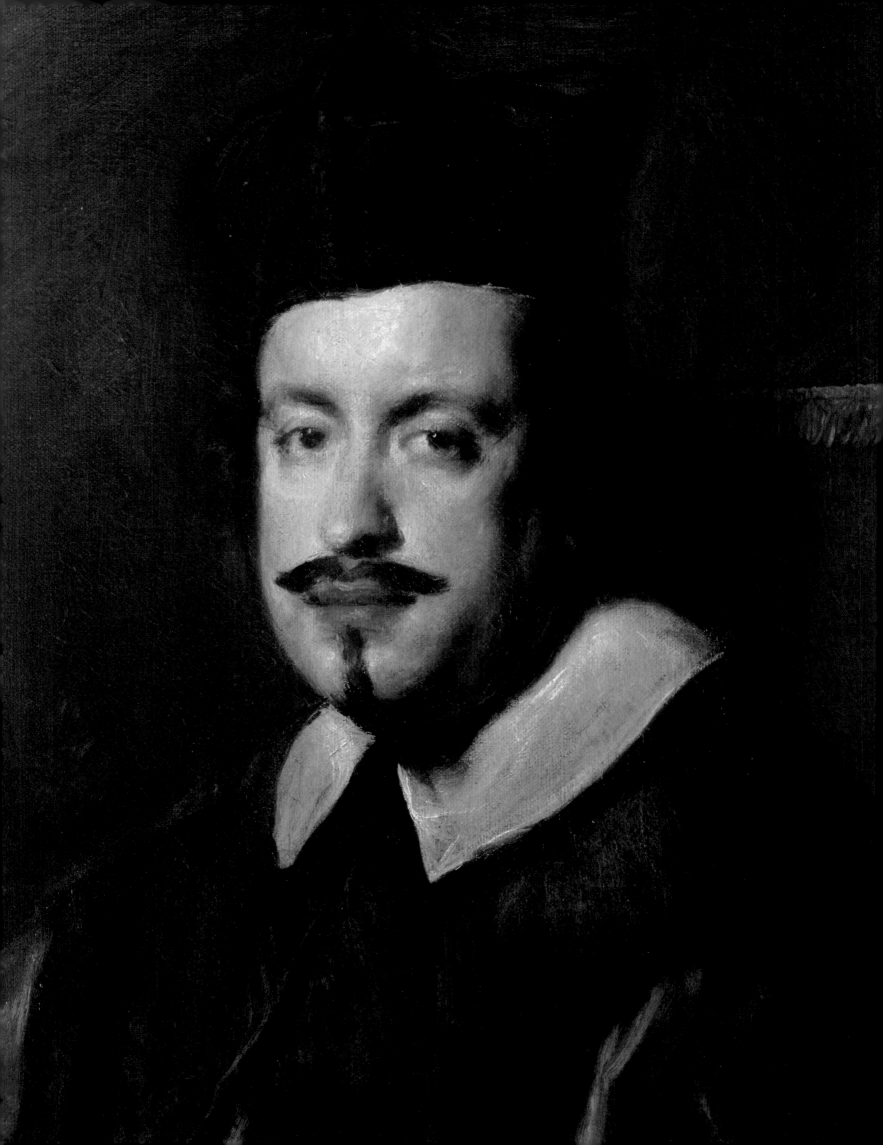

PORTRAYING TWO COURTS:
THE RETURN TO ITALY
AND THE FINAL YEARS IN MADRID

Velázquez set off for Italy again in late 1648 and was not back in Madrid until June 1651, though this was not a period of study leave as in 1629–30. His mission was to buy and commission works of art, mainly sculpture, for the decoration of the Alcázar and El Escorial. However, once he settled in Rome, he found time to paint, producing some of the greatest portraits of his career. It seems that Velázquez painted only portraits in Rome – while it is possible that *The Rokeby Venus* (cat. 37) may also have been created there, it is impossible to substantiate this without documentation.

In Rome, Velázquez painted his slave, Juan de Pareja (fig. 29) as an expression of the nobility of the art of portraiture, showing it at the annual exhibition of the Congregazione dei Virtuosi in the Pantheon. With this one exception, all the portraits he made in Rome depict members of the papal court. Velázquez had known Giovanni Pamphilj in his years as nuncio in Madrid during the 1620s, so we can presume that the painter's desire to return to Rome greatly intensified when his former acquaintance was elected pope in 1644, taking the name of Innocent X. Velázquez knew that a portrait of the pontiff would ensure his international fame, and win the pope's support for his admission to one of the Spanish military orders. The resulting portrait (fig. 28) achieved both, and today enjoys universal recognition as one of the greatest portraits ever painted for its insistent presence and projection of personality. One of the artist's greatest demonstrations of his suggestive technique, it must have seemed truly exceptional in relation to contemporary Roman

portraits, which were characterised by a high degree of finish in which brushwork played little role. Its immediate success can be measured by the other portraits that were commissioned. Camillo Massimo (depicted opposite, cat. 40), a high-ranking official in the papal court, was surely a connoisseur of some sophistication to understand and appreciate the broad suggestion of his features, particularly the moustache that looks like the work of mischief up close: two strokes of paint, but so flawlessly modulated that they function perfectly when seen from a proper distance. Velázquez apparently relished painting portraits away from the Spanish court, and all of the Roman works show a freedom in handling that makes them exceptional.

When Velázquez returned to Madrid, the demands for his skill as a portraitist were required by the royal family more than at any other time except during the 1630s. In 1644, Queen Isabella had died and, although Philip expressed no desire to remarry, the death of Baltasar Carlos two years later deprived him of an heir, so it was essential that he find a new wife. His niece, Mariana of Austria, originally betrothed to his son, was found to be the only suitable bride. They married in Velázquez's absence and when he returned to Madrid there was a new sense of hope. He could not set to painting the new queen immediately, however, as a few weeks after his arrival she gave birth to the Infanta Margarita, which required a long convalescence, so the full-length portrait was made only in 1652–3 (cat. 41). While there is perhaps a hint of her condition, it is well masked by Habsburg inscrutability and majestic presence.

Philip's new family was to become the principal subject of Velázquez's last years, but the Infanta María Teresa, the king's daughter with Isabella of Bourbon, was coming of age and suitors from royal houses across Europe were seeking portraits (cat. 43). One of Velázquez's last official acts was to help organise and attend the ceremony on the Isle of Pheasants in 1660, when the Infanta was presented to her new husband, Louis XIV.

Because he feared watching himself grow old, the king had not allowed Velázquez to portray him for almost a decade, but he finally allowed his painter to fulfil his primary function in maintaining an up-to-date image. Velázquez made two similar bust-length portraits a few years apart. The London example (cat. 44) is the last portrait Velázquez made of the man he had faithfully served for so many years. For the painter the king's visage was clearly always majestic, and he cannot hide the sense of sadness that was clearly etched on the monarch's face.

Margarita was a very beautiful child and Velázquez seems to have relished painting her at intervals so that her development could be followed by her cousin Leopold in Vienna, to whom she was promised. Hopes for a male heir were waning when, in 1657, the birth of Felipe Próspero brought great joy. The portraits of Margarita (cat. 45) and Felipe Próspero (cat. 46), dispatched to Vienna in 1659, were Velázquez's last portraits. They, and all the portraits of this period, were painted with such brilliant economy that it is difficult to imagine how Velázquez's technique might have developed further had he lived longer. DC

Camillo Massimo
(detail of cat. 40)

Pope Innocent X, 1650

Oil on canvas, 82 × 71.5 cm
Apsley House, The Wellington Collection, London
English Heritage (WM 1590–1948)

PROVENANCE

Marqués de la Ensenada, Madrid
(by 1768); acquired by Charles III,
Palacio Real Nuevo, Madrid
(1768–1813); Duke of Wellington,
Apsley House, London

ESSENTIAL BIBLIOGRAPHY

Wellington 1901, vol. I, pp. 158–61,
no. 47; Harris 1982, p. 151; Kauffmann
1982, pp. 142–4, no. 185; López-Rey
1996, vol. II, pp. 284–6; De Antonio in
Madrid 1996, pp. 54–5; Harris 1999,
pp. 217–19; Salort Pons 2002, pp. 118,
318–21, no. 12

Velázquez first met the Roman prelate Giovanni Battista Pamphilj in 1626, when Pamphilj arrived in Madrid with the Cardinal Legate Francesco Barberini. As papal nuncio, Pamphilj remained in Spain until 1630, and on various occasions he was helpful to Velázquez.[1] He left Spain with seven portraits of members of the Spanish royal family, some by Velázquez, others by his workshop.

Pamphilj (who was elected Pope Innocent X in 1644) honoured only a few artists, such as Algardi and Bernini, by sitting for his portrait. Velázquez was granted an audience on 13 August 1650, and the portrait he made was, according to Sir Joshua Reynolds, one of the finest in the world (fig. 28).[2] The portrait in the Galleria Doria Pamphilj is the most famous of the paintings Velázquez produced in Rome (see also figs 28–29). A powerful evocation of person and personality, the portrait had a huge impact, not only on painters; its fame is attested by several contemporary copies, most of them reproducing only the pope's bust.

By virtue of its quality and provenance, most scholars identify the Apsley House painting with a canvas Velázquez brought back from Rome. On 8 July 1651, in a letter addressed to Cardinal Camillo Francesco Maria Pamphilj, Giulio Rospigliosi wrote from Madrid that Velázquez had returned from Italy with some paintings, among which is 'a very like portrait of our Lord [Innocent X] which His Majesty has shown to enjoy very much'.[3] It is uncertain whether Velázquez gave the picture to the king, as stated by the artist's friend Lázaro Díaz del Valle in 1656, and it is possibly the papal portrait listed in the 1660 inventory of the artist's possession.[4]

In 1996, the Apsley House painting was examined alongside the Doria Pamphilj portrait in the National Gallery, London, and the comparison suggested that the heads were by the same hand, though the discoloured and cloudy varnish, particularly on the London painting, made confirmation difficult.[5] Though most scholars had not doubted that Velázquez painted the head, many thought that the mozzetta was added by another hand.

The cleaning of the Apsley House painting in 2006 revealed the extent to which the exceptional paint handling had been obscured by the old varnish. The lifelike quality of the head is now forcefully evident, as is Velázquez's strength and brevity of technique, perhaps most impressively seen in the piercing eyes, sitting perfectly in their sockets, formed with a few seemingly irregular strokes of the brush. All of the features are described without labour, nor is there a single dab of paint off the mark, which leaves little doubt that it is Velázquez's work. Comparison with photographs of the Doria Pamphilj head shows that the two paintings were constructed in a very similar manner, almost stroke for stroke, though the modelling of the Doria version is slightly more brief and sure. There is no disjunction between the paint of the head and the costume, so they would seem to have been executed at the same time. The great freedom with which the mozzetta has been described, as well as the achievement of form and depth with great economy, suggest that it too was laid in by Velázquez.

The restoration has not clarified which painting was made first. Palomino describes the picture brought back by Velázquez as a copy, implying that it was made after the Doria portrait, but he might simply have assumed this. It is also possible that the Apsley portrait was the one made in sittings with the pope, and this is lent credence by Velázquez's practice of taking the likenesses of royal sitters in head or bust studies. Also, if the London version were a copy of the Rome painting one would presume that the drapery folds would have been followed more closely. GM/DC

1 Harris 1999, p. 210.
2 The date of the portrait is documented by a letter sent to Francesco d'Este, Duke of Modena, by one of his agents in Rome, see Salort Pons 2002, p. 116 and p. 453, a67.
3 Harris 1958, p. 186.
4 Alternatively, the copy the artist brought back from Rome has been thought to be the Innocent X at the National Gallery of Art, Washington (now attributed to the circle of Velázquez). See Brown and Mann 1990, pp. 123–7 (entry by Brown), and pp. 45, 85 and 95 of this catalogue.
5 Harris 1999, p. 218; Salort Pons 2002, p. 118. See also Keith in this volume, p. 85.

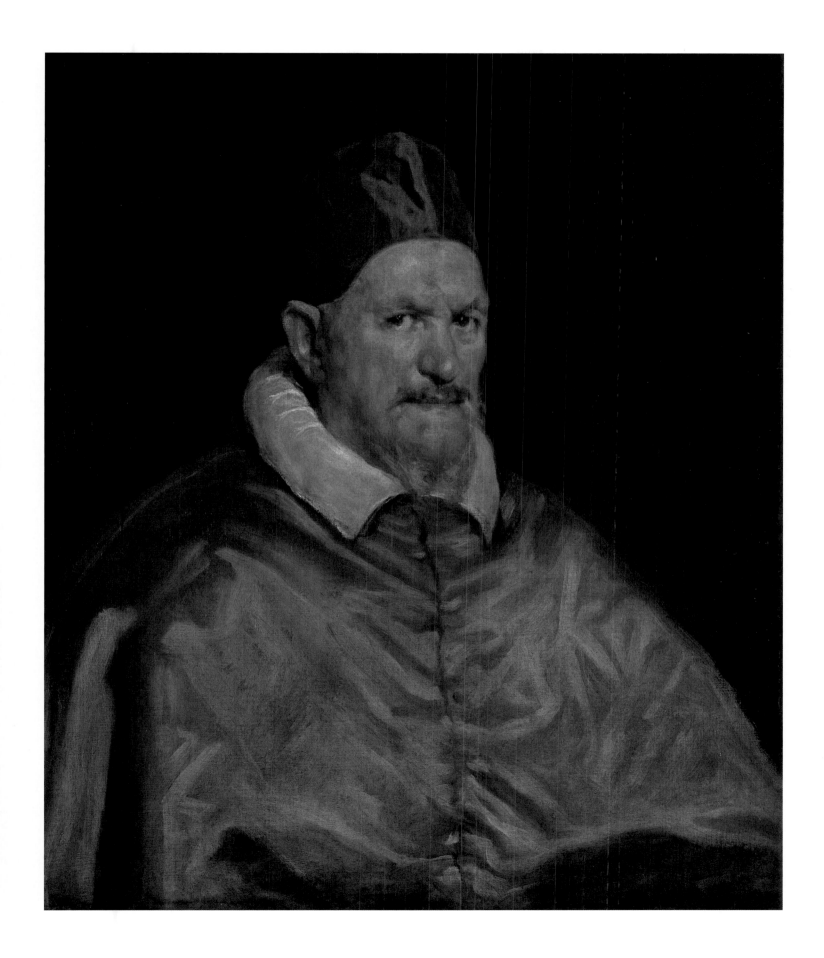

223

Camillo Massimo, 1650

Oil on canvas, 74 × 58.5 cm
Kingston Lacy, The Bankes Collection (The National Trust)

PROVENANCE

Camillo Massimo; Don Gaspar de Haro y Guzmán, Marqués del Carpio, Naples (1682); purchased in Bologna by an ancestor of Ralph Bankes before 1821; Kingston Lacy (Ralph Bankes, who died in 1982, bequeathed the house and its contents to the National Trust)

ESSENTIAL BIBLIOGRAPHY

Harris 1958b; Harris and Lank 1983; Gállego in Madrid 1990, pp. 396–9, no. 68; López-Rey 1996, II, p. 288; Salort Pons in Rome 1999–2000, pp. 82–3, no. 8; Salort Pons 2002, pp. 310–13, no. 9, ; Colomer 2003–4, pp. 41–4

Camillo (born Carlo) Massimo (1620–1677) belonged to one of the oldest and most distinguished of all Roman families, which claimed descent from Quintus Fabius Maximus.[1] After receiving a good humanist education from private tutors and at the Sapienza (University of Rome), he became a regular guest at the house of Francesco Angeloni, an important meeting place for antiquaries in Rome.[2] The circle of scholars and artists who gathered around Cardinal Francesco Barberini, and which included Cassiano dal Pozzo and Nicolas Poussin, also played a key role in Massimo's cultural education (Velázquez met Cardinal Barberini and Dal Pozzo when they visited Madrid in 1626).

As a member of this learned circle, Massimo was among the noblemen who encouraged Velázquez during his second trip to Italy. His ecclesiastical career began in 1646, when he was appointed *cameriere segreto* and apostolic protonotary by Pope Innocent X. In the following year Massimo was made Canon of St Peter's and cleric of the Apostolic Chamber.[3] A patron and collector of exceptional taste and intelligence, Massimo must have appreciated Velázquez's talent as a portraitist. Indeed, although Francesco d'Este, Duke of Modena, introduced Velázquez's painting to Italy (see cat. 28), the artist's main collector was Massimo, who had no fewer than six portraits by Velázquez in his collection.

Four of these portraits, depicting Philip IV, Queen Mariana and the Infantas María Teresa and Margarita, were acquired in 1657, at the time of Massimo's nunciature in Spain (1654–8).[4] The other two were a portrait of Olimpia Maildachini Pamphilj, the powerful sister-in-law of Pope Innocent X (probably painted by Velázquez in July 1650, but now lost), and this portrait, which was identified by Harris in 1958. Massimo was one of the few members of Innocent's court who sat for Velázquez during his second Roman visit, and his friendly relations with the artist are reflected in letters the two exchanged between 1654 and 1659.[5]

The sitter wears the official costume of a *cameriere segreto*, a rich peacock-blue silk soutane and a serge *soprana*, painted in ultramarine, a costly pigment that was better known and more easily available in Italy than in Spain. As noted by Harris, this plain habit is the most unusual feature of the painting as few, if any, prelates adopted it when sitting for their portrait.[6] The lightness of the habit would suggest that the picture was painted during the summer months, so suggesting a date in 1650, when Velázquez worked on the majority of the Roman portraits.[7]

Restoration at the National Gallery in 1983 revealed the remarkable subtleties of technique and colour that distinguish the different fabrics and give character to Massimo's prominent features.[8] The massive volume of the head is cleverly indicated by contrasting light and shade, while the thick lips and heavy-lidded eyes are constructed without drawing.[9] As in the other works of Velázquez's maturity, here the effect is based on absolute truth to life and on economy of paint, which make the physical and psychological veracity of the sitter almost tangible. GM

1 For Massimo's biography see Di Carpegna Falconieri 1996.
2 According to one of Massimo's friends, the art theorist Giovan Pietro Bellori, it was Angeloni who fostered his interest in antiquarian and numismatic studies, see Bellori's preface, in Angeloni 1685, p. VIII.
3 Massimo was appointed Patriarch of Jerusalem in 1653 and finally raised to the Cardinalate in 1670 by Pope Clement X.
4 For the payment of the four pictures and their presence in the inventory of Massimo's collection compiled after his death in 1677, see Colomer in Madrid–Rome 2003–4, appendix 2. a–b, p. 51. The prelate's collection was one of the most notable in Rome, and included classical and modern statues, as well as paintings and drawings, many of them reproducing antique monuments, see Buonocore 1996.
5 Harris 1960; Colomer and Harris 1994.
6 Harris 1958b, p. 410.
7 Salort Pons 2002, p. 310.
8 Harris and Lank 1983.
9 Massimo's strongly marked features have been read as indicating 'rather a surly and coarse character', see Haskell 1963, p. 116.

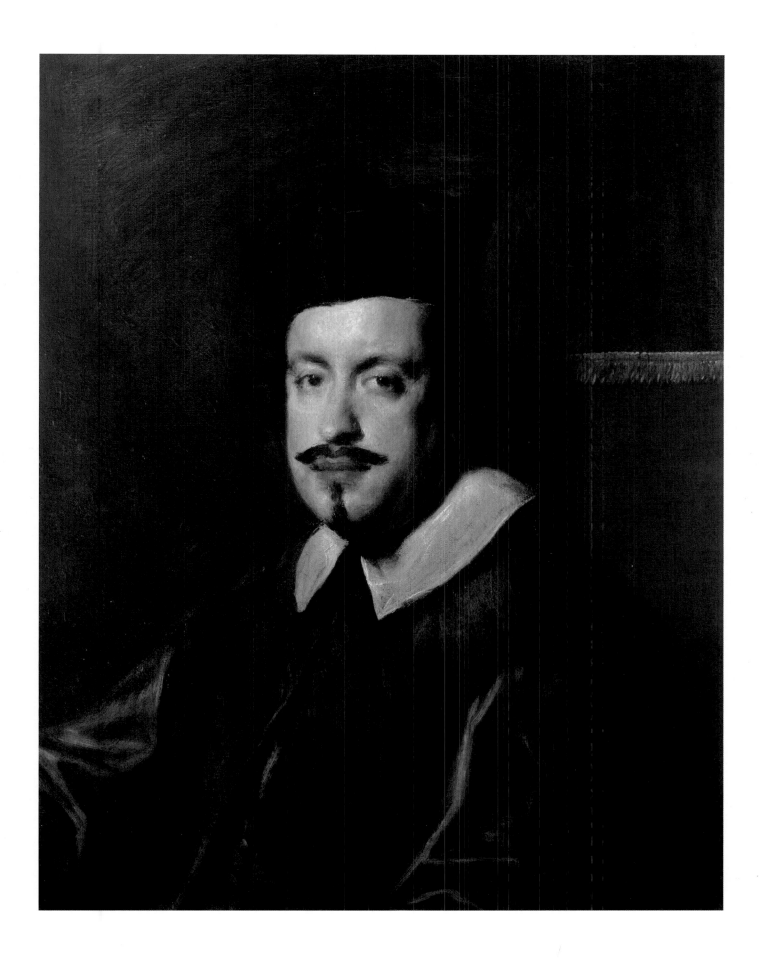

Queen Mariana of Austria, 1652

Oil on canvas, 234 × 131.5 cm
Museo Nacional del Prado, Madrid (1191)

PROVENANCE

El Escorial, Real Monasterio de
San Lorenzo (inventories of 1700,
1746, 1771, 1794, 1838 and 1843);
Museo Nacional del Prado, Madrid,
since 1845

ESSENTIAL BIBLIOGRAPHY

Gállego in New York 1989–90,
pp. 244–51, no. 35; Brown 1986,
pp. 218, 220–1; Garrido Pérez 1992,
pp. 527–37; López-Rey 1996, vol. II,
pp. 298–302; Brown in Madrid
1999–2000, pp. 140–3; Ruiz Gomez
in Madrid 2004–5, pp. 332–3, no. 13

This portrait of Queen Mariana (Maria Anna) of Austria, daughter of the Emperor Ferdinand III and the Infanta María (Philip IV's sister), is one of the most outstanding paintings of Velázquez's last decade. Mariana was betrothed to her cousin, Baltasar Carlos, when his premature death in 1646 left Philip IV without a male heir. To preserve the Habsburg hegemony in Europe the king decided to marry his niece, despite their considerable age difference: on their wedding day, 7 November 1649, Philip was over forty and Mariana just fourteen, only four years older than her stepdaughter María Teresa (whom she resembled closely, see cats 42–3).[1]

On 7 July 1650 Ferdinand III wrote to Philip IV, asking for a portrait of his daughter after her marriage. Velázquez was in Italy at that time, and it seems that one of his assistants started the painting of her mentioned in a letter of 5 May 1651.[2] Two months later Mariana gave birth to her first child, Margarita, and due to illness after her confinement she was probably not able to sit for Velázquez for some time. The work must have been completed by 15 December 1652, when a portrait of the queen was sent to Vienna with the embassy of the Marquis of Caracena. That picture, now in the Kunsthistorisches Museum, Vienna, is a workshop replica of the present painting. A second replica, present whereabouts unknown, was dispatched to Archduke Leopold William on 22 February 1653.[3]

In 1700 the *Queen Mariana* was listed as a pair with the portrait of *Philip IV in Armour with a Lion at his Feet* (now in the Prado and generally attributed to Velázquez's workshop) in the king's chambers in the Escorial. Before this date, a hand other than Velázquez added a piece of canvas to the top of the original composition and painted the upper part of the curtain, to make the picture the same size as Philip IV's portrait. Interestingly, X-rays and infrared reflectography have revealed a head of Philip IV underneath that of Queen Mariana, indicating that Velázquez reused a canvas for this portrait.[4] With exceptionally loose and sparkling brushwork, Velázquez demonstrates his prowess as a colourist, creating an image that 'though close up cannot be understood, from a distance is a miracle'.[5]

In the painting, Velázquez's only full-length portrait of the queen, Mariana holds a rather stiff pose, addressing the viewer with an inexpressive gaze. None the less, the image, which follows the formal etiquette of official court portraits, conveys a sense of royal majesty: Mariana wears a splendid silver-braided black costume adorned with red ribbons and jewellery, including gold chains, bracelets, and a large gold brooch pinned to the bodice.[6] A wide headdress decorated with ribbons and plumes frames her rouged face. By concealing the young queen beneath the armour of courtly constraint, Velázquez reveals her fashionable magnificence as a theatrical show. GM

1 Indeed the portrait of María Teresa in the Kunsthistorisches Museum, Vienna (cat. 43), painted by Velázquez in 1653, shows her in a pose almost identical with that of Queen Mariana here.
2 It is possible that this picture was never completed.
3 A third full-length workshop replica, formerly in the Prado, has been in the Louvre since 1941, while additional versions of different formats can be found in other museums, see Madrid 1999–2000, pp. 140–1.
4 Garrido Pérez 1992, pp. 530–1.
5 Palomino 1724 (1982), p. 204.
6 The chair and the table-clock are also symbols of royal status. See further Gállego 1984, pp. 220–3, 226–7.

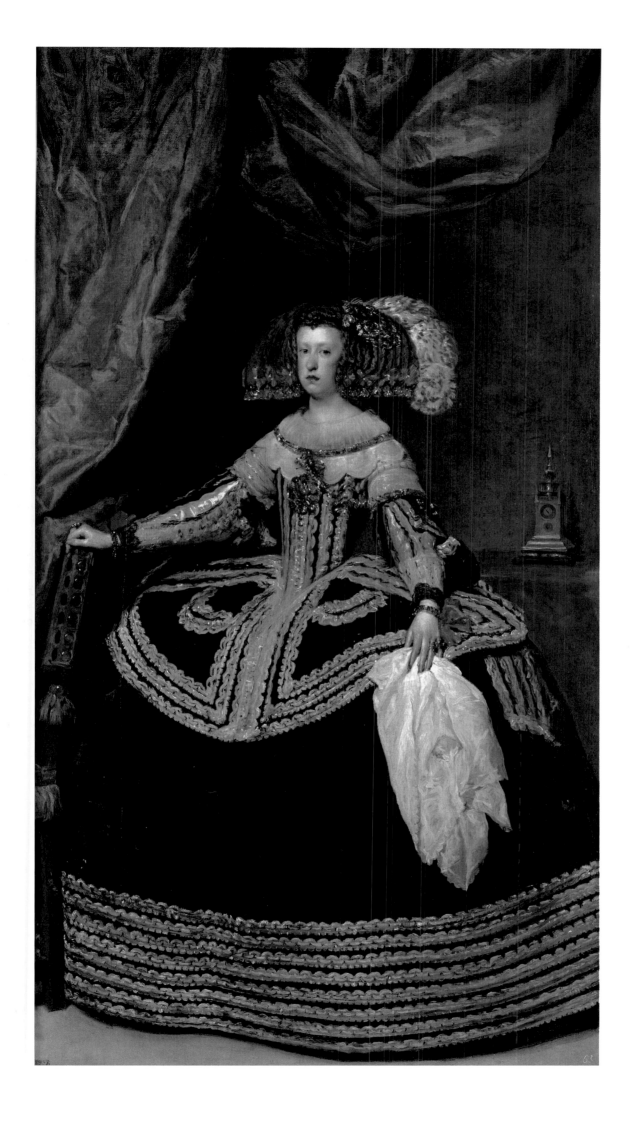

Infanta María Teresa, probably 1652/3

Oil on canvas, 34.3 × 40 cm (original painted surface 32.7 × 38.4 cm)
The Metropolitan Musem of Art, New York
The Jules Bache Collection, 1949 (49.7.43)

PROVENANCE

Philippe Ledieu, Paris (by 1874; died 1899); Colonel Oliver H. Payne, New York (probably from 1899, died 1917); Harry Payne Bingham, New York (1917–27); Duveen, New York, and Knoedler & Co., New York (November 1927–February 1928); Duveen, New York, 1928; Jules S. Bache, New York (died 1944; his estate, 1944–9)

ESSENTIAL BIBLIOGRAPHY

Zimmermann 1905, p. 189, fig. 16; López-Rey 1963, p. 104, no. 385, pl. 141; Gudiol 1973, no. 145; Brown 1986, pp. 217ff; New York 1989–90, no. 34; Madrid 1990, no. 70; López-Rey 1999, no. 118

108.

Infanta María Teresa, 1651?
Oil on canvas, 48 × 37 cm
The Metropolitan Museum of Art, New York
Robert Lehman Collection
(1975.1.147)

An outline of María Teresa's biographical details and the dynastic-political entanglements between the various candidates for her hand in marriage is given in cat. 43. The dynastic complications intensified in 1646, when the Infante Baltasar Carlos died, and until the birth of Infante Felipe Próspero in 1657, the Spanish Habsburg throne had no successor. During this period the Infanta was, so to speak, 'on the market'. Despite these pressures, the court delayed negotiations until the end of the war between Spain and France in 1660 so that she could marry the French king, Louis XIV, a match that was both long contemplated and pleasing to the infatuated princess. However, from the broader Spanish point of view, there were potential French claims to the Spanish throne to contend with, arising from the marriage of an infanta to a non-Habsburg power. Paradoxically, it was the grandson of María Teresa from her marriage to Louis XIV, Philip of Anjou (1683–1724, King Philip V of Spain in 1700), who was later to assert his claim against other pretenders to the throne, above all against the claims of the younger son of Emperor Leopold I, later Emperor Charles VI (as rival candidate King Charles III of Spain).

The call for portraits of the young infanta escalated after she had reached marriageable age, around 1651–2, a date coinciding with the return of the highly admired court painter Velázquez from Italy. Besides his duties as governor of the royal household and as master of the ceremonies of the Madrid court (*aposentador mayor de palacio*),[1] a post he held for the following nine years, Velázquez's task now was to portray the new family of King Philip IV. Philip had entered into a second marriage in 1649, this time to his niece Mariana (Maria Anna). In addition to painting the young queen (cat. 41) and the ageing king (cat. 44), Velázquez and his workshop had to paint their children, among them the sole surviving child of Philip from his first marriage, María Teresa.

Despite the protracted war between France and Spain, an exchange of portraits between the courts of Paris and Madrid was agreed upon and welcomed on both sides; for although the siblings of Anne of Austria, the wife of Louis XIII, and Philip IV were estranged, political calculation weighted the scales, as, in the final event, did the palpable and

exploitable ties of blood. It has never been proved definitively that the present portrait was one of the works sent to France through the agency of the ambassador of the Venetian Republic in 1653, or that it was among the nineteen portraits that Anne of Austria requested from Philip IV in March 1654,[2] or that the portrait of the Infanta now in the Louvre belongs to this group – the provenance of the pictures in France simply does not go back far enough.[3]

This is a fragment of a lost, probably half-length, version preserved by a workshop copy in the John G. Johnson Collection at the Philadelphia Museum of Art. The Infanta wears an elaborately dressed wig: the waved, brown hairpieces have been adorned with starched ribbons interwoven with silver threads in the form of butterflies. The eyes scrutinising the beholder, the cheeks, still half-childishly rounded, the rouged lips, already featuring a slight Habsburg fullness, are painted with all the sensuous luminosity and delicacy available to Velázquez, especially after his experiences in Italy, and which magically characterise the adolescent child. Only Van Dyck was capable of rendering youth with such conviction, indeed, such tenderness.[4]

It is not an easy task to establish a chronological order for the surviving group of pre-marital portraits of the Infanta, attributed variously to Velázquez himself and to his workshop.[5] Guessing age, especially with children, is notoriously inexact. Hence the opinion that the portrait of the Infanta in the Lehman Collection of the Metropolitan Museum (fig. 108) was painted before Velázquez's departure for Italy in November 1648[6] (because she looks much younger than in the present portrait) has not been without controversy. But it is difficult to arrive at a scholarly consensus when assessing undocumented portraits.

Admittedly, a chronological order, according to the Infanta's age, of first fig. 108, then cat. 42 and finally cat. 43 and fig. 109 is plausible, although it is hard to believe that three years lie between the Lehman Collection portrait and the present one. It is more likely that the Infanta of the Lehman Collection was not ten, but thirteen years of age in the summer of 1651. Thus the present picture portrays a fourteen-year-old and cat. 43 a fifteen-

108

year-old. However, young girls tend to change very rapidly at this age. This is presuming, of course, that Velázquez proceeded 'realistically' in his royal portraits, which is not at all proven.

Just as we are accustomed to seeing the Stuart court through the eyes of Van Dyck, so we see the Habsburg court in Madrid through the eyes of Velázquez and his workshop; however, we may have our doubts whether these persons looked like this in reality. Apart from the incomparable quality of Velázquez's execution, the Infanta Margarita, for instance – María Teresa's half-sister and wife of Emperor Leopold I – did look rather different when painted at the Viennese court by Central European artists.[7] The same is true of the Infanta María Teresa painted as queen of Louis XIV by Charles and Henry Beaubrun.[8]

The portrait closest in style to the present picture seems to be the full-length one of María Teresa's stepmother Mariana in the Museo del Prado (cat. 41), which can be dated fairly securely to the end of the year 1652.[9] WP

1 Brown 1986, pp. 215–17; see Justi (1933), under *aposentador*.
2 On the despatching of these pictures see Zimmermann 1905, pp. 187–c; Brown 1986, pp. 217ff.
3 López-Rey 1963, no. 389, pl. 333.
4 One thinks here of the young Marchese di Borgomanero(?) in the Kunsthistorisches Museum, Vienna, of 1634. See Barnes et al. 2004, no. III, 79.
5 López-Rey 1963, nos 384–93.
6 López-Rey, no. 109.
7 See Kunsthistorisches Museum, Vienna 1982, figs 214, 219; Graz 1933, nos 6–8.
8 See Nantes-Toulouse 1997, ill. pp. 24, 25, 51.
9 López-Rey 1999, no. 121.

Infanta María Teresa, 1653

Oil on canvas, 127 × 98.5 cm (originally full-length, cut considerably
at the sides and at bottom)[1]
Kunsthistorisches Museum, Gemäldegalerie, Vienna (353)

PROVENANCE

In the Imperial collection from
about 1653

ESSENTIAL BIBLIOGRAPHY

Zimmermann 1905, pp. 185, 188;
Justi (1933), p. 667 (regarded as
the portrait of Mariana (Maria Anna)
in 1888, corrected by the editor in
the 1933 edition); López-Rey 1963,
pp. 104f, no. 386, pl. 143; Gudiol 1973,
no. 150; Brown 1986, pp. 217, 299
note 22; López-Rey 1999, pp. 191,
193, no. 119

The Infanta María Teresa was the daughter of King
Philip IV and his first wife Isabella of Bourbon
(daughter of Henry IV of France and Maria de' Medici).
Her markedly Habsburg features derive from her
father, as well as her Bourbon mother, both of whose
parents contributed hereditary Habsburg traits.
María Teresa's similarity to her stepmother, Philip IV's
second wife Mariana – a purely Habsburgian
queen one could say, only 4 years older than her
stepdaughter – was the cause of frequent confusion
when dealing with unidentified portraits (even for
such a brilliant connoisseur as Justi).[2]

In the complicated rivalry between the courts of
Madrid, Vienna and Paris, María Teresa was marked
out by the French Prime Minister, Cardinal Jules
Mazarin, to marry the successor to the French throne,
the future Louis XIV, who was her age and a first
cousin through his mother, Anne of Austria, sister
of Philip IV.[3] However, after the death of the Spanish
crown prince Baltasar Carlos in 1646 any marriage
that introduced the possibility of a French claim
to the Spanish throne was regarded with suspicion
on the Spanish side as long as there was a chance
of a legitimate Spanish-Habsburg successor. Only
after the birth of the Infante Felipe Próspero in
1657 (cat. 46) did a ceremonial wooing of the bride
take place in the late autumn of 1659. The peace
treaty between Spain and France, sealed in 1660
on the Isla de los Faisanes (the Isle of Pheasants,
see p. 22) in the Pyrenees, then paved the way for
the couple's marriage – both of whom were now
quite 'mature' for the conventions of the time –
in June that year.

There had been previous endeavours to find
a suitable husband for this pretty and vivacious
princess:[4] first to the eldest son of Emperor
Ferdinand III, Ferdinand IV (King of the Romans
in 1653, who died young in 1654 however); then to
Ferdinand III's already elderly brother Archduke
Leopold William (the famous collector).[5] All this
courtship led to the production and dispatching
of numerous portraits of the young princess
(see also cat. 42). The present portrait can be dated
roughly to early 1653, as on 22 February 1653 Philip IV
had another version (now Museum of Fine Arts,
Boston) sent to Archduke Leopold William.

109

Whether the portrait exhibited here was sent
at the same time to Philip IV's father-in-law, the
Emperor Ferdinand III, or only sometime later,
before December 1653, cannot be confirmed by
the somewhat vague references in the letter of the
Venetian ambassador in Madrid.[6] However, at
the end of December 1653 or early in January 1654,
another version of the painting was sent to Paris
(although it is unlikely that this was the half-length
version now in the Louvre).[7] At any rate three
potential candidates for the hand of the 15-year-old
princess were supplied with portraits.

The Vienna picture of María Teresa shows her
standing in front of a bluish-green background,
resting her right hand on a table covered with a
green cloth. The dress and accessories, and the
head, with the slightly protruding eyes, are rendered
in a subtle interplay of silver, white and pink. Her
crinoline, the *guardainfante*, is in the wide, side-
pannier fashion then very much in vogue, with two
watches attached to it with red ribbons.[8] She wears a
voluminous, richly decorated wig, a collar of pleated

109.
Infanta María Teresa, 1653
Oil on canvas, 128.6 × 100.6 cm
Museum of Fine Arts, Boston
Gift of Charlotte Nichols Greene in
memory of her father and mother,
Mr and Mrs Howard Nichols, 1921
(21.2593)

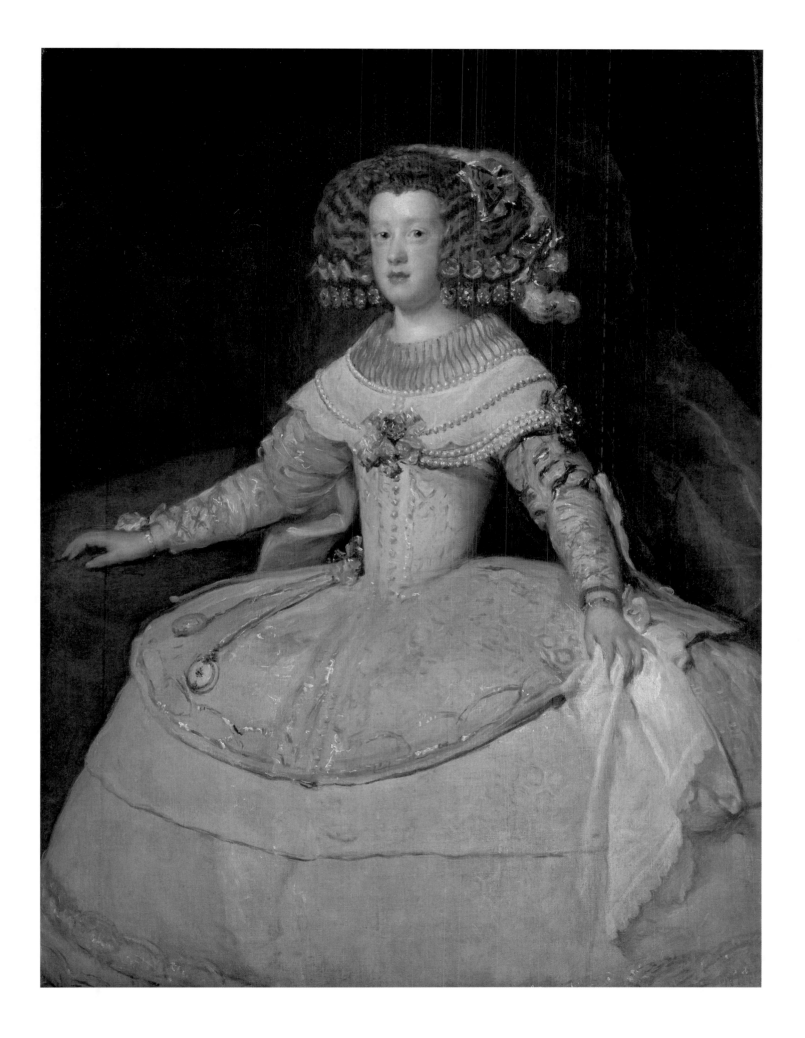

tulle frills, and a closely fitted waisted top with hanging sleeves. Harmonious in colour, although entirely artificial in affecting 'the natural look', the thick make-up in red and mother-of-pearl tones blends in with the pink tulle collar. The material of the *guardainfante* is comparatively frugal in detail, with few highlights, but the richness of colour and description intensifies towards the upper body and head, culminating in a scintillating display of disparate, tightly applied brushstrokes which coalesce only at a certain distance. The heavily made-up face is painted into chased and polished smoothness, implying that the lack of detail in the lower half of the picture does not necessarily indicate an unfinished state – the painting was intended for the emperor after all – but a deliberate artistic technique. WP

1 The original dimensions of the version from Archduke Leopold William's collection, which came to Vienna with the rest of his collection in 1656 and was also kept in the Kunsthistorisches Museum until 1921 (no. 618), provide evidence for the original format of the picture exhibited here: inventory of 1659, German and Netherlandish paintings, no. 390: converted dimensions 207 × 128 cm (published in *Jahrbuch der kunsthistorischen Sammlungen des Allerhöchsten Kaiserhauses*, 1, 1883). This version has been in the Boston Museum of Fine Arts since 1921 (dimensions now 128.5 × 100.5 cm), see López-Rey 1963,

no. 387, pl. 331, and is generally regarded as a studio copy with only minor contribution by the master himself. For the basic dates see also *Verzeichnis der Gemälde*, Kunsthistorisches Museum, Vienna 1991, p. 128.

2 See Justi (1933), p. 667. The 'bad-tempered' expression of Queen Mariana conveyed by the downturned mouth provides an excellent example with which to distinguish her features from those of the Infanta María Teresa; in addition, her eyes are more protruding than those of her stepmother.

3 On the political situation and time of engagement, and on the princess's genuine love for King Louis, declared of age in 1651, see Justi (1933), pp. 671–6.

4 See the description of the Infanta by Madame de Motteville, lady-in-waiting and friend of Queen Anne of Austria, written in 1660 in a letter to her brother: Zimmermann 1905, pp. 191–2.

5 See Schreiber 2004, pp. 38–41 (Der 'baufällige' Heiratskandidat). In 1655/6 Madrid considered the crown prince Leopold (future Emperor Leopold I) as a possible candidate for María Teresa.

6 See Zimmermann 1905, pp. 186–90, with details of the various ambassadorial reports on the dispatch of the portraits; on the interpretations of the sections in the letters: see Brown 1986, pp. 299ff. On the Boston example see note 1; conspicuous by their absence are the fabric rosette attached to the collar above the right upper arm, and a chain of pearls that links it to the bow over the breast.

7 López-Rey 1963, no. 389, fig. 332 (not 333); nothing is known of its earlier provenance. It is a part copy of the picture exhibited here, thus the version for the emperor.

8 In Leopold William's inventory they are described as 'zwey kleine Vhrl' (two little watches); though the one placed further to the rear could be a miniature portrait in oval form.

Philip IV of Spain, about 1656–7

Oil on canvas, 64.1 × 53.7 cm
The National Gallery, London (NG 745)

PROVENANCE

In the collection of Prince Anatole
Demidoff, convent of San Donato,
Florence, by September 1862, and
still there in September 1864;
purchased from Emanuel Sano,
Paris, in June 1865

ESSENTIAL BIBLIOGRAPHY

MacLaren 1970, pp. 108–13; Brown
1986, pp. 229–30; Gállego in New
York 1989–90, pp. 260–5, no. 38;
López-Rey 1996, vol. I, pp. 188, 203;
Morán Turina 2004b, pp. 102–5

In a letter to Sister Luisa Magdalena de Jesús, written in July 1653, Philip IV apologised for not being able to send her a portrait of himself, revealing that he had not had one made for nine years. He admitted to being not entirely happy with Velazquez's phlegmatic approach – his *flema* – or at seeing himself ageing.[1] Nevertheless, the king of Spain must have changed his mind, because he agreed to pose for a bust-length portrait in the Prado (fig. 110) before 1655, when the likeness was used by Pedro Villafranca in an engraving. The National Gallery painting was made a few years later, judging from the king's ageing features, and certainly before 1657, when it was used by Villafranca for the frontispiece of Francisco de los Santos' *Descripción breve de San Lorenzo el Real de El Escorial*.[2] Considering the king's expressed fear of seeing himself age, we are left to wonder why the second portrait was made.

In the Prado version the king wears a simple black silk costume. In the present painting the dress, probably made of velvet or wool, is adorned with gilded buttons and embroidery on the sleeves. Furthermore, the sitter wears a gold chain with the badge of the Golden Fleece. The treatment of the head and collar in the two pictures differs only in small ways, the greater variation being the more pronounced signs of ageing in the London portrait.[3] It is painted in such a similar manner, with almost matching brushstrokes, that it might represent an adjustment to the Prado portrait made without the sitter. Adopting an austere composition Velázquez used no flattery in depicting the fifty-year-old king's sagging flesh, puffy eyelids and scaly eyebrows.

With great economy, Velázquez created a faithful representation of his royal patron, an image that is convincing in its humanity. Velázquez's late portraits of Philip IV convey a sense of weariness and sadness, the disillusion of a monarch who, at that time, was struggling with political problems in Spain and the rest of Europe. The contemporary writer Lázaro Díaz del Valle, who saw in a late portrait of the king 'much soul in live flesh', wrote that it 'inspired respect and aroused much worthy veneration and reverence, since it only lacked the voice'.[4]

The attribution of this picture has been sometimes doubted, especially for the quality of the

110

painting of the costume and chain, inferior to other royal portraits executed by Velázquez in this period.[5] Nevertheless, the success of this image, clearly approved by the king and copied many times, as well as the quality of the head, make it likely that it was painted by Velázquez.[6] GM

1 Moreno Garrido and Garmontal Torres 1988, p. 21.
2 For the two engravings, see McDonald 2000, pp. 43–5.
3 Acknowledging the poorer condition of the version in London, Brown (1986, p. 229) noted that the head is painted in a smoother manner than that in the Prado portrait and compares it to the 1659 *Portrait of the Infanta Margarita* in Vienna.
4 Díaz del Valle 1656–9, p. 27.
5 López-Rey (1996, vol. I, p. 188) attributes the portrait to Juan Bautista Martínez del Mazo.
6 The best-known copies of this portrait are in Vienna and Cincinnati; for a list of the copies see New York 1989–90, p. 264. In a number of portraits of Philip IV of entirely different composition, the head is copied from the present painting or a similar version. See for example the *Philip IV in Armour*, attributed to the workshop of Velázquez, and the *Philip IV* by Pedro da Villafranca, both in the Prado. The function of the late portraits of Philip IV in London and Madrid has been the subject of debate (see Brown 1986b, p. 143), but most scholars now agree that they were intended as official images, which were later copied and used as models for different compositions.

110.
Philip IV of Spain, before 1655
Oil on canvas, 69 × 56 cm
Museo Nacional del Prado,
Madrid (1185)

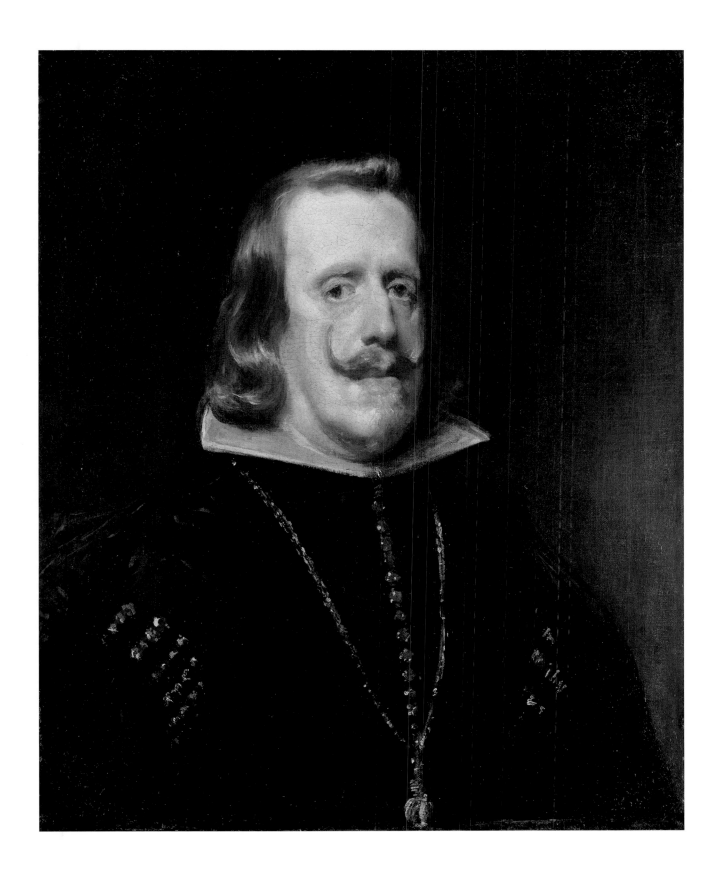

235

Infanta Margarita in a Blue Dress, 1659

Oil on canvas, 127 × 107 cm (cut on all sides)
Kunsthistorisches Museum, Gemäldegalerie, Vienna (2130)

This painting is the latest of three portraits of the Infanta Margarita by Velázquez in the Kunsthistorisches Museum. All three testify to the close dynastic connection between the Spanish and Austrian branches of the Habsburgs in the seventeenth century, a densely intertwined family tree that (apart from other 'dynastic' motives) contrived to foil possible hereditary claims of non-Habsburgian families. This was a matter of some concern because of a dearth of children in both branches, and because of the precarious health of many family members. The frequent intermarriages between extremely close relatives led to a loss of fertility and increased the Habsburgs' susceptibility to illness and disease.

The Infante Baltasar Carlos, only son of Philip IV of Spain and Isabella of Bourbon and a bright hope as successor to the throne, died suddenly in 1646 at the age of sixteen, forcing Philip, a widower since 1644, to consider re-marriage. He chose the young Archduchess Mariana (Maria Anna) (1634–1696, cat. 41), his niece. She was the daughter of his sister María (wife of Emperor Ferdinand III) and had been betrothed to Baltasar Carlos before his death. The marriage ceremony took place by proxy in Vienna in October 1649, when the bride was just fourteen. Immediately afterwards she set out on the long journey to Madrid, via Trent and Milan.

Infanta Margarita was born on 12 July 1651, the royal couple's first child. She was promised in early childhood (probably after 1654) to her uncle – also her cousin – the crown prince Leopold, from 1658 Emperor Leopold I. Three portraits of the Infanta by Velázquez were sent to Vienna over the years, and are now in the Kunsthistorisches Museum. The earliest was the *Portrait of Margarita in a Pink Dress*, for which Emperor Ferdinand III thanked his brother-in-law, King Philip IV, on 8 October 1654.[1] Two years later, in 1656, it was followed by the *Portrait of Margarita in a White Dress*, which corresponds both in dress and stylistically to the contemporary portrait of the Infanta in *Las Meninas* (fig. 30). The present work, painted in 1659, was the last. Palomino described it thus: 'The other portrait [to be sent to the Emperor in Germany] was of the Most Serene Infanta Doña Margarita ... of Austria, excellently painted and with

the majesty and beauty of the original. To her right, on a small console table, there is an ebony clock of very elegant design, with bronze figures and animals; in its centre is a circle where the chariot of the sun is painted, and within the same circle there is a smaller one with the division of the Hours.'[2]

Palomino reports that the portrait was despatched to the Viennese court with the *Infante Felipe Próspero* (see cat. 46). In 1666 Margarita Teresa, aged fifteen, went to Vienna and on 12 December married Leopold I.

The couple had four children, of whom only the daughter, Maria Antonia (1669–1692), survived infancy. Margarita Teresa herself died prematurely in 1673 at the age of 22, but Maria Antonia provided the legitimacy for her future husband, the Bavarian elector Max Emanuel, to claim the Spanish throne for his under-age son Joseph Ferdinand (born 1699), while the childless Spanish king, Charles II (died 1700), was still alive. This countered the claims of Emperor Leopold's son, later Emperor Charles VI, from his third marriage and of the Bourbon Pretender, Philip of Anjou, grandson of Louis XIV of France from his marriage to the Infanta María Teresa (cat. 43), the stepsister (daughter of Philip IV from his first marriage) of Margarita Teresa, portrayed here.

The portrait was cut, probably in the eighteenth century, into an irregular oval. It then disappeared from view until 1923, when it was found in a depot in the Hofburg, re-shaped into a rectangular format, with the corners added on. Gustav Glück pronounced it the original Velázquez mentioned by Palomino, an attribution uncontested to this day.[3]

Until the rediscovery of *Infanta Margarita in Blue* a portrait of *Infanta Margarita in a Green Dress* (now in Budapest, fig. 111) was regarded as the one Palomino had described.[4] Justi did not consider this to be Velázquez's work when he saw it in the Imperial Gallery in Vienna, where it was regarded as by Mazo or Carreño (the consensus today gives it to Mazo).[5] Apart from the colouring – a green rather than a blue dress – this work corresponds almost exactly to the present portrait. The Budapest version is also cut on all four sides, but since it has been better preserved and is more complete than the present picture, its serves to reconstruct cat. 45 – especially

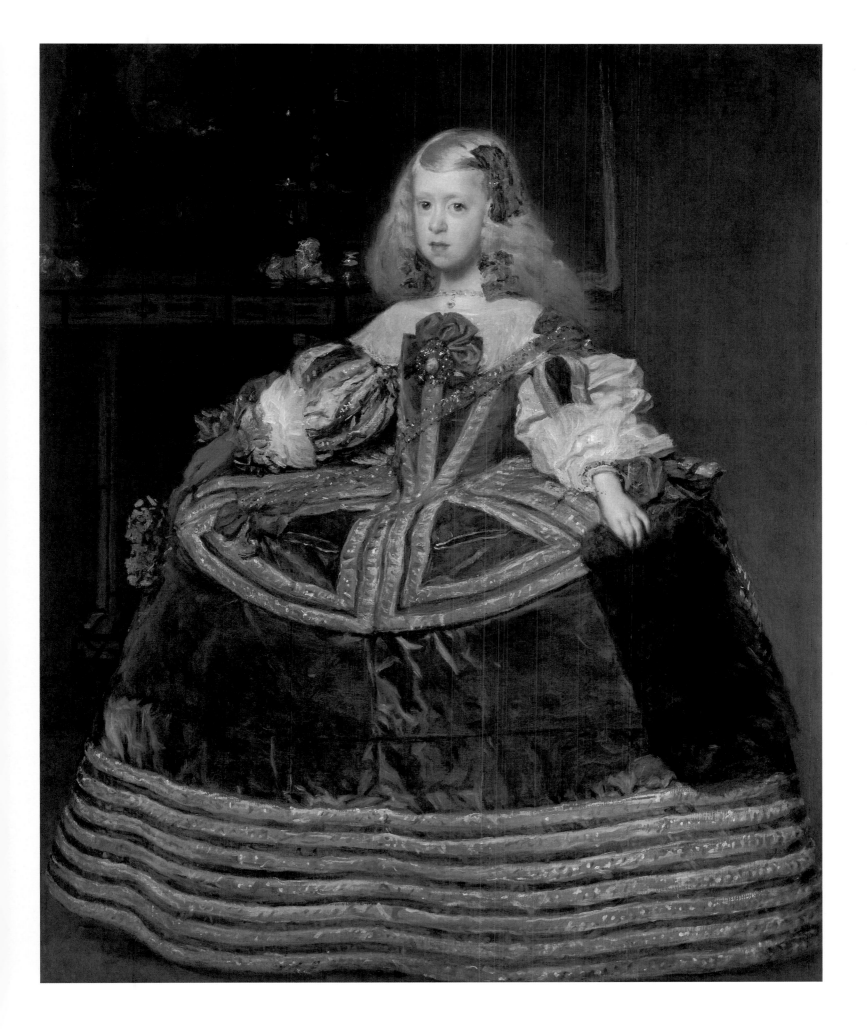

111.
Juan Bautista Martínez del Mazo
(about 1612/16; died 1667)
**Infanta Margarita in
a Green Dress**,
about 1659
Oil on canvas, 121 × 107 cm
Szépművészeti Múzeum,
Budapest

perhaps the background, although this is not clearly defined in the Budapest version either.

Margarita Teresa wears a blue silk dress richly adorned with silver borders after the Spanish fashion in vogue from the 1640s, its most striking characteristic the huge expanse of the voluminous crinoline, the *guardainfante*. Its width is further accentuated by the horizontal pattern of the trimmed borders, the wide lace collar, the puffed sleeves and the enormous fur muff – might this last have been a present from Vienna? The palette is restricted to a few blue, silver and white tones –

and some browns – tones that enhance the pale countenance of the young girl. The princess is presented as pretty and appealing. The room remains in shadow for the most part, but in the background one can make out a high console table with a sketchy round mirror (mainly reconstructed after Mazo's copy) behind it. On the table is a clock, as Palomino described, and one of the two bronze lions seen in the copy. The brown oblong area on the right perhaps depicts a textile decoration.

In his royal portraits, Velázquez employs his superb painterly skills – once defined as a combination of an infallible eye and speed of execution[6] – to instil new life into the traditional sixteenth-century Spanish court portrait that, after more than a century, had petrified into a rigid format. The basic problem of the courtly portrait is that of reconciling the traditional portrait formula, and its clichés of gesture and deportment, with an in-depth interpretation of character: a delicate balance, masterfully controlled by Velázquez. His consummate skill is even more keenly felt here than in works by that other great court portrait painter, Van Dyck – because it is achieved without affectation. With incredible assurance, Velázquez weaves what he sees into a seemingly loose structure of freely placed, unmixed strokes and dots of colour. The web of brushstrokes fuses into coherence only when viewed from a certain distance. WP

1 Madrid 1999–2000, p. 158.
2 Palomino 1724 (1987), p. 173.
3 Glück 1926. A condition report and a catalogue entry on the last cleaning and restoration of the painting by Hubert Dietrich are published in Vienna 1996, no. 38.
4 Museum of Fine Arts, Budapest (inv. no. 1826). See Nyerges in Budapest 1996 and Budapest 2006.
5 See Justi (1933), no. 120.
6 Justi (1933), pp. 636–44.

111

Infante Felipe Próspero, 1659

Oil on canvas, 128.5 × 99.5 cm (cut at least 6 cm at right and top)[1]
Kunsthistorisches Museum, Gemäldegalerie, Vienna (319)

PROVENANCE

In the eighteenth century in the Graz castle, Kunstkammer; 1765 in the Imperial Castle, Vienna; from 1816 in the Imperial Gallery of Paintings, Belvedere Palace, Vienna; 1891 transferred to the Kunsthistorisches Museum, Vienna

ESSENTIAL BIBLIOGRAPHY

Justi (1933), pp. 681–3; López-Rey 1963, pp. 115 ff., no. 334; Gudiol 1973, no. 158; Brown 1986, p. 229; López-Rey 1999, vol. 1, pp. 184, 225, vol. 2, no. 129; Brown in Madrid 1999–2000, no. 12; M. Mena Marques in Madrid 2004, no. 54; Pérez Sánchez in Naples 2005, no. 27

The portrait of the fervently awaited crown prince – his first names chosen so as to place him in the dynastic line of the Spanish royal ancestors and to presage a felicitous future – was probably painted in 1659, but not as a pendant of the portrait of his sister Margarita (cat. 45). According to Palomino, it was sent together with the latter to emperor Leopold I in Vienna:

> In that year of 1659, Velàzquez executed by order of His Majesty two portraits to be sent to the Emperor in Germany. One was that of the Most Serene Prince of Asturias, Don Philip Prosper, who was born on Wednesday, the 28th of November of the year 1651 [printer's error for 1657], at eleven thirty in the morning. It is one of the finest portraits he ever painted, in spite of how difficult it is to portray children on account of their liveliness and restlessness. He painted him standing and in the clothes appropriate to his tender years; next to him, on a plain stool, is a hat with white plumes; on the other side there is a crimson chair on which he rests his hand lightly. In the upper part of the picture there is a curtain; at the back of the room is painted an open door; everything [is] done with the utmost grace and art and with the beauty of colour and the grand manner of this illustrious painter. On the chair is a little bitch that seems alive and is the likeness of one for which Velázquez felt great affection. It seems that the same thing happened to him as to the excellent painter Publius, who portrayed his beloved little bitch Issa so as to make her immortal, as Martial wittily says, and he could have also said it about Velázquez: 'So that death should not rob him of her completely, Publius portrayed her in a picture, in which you will see an Issa so like her that not even she is so like herself. Put Issa alongside her picture; you will think that they are both painted; you will think that they are both real.' (Martial, *Epigrammata* 1, 110)[2]

Palomino added that the two portraits, along with a (now lost) miniature portrait of Queen Mariana, were among Velázquez's last and most consummate works. His description (or that in his sources) and the reflections on image and reality in art with its reference to Martial can hardly be improved on; nevertheless, they are part of the ekphrastic repertoire, just

as the utilisation of the portrait for status belongs to the tradition of courtly portraiture: drapery, chair,[3] carpet,[4] dog, hat, the view into the room behind the subject[5] reveal the successor to the throne, a scenario in miniature, as it were, a combination of poignant insight into the *conditio humana* of the sickly prince and the demands of courtly decorum. Though the prince wears a child's attire[6] – over the red, silver-embroidered dress he has on a white, fine, indeed cunningly made pinafore which allows the red garment to shine through – he also has an amulet against the evil eye, an amber apple against infections, and small bells, which inform of the little prince's whereabouts, indications of the Madrid court's anxiety about mishap and illness befalling the Infante.

Velázquez was silent about the actual health of the crown prince, probably the only time in his career as court painter that he was so restrained; yet we sense behind the prince's transparent white skin and his 'wobbly' head not only physical weakness but also the fragile mental state of the child, who did indeed suffer an early death on 1 November 1661. The Venetian ambassador to the Madrid court, Giacomo Querini, provided this diagnosis in early September 1661:

> His condition is delicate, his movements sluggish, no colour in his face 'all'Austriaca' [that is, in the Habsburg mould], his mouth hangs open; he has blue eyes and a large head, no bounce in the knees, to use an expression for weakness and frailty. It was His Highness's pleasure in this state to recover the whole time in the arms of the Franciscan Father Antonio di Castilla, already 74 years old. And although the latter's inexperience put him frequently in danger (of dropping [the prince]), the priest was not allowed to leave him alone.[7]

Whereas the portraits of the Infante's sisters, María Teresa and Margarita, are characterised as the epitome of arrogance tempered with naivety, with Felipe Próspero this scenario of courtly aggrandisement and formality seems to emphasise the expression of helplessness and fragility. W P

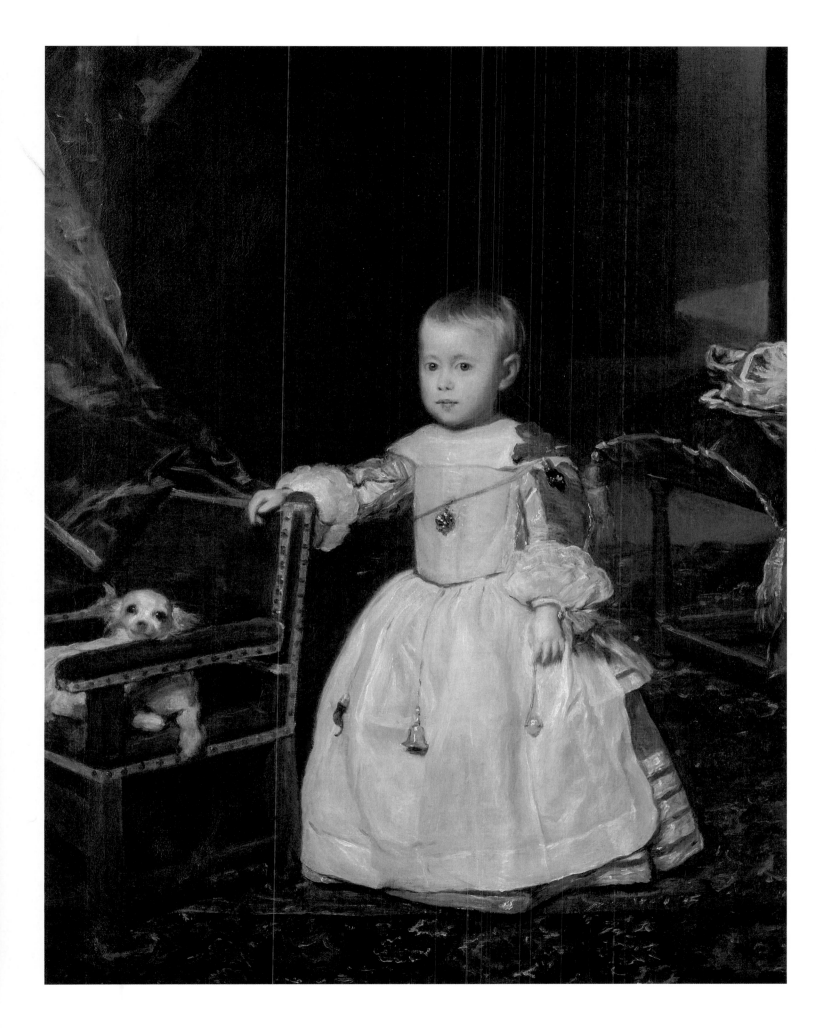

1 Dietrich in Vienna 1996, no. 39: paint films from the stretcher bars are visible at left and bottom edges, while they are missing at right and top edges. This suggests a reduction of the format at right and top by at least 6 cm.

2 Palomino 1724 (1987) pp. 172ff.

3 The proportions of a chair are a prime method of creating an image of childhood in the eye of the beholder.

4 Velázquez rarely places his royal models on elaborate knotted carpets (in this case it is a so-called Isfahan carpet); it happens more frequently in the later period than in the 1620s and 30s where there is a predominance of bare, undefined floors (see, however, the portraits of Baltasar Carlos of about 1631 in Boston and London); in Van Dyck's dark and warmly hued portraiture, especially of the Genoese aristocracy, the models nearly always stand on knotted carpets.

5 Only the latest restoration in 1995, which involved the reduction of the discoloured and degraded varnish and the removal of altered, touched-up spots, has once more allowed clear interpretation of the spatial situation in which the Infante is standing.

6 The child's pinafore is what distinguishes this late portrait by Velázquez from the portraits of the first, distinctly robust, crown prince from Philip's first marriage, Baltasar Carlos, in Boston and London (Wallace Collection): Madrid 1999–2000, no. 11. On a workshop variant (formerly in the Contini Bonacossi collection, Florence, see López-Rey 1963, no. 335, fig: 310), the Infante is wearing bucket-top boots, trousers, and doublet; his hydrocephalus is clearly visible.

7 Justi (1933), p. 682; Madrid 1999–2000, p. 158. Though we have to be wary of biographical knowledge creeping into the interpretation of the picture, here Velázquez seems to be showing more respect for courtly decorum than his successors did a few years later (e.g. Carreno de Miranda) when portraying the likewise mentally and physically challenged future king Charles II, the last son of Philip IV and the Infanta Mariana.

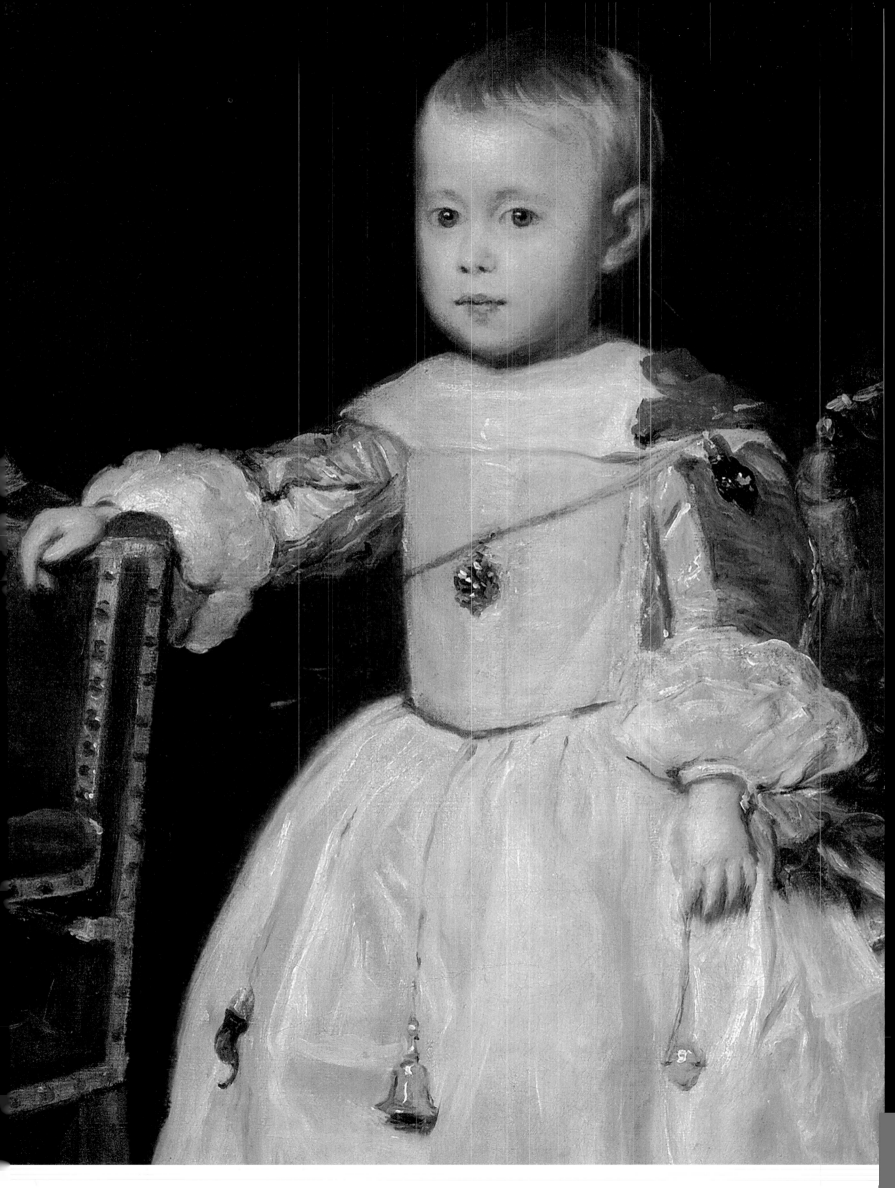

NEAD 1992
L. Nead, *Female Nude. Art, Obscenity and Sexuality*, London and New York 1992

NEAD 2003–4
L. Nead, 'Diego Velázquez: The Toilet of Venus ('The Rokeby Venus')' in London 2003–4, pp. 74–9

NEW YORK 1989–90
Velázquez, eds A. Domínguez Ortíz, A. E. Pérez Sanchez and J. Gállego, exh. cat., Metropolitan Museum of Art, New York 1989

OLSEN 1951
H. Olsen, 'Kardinal Silvio Valenti Gonzaga samling', *Kustmuseets Arsskrift*, Copenhagen 1951

ORMOND 1975
L. and R. Ormond, *Lord Leighton*, London 1975

ORMOND AND PIXLEY 2003
R. Ormond and M. Pixley, 'Sargent after Velázquez: the Prado studies', *Burlington Magazine*, CXLV (2003), pp. 632–40

ORSO 1986
S.N. Orso, *Philip IV and the Decoration of the Alcázar of Madrid*, Princeton 1986

ORTIZ DE ZÚÑIGA 1677
D. Ortiz de Zúñiga, *Anales Eclesiásticos y Seculares de la muy noble y muy leal ciudad de Sevilla*, Madrid 1677

OVIEDO 1999–2000
En Torno a Velázquez Pintura Española del Siglo de Oro, exh. cat., Museo de Bellas Artes de Asturias, Oviedo 1999–2000

PACHECO 1649
F. Pacheco, *El Arte de la Pintura*, Seville 1649

PACHECO 1649 (1956)
F. Pacheco, *Arte de la Pintura*, ed. F.J. Sánchez Cantón, Madrid 1956

PACHECO 1649 (1982)
F. Pacheco, *Arte de la Pintura*, Seville 1649, lib. I, chp VIII, trans E. Harris in Harris 1982, pp. 191–5

PACHECO 1649 (1986)
F. Pacheco, *Arte de la pintura, su antiguedad y grandezas*, Seville 1649, Book III, chaps 1–3 and 5–8, trans. in *Artists' Techniques in Golden Age Spain: Six Treatises in Translation*, ed. and trans. Z. Veliz, Cambridge 1986, pp. 30–106

PACHECO 1649 (1990)
F. Pacheco, *El arte de la pintura*, ed. B. Bassegoda i Hugas, Madrid 1990

PALM 1967
E.W. Palm, 'Diego Velázquez: Aesop und Menip', *Lebende Antike. Symposion für Rudolf Sühnel*, eds H. Meller and H.-J. Zimmermann, Berlin 1967, pp. 207–17

PALOMINO 1715–24
A. Palomino, *El Museo Pictórico y Escala Optica*, 3 vols, Madrid 1715–24

PALOMINO 1724 (1739)
An Account of the Lives and Works of the most Eminent Spanish Painters, Sculptors and Architects; and where their several performances are to be seen: translated from the Musæum Pictorium of Palomino Velasco, London 1739

PALOMINO 1724 (1982)
A. Palomino, *El Museo Pictorico Escala Optica*, Madrid 1715–24, vol. 3, *El Parnaso Espanol Pintoresco Lareado* (1724), trans. E. Harris in Harris 1982, pp. 321–54

PALOMINO 1724 (1987)
A. Palomino, *Lives of the Eminent Spanish Painters and Sculptors*, trans. N. A. Mallory, Cambridge 1987

PANTORBA 1955
B. de Pantorba, *La vida y la obra de Velázquez. Estudio biográfico y crítico*, Madrid 1955

PARDO CANALIS 1978–9
E. Pardo Canalis, 'Una visita a la Galería del Príncipe de la Paz', *Goya: Reviste de Arte*, 148–50 (1978–9), pp. 300–11

PARIS-NEW YORK 2002–3
Manet/Velázquez: The French Taste for Spanish Painting, ed. Gary Tinterow and Genevieve Lacambre, exh. cat., Musée d'Orsay, Paris, and Metropolitan Museum of Art, New York, 2002–3

PENNY 2003
N. Penny, 'The Rack, the Rapier, the Ruff and the Fainting Nun', *London Review of Books*, 10 July 2003, pp. 27–8

PÉREZ ESCOLANO 1977
V. Pérez Escolano, *Juan de Oviedo y de la Bandera*, Seville 1977

PÉREZ LOZANO 1990
M. Pérez Lozano, 'Fuentes y significado del cuadro "Cristo en casa de Marta" de Diego Velázquez', *Cuadernos de Iconografia*, 1990, pp. 55–64

PÉREZ LOZANO 1991
M. Pérez Lozano, 'Velázquez, en el entorno de Pacheco: las primeras obras', *Ars Longa*, 2 (1991), pp. 89–102

PÉREZ LOZANO 1993
M. Pérez Lozano, 'Velázquez y los gustos conceptistas: El Aguador y su destinario', *Boletín del Museo e Instituto Camón Aznar*, 54 (1993), pp. 25–47

PÉREZ SÁNCHEZ 1989–90
A.E. Pérez Sánchez, 'Velazquez and his Art' in New York 1989–90, pp. 21–56

PÉREZ SÁNCHEZ 2004
A.E. Pérez Sánchez, 'Velázquez and the Baroque Portrait' in Madrid 2004, pp. 166–99

PÉREZ VILLANUEVA 1986
J. Pérez Villanueva, *Felipe IV y Luisa Enríquez Manrique de Lara, Condesa de Paredes de Nava. Un epistolario inédito*, Salamanca 1986

PETITOT AND MONMERQUÉ 1827
A. Petitot and J.N. Monmerqué, *Collections des Mémoires relatifs à l'histoire de la France*, 57, Paris 1827

PITA ANDRADE 1952
J.M. Pita Andrade, 'Los cuadros de Velázquez y Mazo que poseyo el septimo Marques del Carpio', *Archivo español de arte*, 25 (1952), pp. 223–36

PONZ (1947)
A. Ponz, *Viaje de España, seguido de los dos tomos del Viaje fuera de España*, ed. de Casto María del Rivero, Madrid 1947

PORTÚS 1996
J. Portús, 'Fray Hortensio Paravicino: a Academia de San Lucas, las pinturas lascivas y el arte de mirar', *Espacio, Tiempo y Forma*, series VII, Ix (1996), pp. 77–106

PORTÚS 1997
J. Portús, 'Las Majas de Goya o el desnudo como género', *Arte y Parte*, 11 (1997), pp. 40–55

PORTÚS 1998
J. Portús, *La Sala Reservada del Museo del Prado y el coleccionismo de pintura de desnudo en la Corte española 1554–1838*, Madrid 1998

PORTÚS 2005
J. Portús, 'Las Hilanderas como fábula artística', *Boletín del Museo del Prado*, 23 (2005), pp. 70–83

POWELL AND RESSORT 2004
V. Powell and C. Ressort, *Ecoles Espagnole et Portugaise*, Musée du Louvre, Paris 2004

PRATER 2002
A. Prater, *Venus at her Mirror*, Munich 2002

PROSKE 1967
G.B. Proske, *Martínez Montañés: Sevillian Sculptor*, New York 1967

QUIN 1824
M.J. Quin, *A visit to Spain*, London 1824

RAMÍREZ-MONTESINOS 1991
E. Ramírez-Montesinos, 'Objetos de vidrio en los bodegones de Velázquez' in *Velázquez y el Arte de su tiempo, V. Jornadas de Arte*, Madrid 1991, pp. 397–404

REDWORTH 2003
G. Redworth, *The Prince and the Infanta*, New Haven and London 2003

REYNOLDS (1856)
W. Cotton, *Sir Joshua Reynolds and his works: gleanings from his diary, unpublished manuscripts, and from other sources*, London 1856

REYNOLDS (1959)
Sir J. Reynolds, *Discourses on Art*, ed. R.W. Wark, London 1959

REYNOLDS (1929)
Letters of Sir Joshua Reynolds, ed. F.W. Hilles, Cambridge 1929

RICO 1991
F. Rico, 'Los filósofos de Velázquez, o el Gran Teatro del Mundo' in *El Siglo de Oro de la pintura española*, Madrid 1991, pp. 345–58

ROBERTSON 1975
I. Robertson, *Los curiosos impertinentes, Viajeros ingleses por España 1760–1855*, Madrid 1975

ROBERTSON 2004
I. Robertson, *Richard Ford 1796–1858, Hispanophile Connoisseur and Critic*, Norwich 2004

ROE 2005
J. Roe, 'The Preacher's *Perspicuitas* and Velázquez's "Truthful Imitation of Nature": An Examination of Scholarly Attitudes to Religious Paintings', *Bulletin of Spanish Studies*, LXXXII, 6 (2005), pp. 735–51

ROME 1999–2000
Velàzquez a Roma, Velàzquez e Roma, ed. A. Coliva, exh. cat., Galleria Borghese, Rome 1999

ROME 2001
Velázquez, eds F.V. Garín Llombart and S. Salort Pons, exh. cat., Fondazione Memmo, Palazzo Ruspoli, Rome 2001

ROSE 1987
I. Rose, 'La segunda visita de González de Sepúlveda a la colección de Manuel Godoy', *Archivo Español de Arte*, LX, 238 (1987), pp. 137–52

RUANO 1993
S. Ruano, *La V. M. Sor Jerónima de la Asunción. Fundadora del Monasterio de S. Clara de Manila y la primera mujer misionera en Filipinas*, Madrid 1993

RUIZ PÉREZ 1999
P. Ruiz Pérez, *De la pintura y las letras. La biblioteca de Velázquez*, Seville 1999

RUSKIN 1903–12
The Works of John Ruskin, eds E.T. Cook and A. Wedderburn, 39 vols, London 1903–12

RUSSELL 2004
F. Russell, *John, 3rd Earl of Bute: Patron & Collector*, London 2004

SAAVEDRA FAJARDO 1640
D. Saavedra Fajardo, *Idea de un príncipe politico-christiano*, Munich 1640

SALAZAR 1928
C. Salazar, 'El testamento de Francisco Pacheco', *Archivo Español de Arte*, 4 (1928), pp. 155–60

SALE CATALOGUES 1711–59
Sale Catalogues of the Principal Collections of Pictures (171 in number) sold by auction in England within the years 1711–1759, in National Gallery Library

SALORT PONS 2002
S. Salort Pons, *Velázquez en Italia*, Madrid 2002

SALTILLO 1944–5
Marqués del Saltillo, 'Un pintor desconocido del siglo XVII: Domingo Guerra Coronel', *Arte Español*, XV (1944–5), pp. 43–8

SÁNCHEZ CANTÓN 1960
Francisco Javier Sánchez Cantón, 'La Venus del espejo', *Archivo Español de Arte* (1960), pp. 137–48

SCHNEIDER 1905
F. Schneider, 'Mathias Grünewald et la mystique du moyen age', *Révue de l'art chrétien*, 48 (1905), pp. 92–4 and 157–8

SCHREIBER 2004
R. Schreiber, 'Ein galeria nach meinem Humor' – Erzherzog Leopold Wilhelm, Vienna 2004

SERRERA 1996
J.M. Serrera, 'Velazquez and Sevillian Painting of his Time' in Edinburgh 1996, pp. 37–44

SERRERA 1999
J.M. Serrera, 'La Adoración de los Reyes Magos, un retrato casi de familia' in *Velázquez*, published by Amigos del Museo del Prado, Barcelona 1999, pp. 251–66

SESEÑA 1991
N. Seseña, 'Los barros y lozas que pintó Velázquez', *Archivo Español de Arte*, 254 (1991), pp. 171–9

SEVILLE 1973
A. Pérez Sánchez, *Caravaggio y el naturalism español*, exh. cat., Reales Alcázares, Seville 1973

SEVILLE 1999
Velázquez y Sevilla. Estudios, exh. cat., Monasterio de la Cartuja de Santa María de las Cuevas, Seville 1999

SEVILLE-BILBAO 2005-6
Da Herrera a Velázquez: el primer naturalismo en Sevilla, eds A.E. Pérez Sanchez and B. Navarrete Prieto, exh. cat., Hospital de los Venerables, Seville and Museo de Bellas Artes de Bilbao 2005-6

SNARE 1848
J. Snare, *Proof on the authenticity of the portrait of Prince Charles (afterwards Charles the First), painted at Madrid in 1623, by Velasquez*, London 1848

SORIA 1949
M.S. Soria, 'An Unknown Early Painting by Velázquez', *Burlington Magazine*, 554, XCI, (1949), pp. 123-8

SORIA 1954
M. Soria, 'Las Lanzas y los Retratos Ecuestres de Velázquez', *Archivo español de arte*, 27 (1954), pp. 93-108

STEVENSON 1895
R.A.M. Stevenson, *The Art of Velázquez*, London 1895

STEVENSON 1902
R.A.M. Stevenson, *Velasquez*, London 1902

STOYE 1952
J.W. Stoye, *English Travellers Abroad, 1604-1667*, London 1952

STIRLING-MAXWELL 1848
W. Stirling-Maxwell, *Annals of the Artists of Spain*, 3 vols, London 1855

STIRLING-MAXWELL 1855
W. Stirling-Maxwell, *Velazquez and his Works*, London 1855

STRADLING 1988
Robert Stradling, *Philip IV and the Government of Spain, 1621-1665*, Cambridge 1988

STRATTON-PRUITT 2002
The Cambridge Companion to Velázquez, ed. S.L. Stratton-Pruitt, Cambridge 2002

STRATTON-PRUITT 2003
Masterpieces of Western Painting. Velázquez's Las Meninas, ed. S.L. Stratton-Pruitt, Cambridge 2003

SUIDA 1958
B. and W. Suida, *Luca Cambiaso. La vita e le opere*, Milán 1958

SWEETMAN 2005
J. Sweetman, 'John Frederick Lewis and the Royal Scottish Academy I: the Spanish connection, *Burlington Magazine*, CXLVII (2005), pp. 310-15

SWINBURNE 1787
H. Swinburne, *Travels through Spain in the years 1777 and 1776*, 2nd edition, London 1787

SZIGETHI 1993
L'Europa della pittura del XVII secolo. 80 capolavori dai musei ungheresi, ed. A. Szigethi, Milan 1993

TATSAKIS 2003
S. Tatsakis, *Spanish Master Drawings from Dutch Public Collections (1500-1900)*, Rotterdam 2003

THORP 1987
N. Thorp, 'Studies in Black and White: Whistler's Photographs in Glasgow University Library' *in James McNeill Whistler: A re-examination*, ed. Ruth E. Fine, Washington, DC, 1987

TIFFANY 2005
J.T. Tiffany, 'Visualizing Devotion in Early Modern Seville: Velázquez's Christ in the House of Martha and Mary', *Sixteenth Century Journal*, XXXVI/2 (2005), pp. 433-53

TOWNSEND 1792
J. Townsend, *A Journey through Spain in the years 1786 and 1787*, London 1792

TREVOR-ROPER 1970
H.R. Trevor-Roper, 'Spain and Europe 1598-1621', *The New Cambridge Modern History*, vol. 4, Cambridge 1970

TROMANS 1996
N. Tromans, 'The iconography of Velázquez's Aesop', *Journal of the Warburg and Courtauld Institutes*, 59 (1996), pp. 332-7

TROMANS 2000
N. Tromans, 'Museum or Market? The British Institution' in *Governing Cultures: Art Institutions in Victorian London*, eds Paul Barlow and Colin Trodd, Aldershot 2000, pp. 44-55

TROMANS 2002
N. Tromans, 'Like splendid dreams realised, David Wilkie's image of Spain', *British Art Journal*, I I, 3 (2002), pp. 35-42

TROMANS 2006
N. Tromans, 'Between the Museum and the Mausoleum: Showing Spain to Britain', in *Redistributions*, Getty/INHA Conference Proceedings, Paris 2006 (forthcoming)

TWISS 1775
R. Twiss *Travels through Portugal and Spain in 1772 and 1773*, London 1775

UMBERGER 1993
E. Umberger, 'Velázquez and Naturalism I: Interpreting *Los Borrachos*,' *Res: Anthropology and Aesthetics* 24 (1993), pp. 21-43

VALDIVIESO AND SERRERA 1985
E. Valdivieso and J.M. Serrera, *Historia de la pintura española. Escuela sevillana, primer tercio del siglo XVII*, Madrid 1985

VAN EIKEMA HOMMES 2004
M. van Eikema Hommes, *Changing Pictures: Discoloration in 15th-17th Century Oil Paintings*, London 2004

VARONA 1999
C. Varona, 'Sobre el supuesto boceto de Las Meninas y otros Velázquez que poseyó el Duque de Arcos', *Symposium Internacional Velázquez*, Seville 1999, pp. 329-40

VARIA VELAZQUEÑA 1960
Varia velazqueña : homenaje a Velázquez en el III centenario de su muerte, 1660-1960, Madrid 1960

VELIZ 1996
Z. Veliz, 'Velázquez's early technique' in Edinburgh 1996, pp. 79-84

VELIZ 1998
Z. Veliz, 'Aspects of Drawing and Painting in Seventeenth Century Spanish Treatises' in *Looking Through Paintings: The Study of Painting Techniques in Support of Art Historical Research*, ed. Erma Hermens, Leiden 1998, pp. 295-319

VÉLIZ 1999
Z. Véliz, 'Retratos de sor Jerónima de la Fuente: iconografía y función' in *Velázquez*, published by Amigos del Museo del Prado, Barcelona 1999, pp. 397-414

VELIZ 2004
Z. Veliz, 'Signs of Identity in *The Lady with a Fan* by Diego Velazquez: Costume and Likeness Reconsidered , *The Art Bulletin*, 86, 1 (2004), pp. 75-95

VENTURI 1882
A. Venturi, *La Regia Galleria Estense in Modena*, Modena 1882 (reprinted 1989)

VERGARA 1999
A. Vergara. *Rubens and his Spanish Patrons*, Cambridge 1999

VERGARA 2002
A. Vergara, 'Velazquez and the North' in Stratton-Pruitt 2002, pp. 48-67

VIARDOT 1860
L. Viardot, *Musées d'Angleterre, de Belgique, de Hollande et de Russie*, Paris 1860

VIENNA 1982
Schloß Ambras, Porträtgalerie zur Geschichte Österreichs von 1400-1800, 2nd edn, Kunsthistorisches Museum, Vienna 1982

VIENNA 1996
Restaurierte Gemälde. Die Restaurierwerkstätte der Gemäldegalerie des Kunsthistorischen Museums 1986-1996, ed. W. Seipel, exh. cat., Kunsthistorisches Museum, Vienna 1996

VOLK 1981
M.C. Volk, 'Rubens in Madrid and the Decoration of the King's Summer Apartments', *Burlington Magazine*, CXXIII, 942 (1981), pp. 513-29

WAAGEN 1854
G.F. Waagen, *Treasures of Art in Britain*, vol. III, London 1854

WATERHOUSE 1951
E. Waterhouse, *Catalogue of an exhibition of Spanish paintings from El Greco to Goya*, Edinburgh 1951

WELLINGTON 1901
E. Wellington, *A descriptive and historical catalogue of the collection of pictures and sculpture at Apsley House, London*, London 1901

WHITE 1998
F. White, J. Pilc and J. Kirby, 'Analyses of Faint Media,' *National Gallery Technical Bulletin*, 19 (1998), pp. 74-95

WHITLEY 1915
W.T. Whitley, *Thomas Gainsborough*, London 1915

WILSON-BAREAU 2003
J. Wilson-Bareau, 'Manet and Spain' in Paris-New York 2002-3, pp. 203-58

WIND 1987
B. Wind, *Velázquez's Bodegones: A Study in Seventeenth-Century Spanish Genre Painting*, George Mason University Press, Fairfax 1987

WIND 1998
B. Wind, *A Foul and Pestilent Congregation: Images of Freaks in Baroque Art*, Ashgate 1998

XIMÉNES 1764
A. Ximénes, *Descripción del Real Monasterio de San Lorenzo del Escorial*, Madrid 1764

YOUNG 1820
J. Young, *A Catalogue of the Pictures at Grosvenor House*, London 1820

YOUNG AND ACKROYD 2001
C. Young and P. Ackroyd, 'The Mechanical Behaviour and Environmental Response of Painting to Three Types of Lining Treatment' in *National Gallery Technical Bulletin*, 22 (2001), pp. 85-104

ZIMMERMANN 1905
H. Zimmermann, *Zur Ikonographie des Hauses Habsburg*, Jahrbuch der kunsthistorischen Sammlungen des Allerhöchsten Kaiserhauses 25, 1905

ZUCCARI, VELIZ AND FIELDER 2005
F. Zuccari, Z. Veliz and I. Fielder, 'Saint John in the Wilderness: Observations of Technique, Style, and Authorship' in *Conservation at the Art Institute of Chicago*, New Haven and London 2005

INDEX

Numbers in *italics* refer to illustrations

LIST OF LENDERS

PHOTOGRAPHIC CREDITS